779.9688 W959t
Ten frames per second
:an animated adventure /
Wu

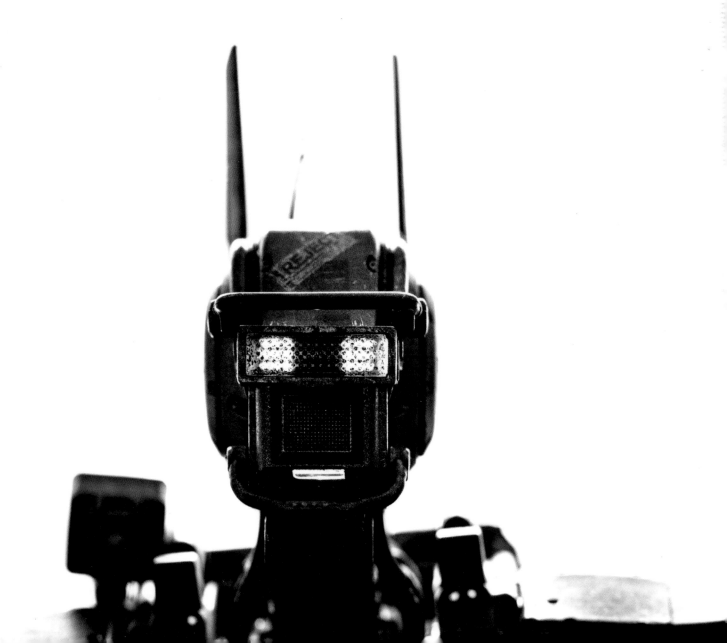

Nick Barrucci, CEO / Publisher
Juan Collado, President / COO

Joe Rybandt, Executive Editor
Matt Idelson, Senior Editor
Anthony Marques, Associate Editor
Kevin Ketner, Editorial Assistant

Jason Ullmeyer, Art Director
Geoff Harkins, Senior Graphic Designer
Cathleen Heard, Graphic Designer
Alexis Persson, Graphic Designer
Chris Caniano, Digital Associate
Rachel Kilbury, Digital Assistant

Brandon Dante Primavera, V.P. of IT and Operations
Rich Young, Director of Business Development

Alan Payne, V.P. of Sales and Marketing
Janie MacKenzie, Marketing Coordinator
Pat O'Connell, Sales Manager

DYNAMITE®
WWW.DYNAMITE.COM

Dynamite addresses:
113 Gaither Dr., STE 205
Mt. Laurel, NJ 08054
Online at www.DYNAMITE.com
On Facebook /Dynamitecomics
On Instagram /Dynamitecomics
On Tumblr dynamitecomics.tumblr.com
On Twitter @dynamitecomics
On YouTube /Dynamitecomics
First Print
10 9 8 7 6 5 4 3 2 1
Standard Edition ISBN: 978-1-5241-0462-7
Kickstarter Exclusive Edition ISBN: 978-1-5241-0675-1

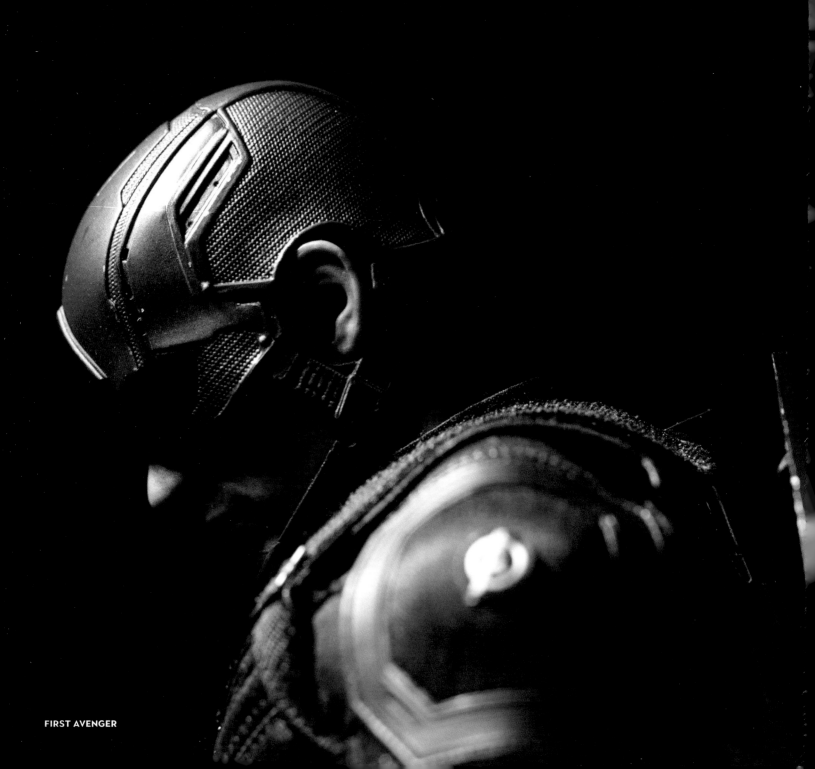

FIRST AVENGER

TEN FRAMES PER SECOND

BY SGT BANANAS/JOHNNY WU

AN ARTICULATED ADVENTURE

THANK YOU

I'd like to take this opportunity to thank everyone who
supported and purchased my book. You've made this experience
something I'll remember for the rest of my life.

I'd also like to thank anyone and everyone who's supported me
throughout my journey. Friends and family, you know who you are.

Thanks especially to my mom for always supporting me and giving
me a great childhood. From making me the best Halloween costumes
to surprising me with cool toys, she always made it memorable.

To the Instagram toy community, I honestly owe all this to you. Without
your support and words of encouragement I don't know if I would have
kept the same drive to push forward and see what was possible.

Last but certainly not least I'd like to take this time to thank all the companies
who have helped me along the way. Having support from companies that
make the toys I love is hard to put into words. You are all amazingly awesome!

BLUFIN
THREEA/THREEZERO
BEAST KINGDOM
HEROCROSS
COMICAVE
NECA
ACID RAIN
DISNEY INFINITY
JAKKS PACIFIC
ARTICULATED ICONS
MONDO
ASMUS COLLECTIBLES

Special thanks to Crystal Nuccio for being the
best mentor I could ask for. Her knowledge of
photography and photoshop played a crucial role in
this book and in many of the photos included here.

CAMERA ROLL

8 PIZZA TIME!
30 BLIND BOX
54 STICKS AND STONES
60 INFINITY AND BEYOND
74 IT'S A SNAP!
100 TOY-POCALYPSE
106 GREAT SCOTT!
114 MEDIEVAL TIMES
120 SPACE INVADERS
130 BOTS
144 HEROES AND VILLAINS
162 THE WOOKIEE
168 SLICE AND DICE
176 POSABLE JOKES
194 BACKSTAGE

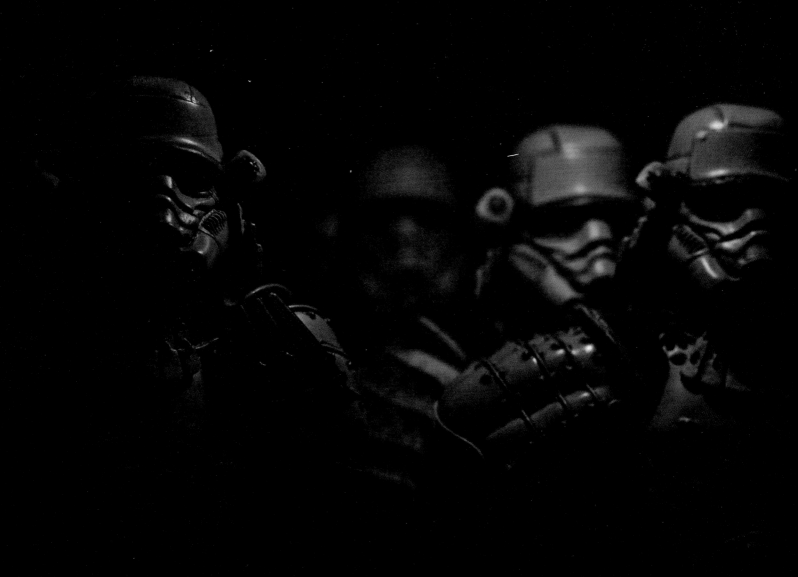

Have you ever imagined seeing the world through the eyes of a toy? When I was young all I wanted to do was play with toys. The most excited I ever got as a kid was when I got a new action figure. I would proudly display them on my dresser for everyone to see. Fast forward 25 years, and not much has changed. I still get just as excited by the arrival of a new toy—maybe more excited. TEN FRAMES is the culmination of my childhood imagination joining my newfound love for photography. I hope this book will transport you back to being a kid playing with your toys in your room or backyard. As a lifelong toy fan and collector, I've always had wild ideas in my head about how toys can tells stories, and it wasn't until I started taking photos of them that I realized my true passion in life. Follow me and these toys on an adventure across time and imagination, and you'll be reminded of what it's like to believe in worlds where anything is possible.

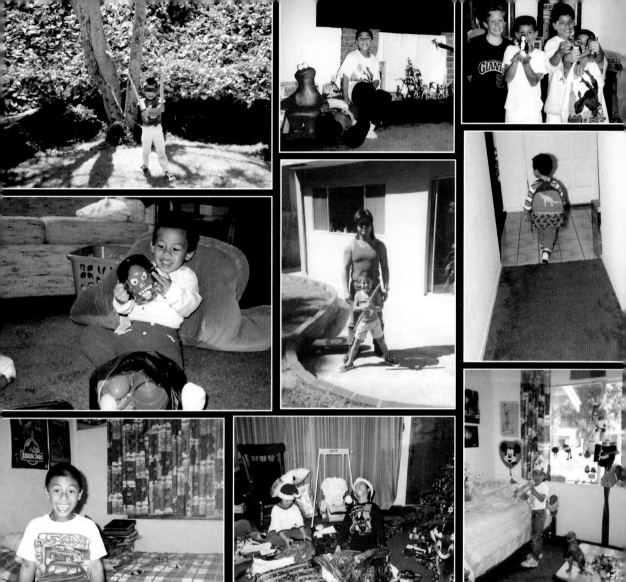

THE BEGINNING

This is where is all started. From dressing up as a ninja turtle, to opening the best present ever on Christmas, and proudly displaying my collection by the fireplace I think you get what I mean when I say pure happiness.

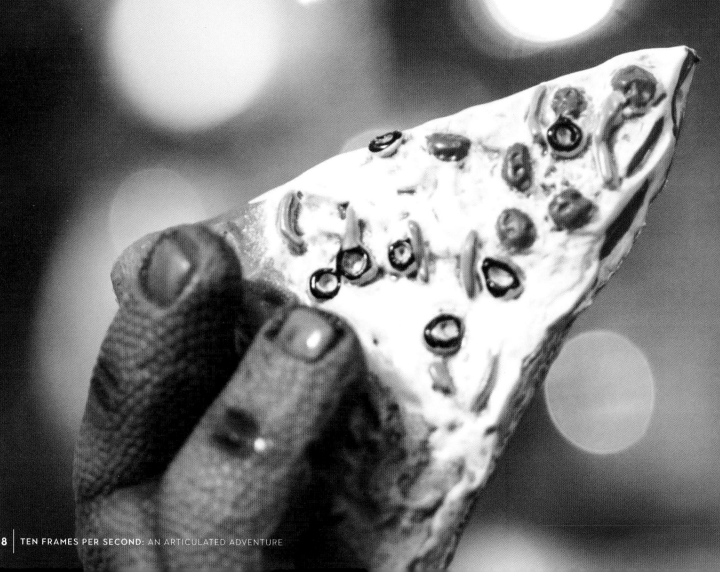

PIZZA TIME!

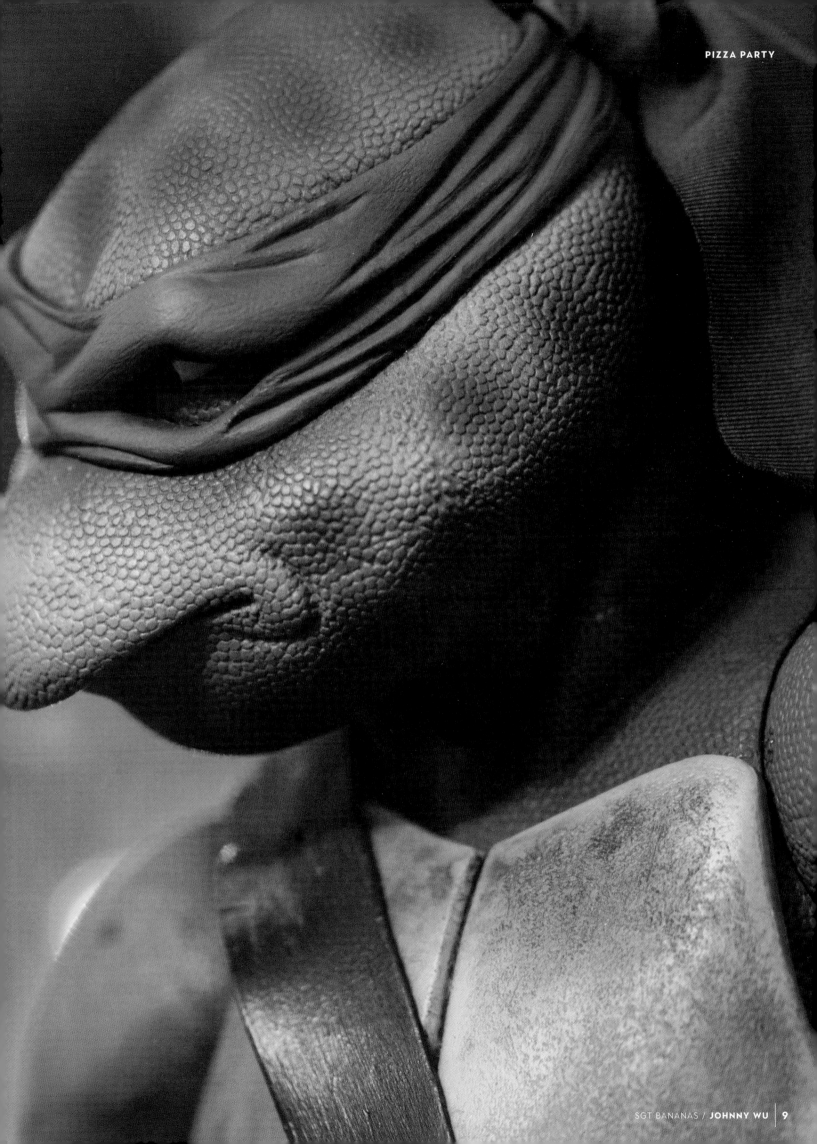

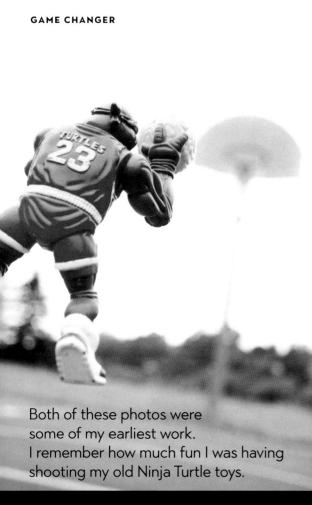

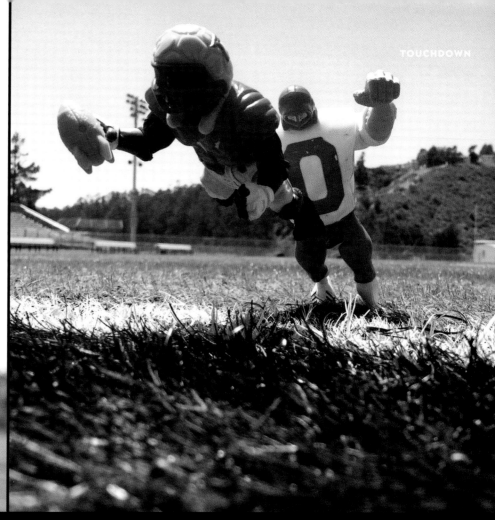

Both of these photos were some of my earliest work. I remember how much fun I was having shooting my old Ninja Turtle toys.

At the time, I was obsessed with making the toys look like they were in action. This would become an ongoing theme in my photos.

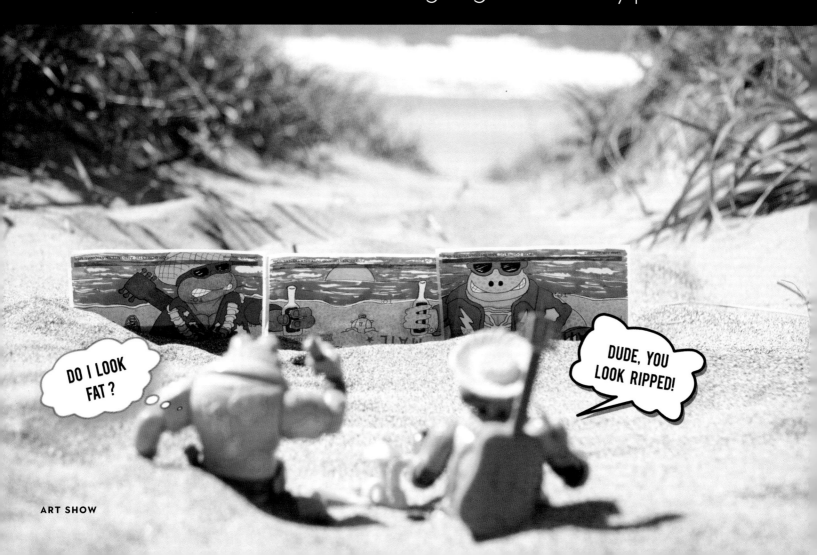

There's something about the old
TMNT toy line that no other line has.
The variety of characters and
costumes they wore are still
unmatched in my opinion.
These beach themed turtles are
some of my absolute favorites.
This photo is how I imagined
they'd be partying on the beach.

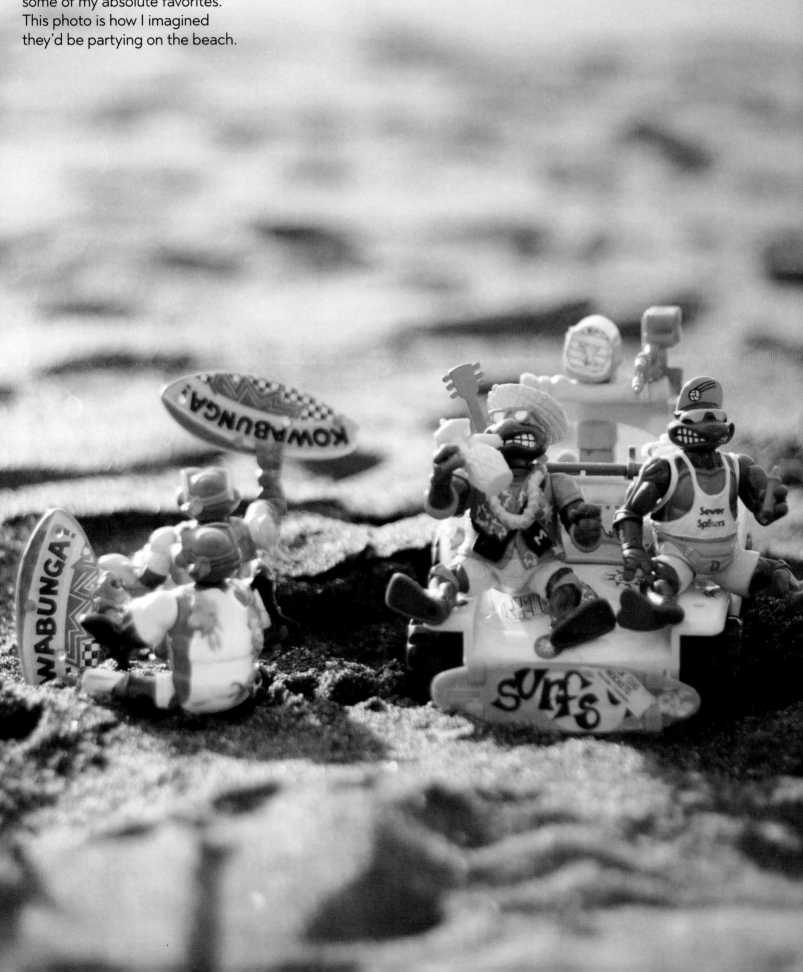

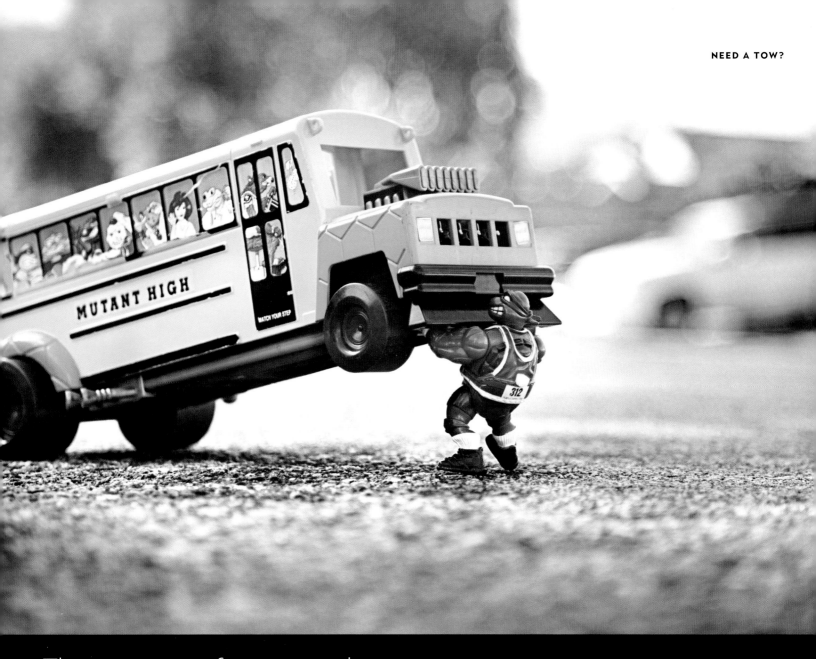

This one was a fun one to shoot.
Sometimes the idea comes straight from the toy itself ...
so I tried to use this character to his strengths.

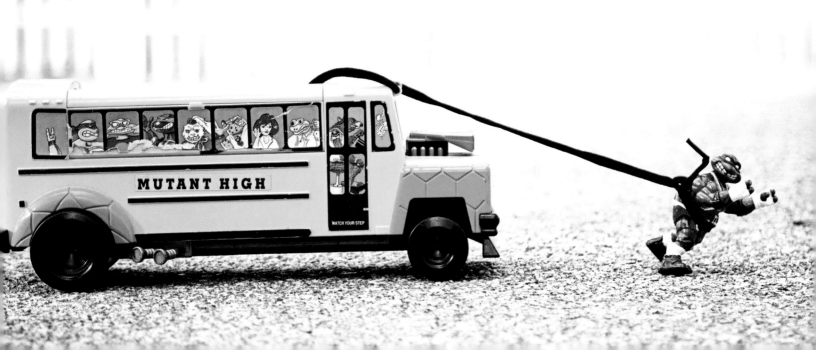

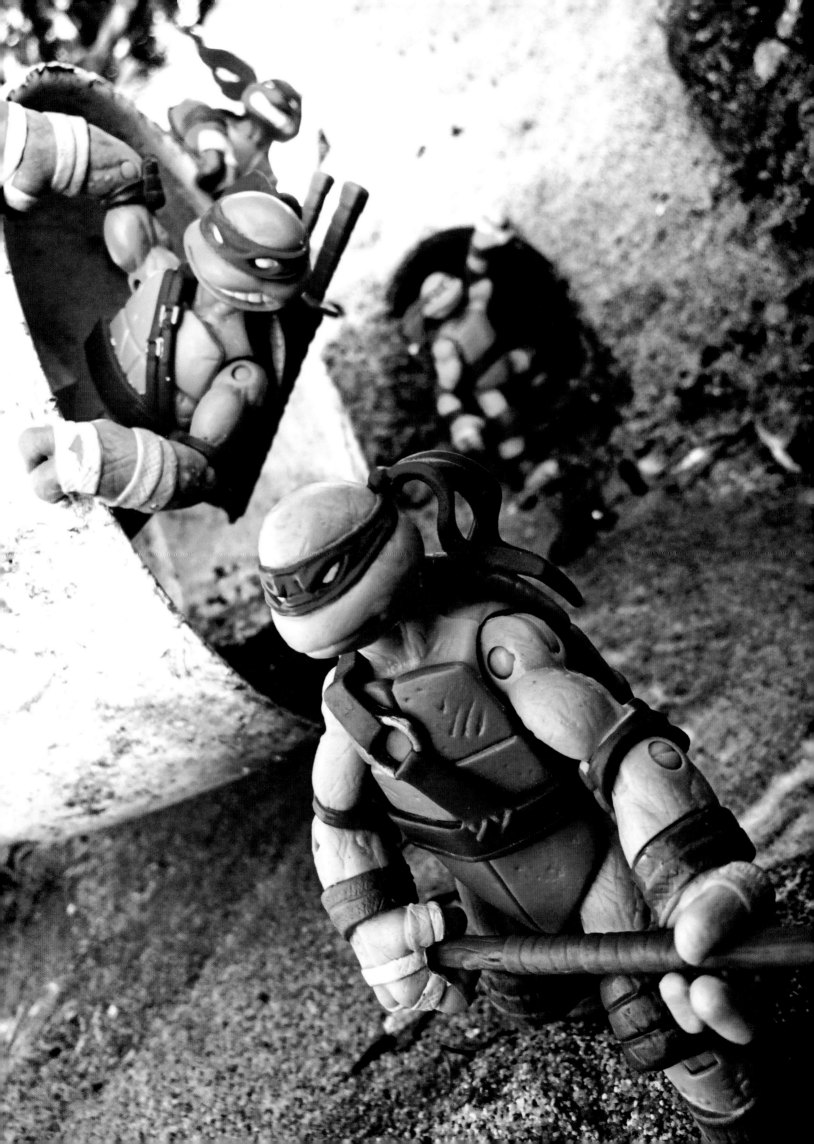

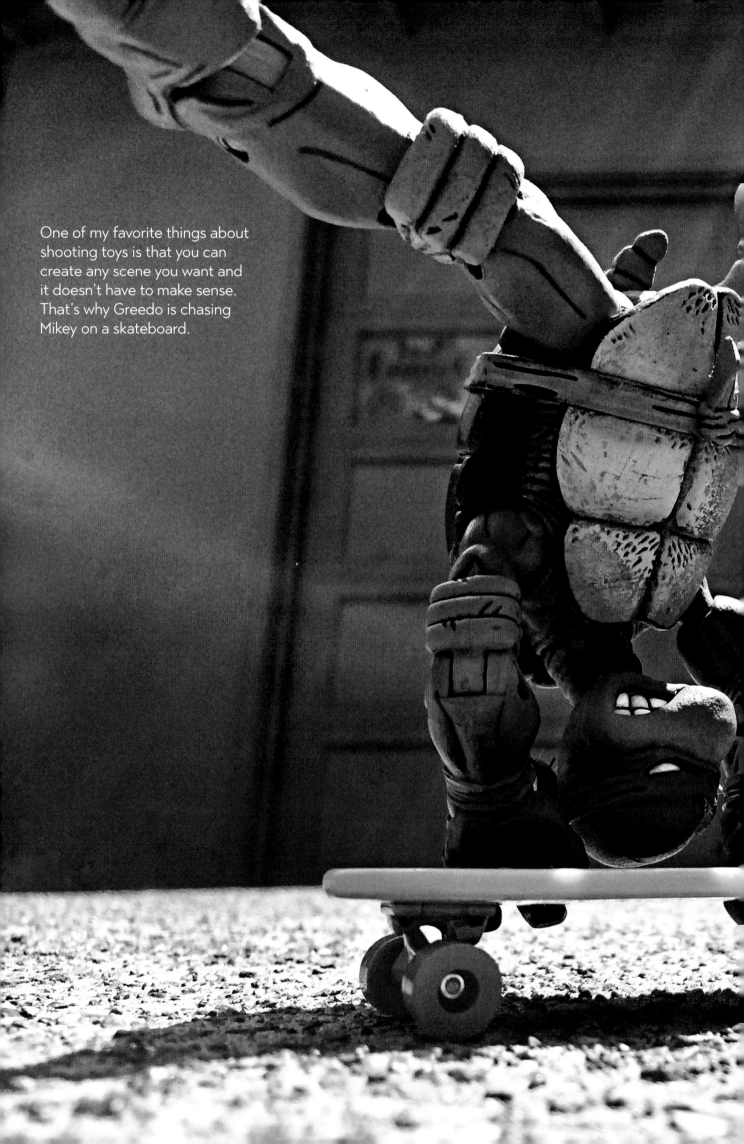

One of my favorite things about shooting toys is that you can create any scene you want and it doesn't have to make sense. That's why Greedo is chasing Mikey on a skateboard.

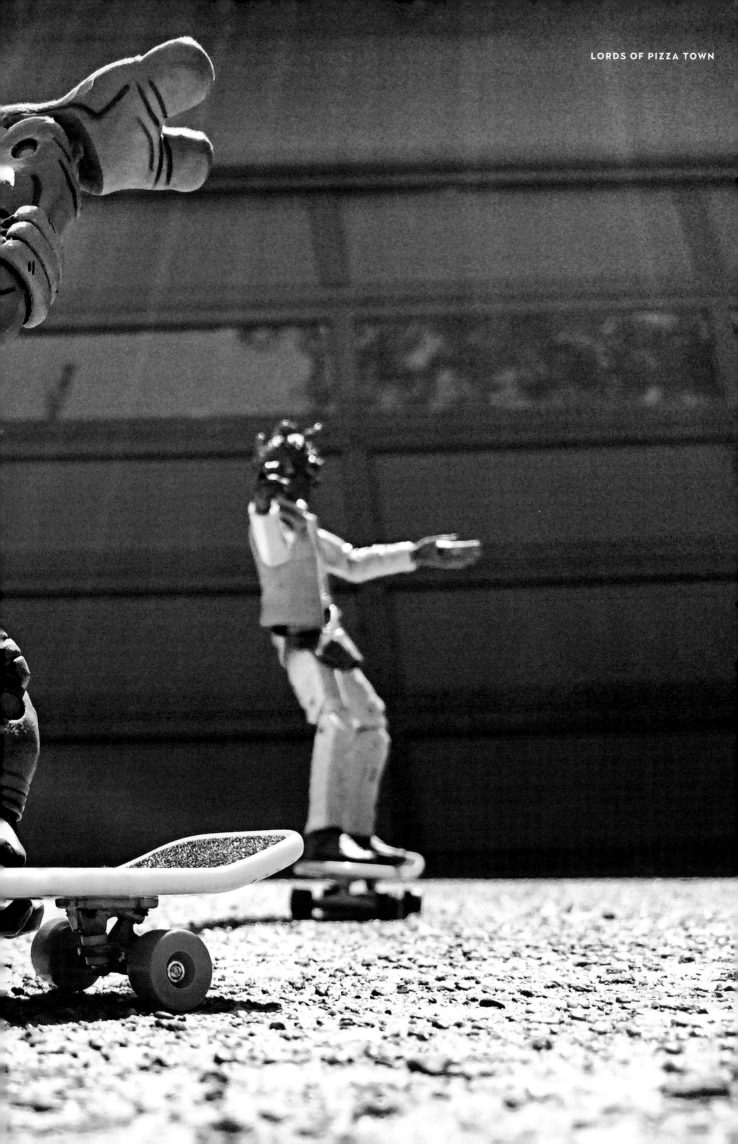

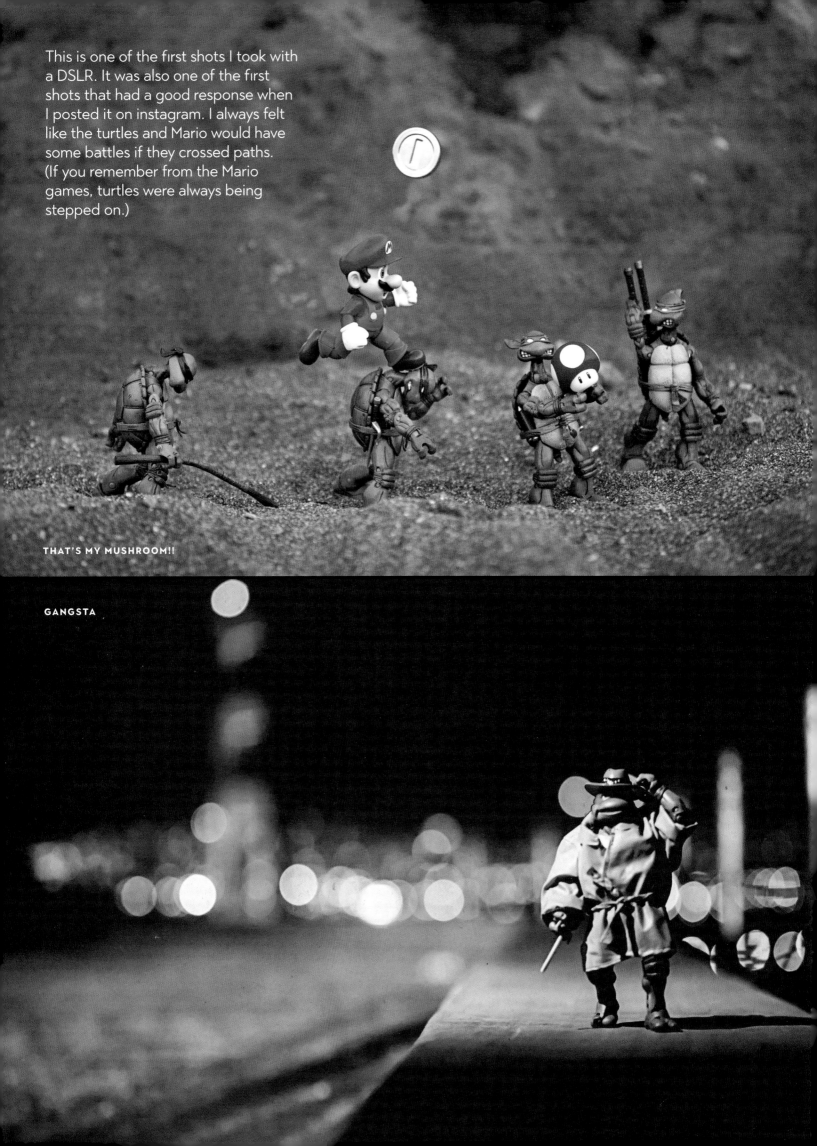

This is one of the first shots I took with a DSLR. It was also one of the first shots that had a good response when I posted it on instagram. I always felt like the turtles and Mario would have some battles if they crossed paths. (If you remember from the Mario games, turtles were always being stepped on.)

THAT'S MY MUSHROOM!!

GANGSTA

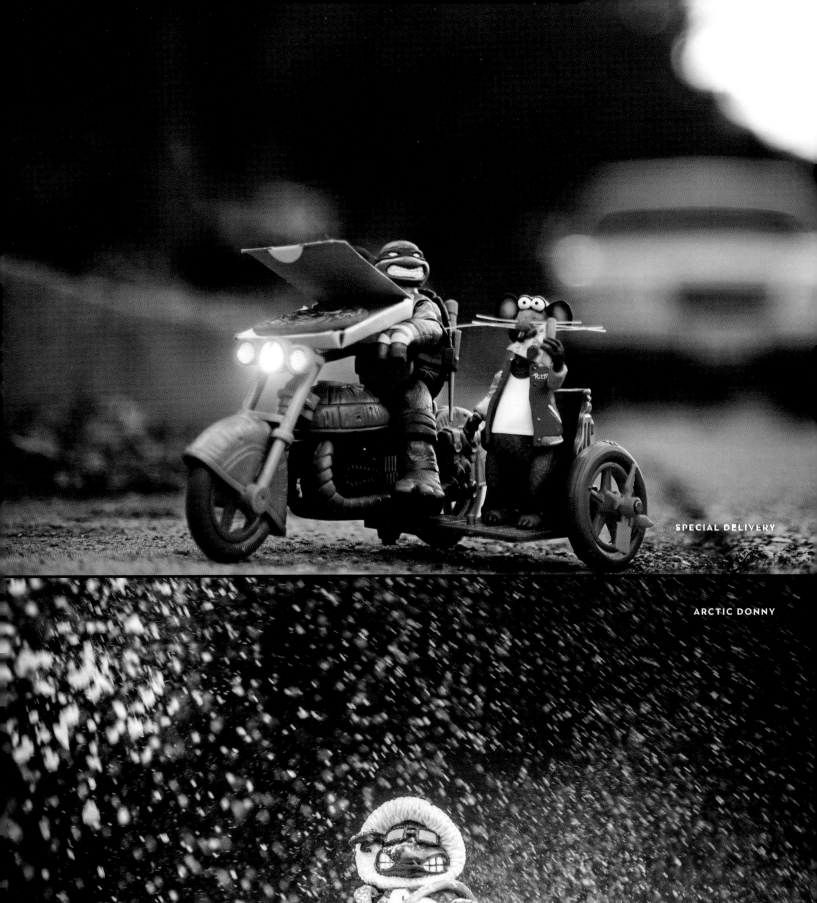

SPECIAL DELIVERY

ARCTIC DONNY

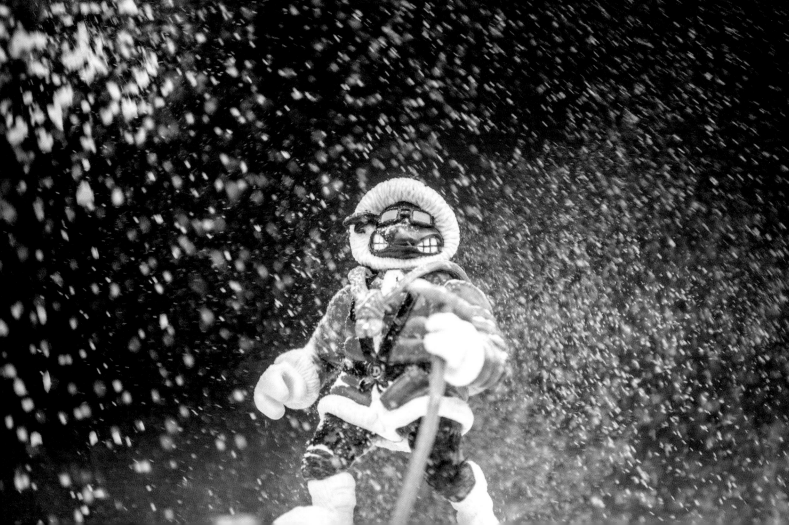

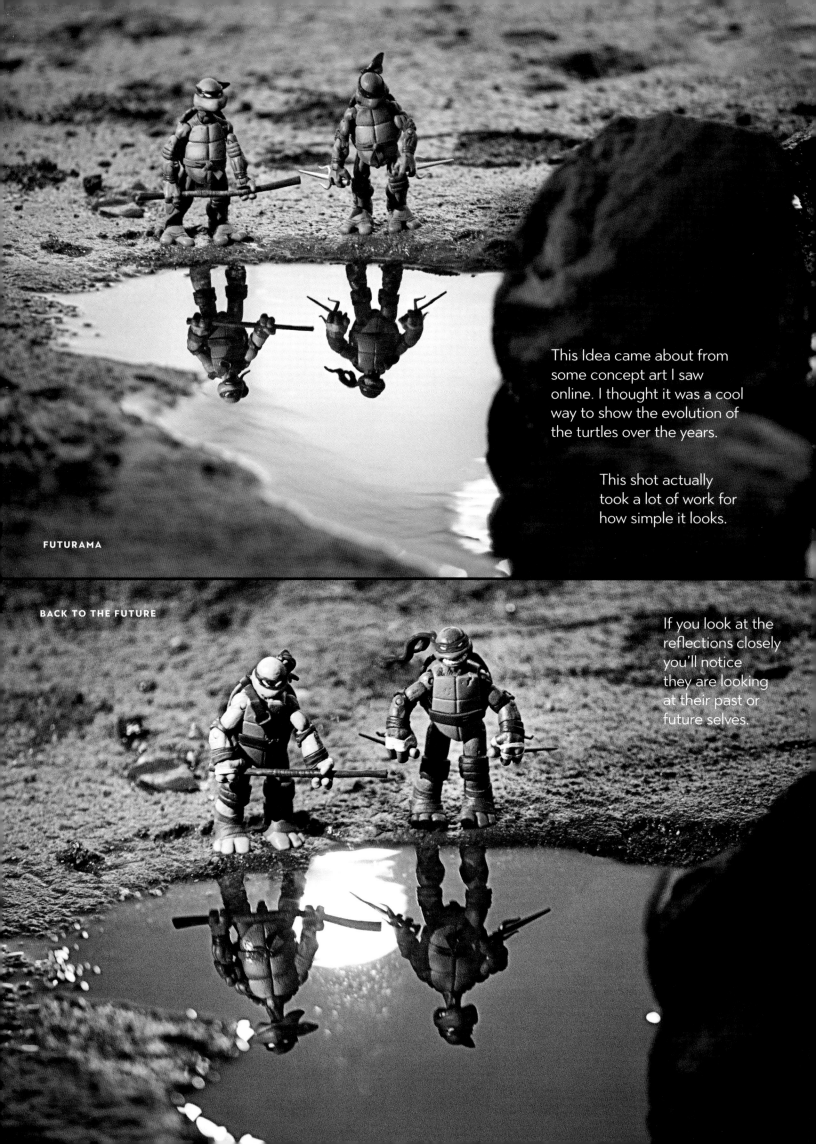

FUTURAMA

This Idea came about from some concept art I saw online. I thought it was a cool way to show the evolution of the turtles over the years.

This shot actually took a lot of work for how simple it looks.

BACK TO THE FUTURE

If you look at the reflections closely you'll notice they are looking at their past or future selves.

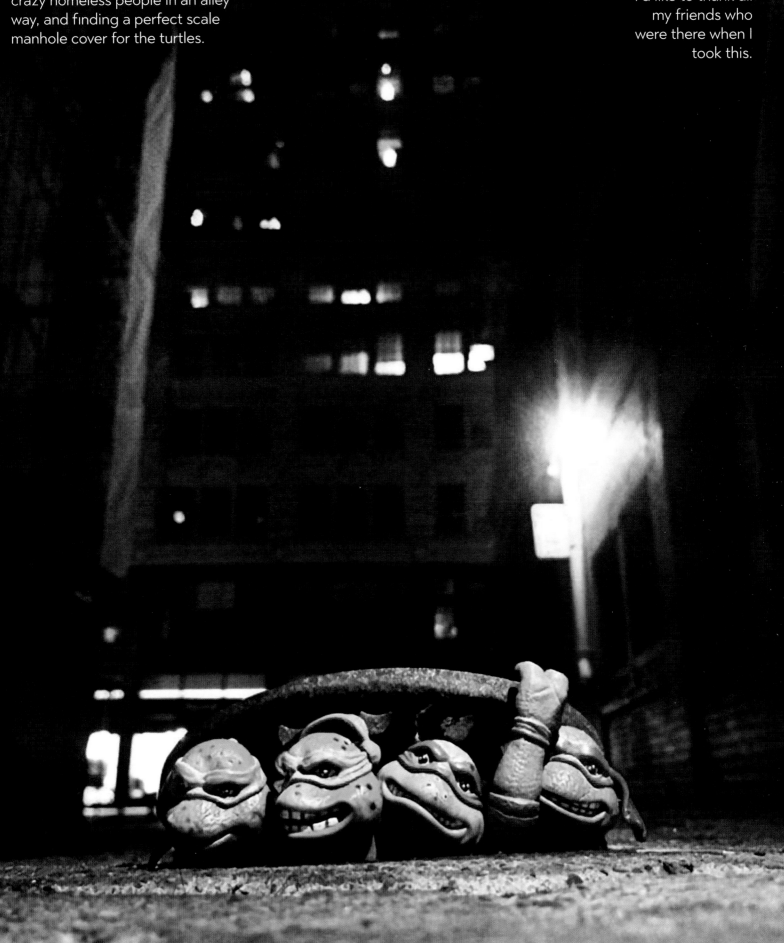

Once in a while a photo I take becomes an instant favorite. This photo is definitely one of those.

So much went into getting this shot—from walking around the city at night with friends, to avoiding crazy homeless people in an alley way, and finding a perfect scale manhole cover for the turtles.

I think this shot is around three years old now and I still love it even today. I'd like to thank all my friends who were there when I took this.

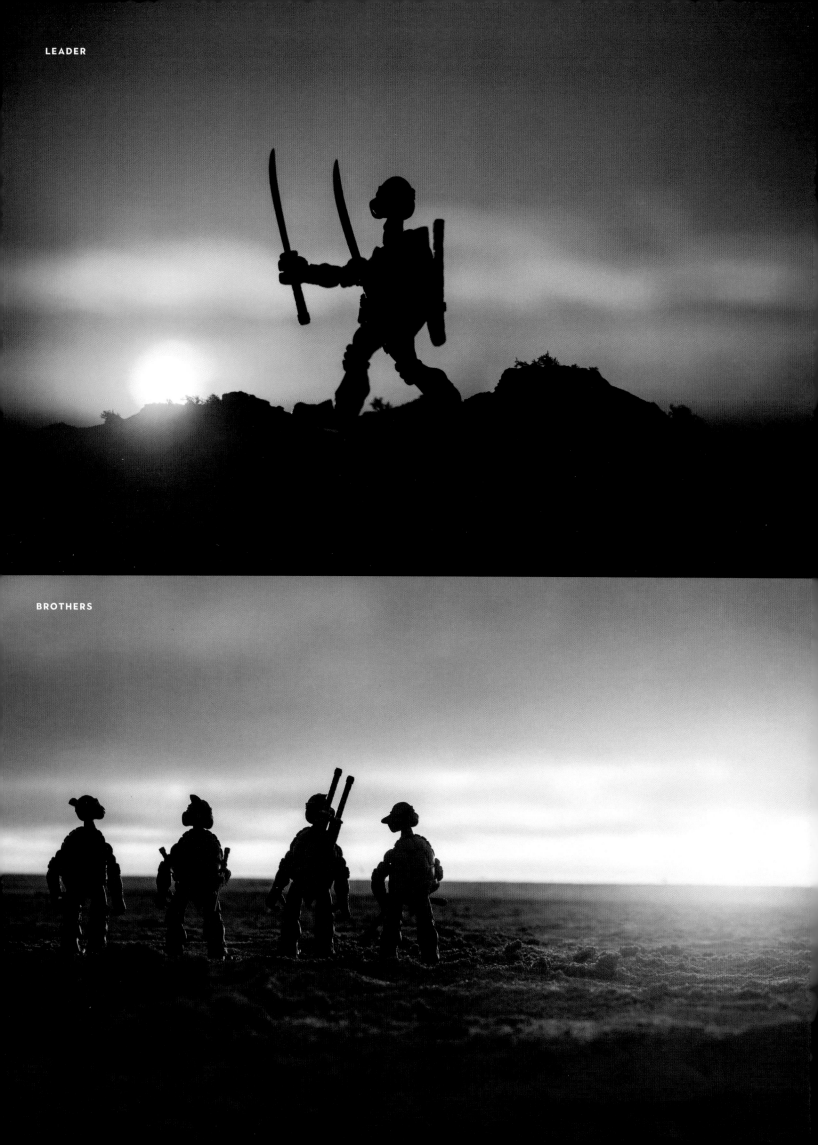

LEADER

BROTHERS

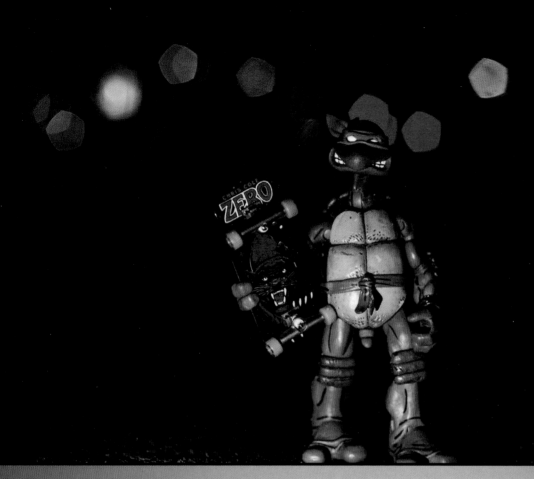

I took this shot and dedicated it to pro skater Chris Cole, who later reposted it on his page. Having someone so well respected in the skating community share my work was definitely a highlight.

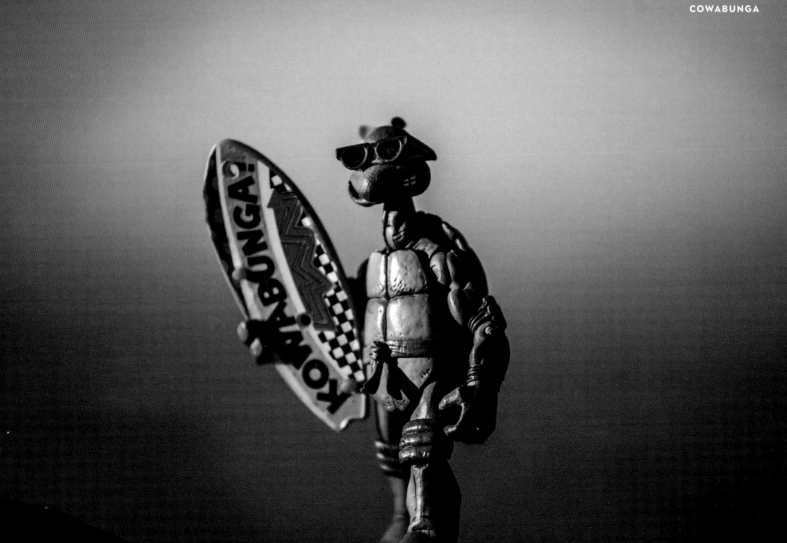

COWABUNGA

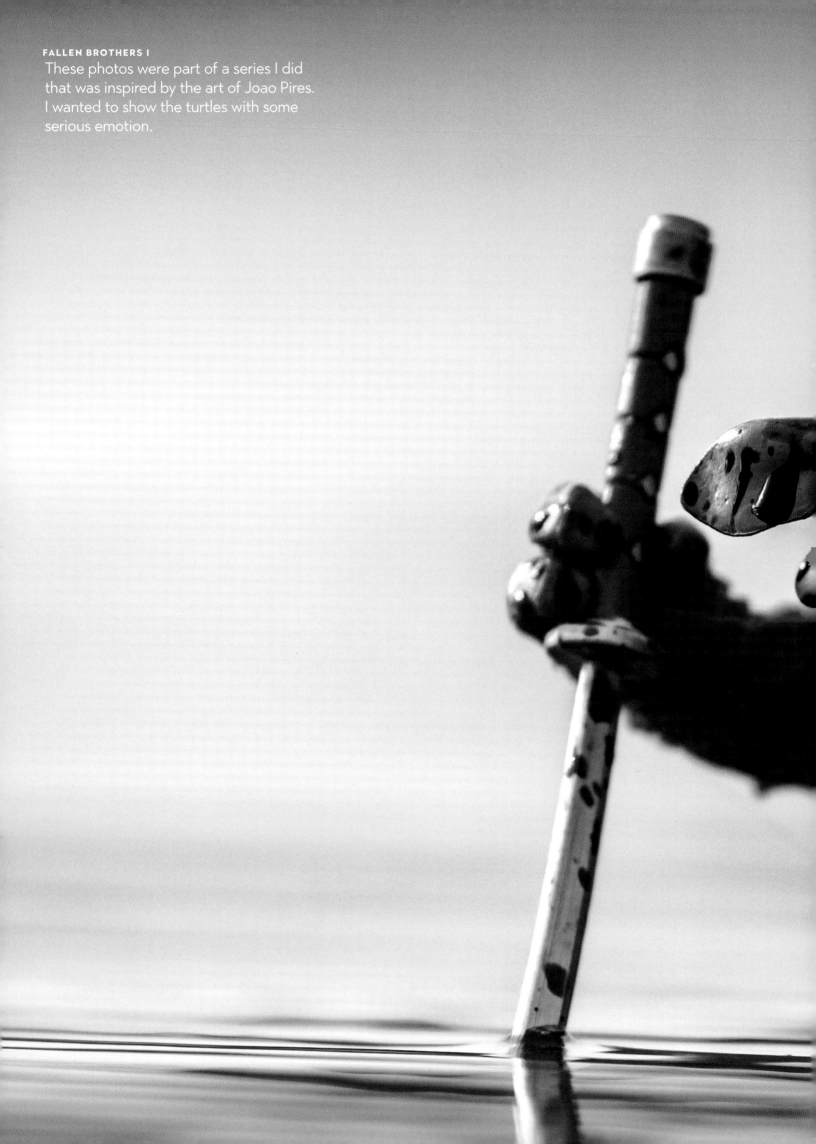

FALLEN BROTHERS I
These photos were part of a series I did
that was inspired by the art of Joao Pires.
I wanted to show the turtles with some
serious emotion.

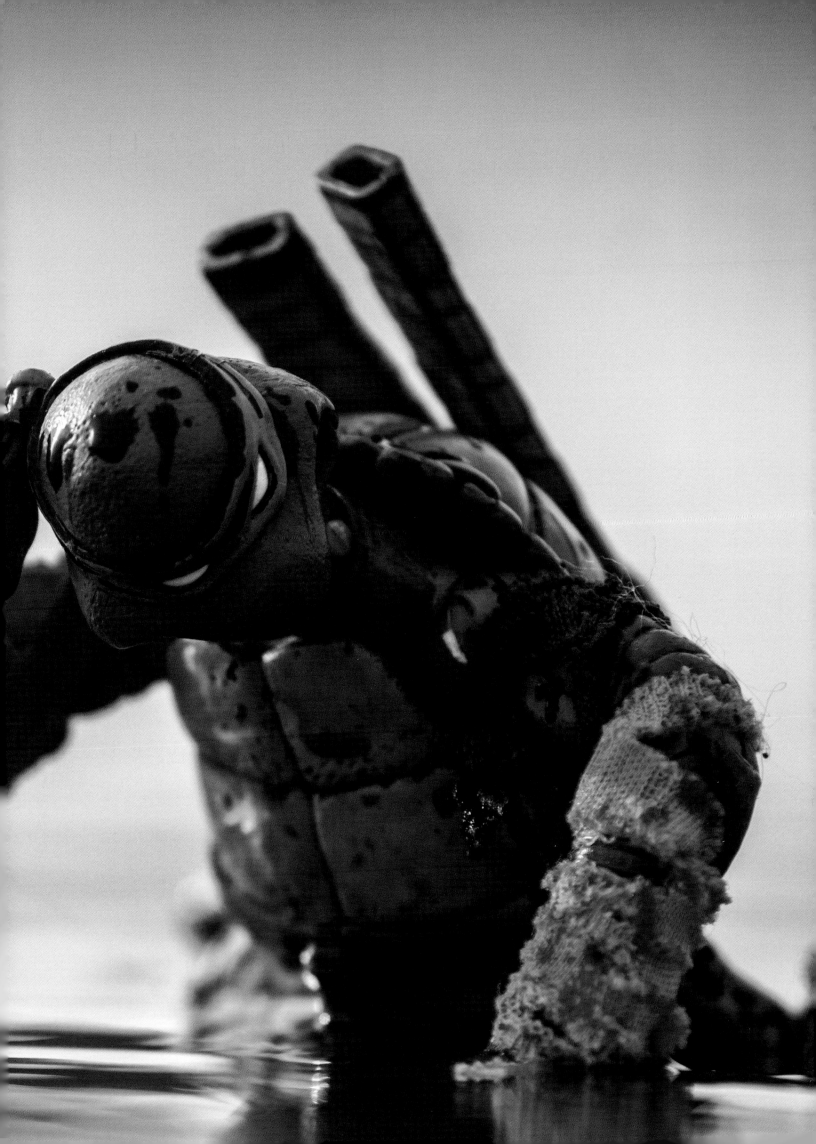

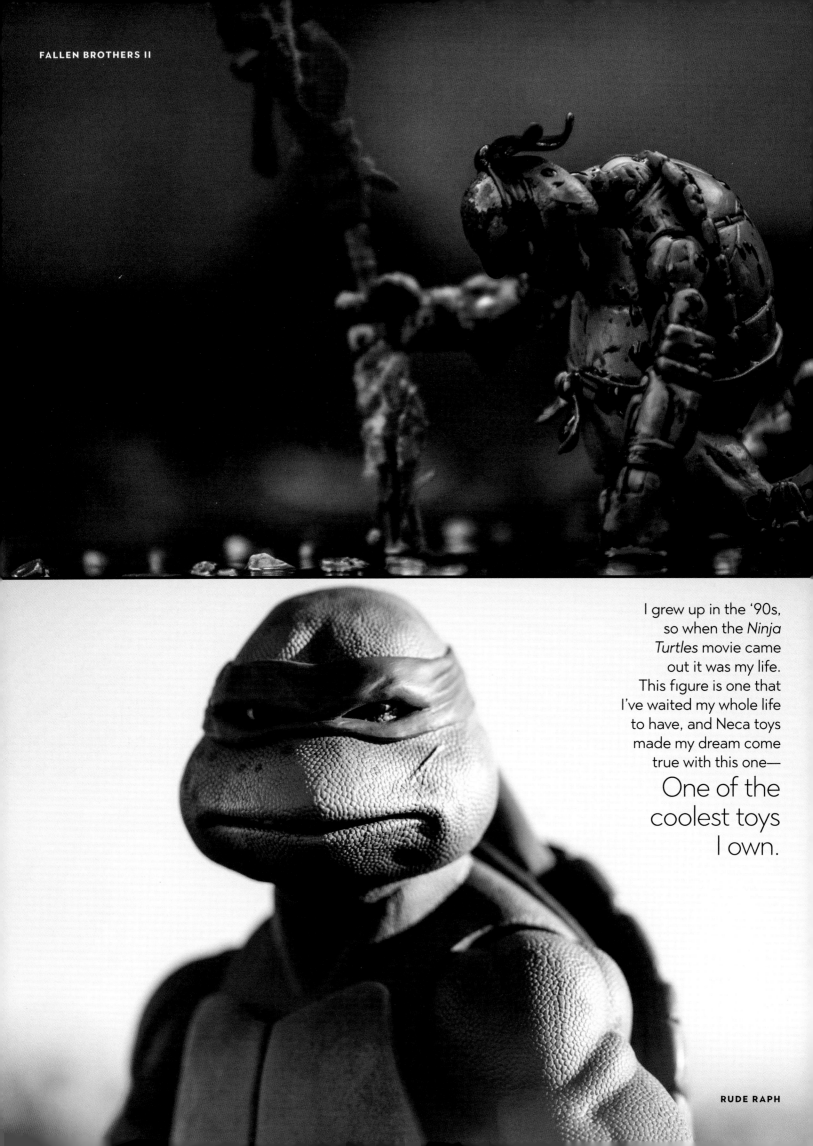

I grew up in the '90s, so when the *Ninja Turtles* movie came out it was my life. This figure is one that I've waited my whole life to have, and Neca toys made my dream come true with this one—

One of the coolest toys I own.

RUDE RAPH

EYE ON THE SLICE!

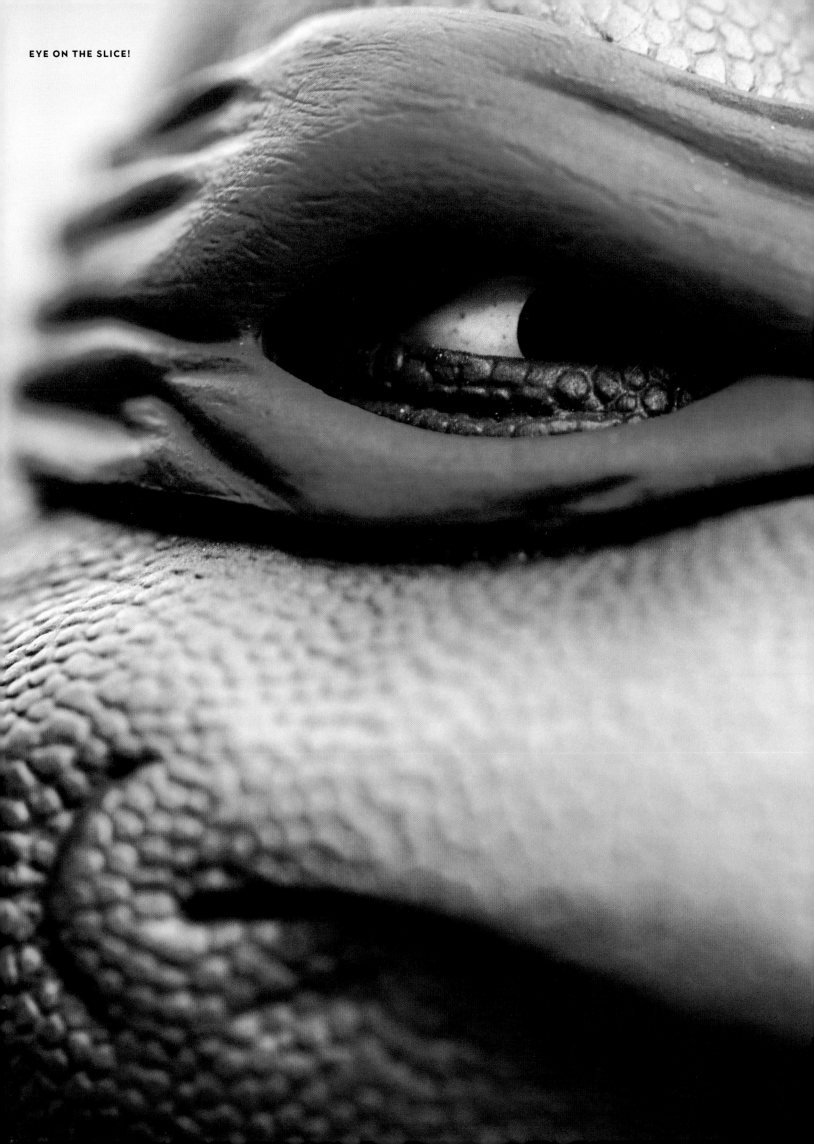

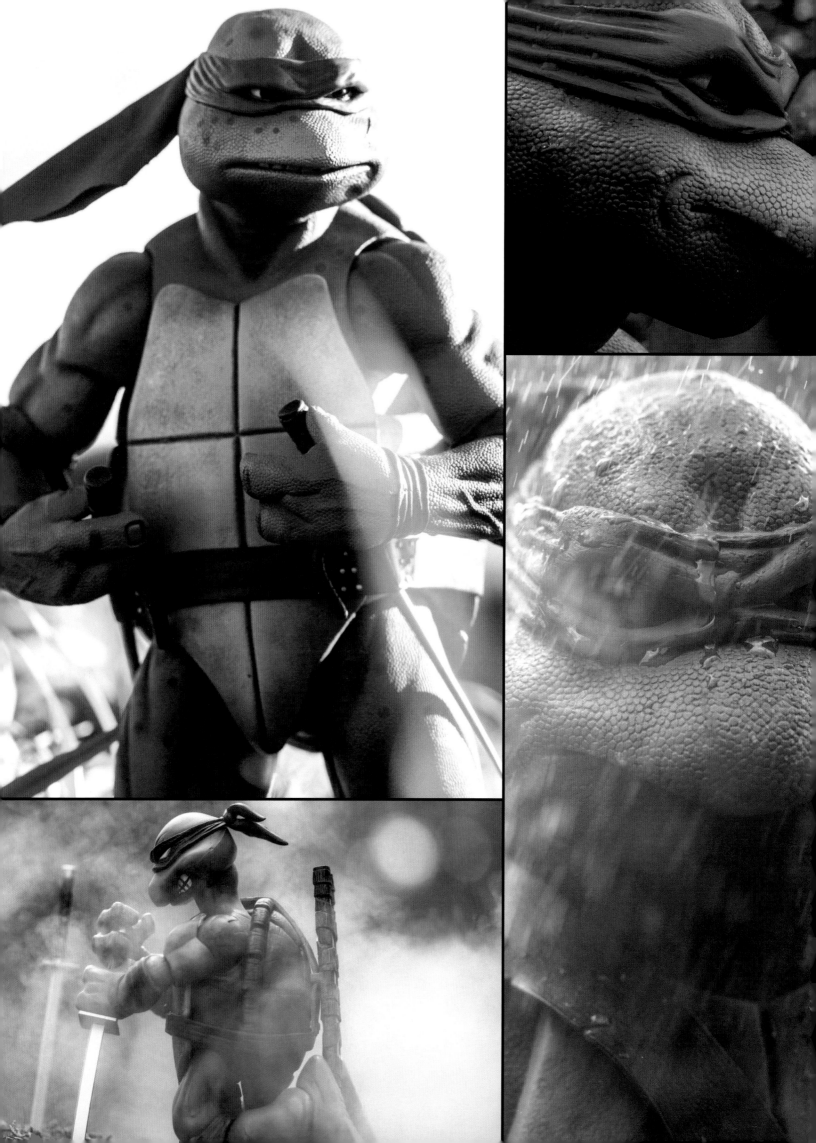

NUMERO UNO

BLIND BOX

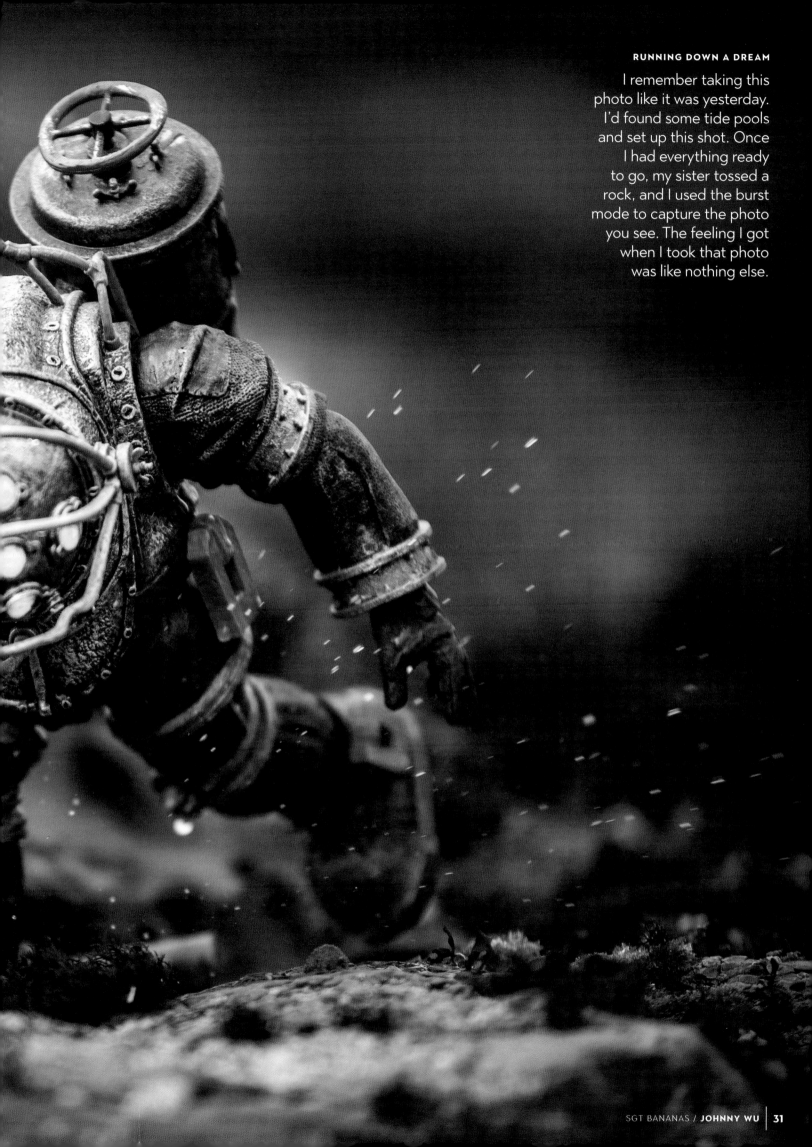

I remember taking this photo like it was yesterday. I'd found some tide pools and set up this shot. Once I had everything ready to go, my sister tossed a rock, and I used the burst mode to capture the photo you see. The feeling I got when I took that photo was like nothing else.

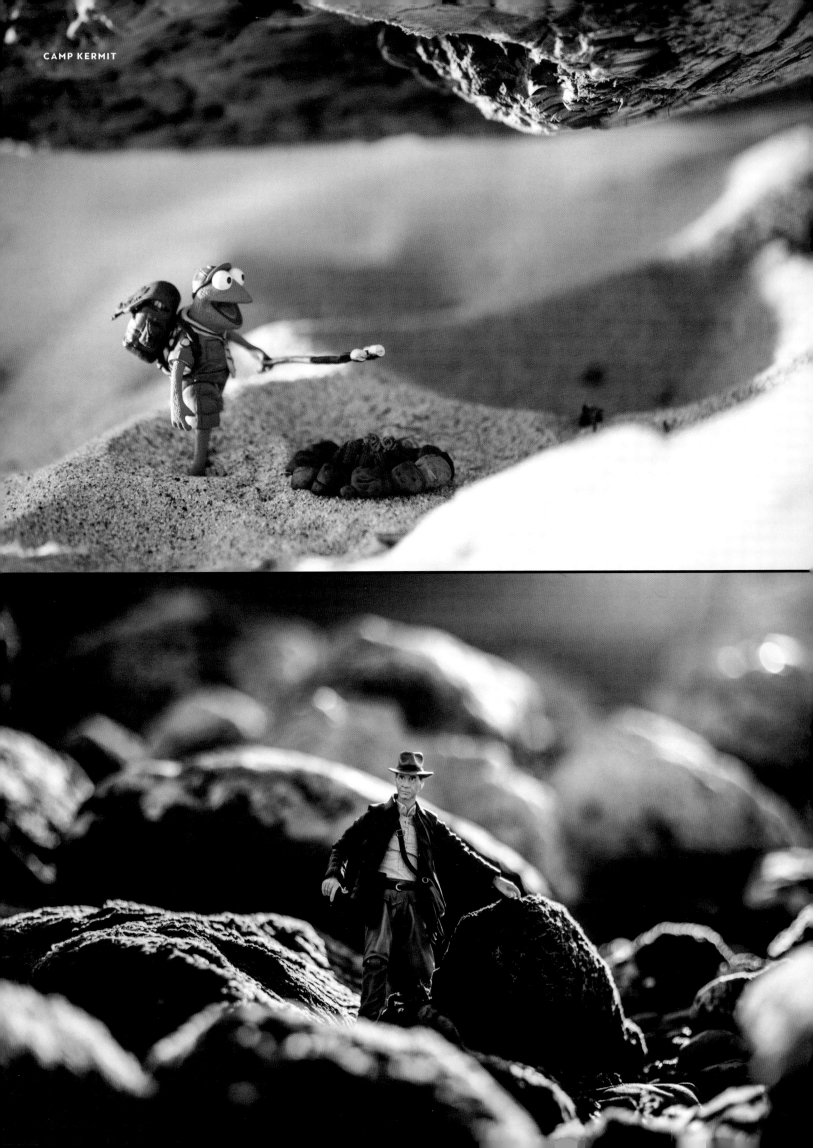

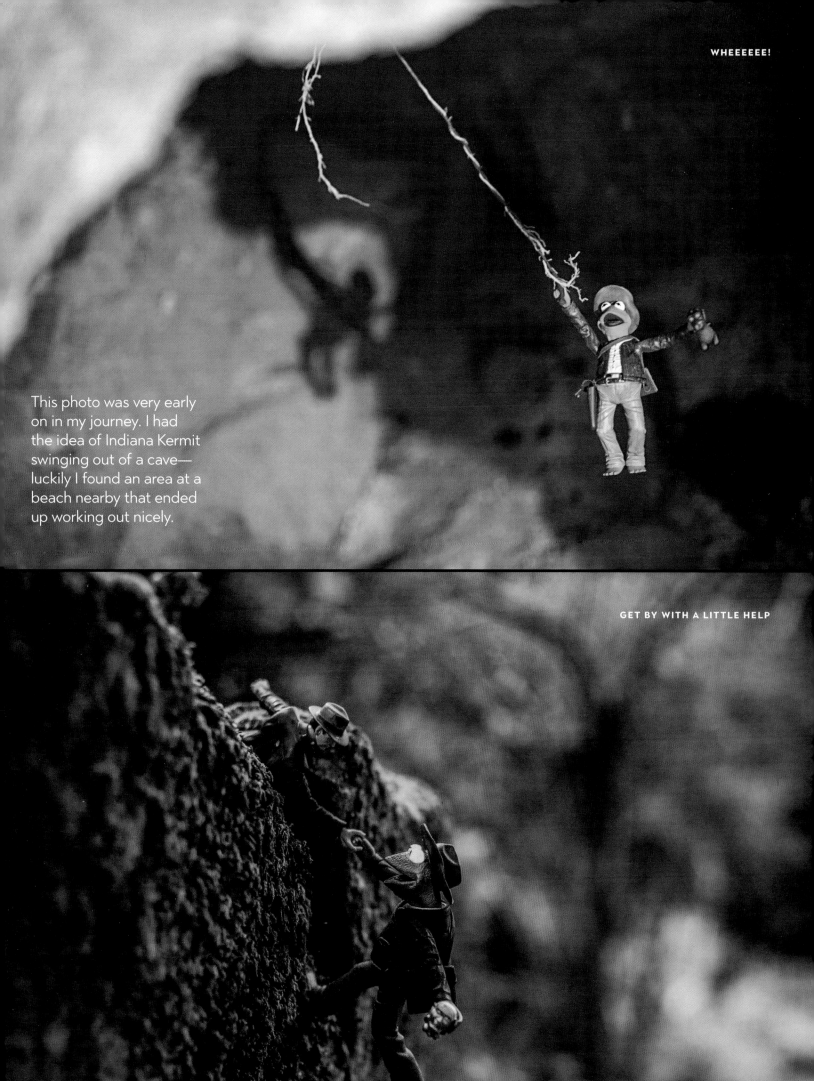

This photo was very early on in my journey. I had the idea of Indiana Kermit swinging out of a cave—luckily I found an area at a beach nearby that ended up working out nicely.

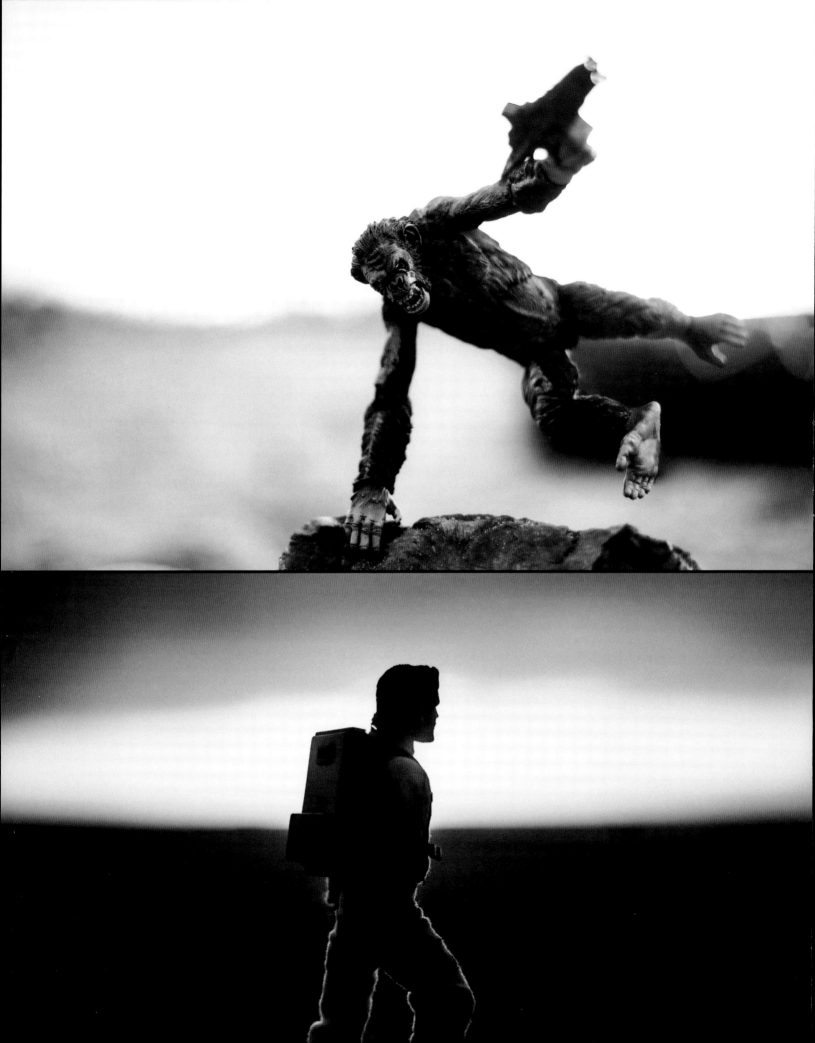

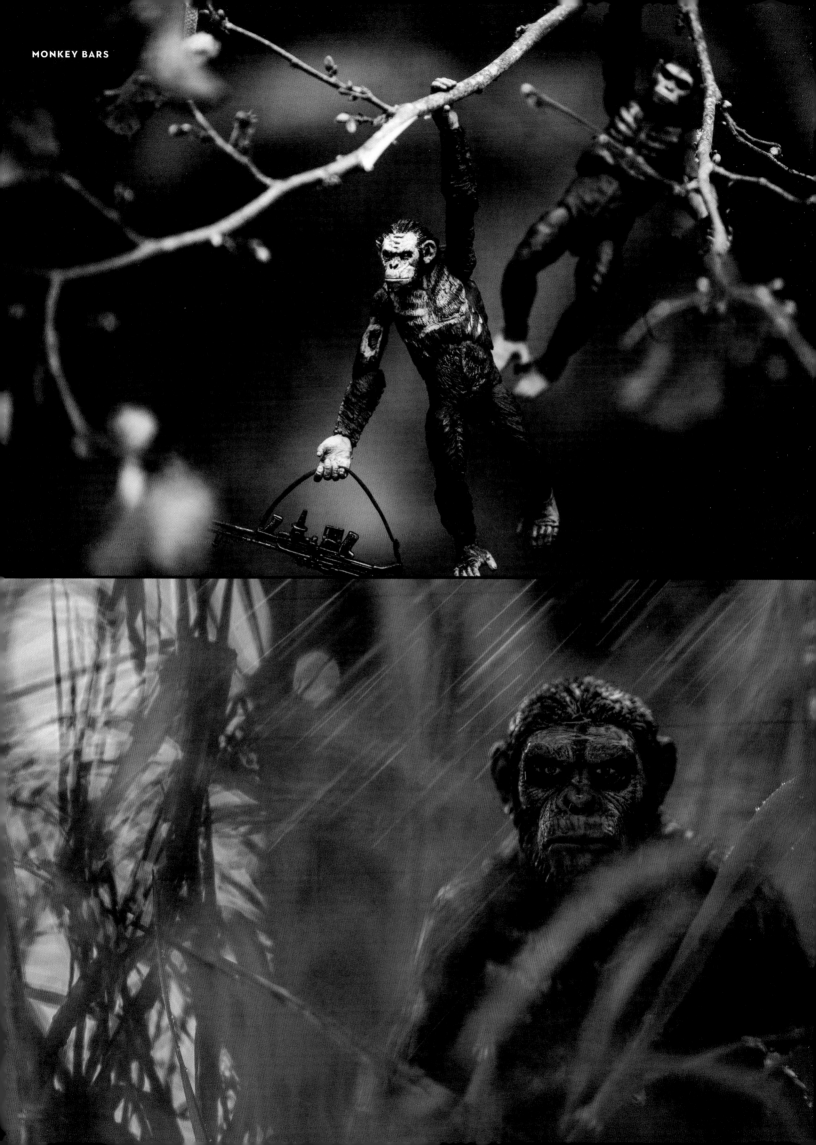

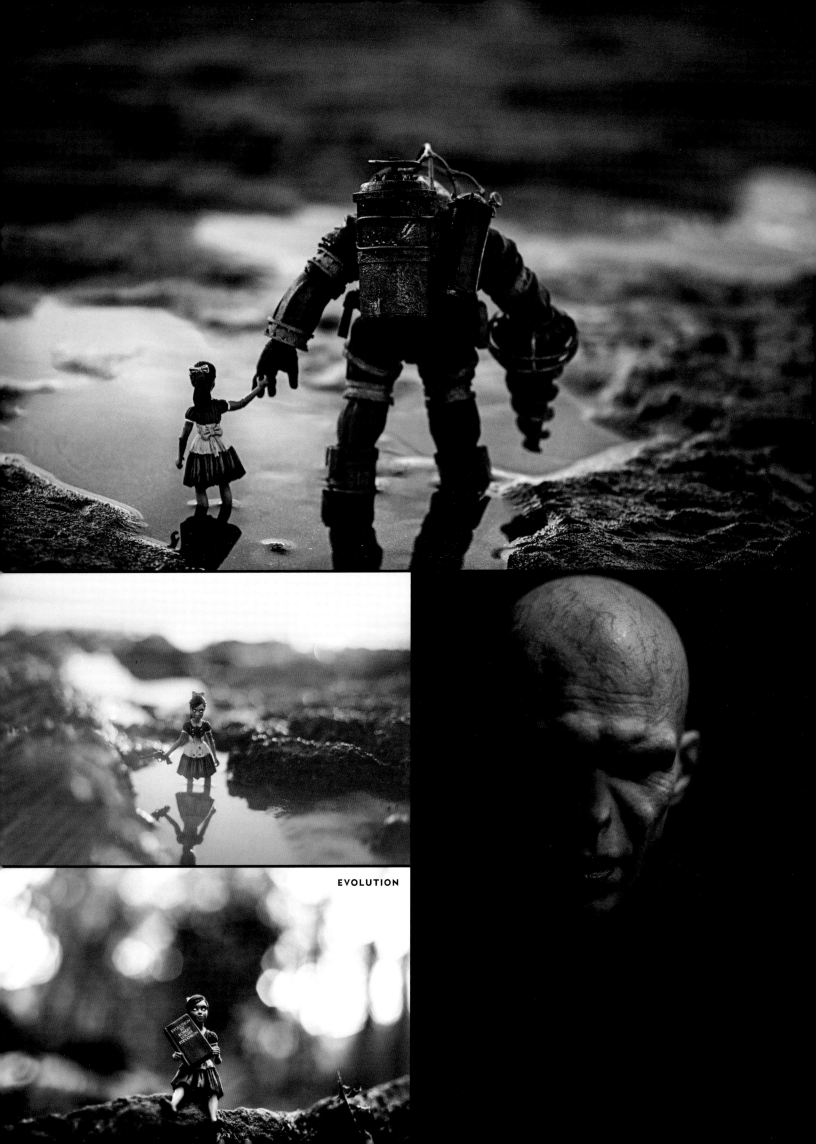

EVOLUTION

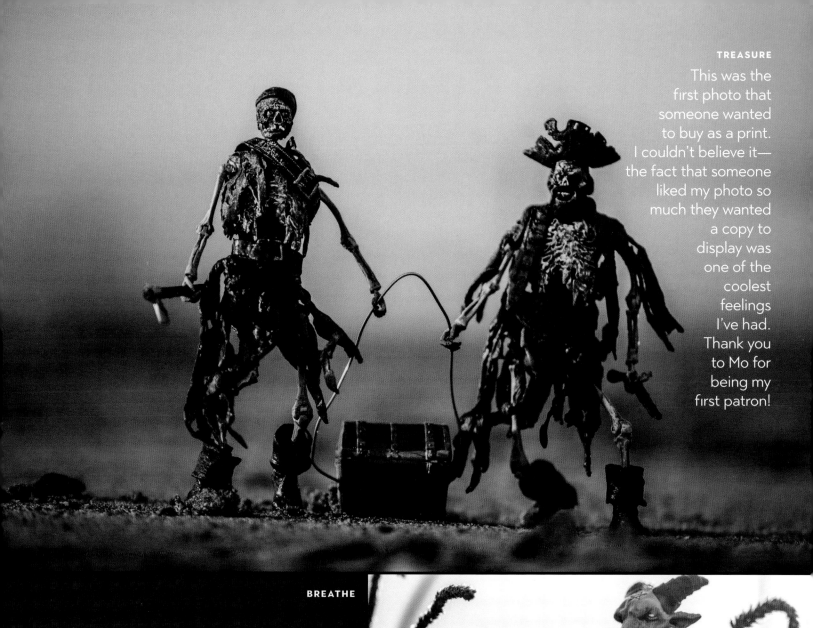

TREASURE
This was the first photo that someone wanted to buy as a print. I couldn't believe it—the fact that someone liked my photo so much they wanted a copy to display was one of the coolest feelings I've had. Thank you to Mo for being my first patron!

BREATHE

◀ Toys have come so far since I was a kid.

Some of these are so realistic you really can't tell from the photographs that they're toys.

That's become a focus of my work when shooting these high end figures.

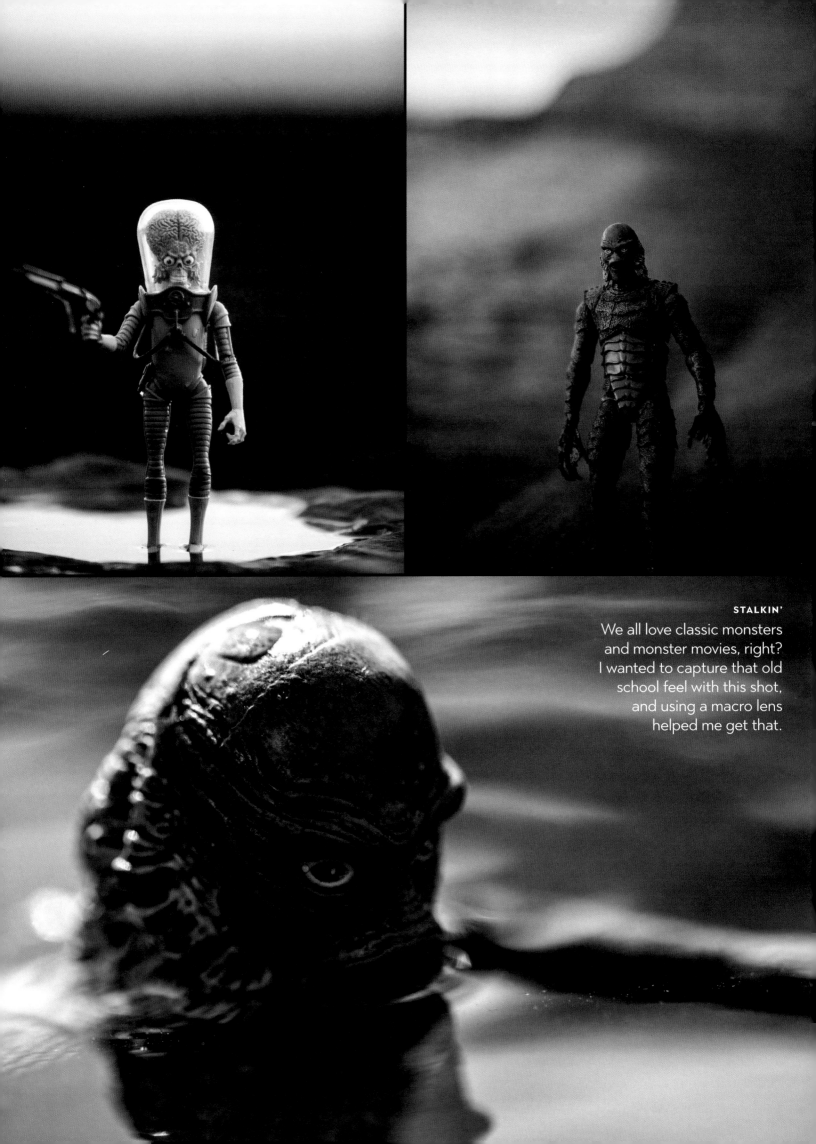

STALKIN'
We all love classic monsters and monster movies, right? I wanted to capture that old school feel with this shot, and using a macro lens helped me get that.

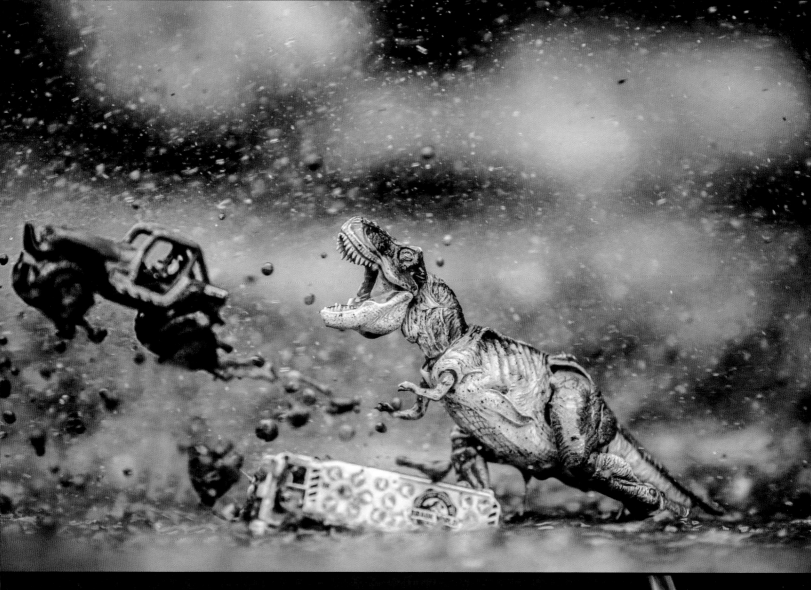

LIKE A FEATHER

This was the first shot I remember taking with a DSLR. At the time depth of field was a new concept to me, but I was immediately drawn to the soft background effect.

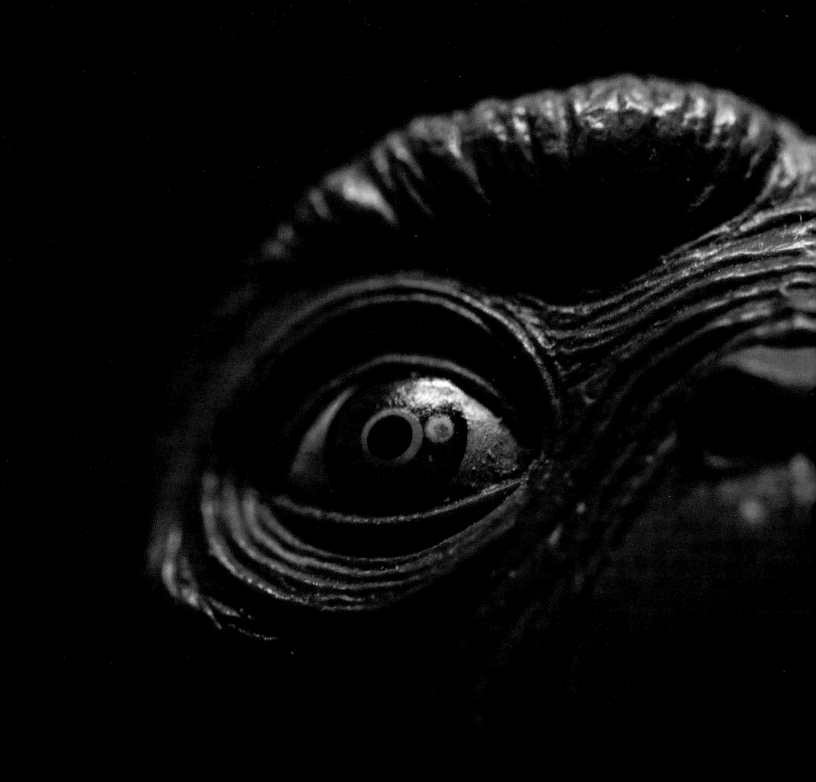

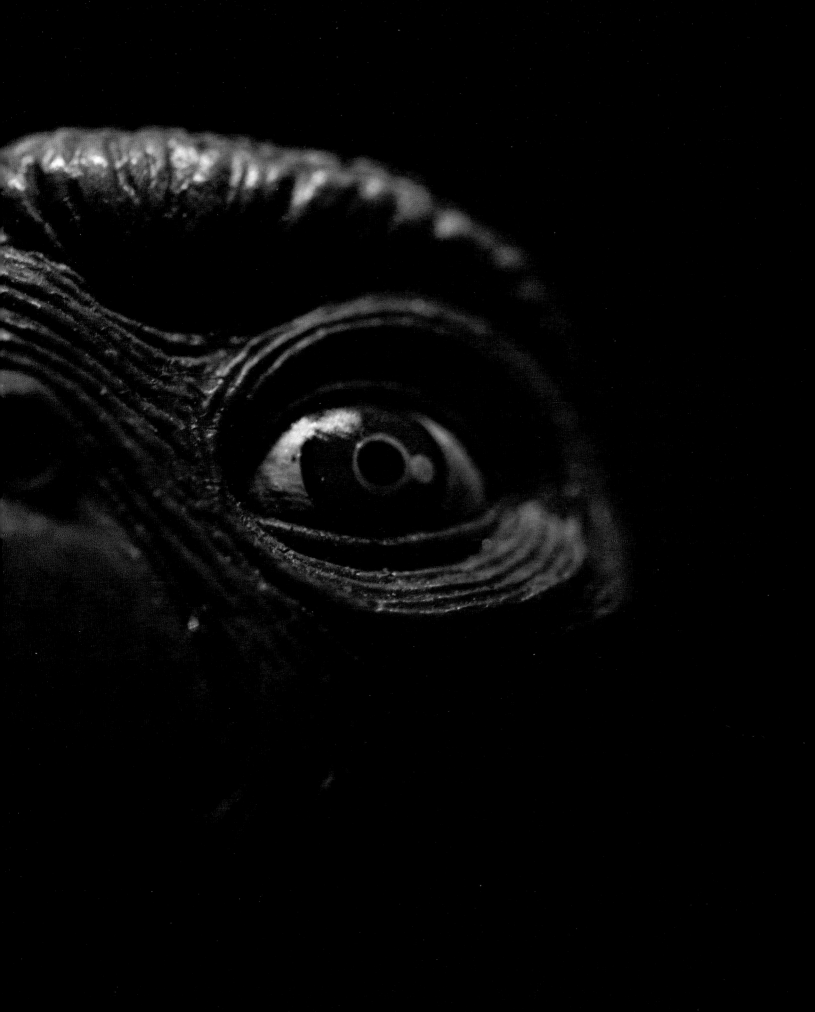

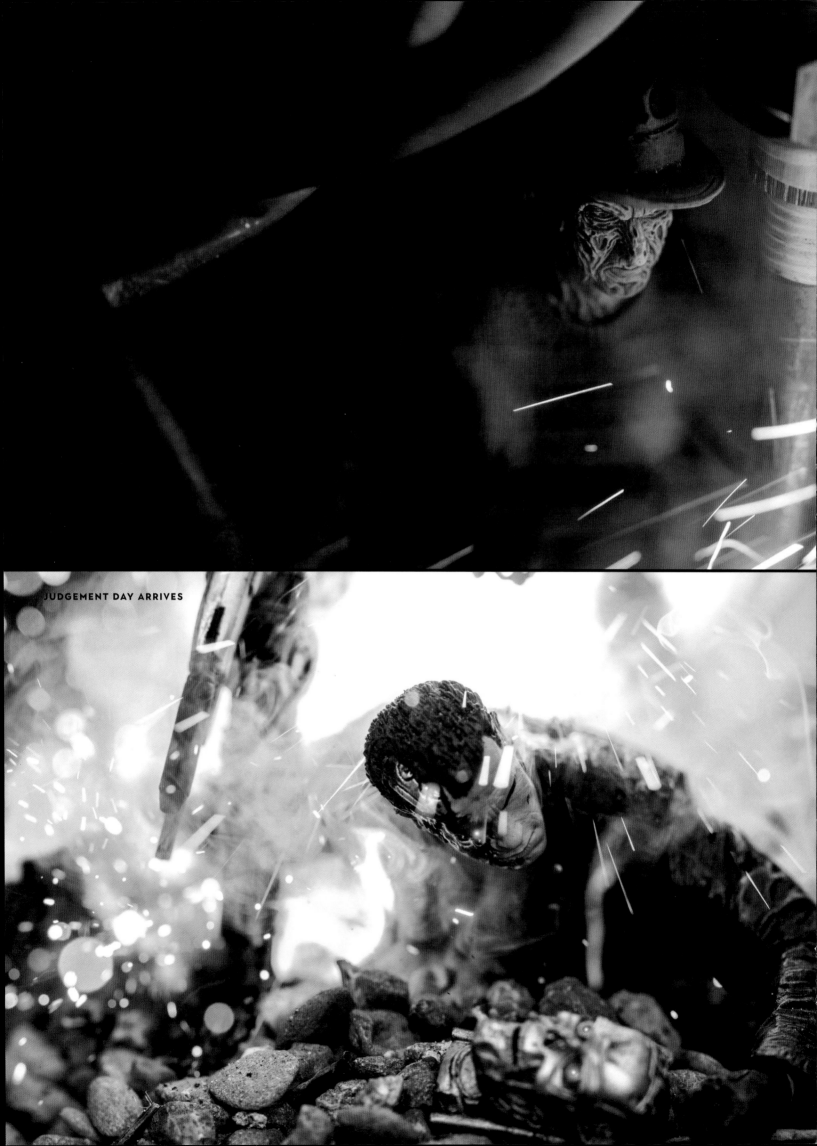

JUDGEMENT DAY ARRIVES

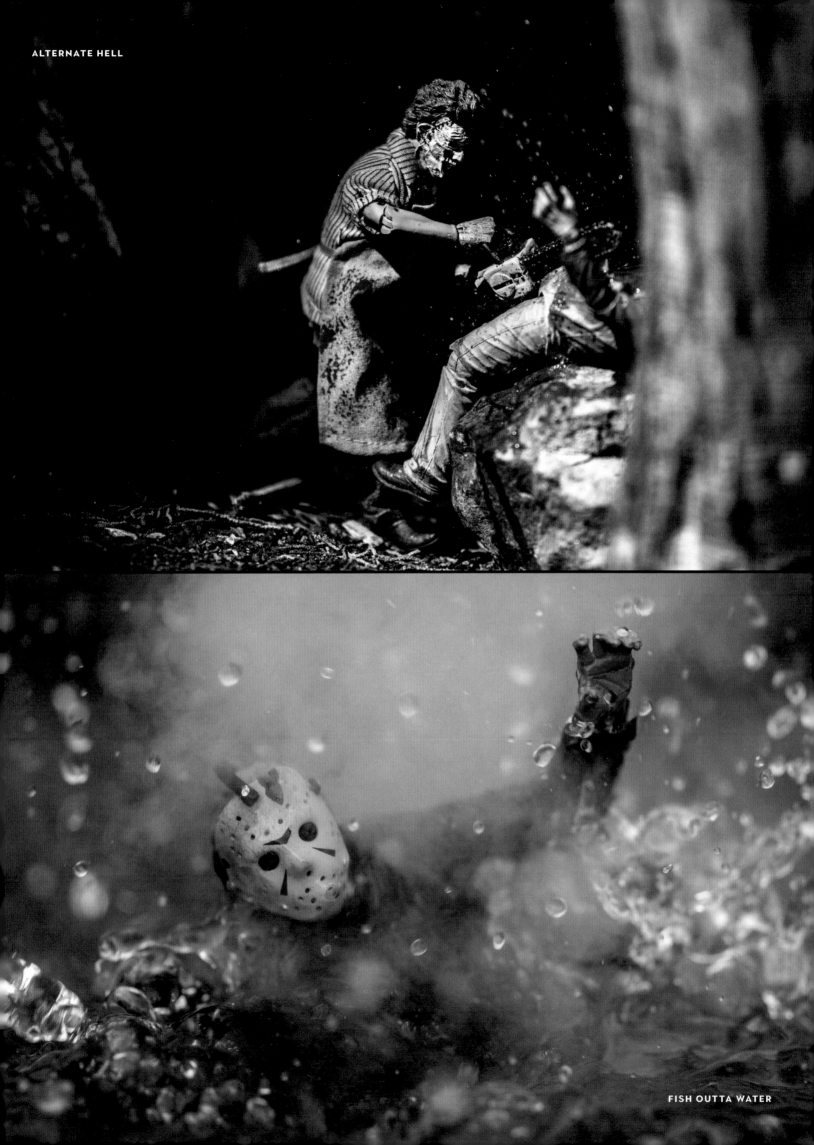

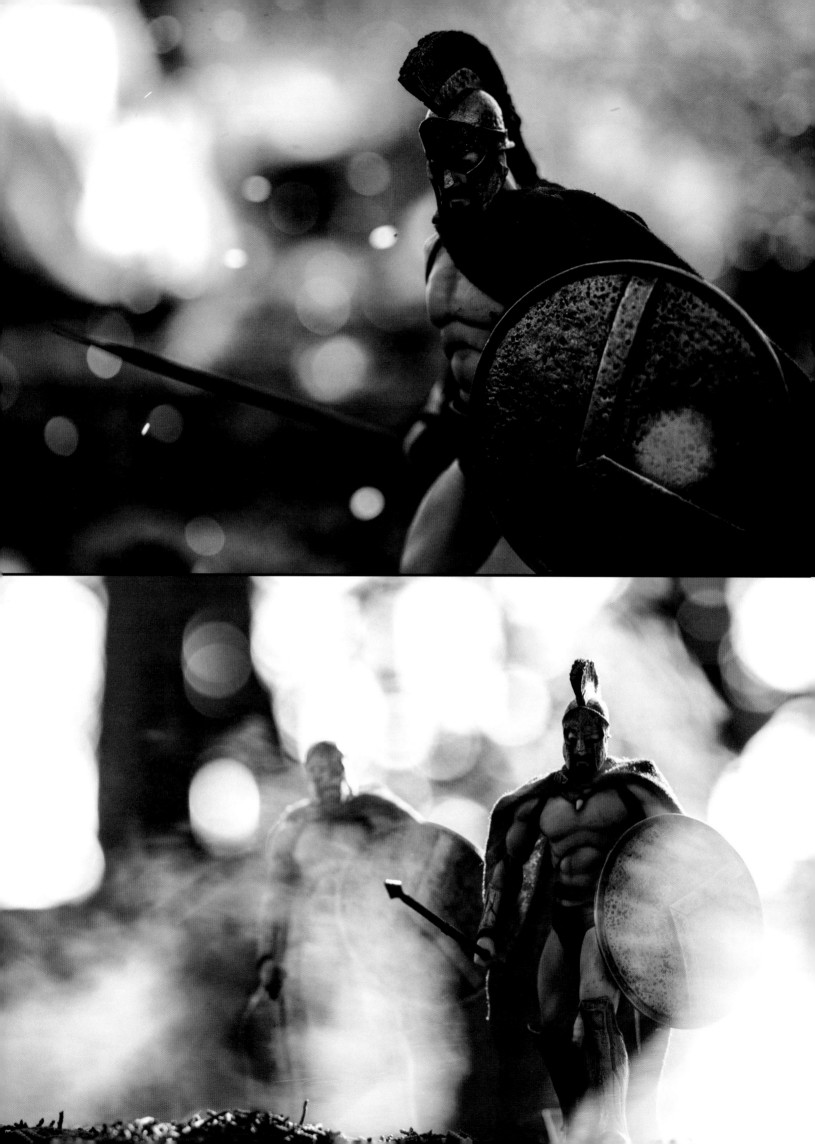

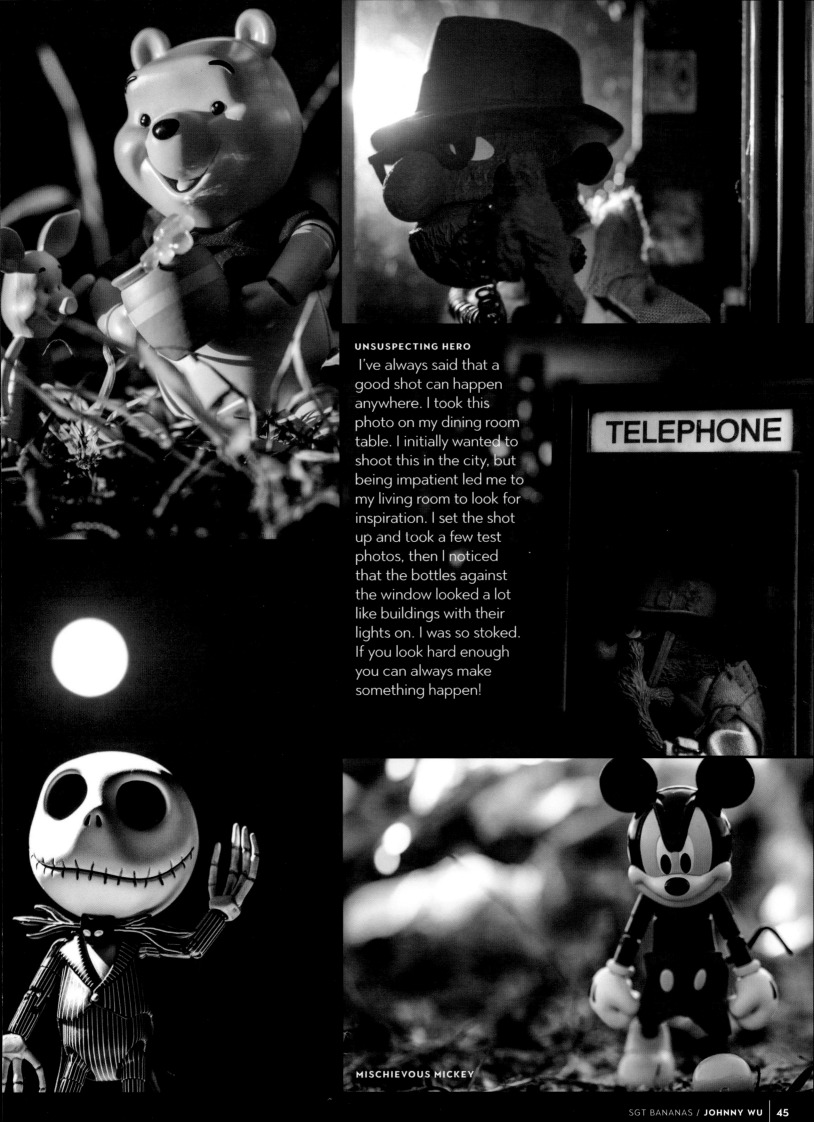

UNSUSPECTING HERO

I've always said that a good shot can happen anywhere. I took this photo on my dining room table. I initially wanted to shoot this in the city, but being impatient led me to my living room to look for inspiration. I set the shot up and took a few test photos, then I noticed that the bottles against the window looked a lot like buildings with their lights on. I was so stoked. If you look hard enough you can always make something happen!

TELEPHONE

MISCHIEVOUS MICKEY

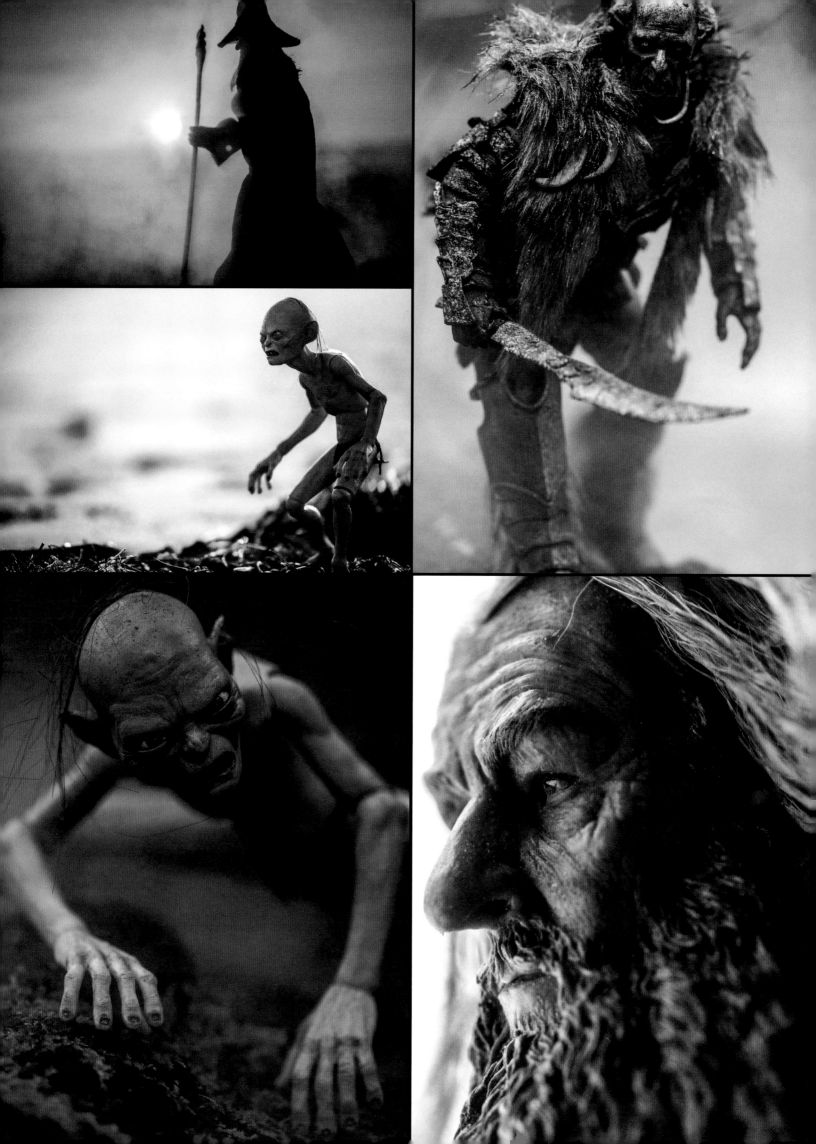

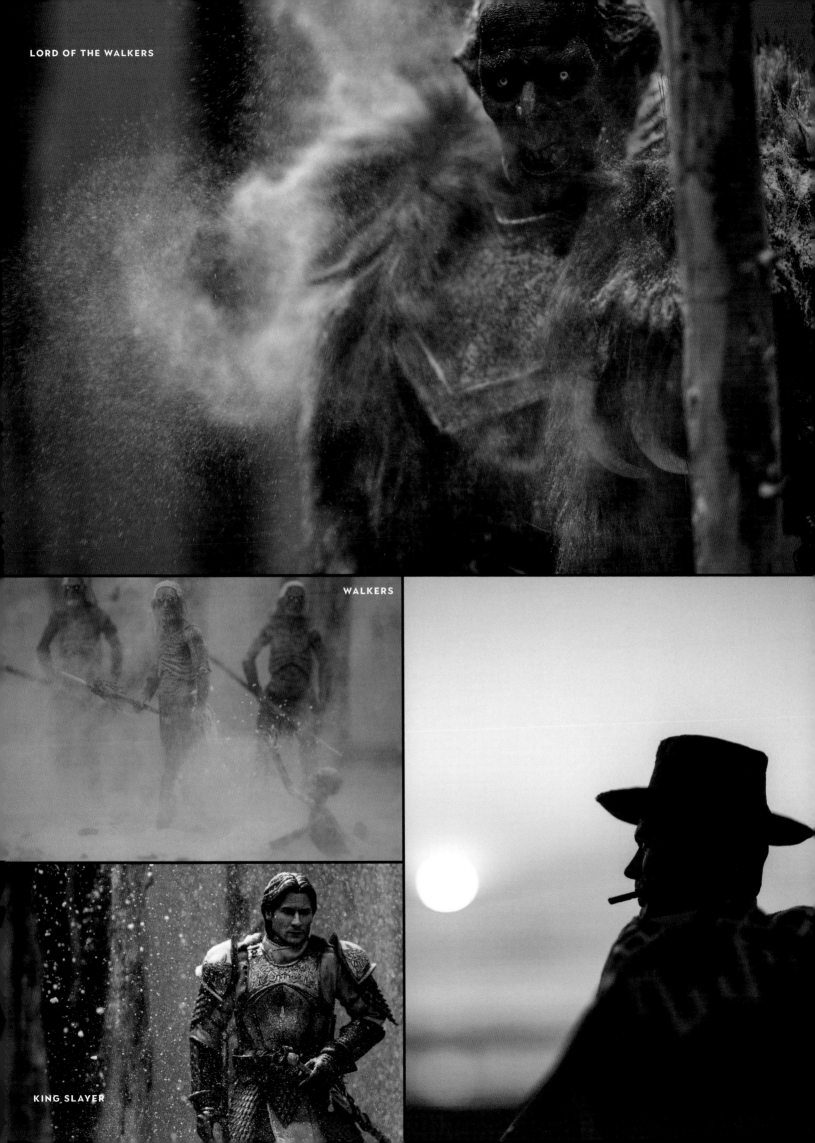

LORD OF THE WALKERS

WALKERS

KING SLAYER

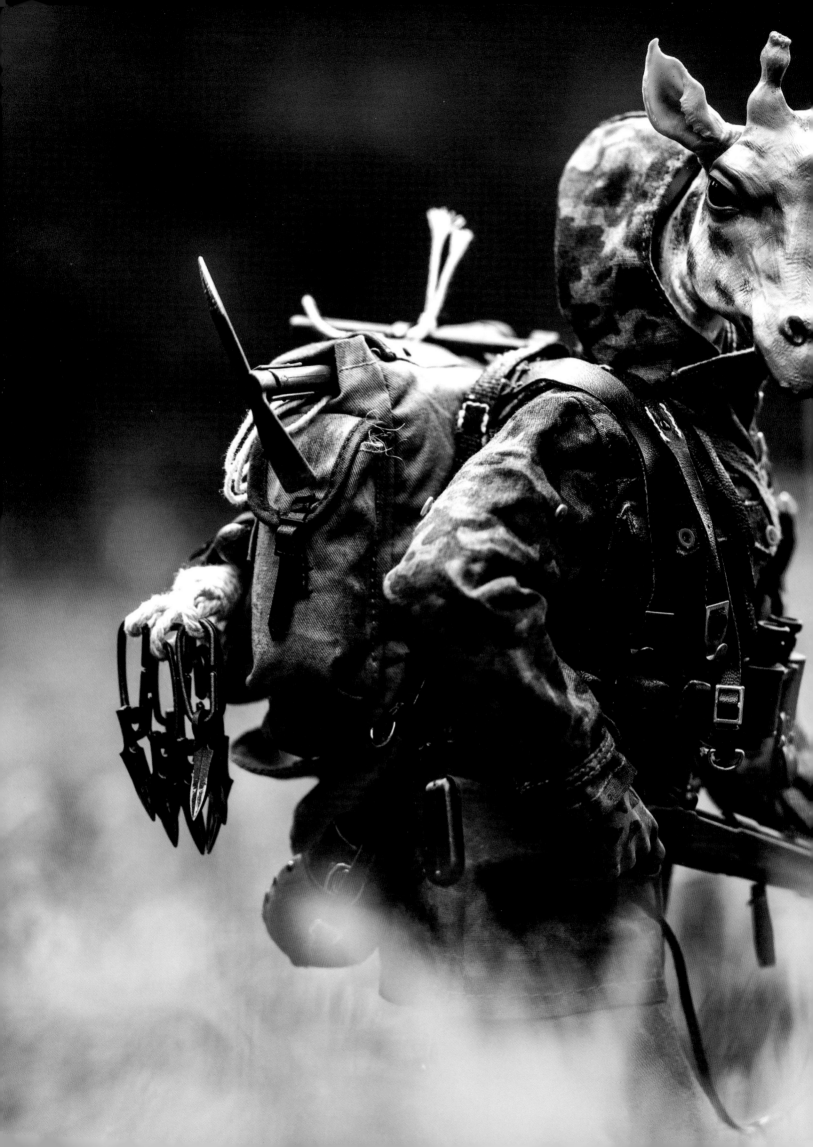

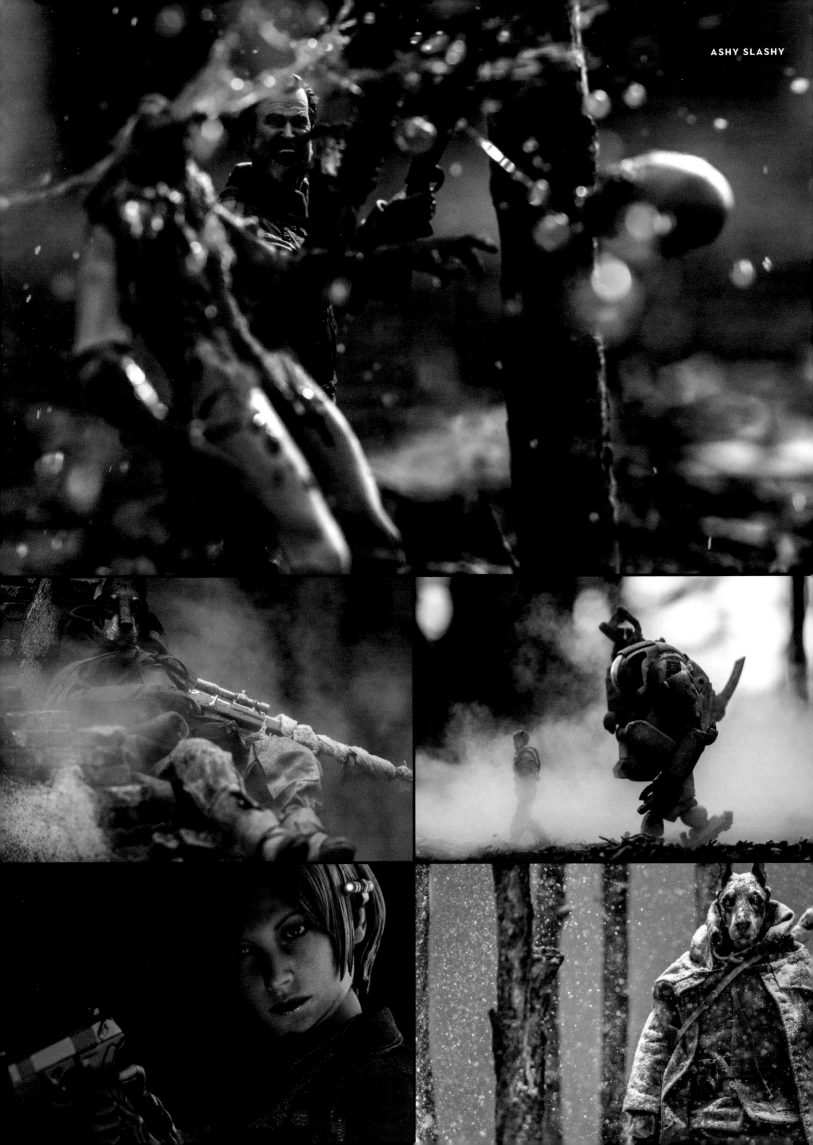

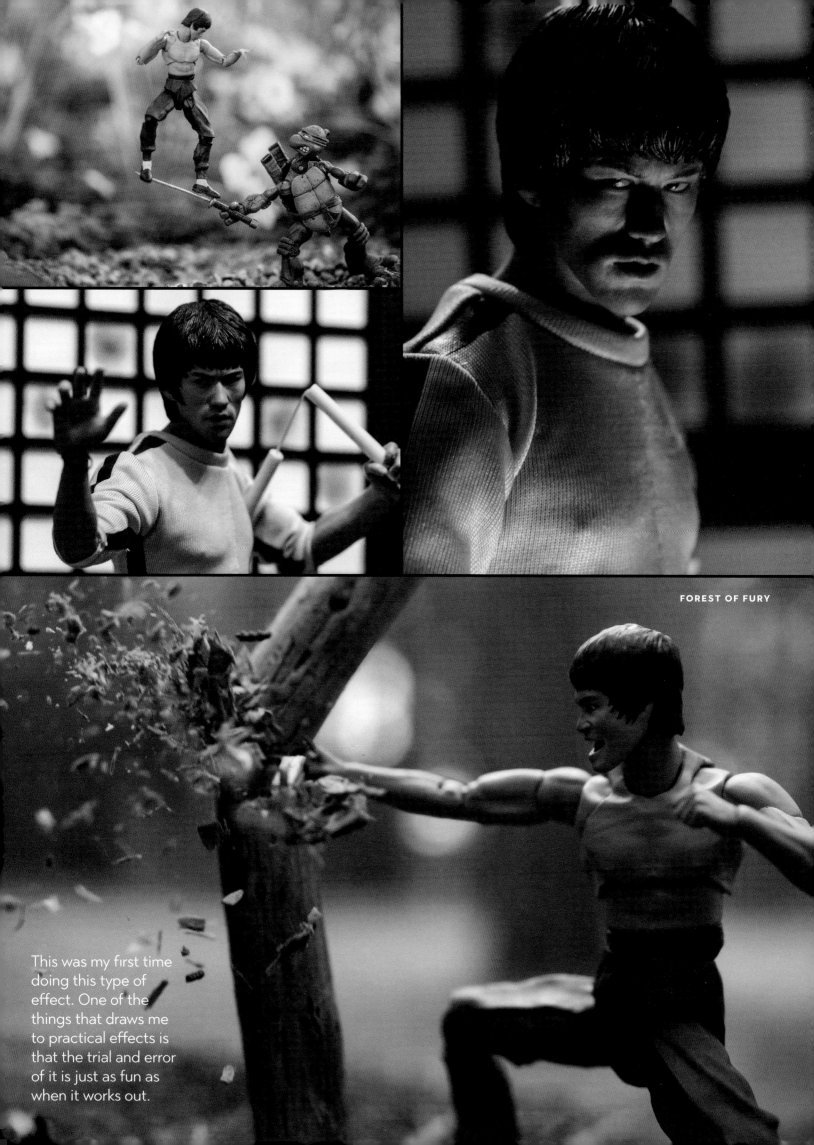

FOREST OF FURY

This was my first time doing this type of effect. One of the things that draws me to practical effects is that the trial and error of it is just as fun as when it works out.

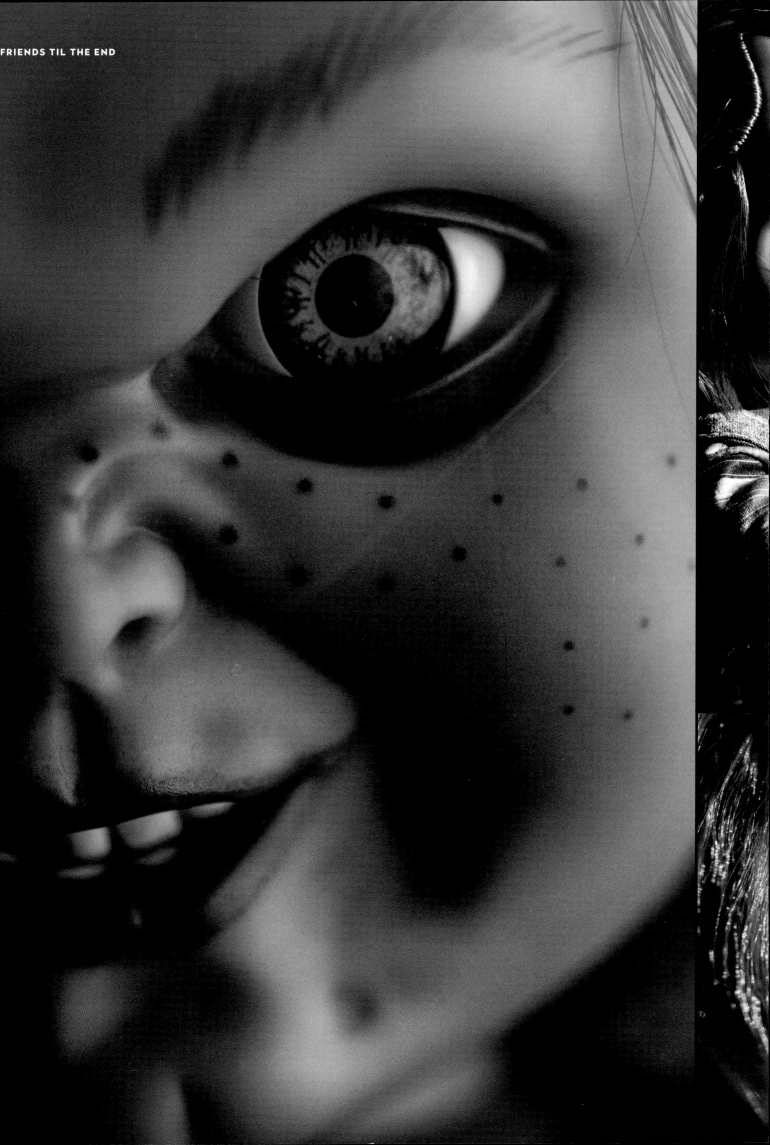

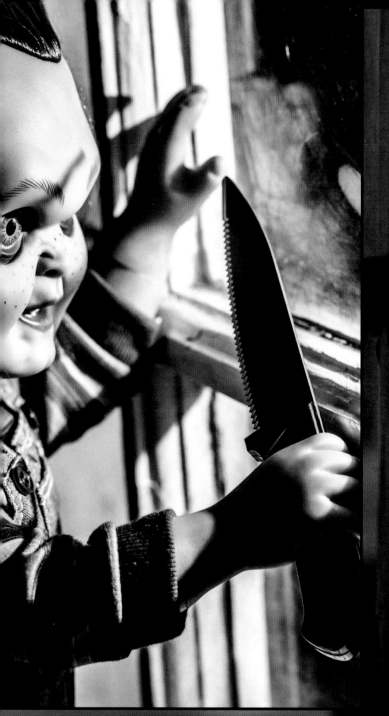

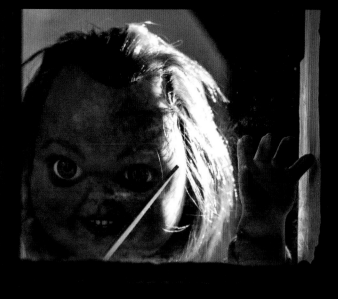

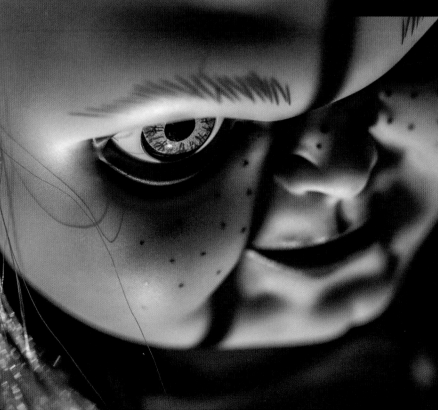

▲ I shot this at Ultra-Spective Photography Studio, where my girlfriend works. When I saw the small window I had the idea of shooting Chucky through it.

It was pretty dark in the room, and I was alone, so it felt a little creepy.

STICKS AND STONES

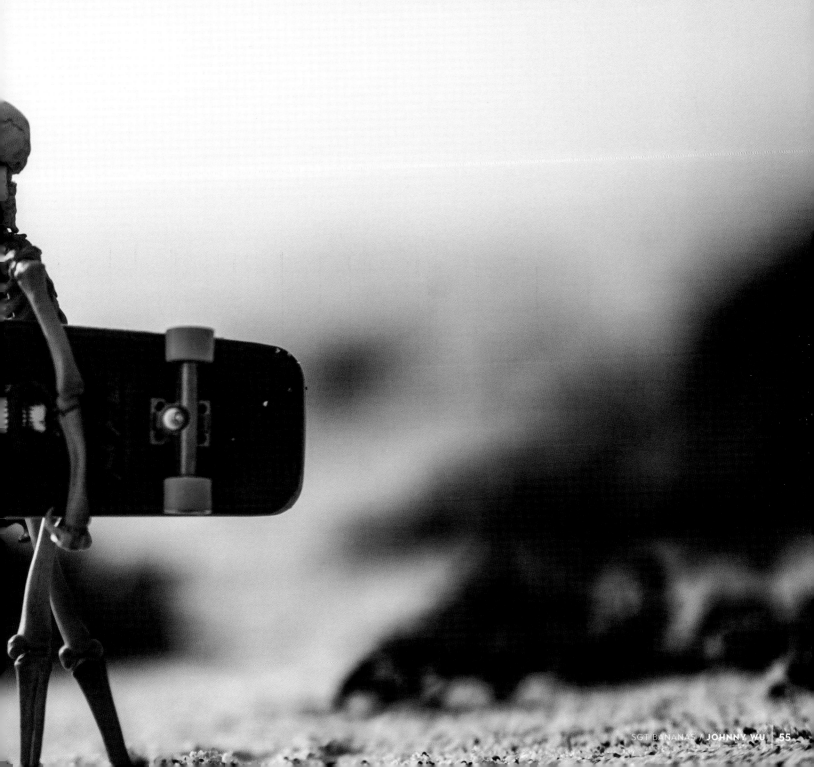

I took this photo while
I was learning to use a
DSLR. I understood the
basics of the camera, but
I still had a lot to learn.
It's not the most exciting
photo, but looking back
at that time and how
new everything was
to me, it has a special
place in my heart.

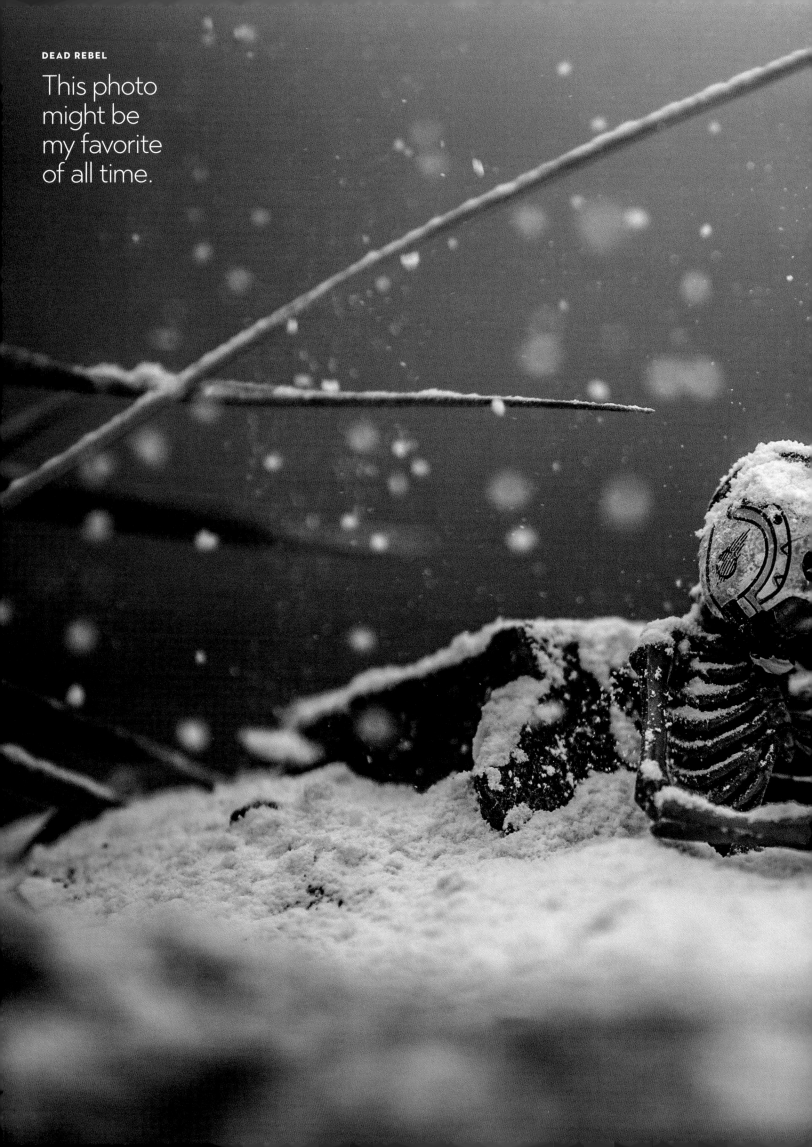

This photo
might be
my favorite
of all time.

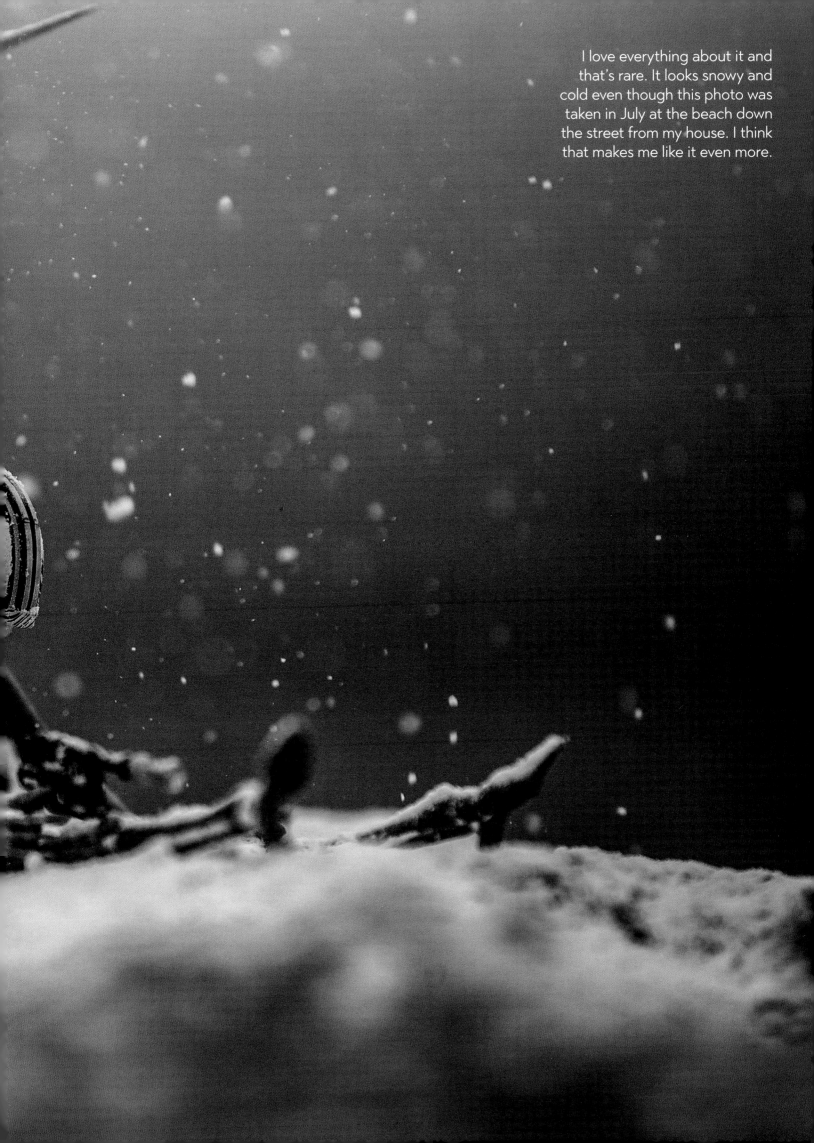

I love everything about it and that's rare. It looks snowy and cold even though this photo was taken in July at the beach down the street from my house. I think that makes me like it even more.

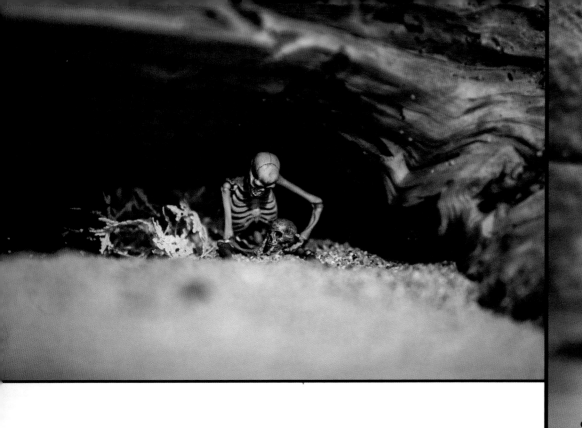

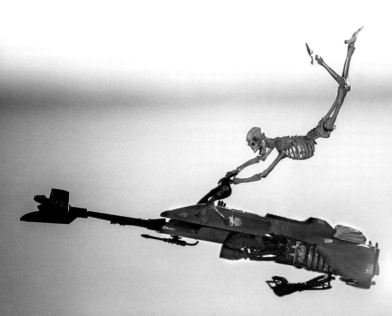

CRASH & BURN

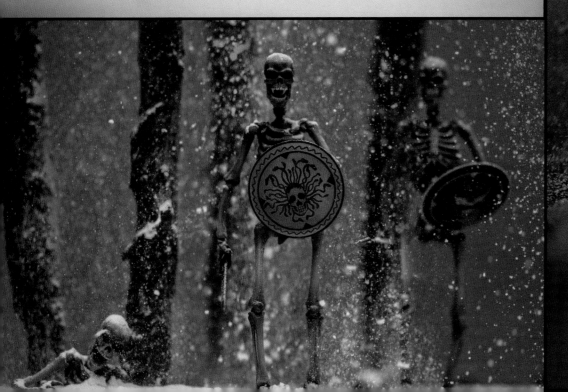

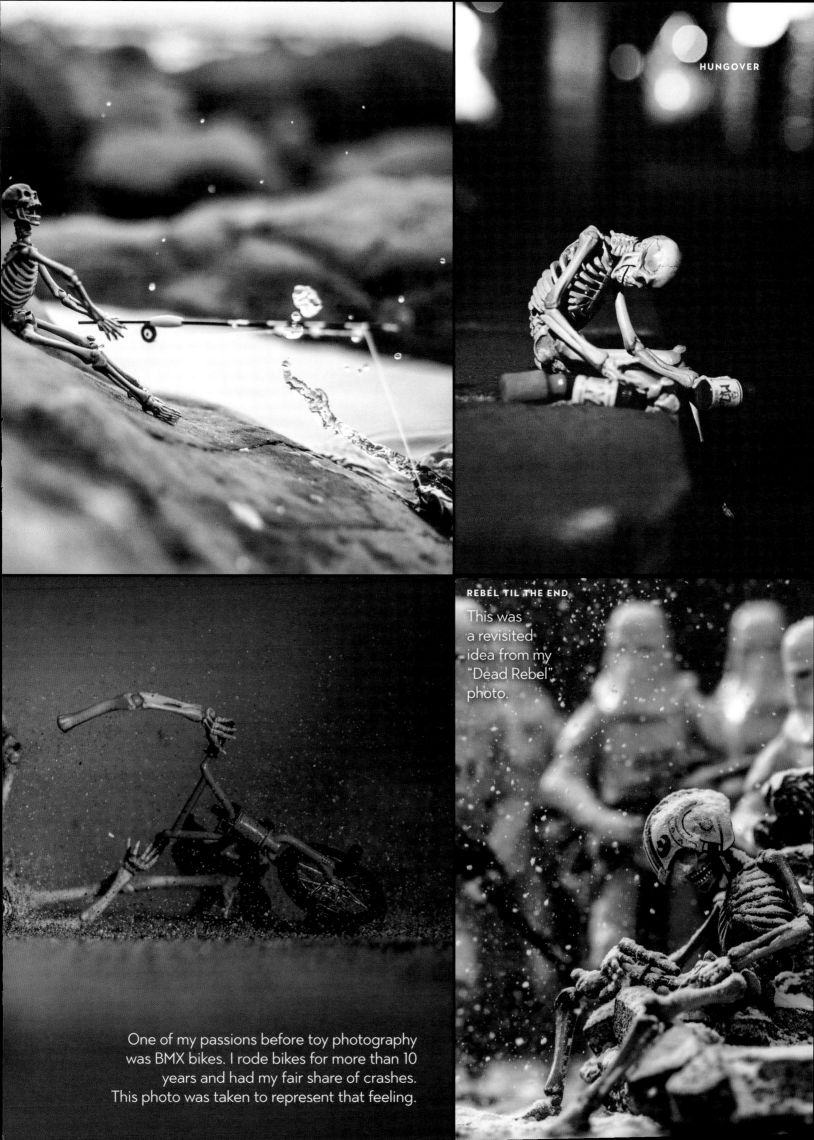

REBEL TIL THE END
This was a revisited idea from my "Dead Rebel" photo.

One of my passions before toy photography was BMX bikes. I rode bikes for more than 10 years and had my fair share of crashes. This photo was taken to represent that feeling.

INFINITY AND BEYOND

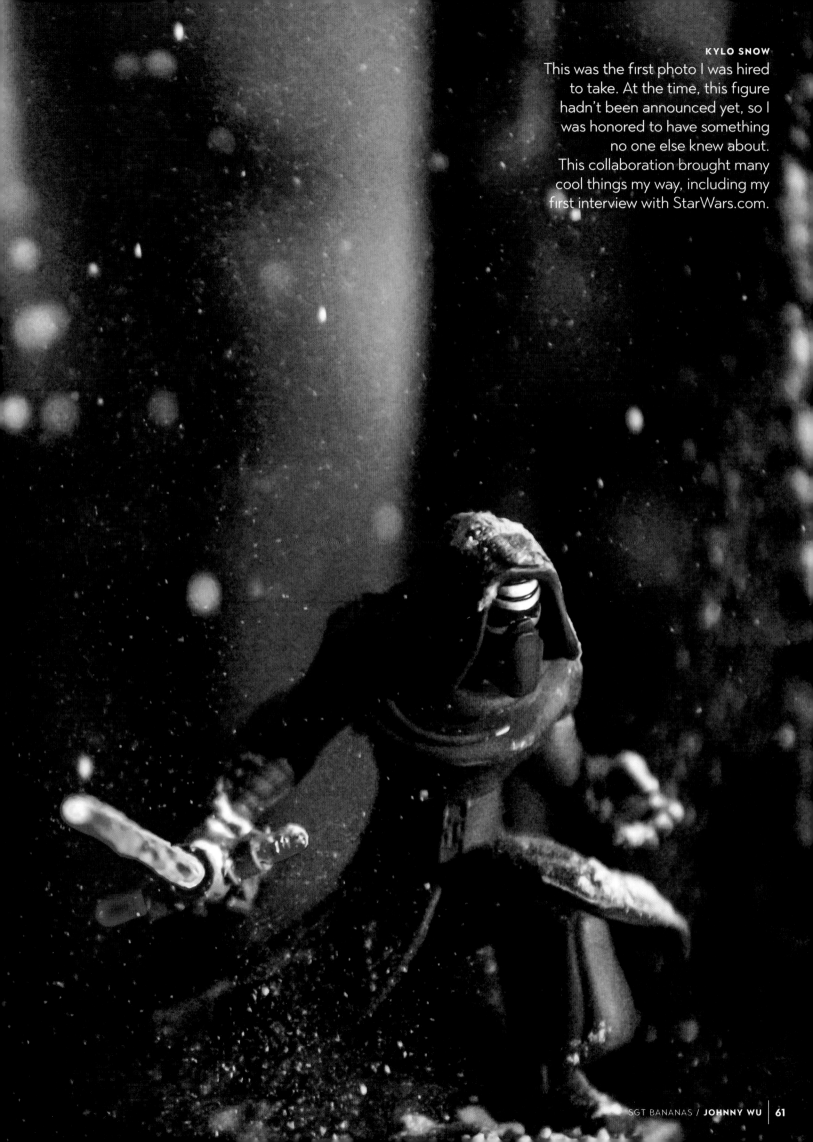

This was the first photo I was hired to take. At the time, this figure hadn't been announced yet, so I was honored to have something no one else knew about. This collaboration brought many cool things my way, including my first interview with StarWars.com.

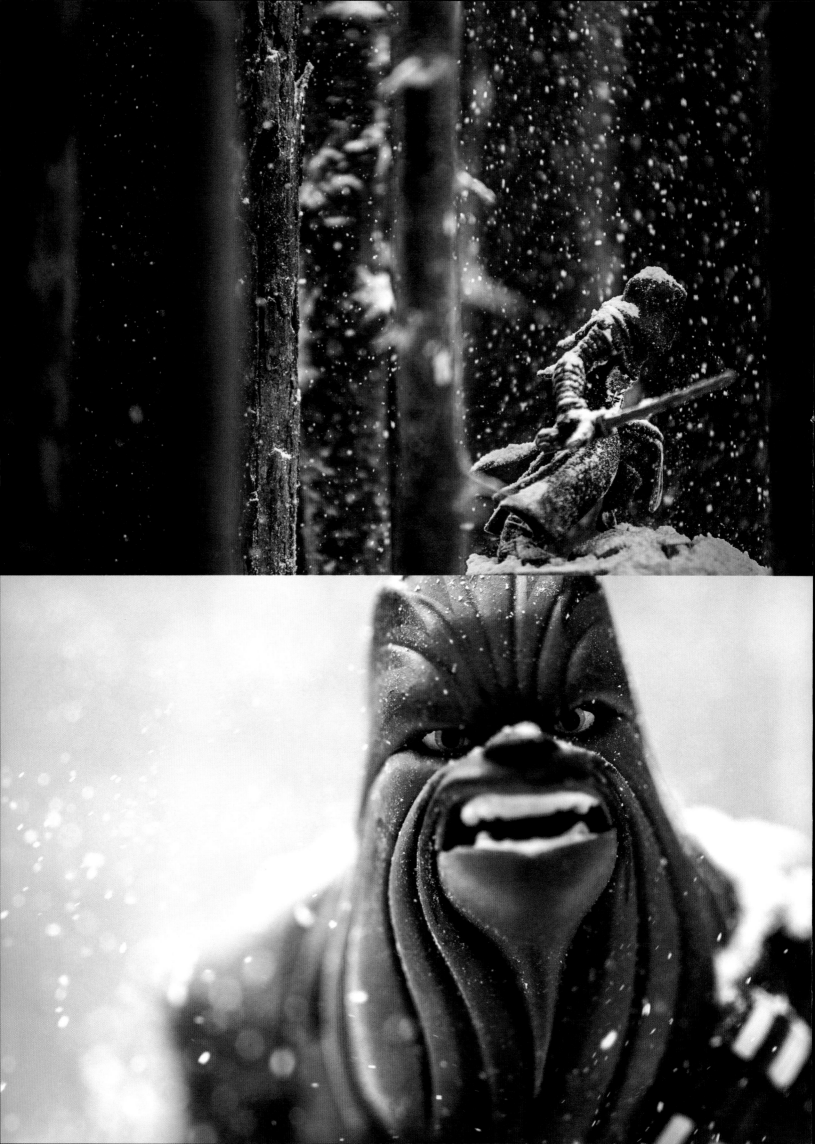

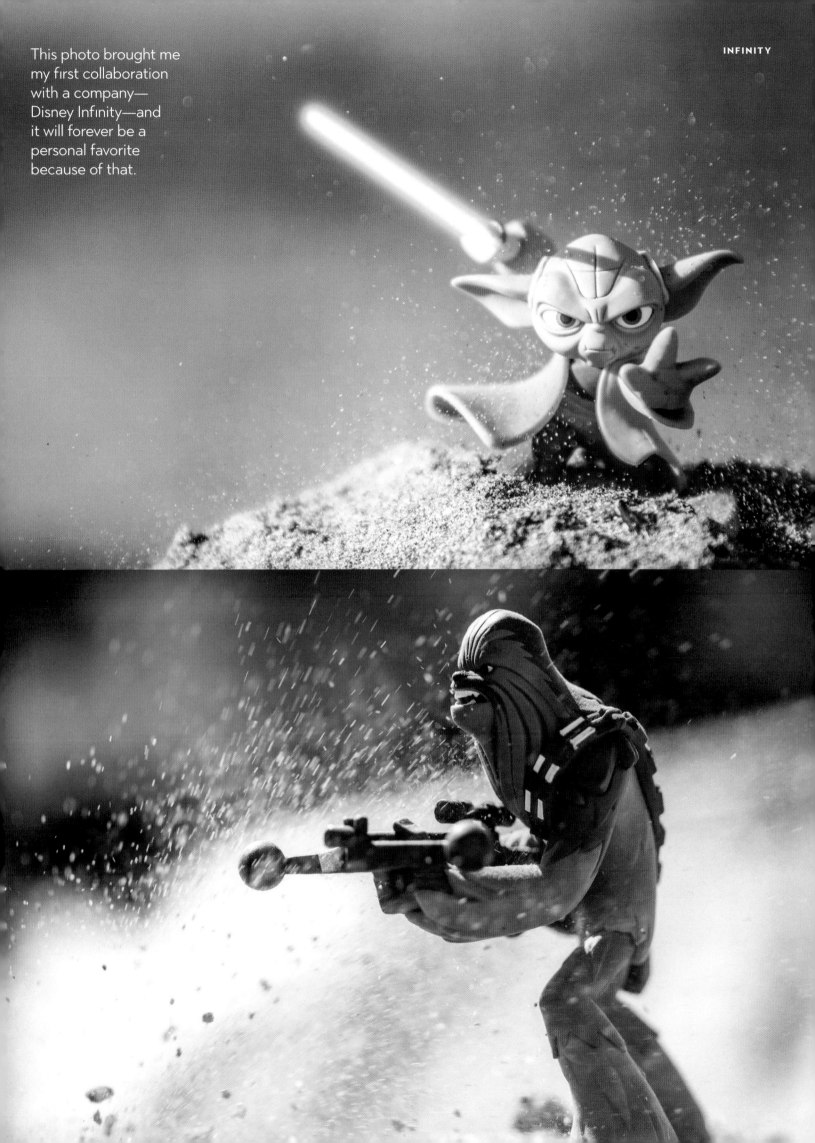

This photo brought me
my first collaboration
with a company—
Disney Infinity—and
it will forever be a
personal favorite
because of that.

ASHOKA

I was inspired by the light coming through my window when I woke up one morning, so I went into my toy room—yes, I have a separate room for toys— and grabbed this Ashoka figure. My girlfriend held her up while I took some shots, and the light coming through actually lit the sabers up—maybe the only time I've been able to do a practical light saber effect.

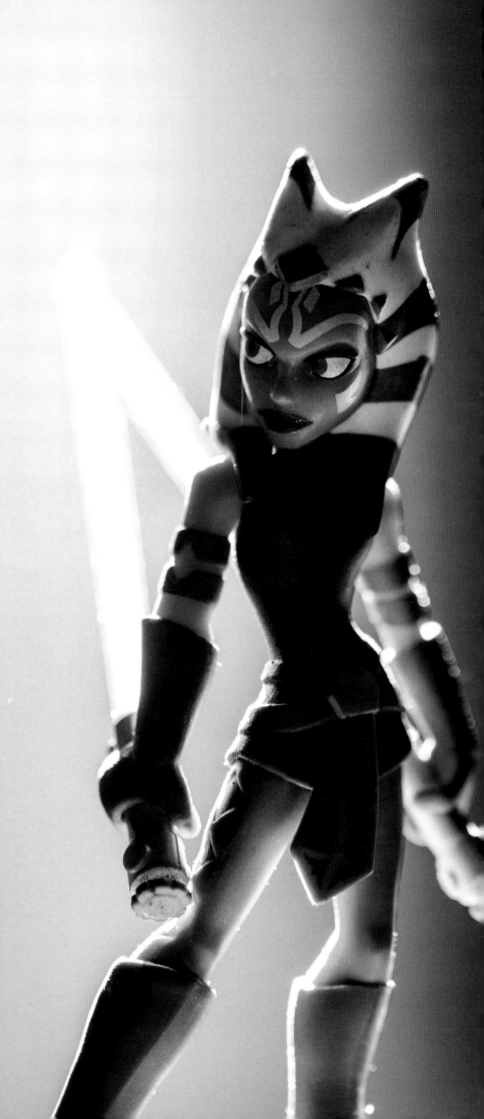

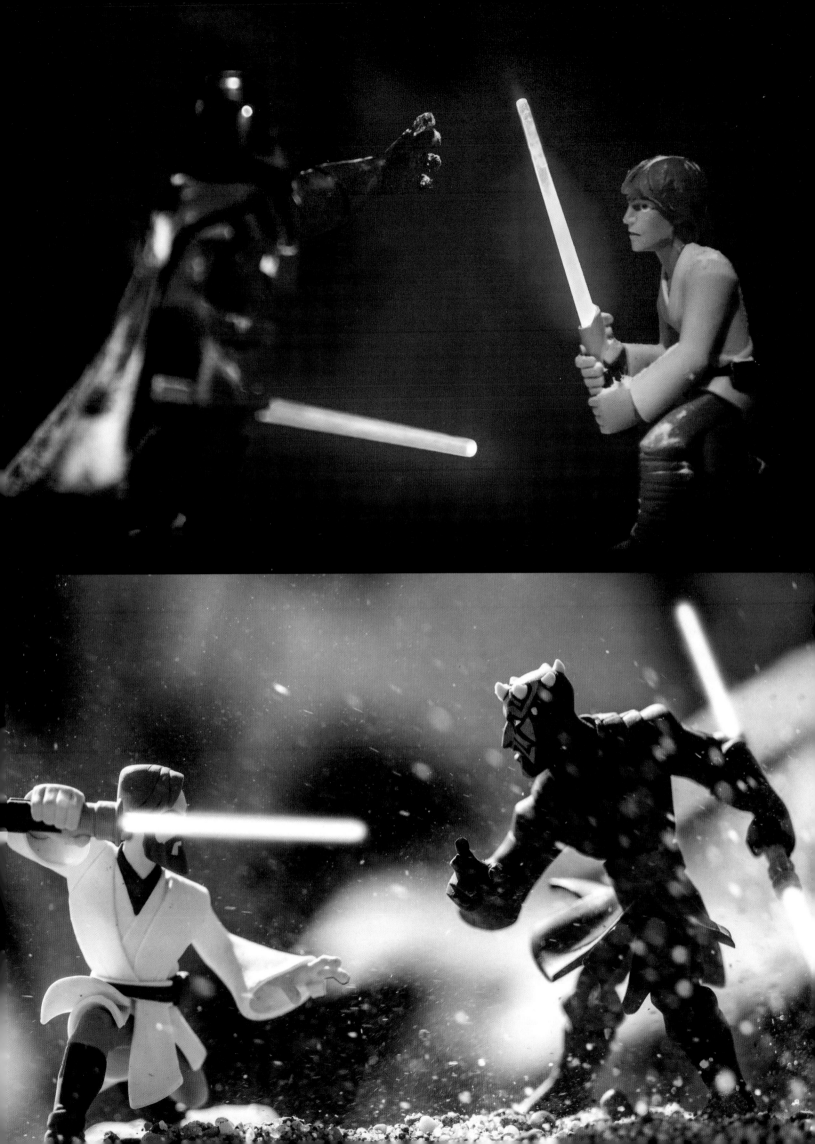

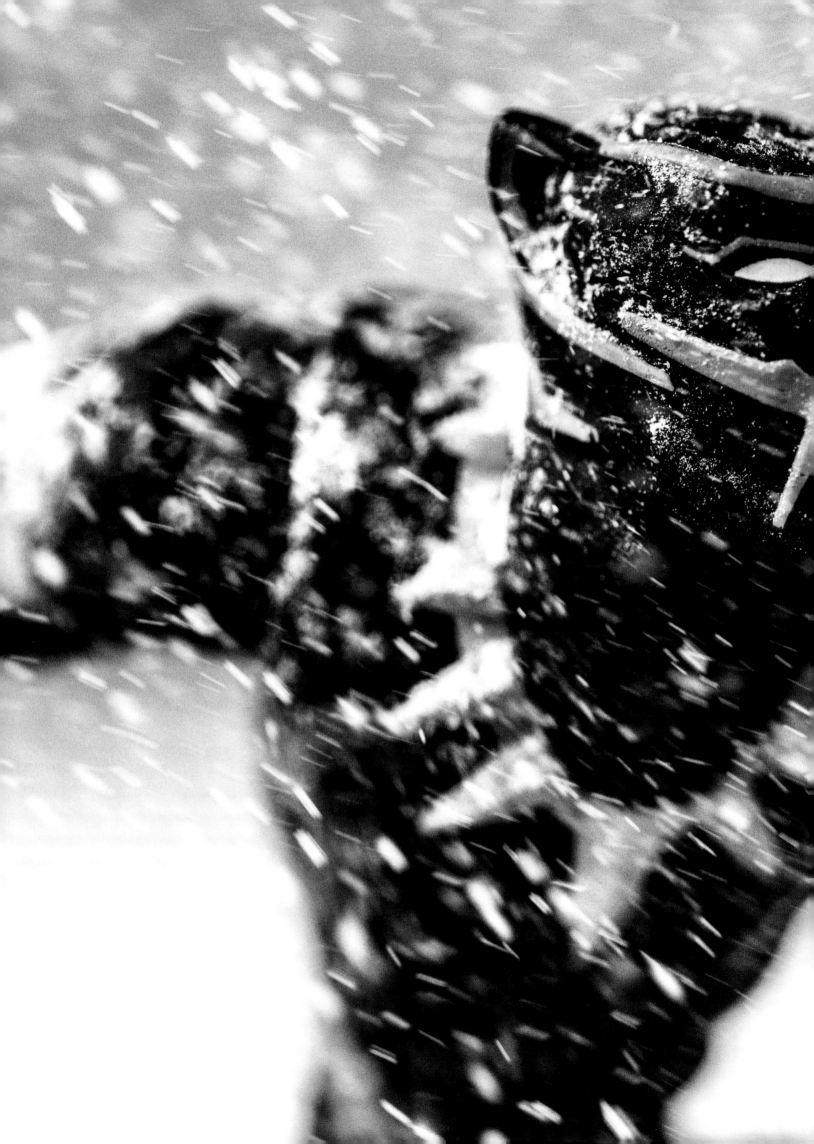

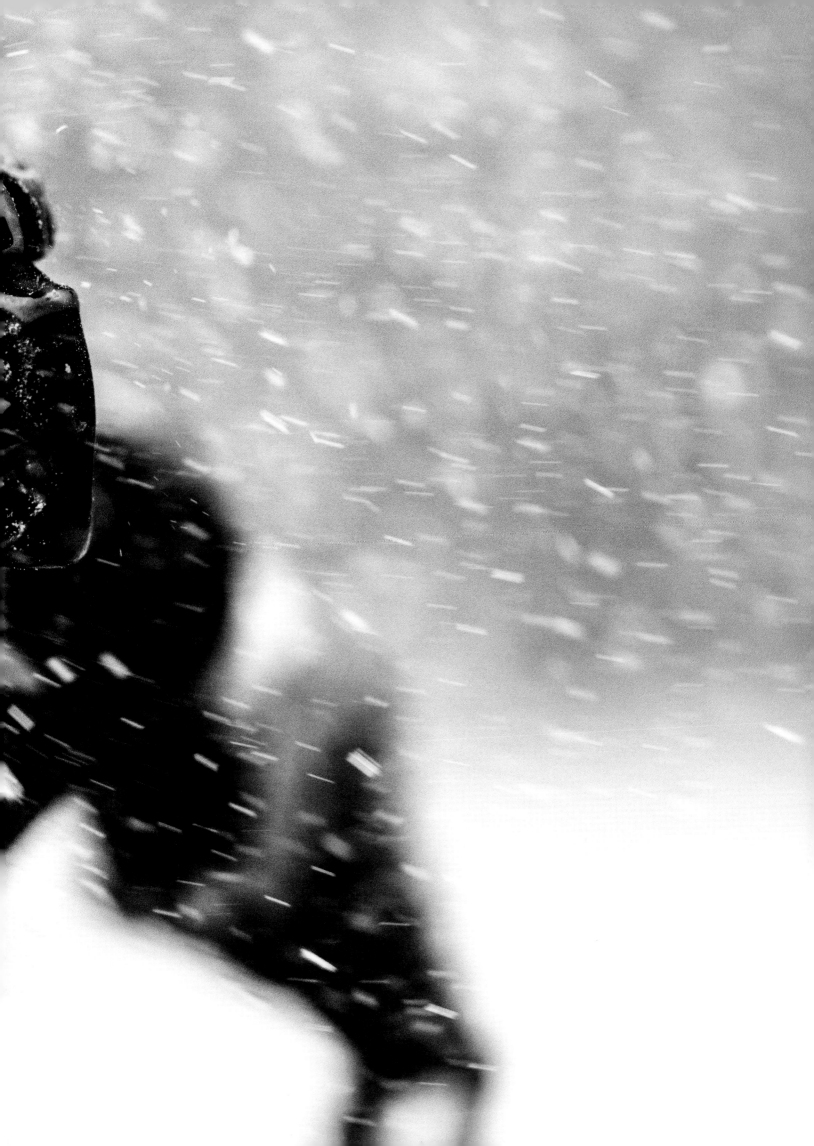

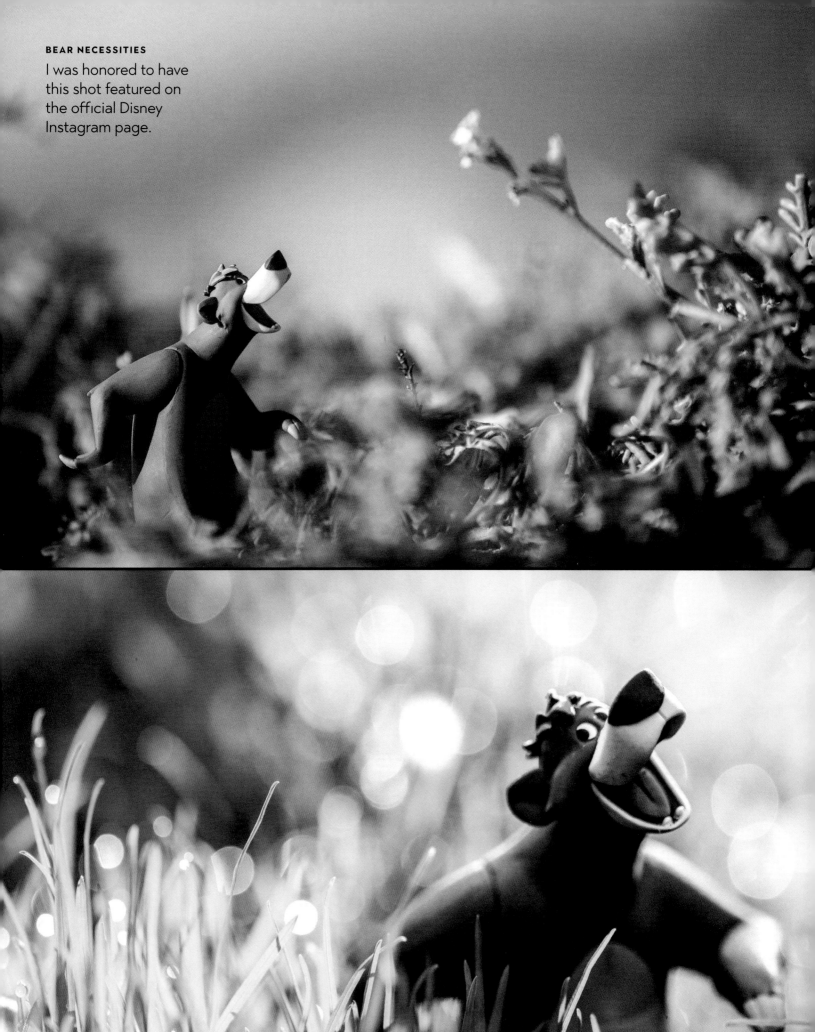

BEAR NECESSITIES
I was honored to have this shot featured on the official Disney Instagram page.

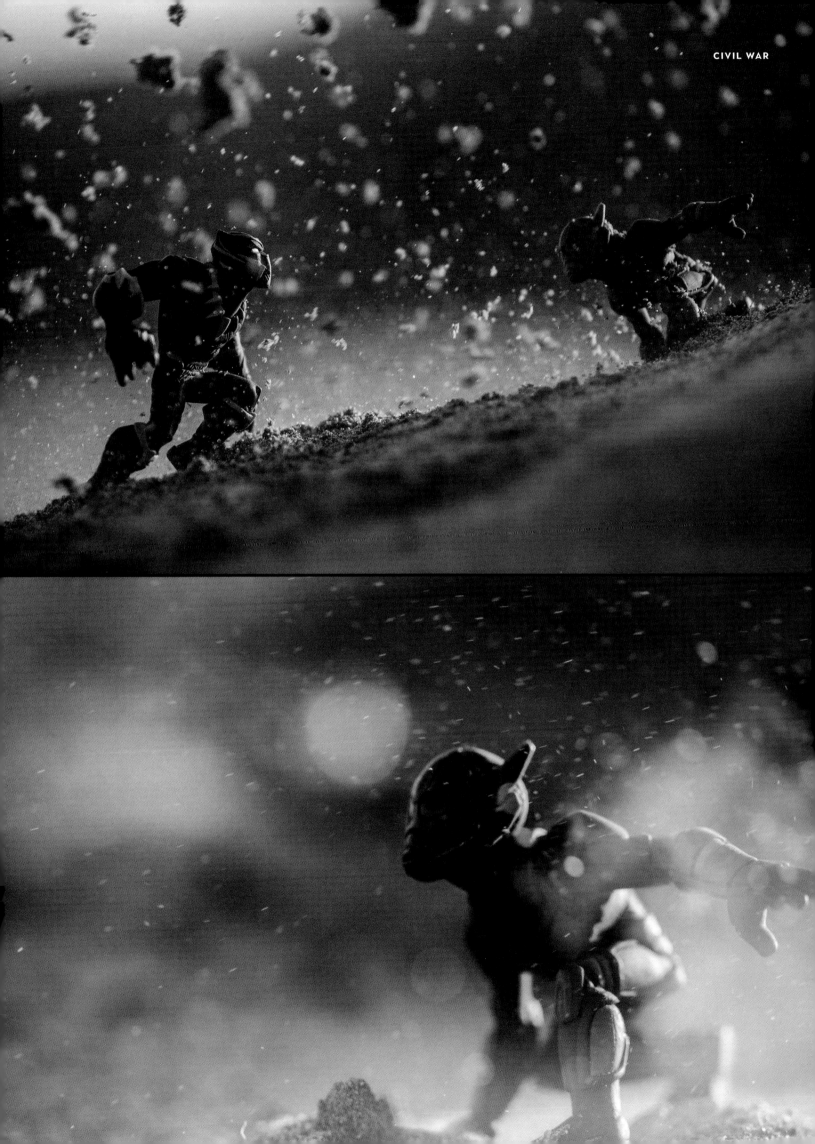

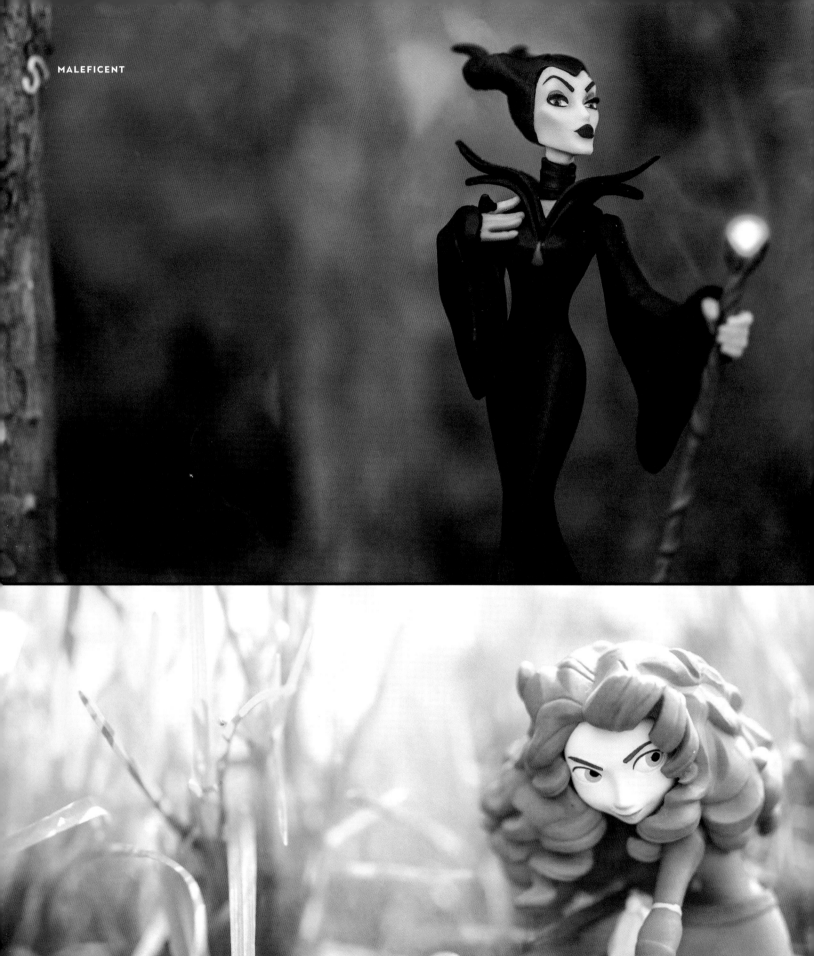

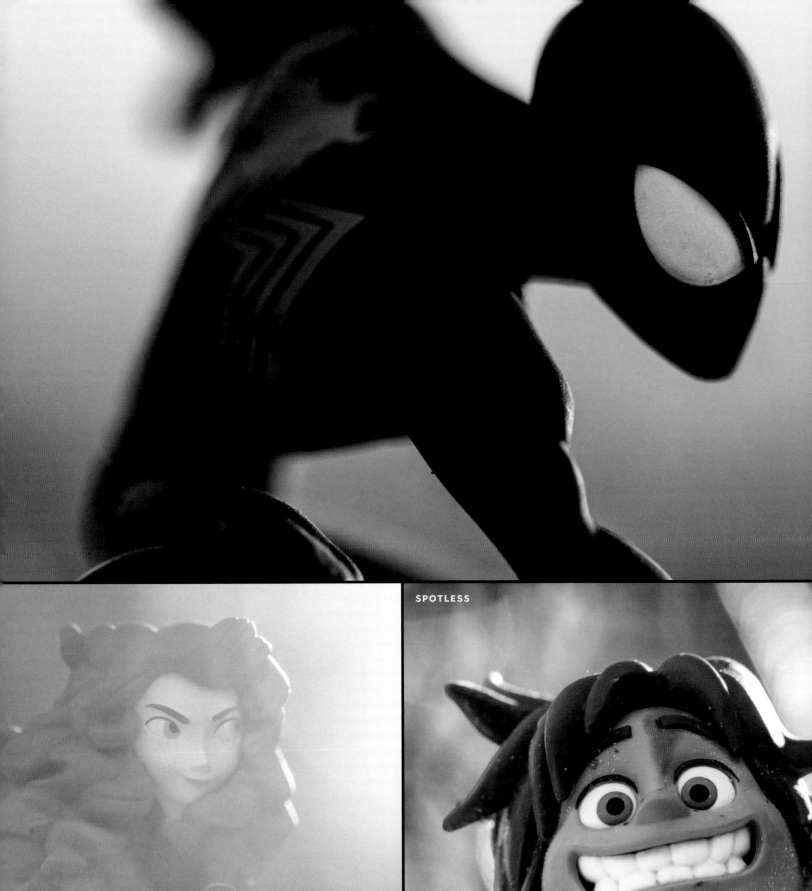

SPOTLESS

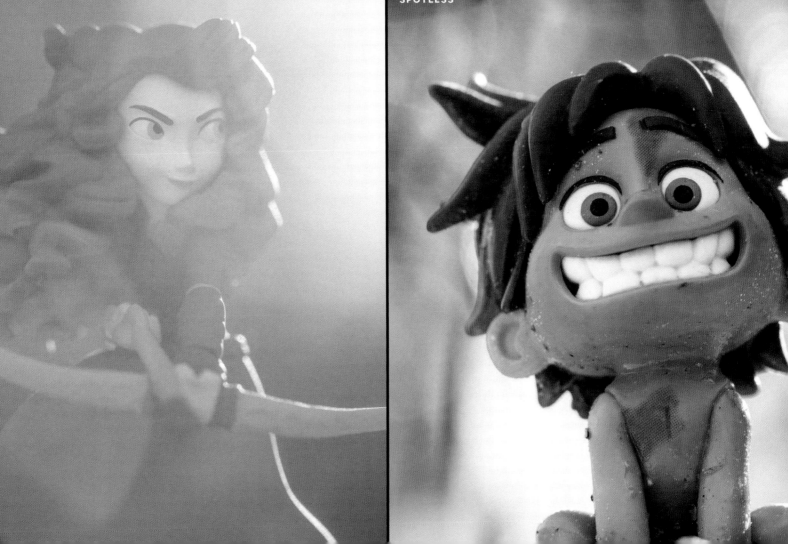

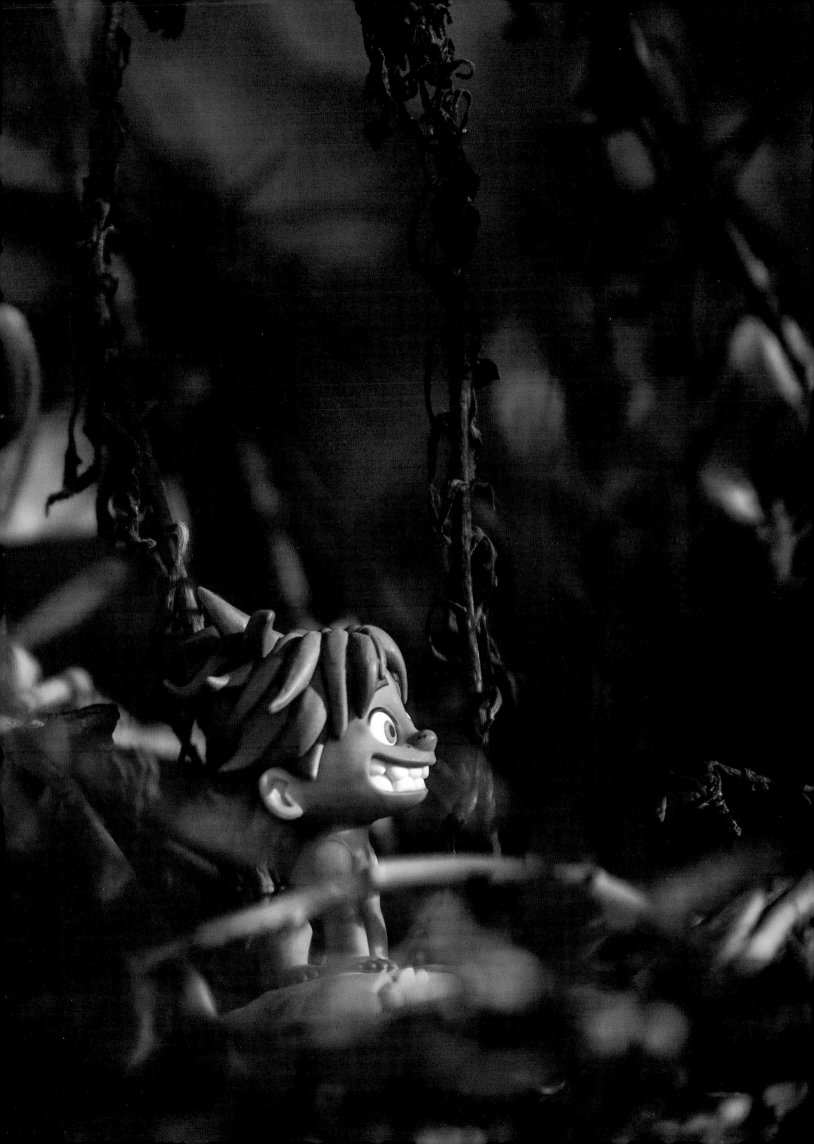

IT'S A SNAP!

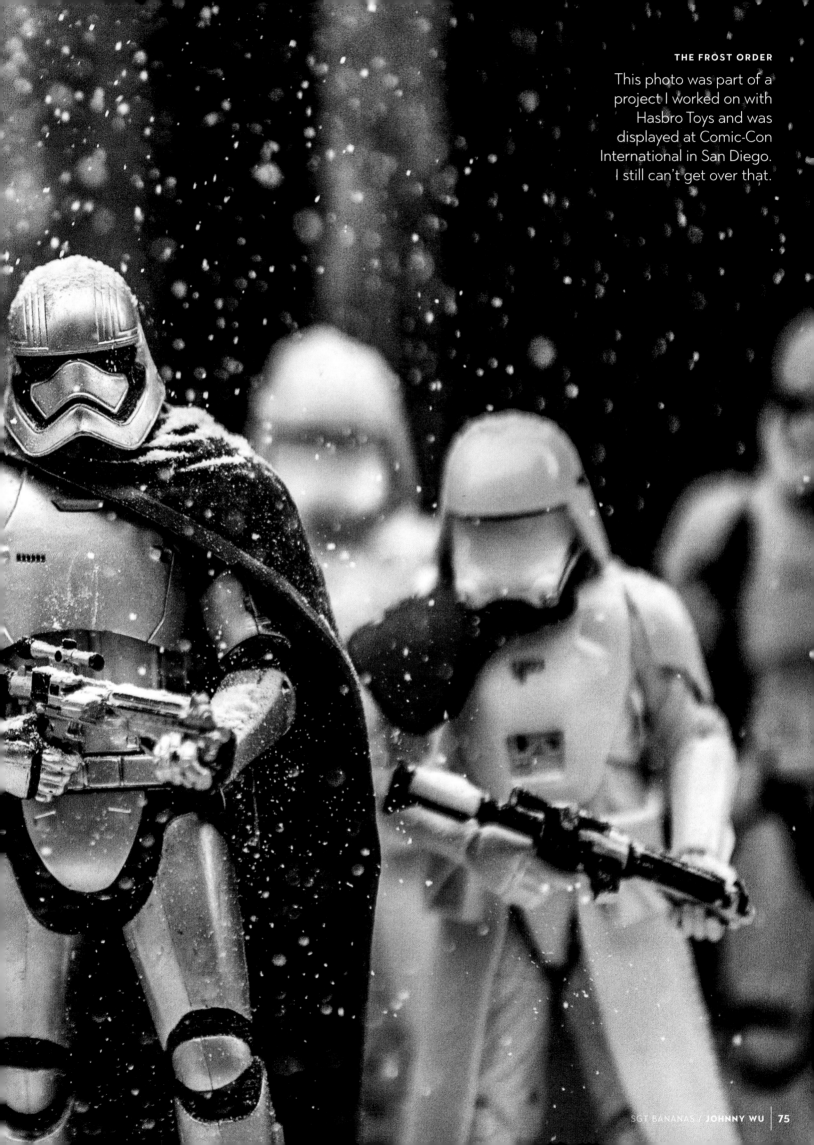

This photo was part of a project I worked on with Hasbro Toys and was displayed at Comic-Con International in San Diego. I still can't get over that.

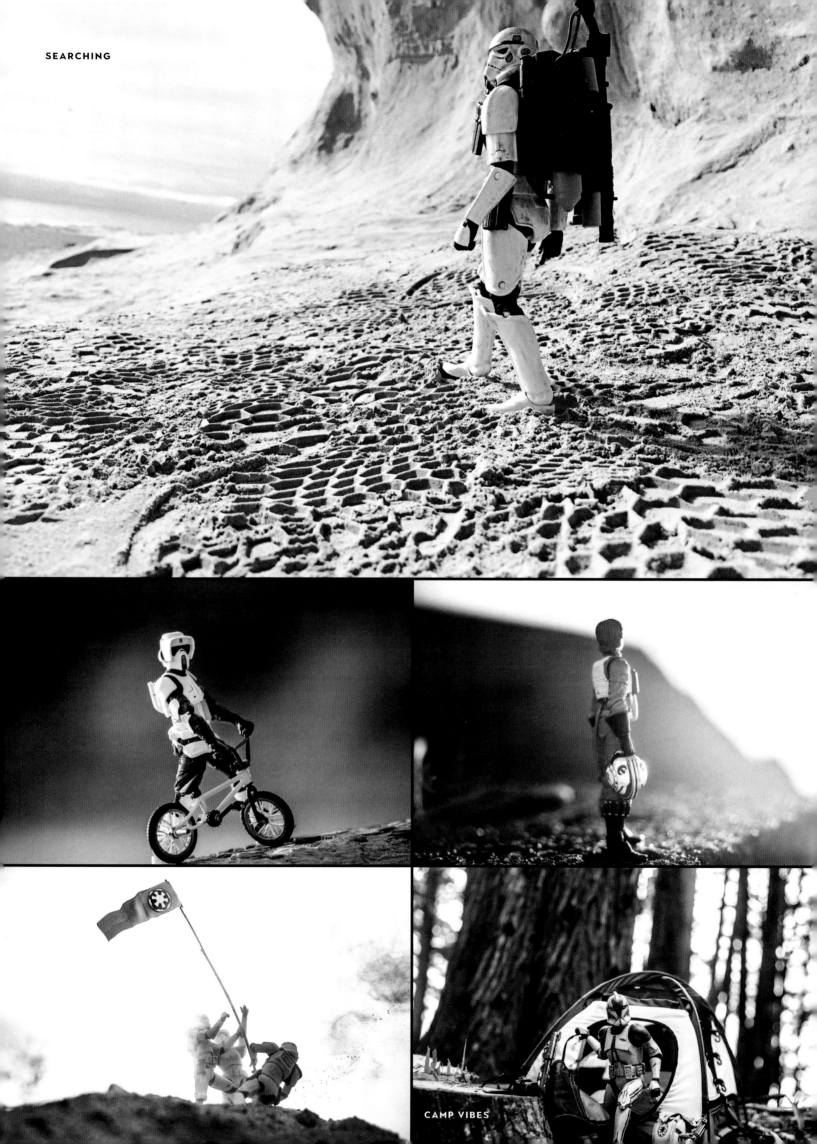

SEARCHING

CAMP VIBES

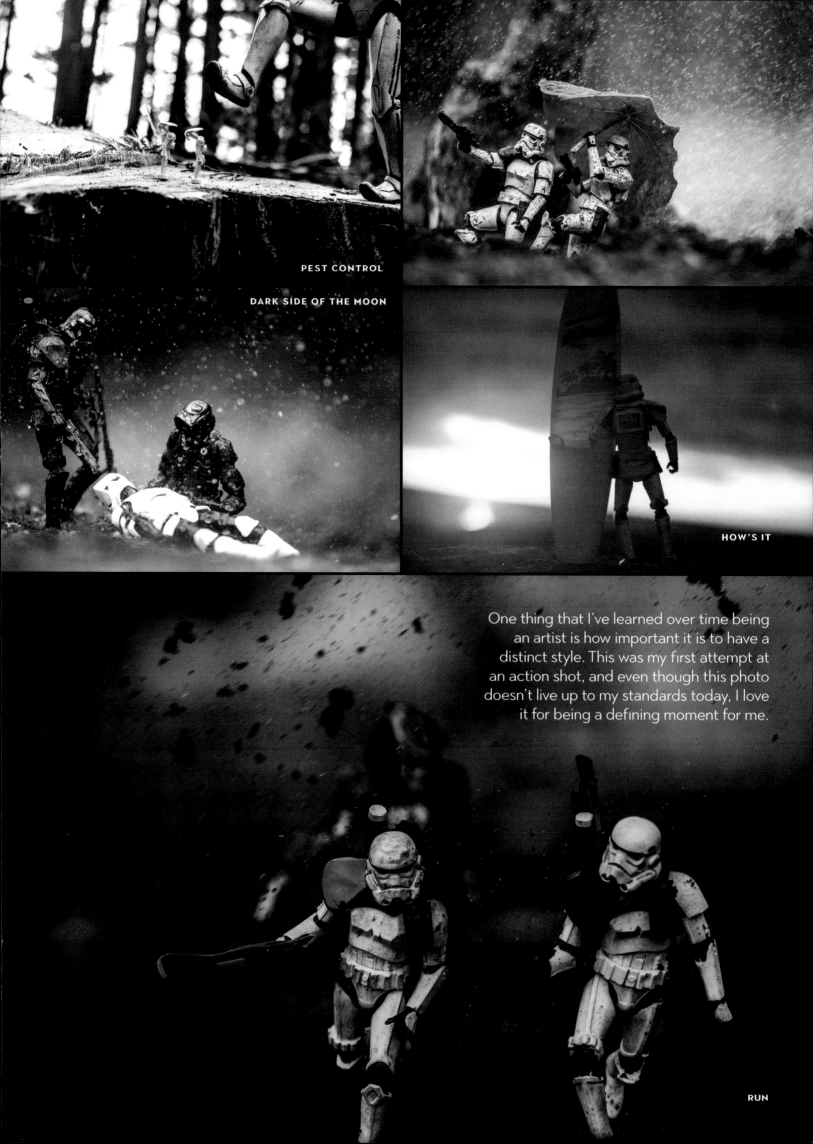

PEST CONTROL

DARK SIDE OF THE MOON

HOW'S IT

One thing that I've learned over time being an artist is how important it is to have a distinct style. This was my first attempt at an action shot, and even though this photo doesn't live up to my standards today, I love it for being a defining moment for me.

RUN

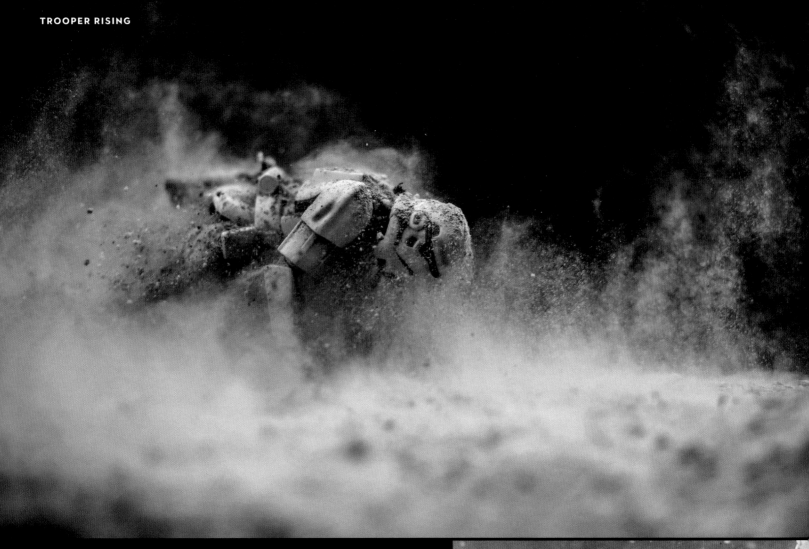

▲ Someone once asked me if I was obsessed with this hobby, and even though the answer is yes, a lot of what keeps me inspired is being obsessed with challenging myself to be better.

Any photographer with passion for their field is familiar with the feeling of knowing when you've taken "the one."

Few shots of mine fall into this category, but this is one of them.

This one has been displayed a lot, including at a mall in Shanghai, which was a proud moment for me.

THE TROOPER

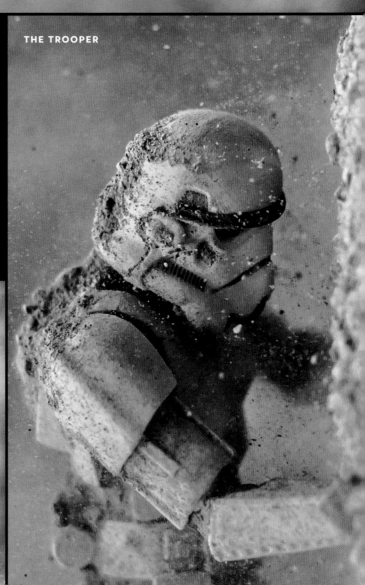

DOWN BUT NOT OUT

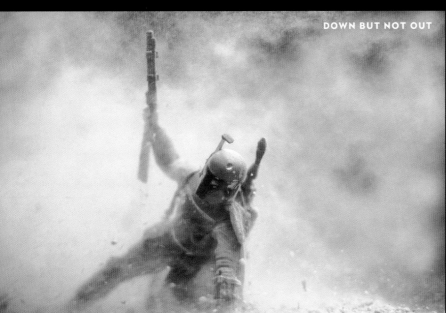

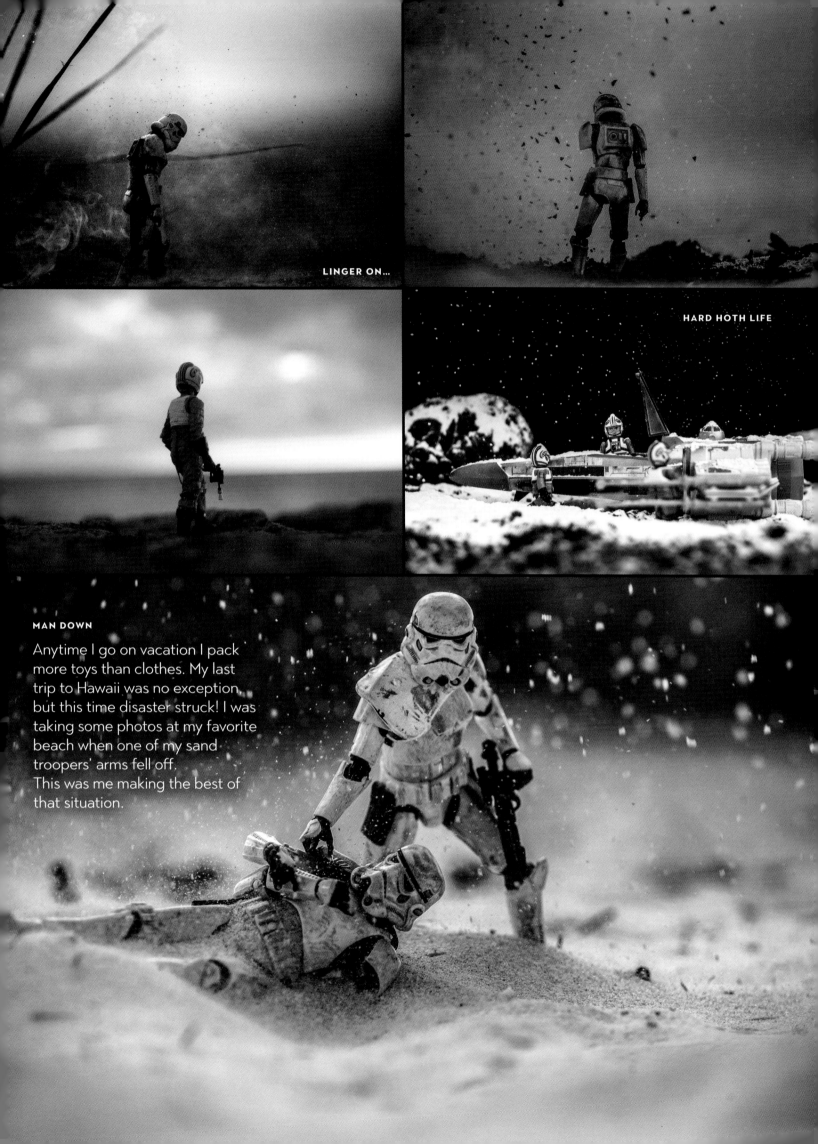

LINGER ON...

HARD HOTH LIFE

MAN DOWN

Anytime I go on vacation I pack
more toys than clothes. My last
trip to Hawaii was no exception
but this time disaster struck! I was
taking some photos at my favorite
beach when one of my sand
troopers' arms fell off.
This was me making the best of
that situation.

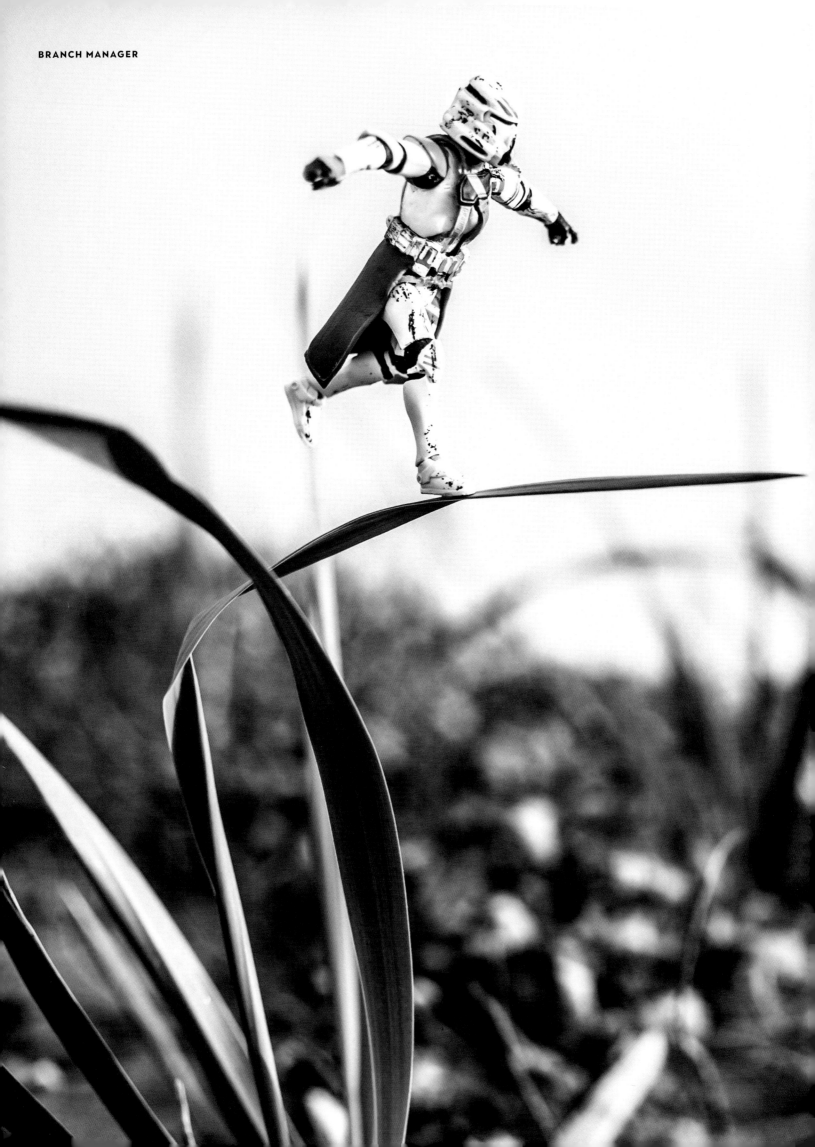

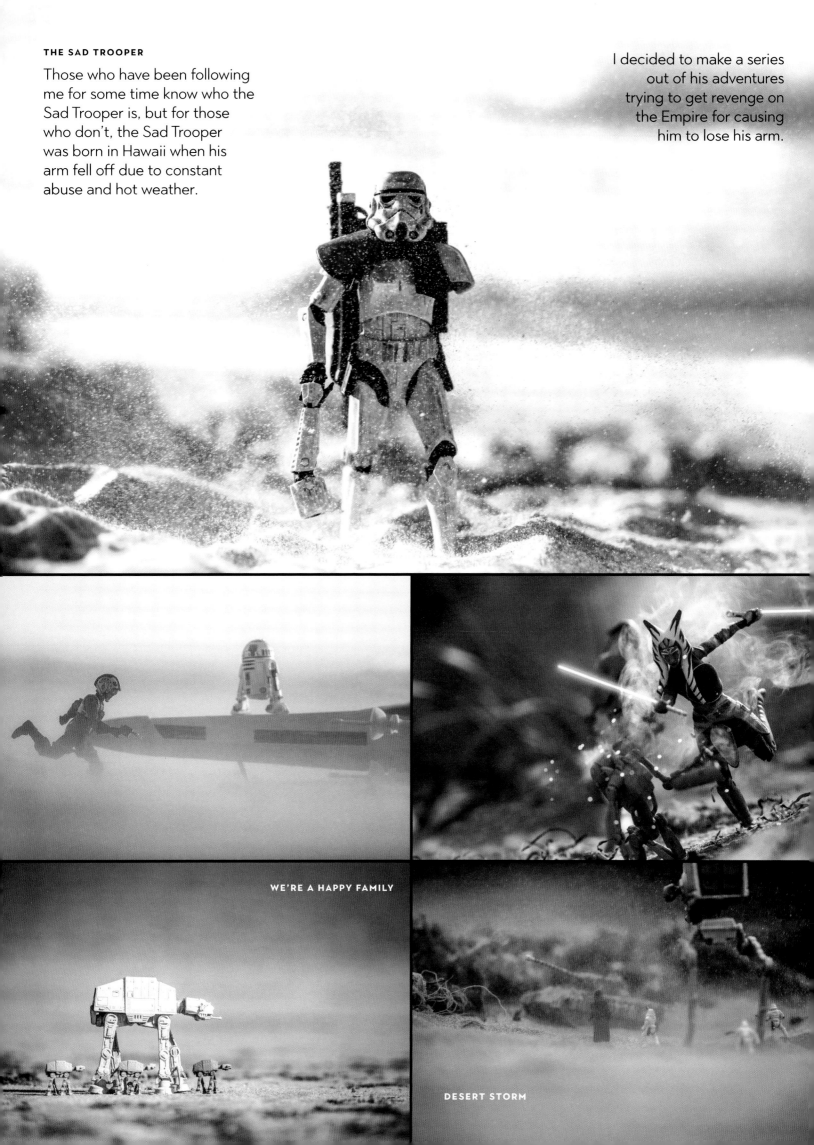

THE SAD TROOPER

Those who have been following me for some time know who the Sad Trooper is, but for those who don't, the Sad Trooper was born in Hawaii when his arm fell off due to constant abuse and hot weather.

I decided to make a series out of his adventures trying to get revenge on the Empire for causing him to lose his arm.

WE'RE A HAPPY FAMILY

DESERT STORM

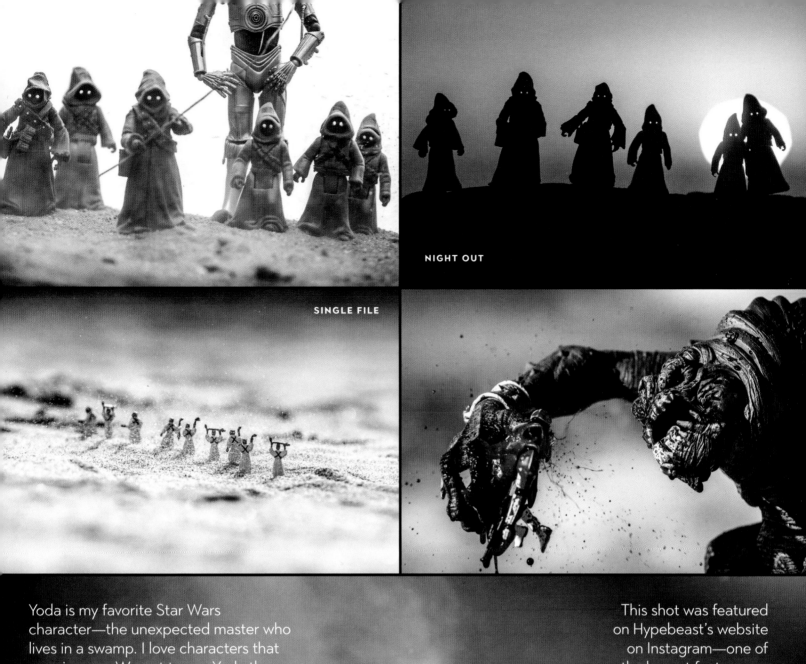

NIGHT OUT

SINGLE FILE

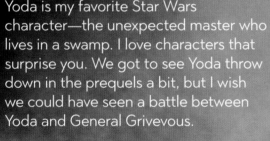

Yoda is my favorite Star Wars character—the unexpected master who lives in a swamp. I love characters that surprise you. We got to see Yoda throw down in the prequels a bit, but I wish we could have seen a battle between Yoda and General Grievous.

This shot was featured on Hypebeast's website on Instagram—one of the largest features on my work.

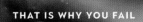

THAT IS WHY YOU FAIL

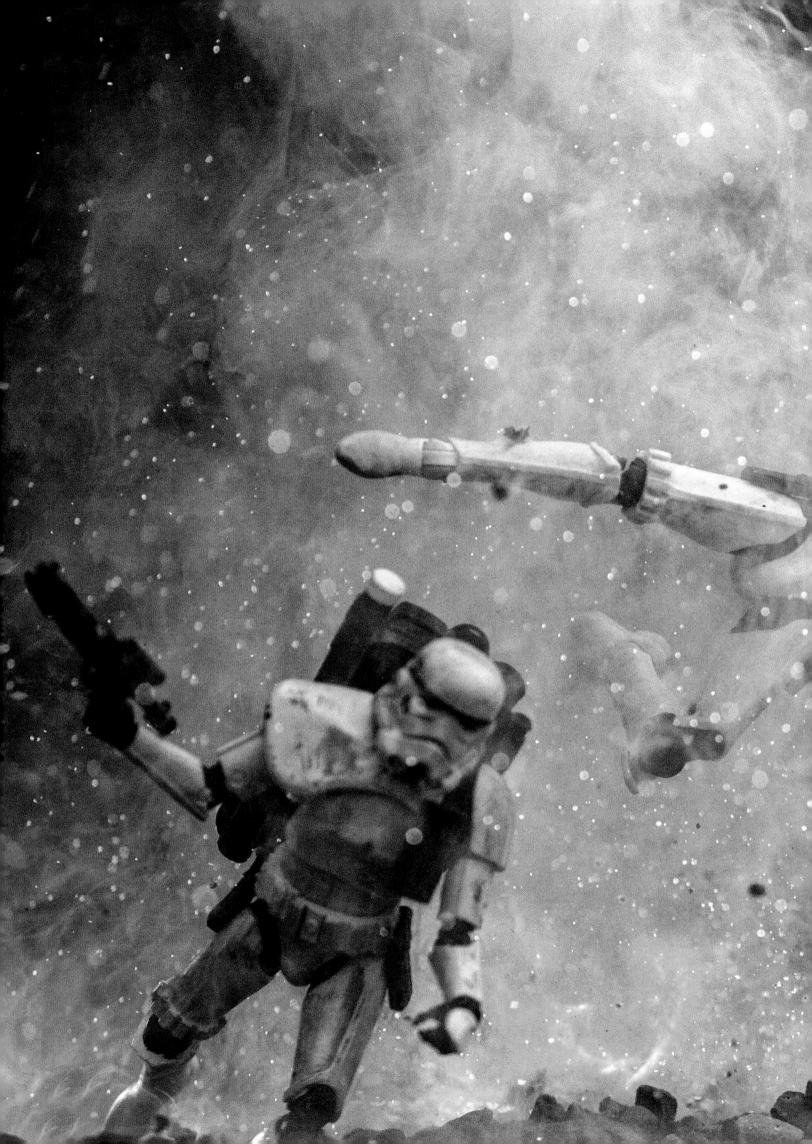

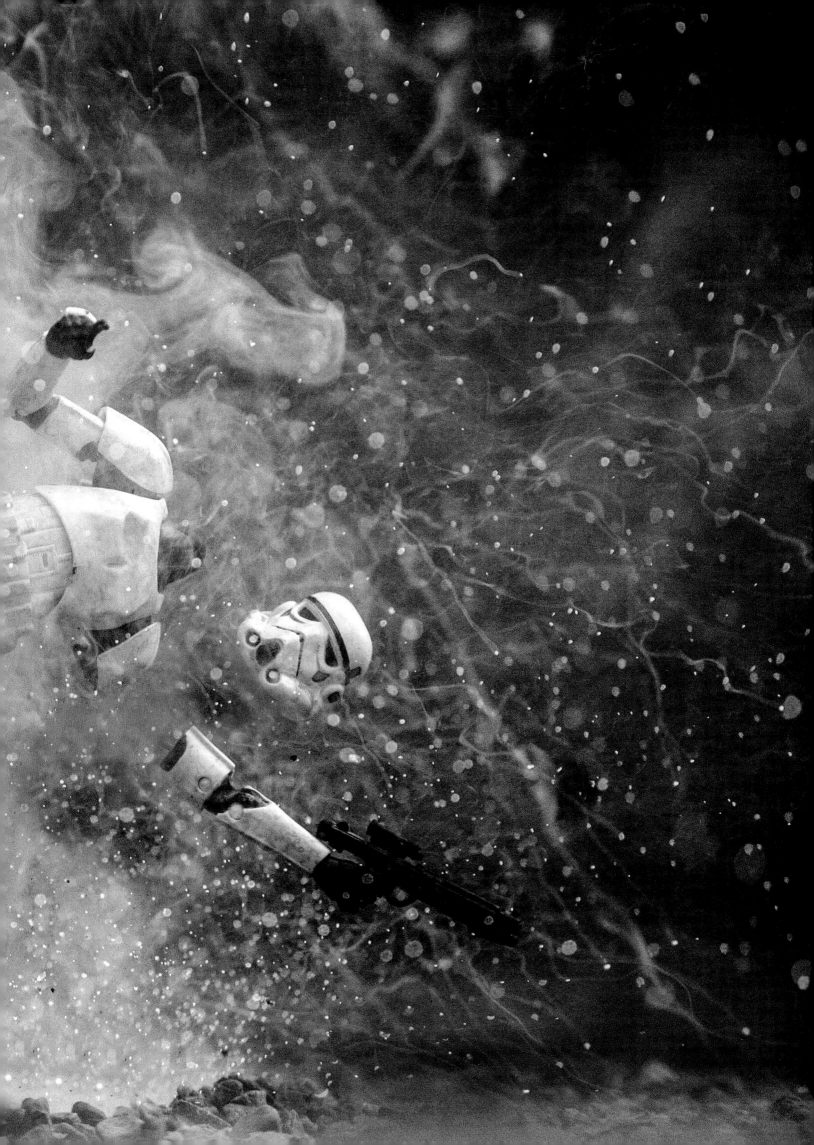

A NEW ERA

Sometimes shooting outdoors can present some real obstacles to work around. In this case, it was strong wind, which made it almost impossible to get a shot without the figures being blown over. I pushed through and secured the figures well enough to fire off a few shots while the sand was blowing across the beach in a cool way.

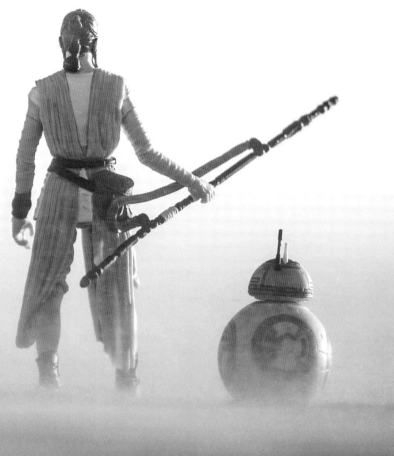

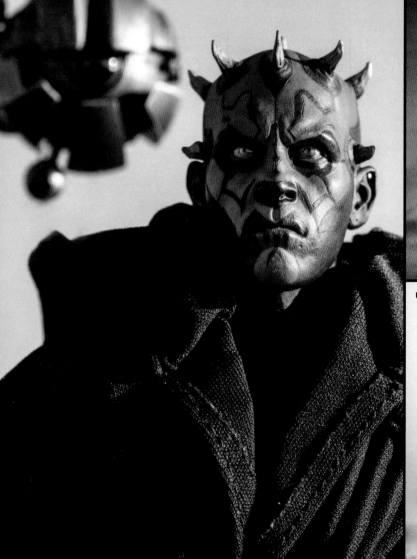

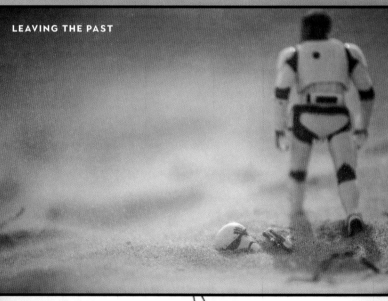

LEAVING THE PAST

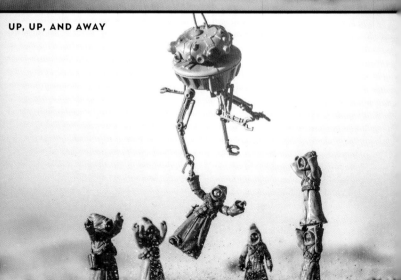

UP, UP, AND AWAY

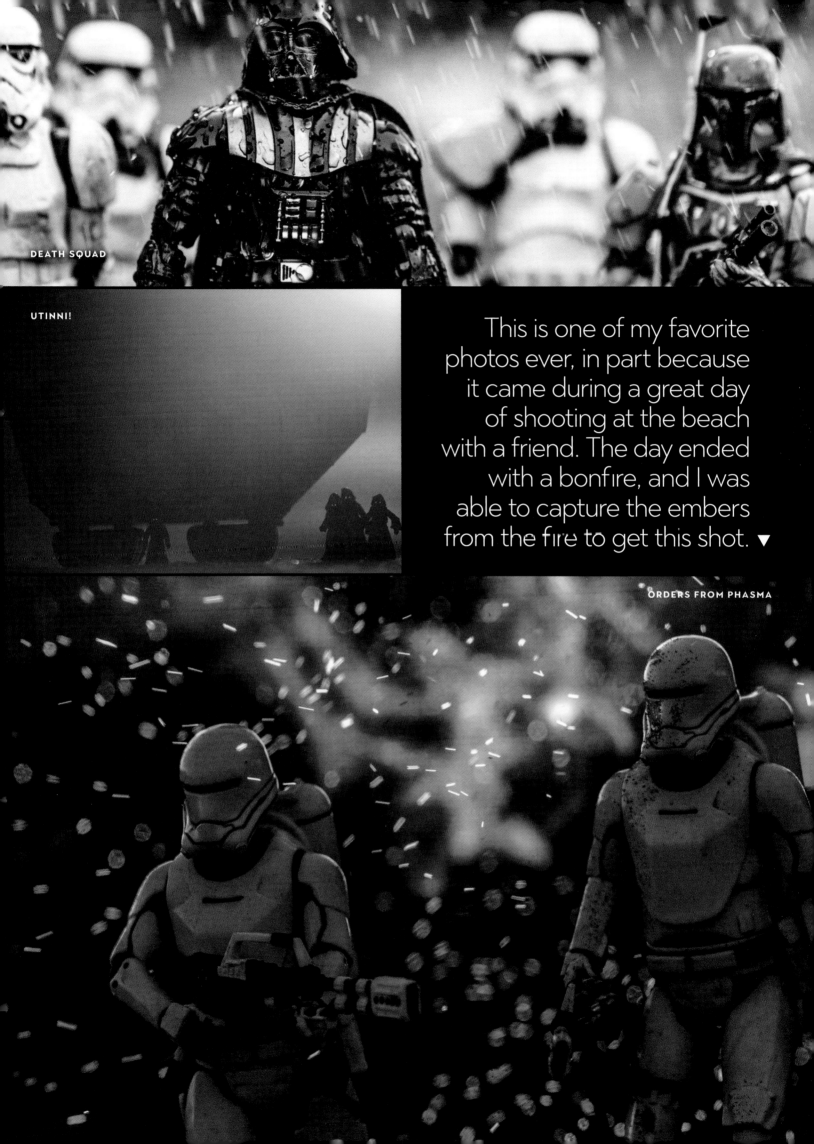

DEATH SQUAD

UTINNI!

This is one of my favorite photos ever, in part because it came during a great day of shooting at the beach with a friend. The day ended with a bonfire, and I was able to capture the embers from the fire to get this shot. ▼

ORDERS FROM PHASMA

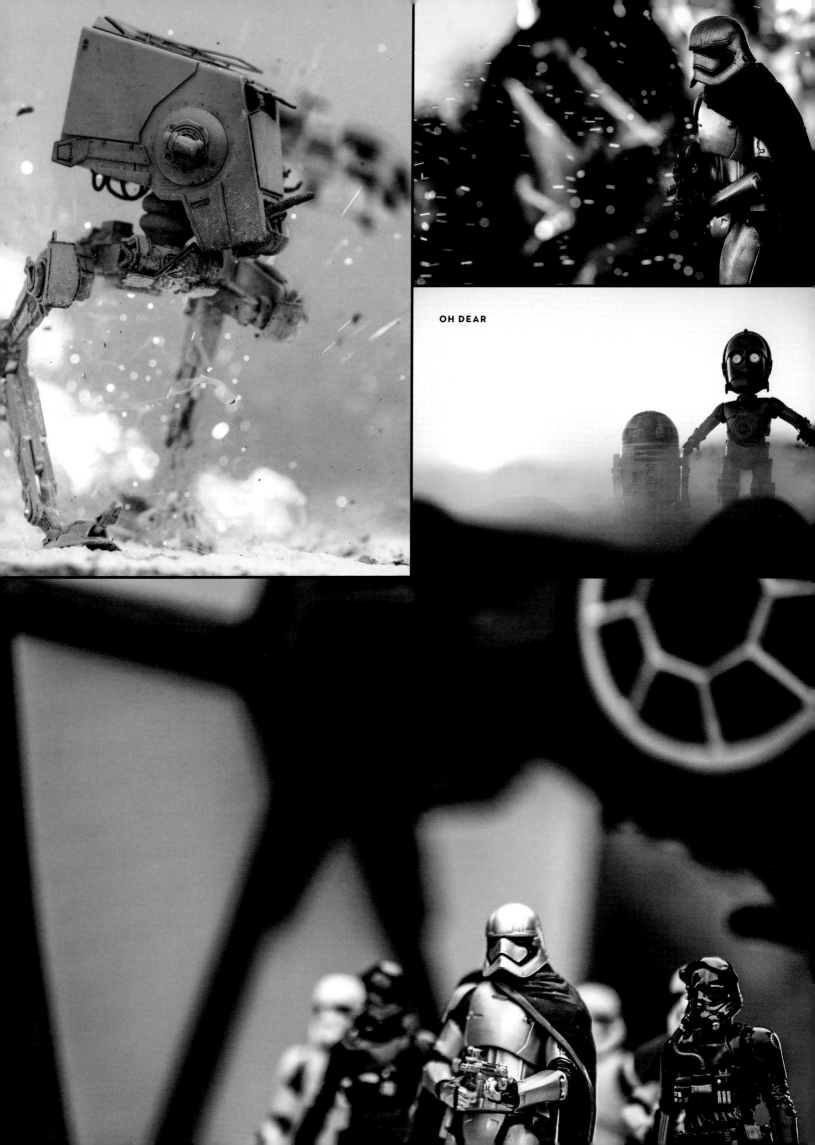

OH DEAR

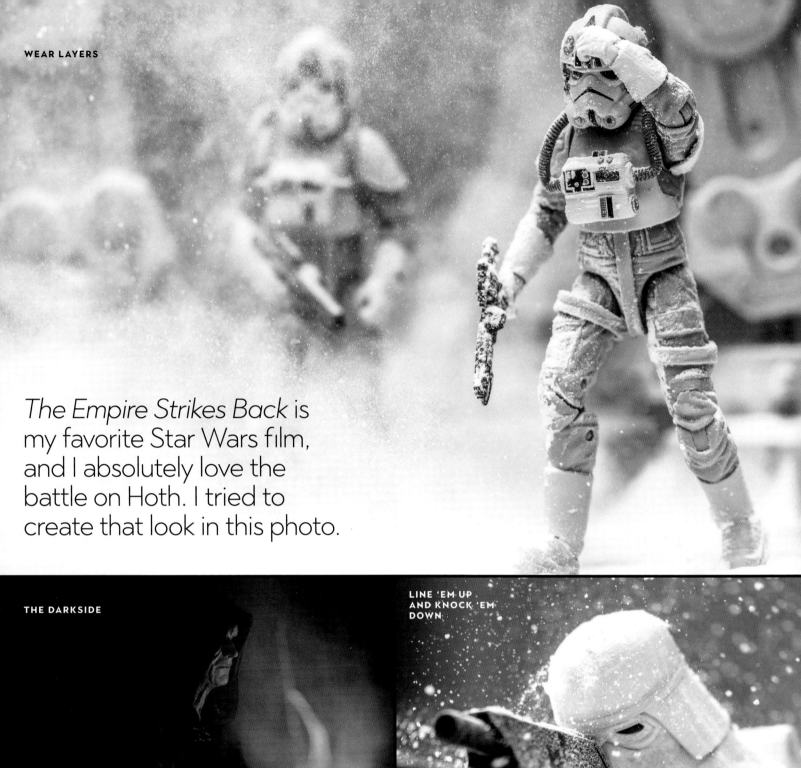

WEAR LAYERS

The Empire Strikes Back is my favorite Star Wars film, and I absolutely love the battle on Hoth. I tried to create that look in this photo.

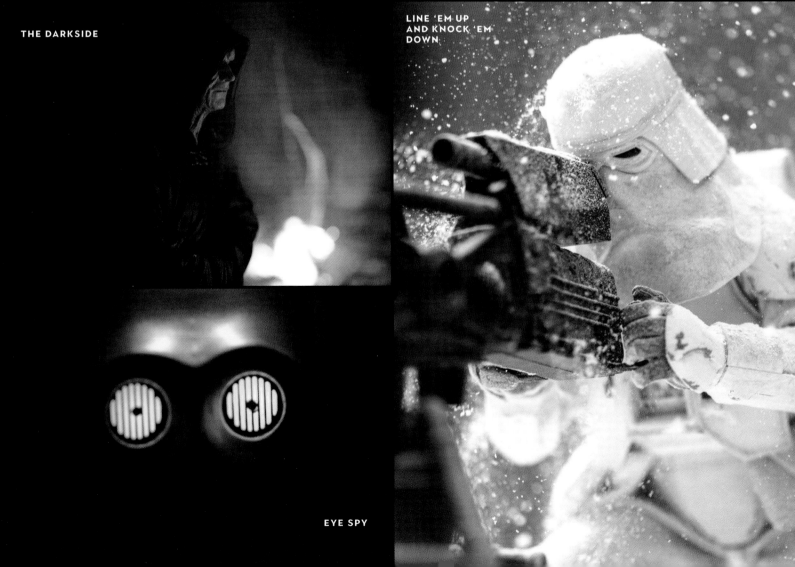

THE DARKSIDE

LINE 'EM UP AND KNOCK 'EM DOWN

EYE SPY

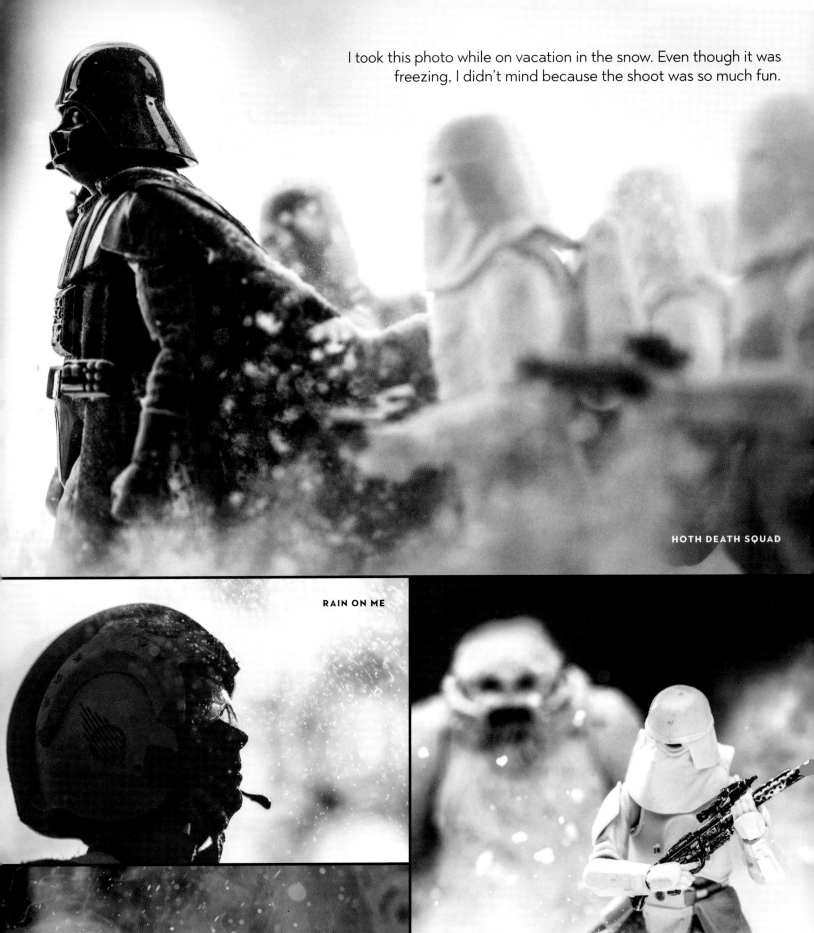

I took this photo while on vacation in the snow. Even though it was freezing, I didn't mind because the shoot was so much fun.

HOTH DEATH SQUAD

RAIN ON ME

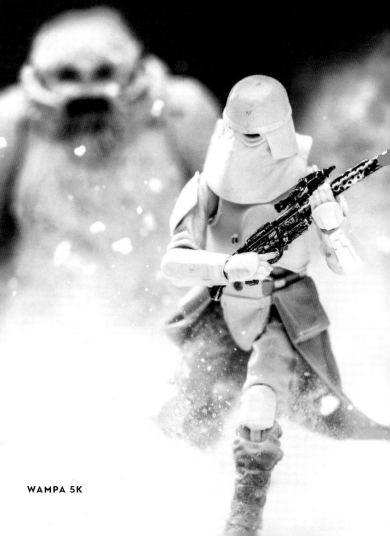

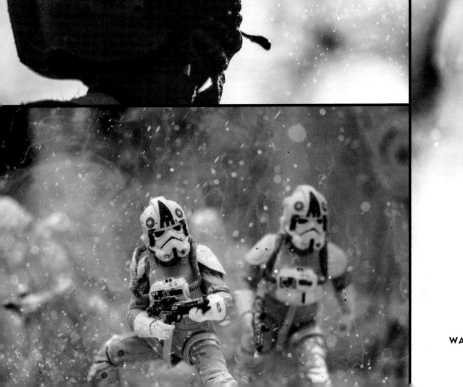

WAMPA 5K

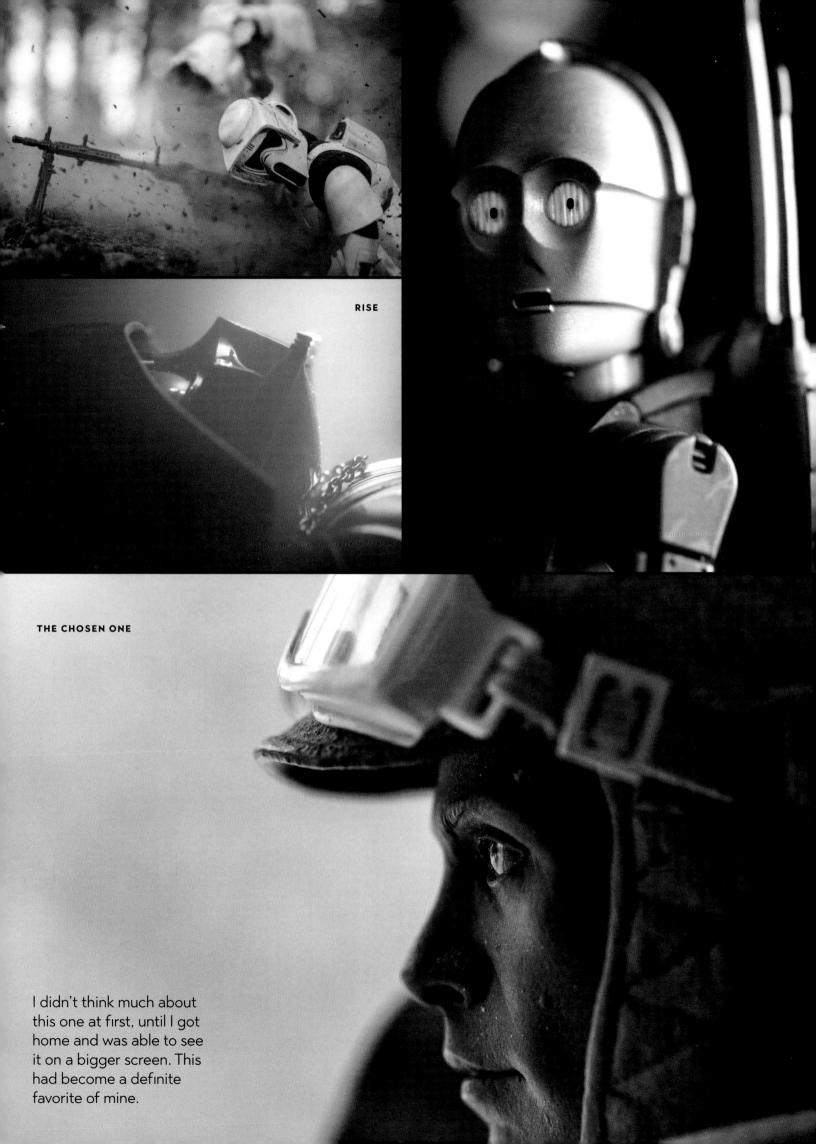

RISE

THE CHOSEN ONE

I didn't think much about this one at first, until I got home and was able to see it on a bigger screen. This had become a definite favorite of mine.

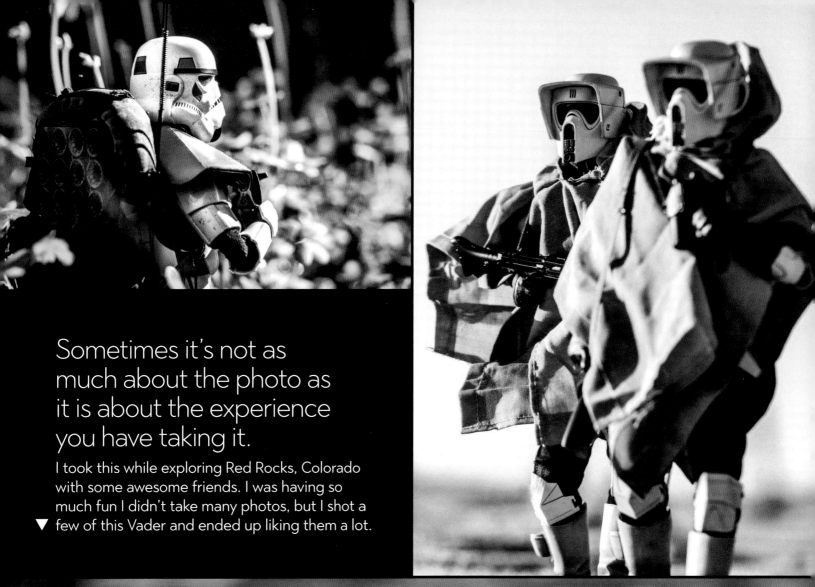

Sometimes it's not as much about the photo as it is about the experience you have taking it.

I took this while exploring Red Rocks, Colorado with some awesome friends. I was having so much fun I didn't take many photos, but I shot a
▼ few of this Vader and ended up liking them a lot.

SMALL BUT MIGHTY

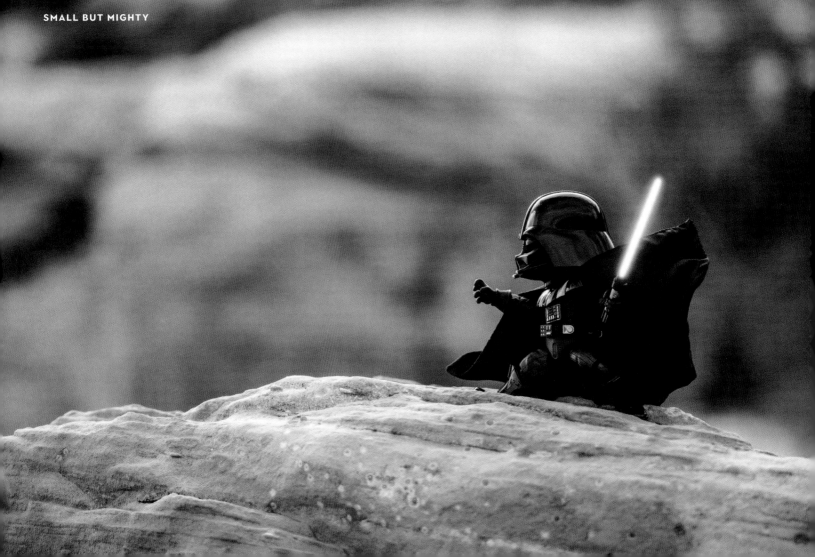

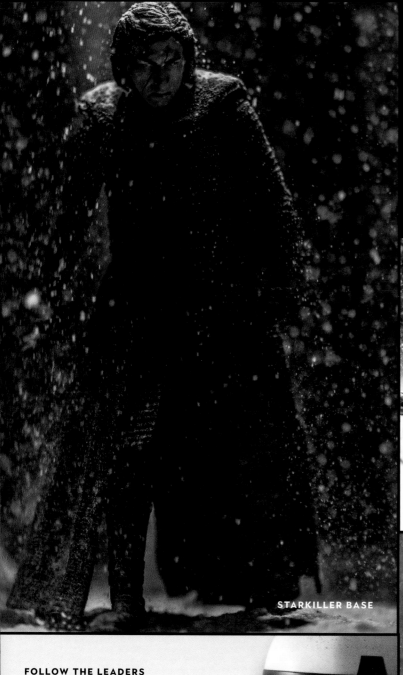

STARKILLER BASE

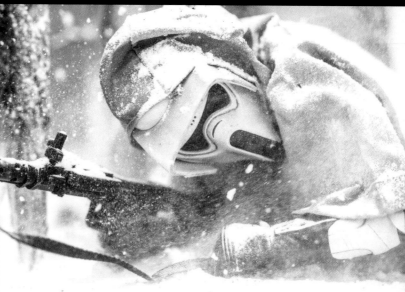

One of my biggest inspirations is a friend of mine by the name of Avanut. He pioneered this effect with Lego minifigs and made it look amazing. I always wanted to recreate some night time snow fall scenes and after getting some lights I finally did. I love the way this photo came out. Big thanks to Avanut for always inspiring.

THE SNOWDOWN SHOWDOWN

FOLLOW THE LEADERS

I'd love to see Luke have another go with a Wampa. I shot this photo with that in mind. ▶

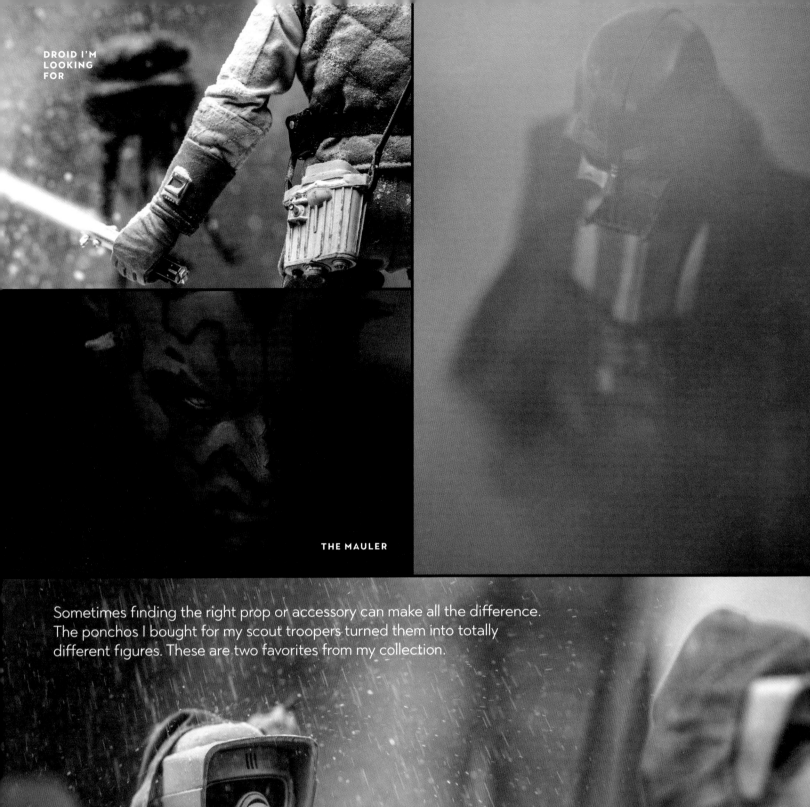

THE MAULER

Sometimes finding the right prop or accessory can make all the difference.
The ponchos I bought for my scout troopers turned them into totally
different figures. These are two favorites from my collection.

RAINY ENDOR

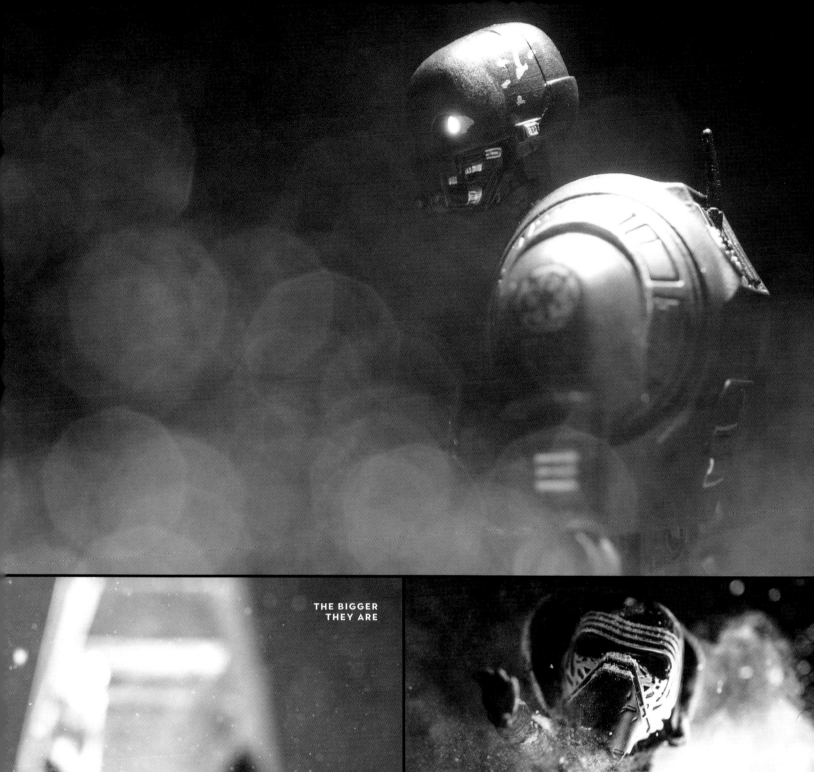

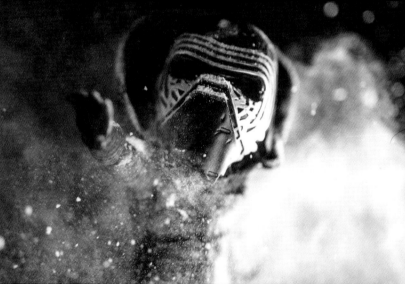

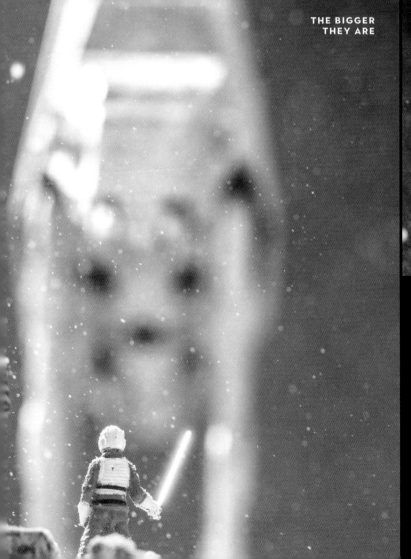

◄ This was inspired by concept art for the Star Wars Battlefront game. I wanted to recreate the scene and attempted it early on, but the original results weren't good. This was from a later attempt that was much more successful.

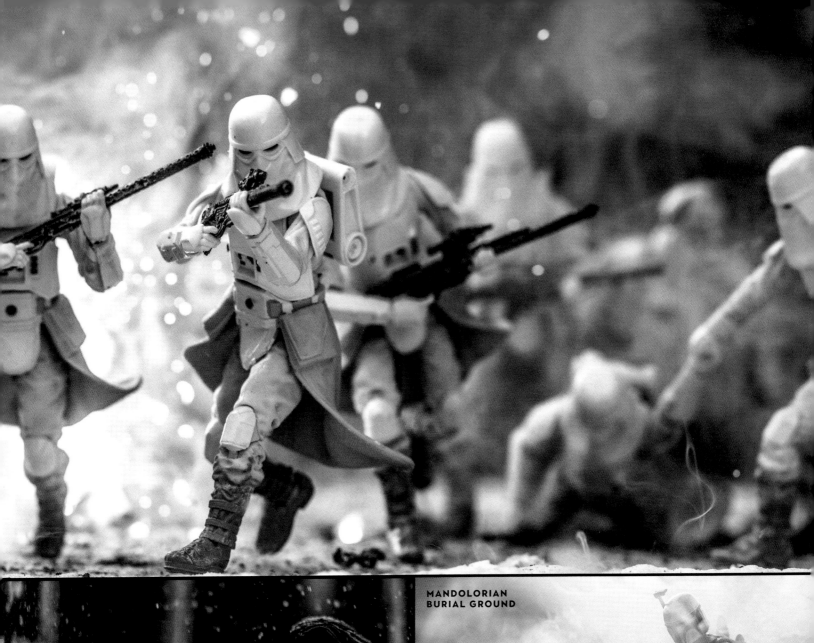

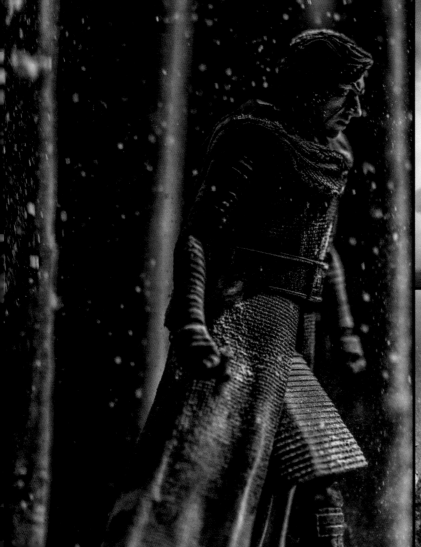

MANDOLORIAN
BURIAL GROUND

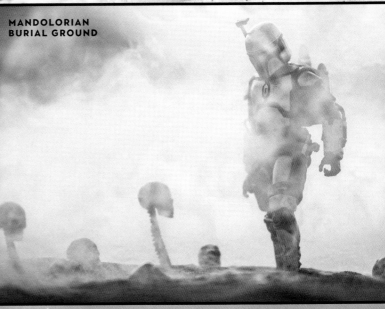

GOT 'EM

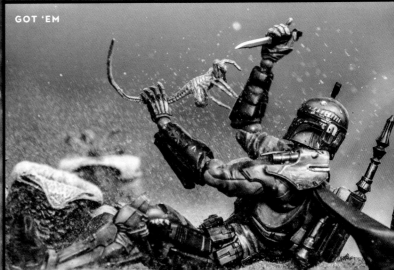

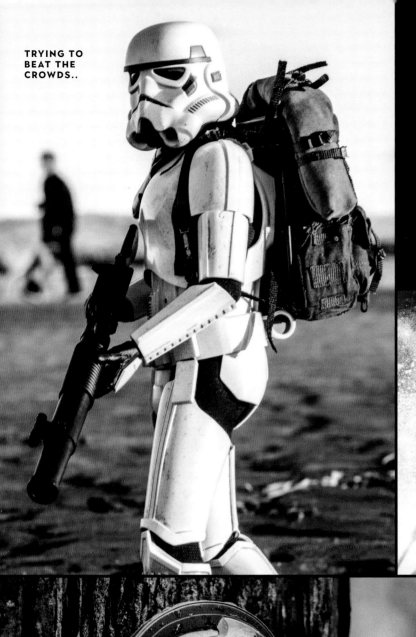

◄ Forced perspective is something I enjoy, but this was a happy accident. The guy walking his dog was pure chance—I'm glad it worked out!

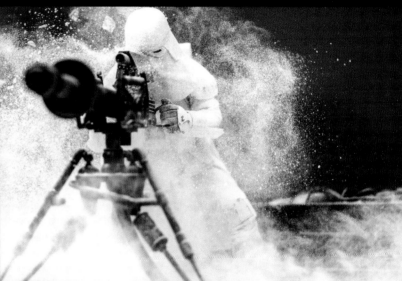

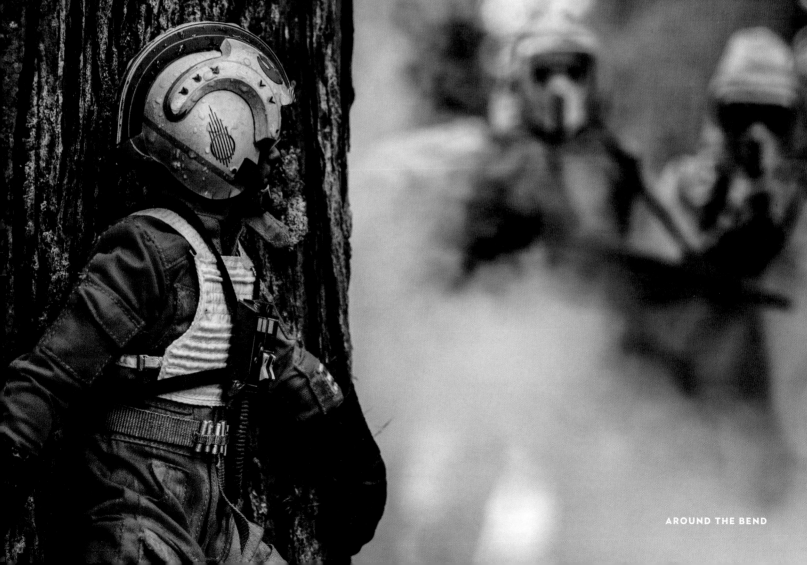

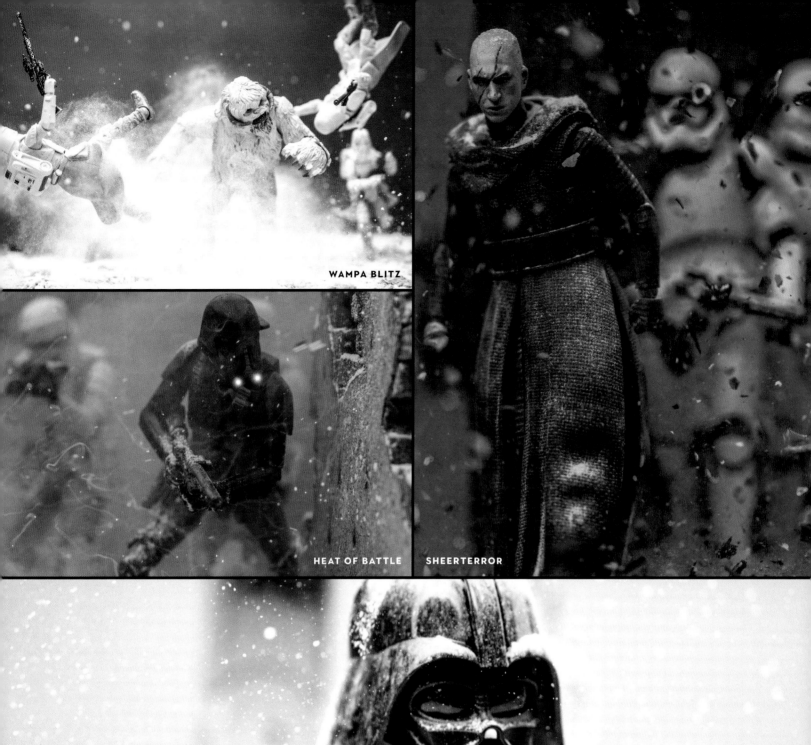

WAMPA BLITZ

HEAT OF BATTLE

SHEERTERROR

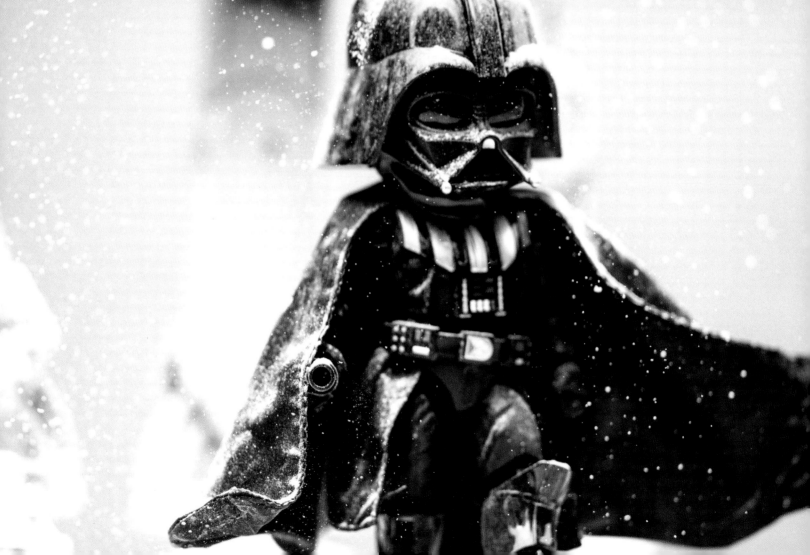

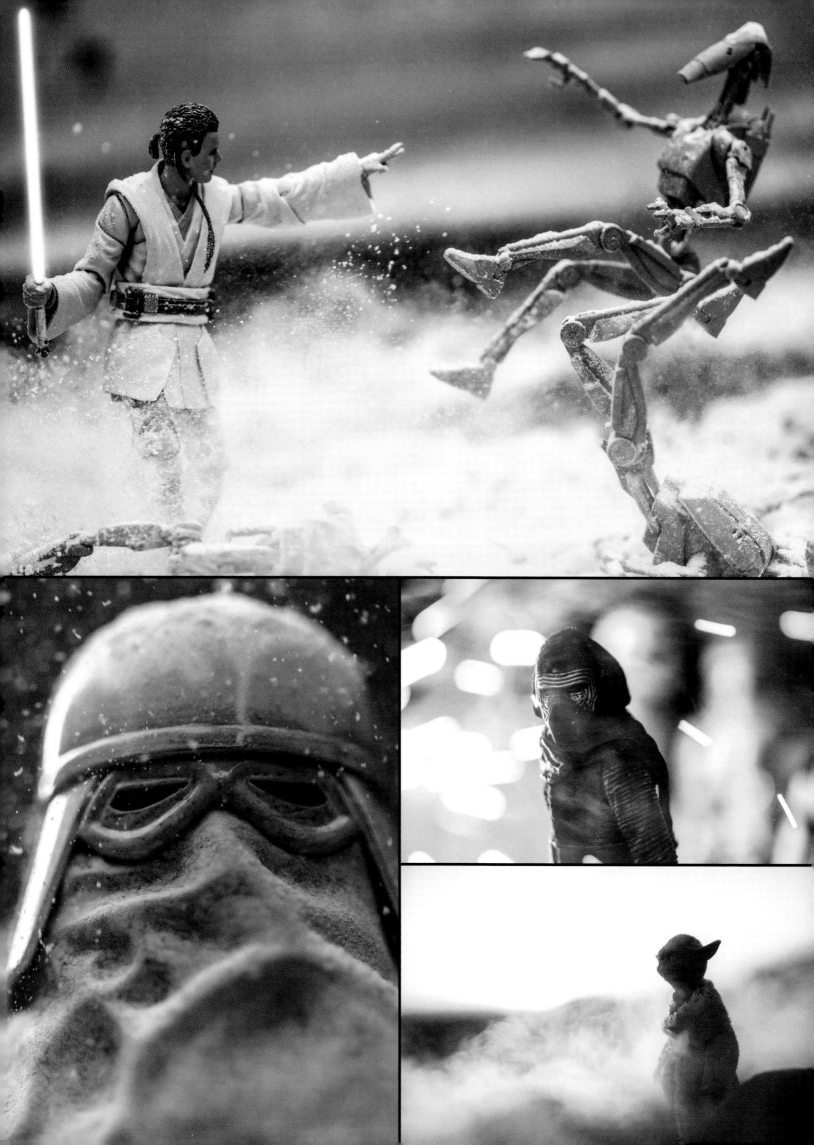

TOY-POCA-LYPSE

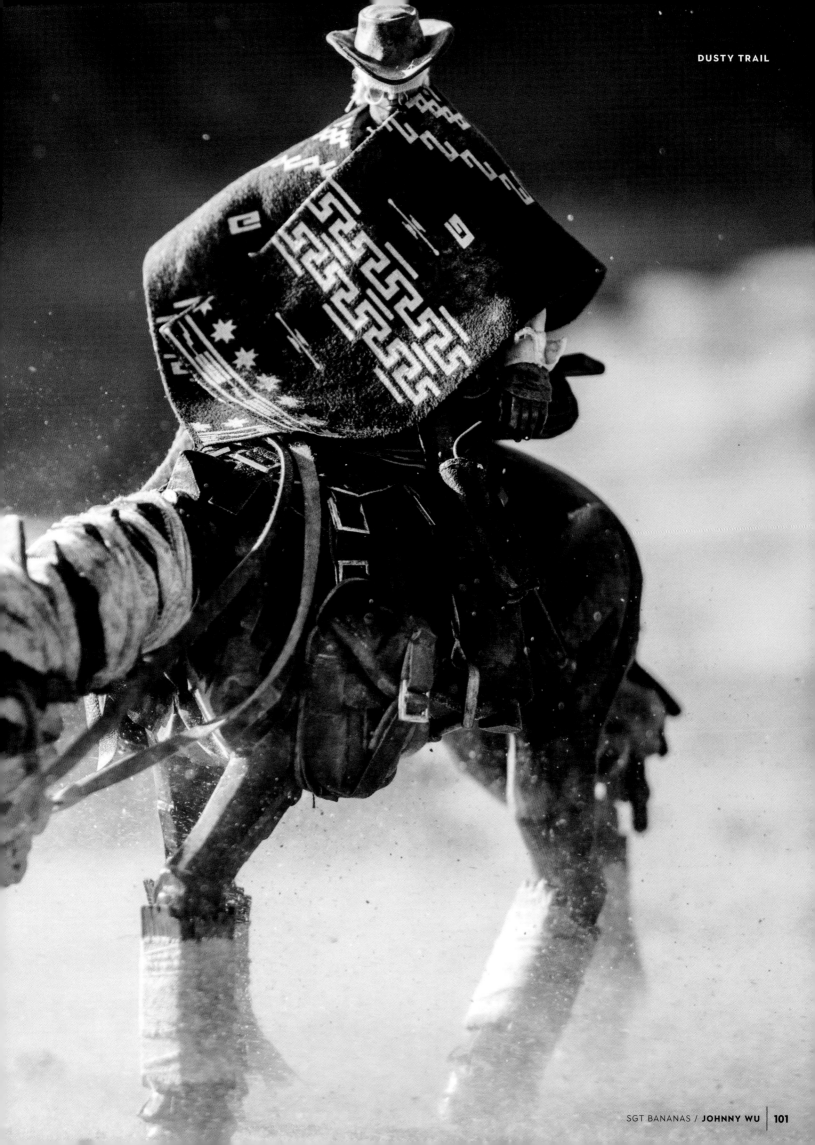

An early shot of my experiments with fireworks, this time using sparklers to create the effect. Wish I could tell you nothing was burned while shooting this ...

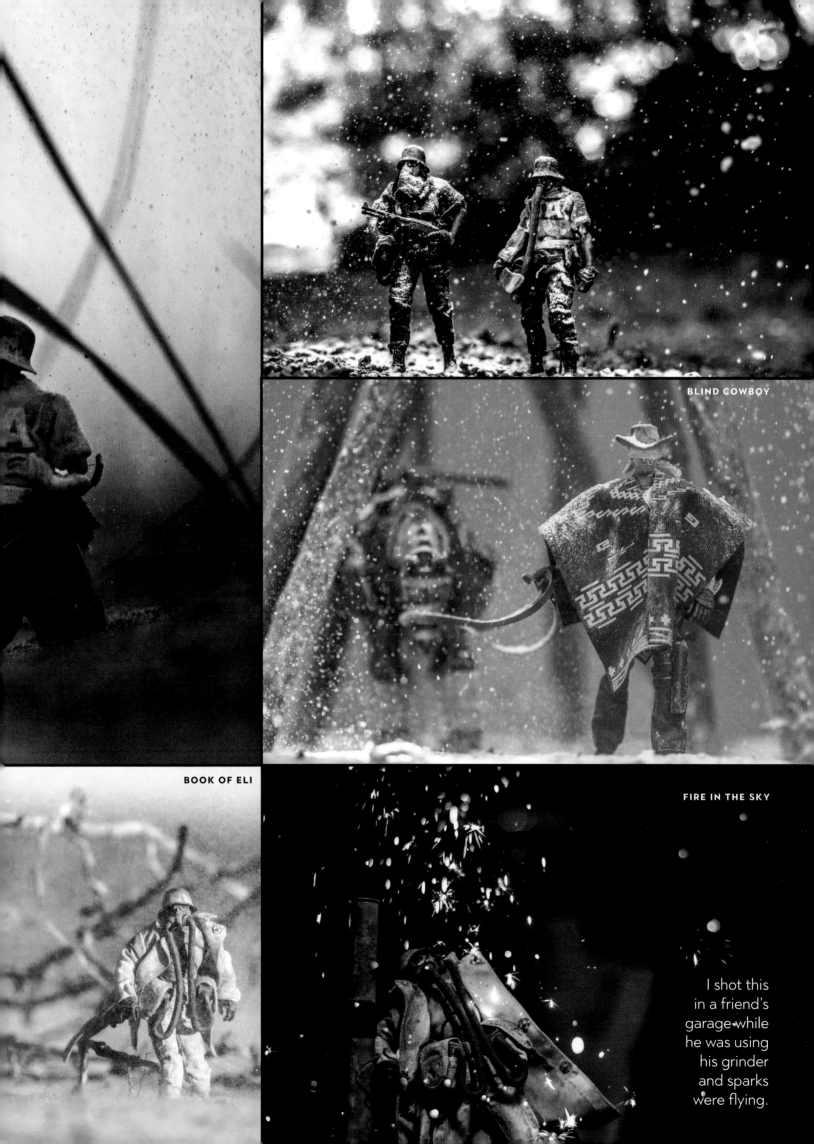

BLIND COWBOY

BOOK OF ELI

FIRE IN THE SKY

I shot this
in a friend's
garage while
he was using
his grinder
and sparks
were flying.

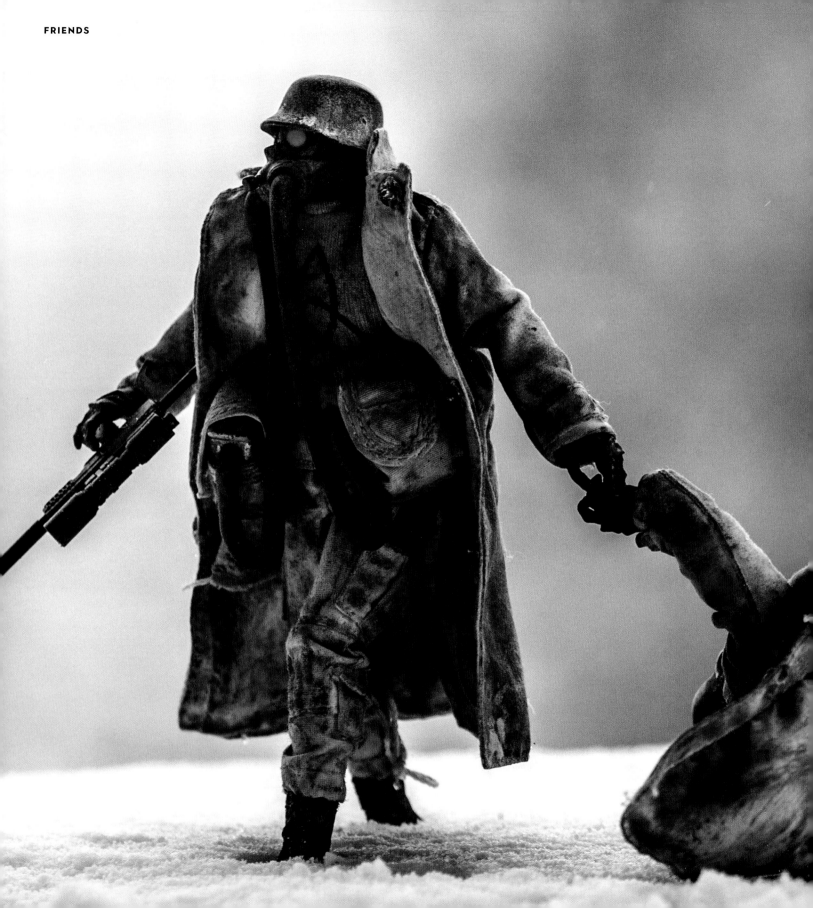

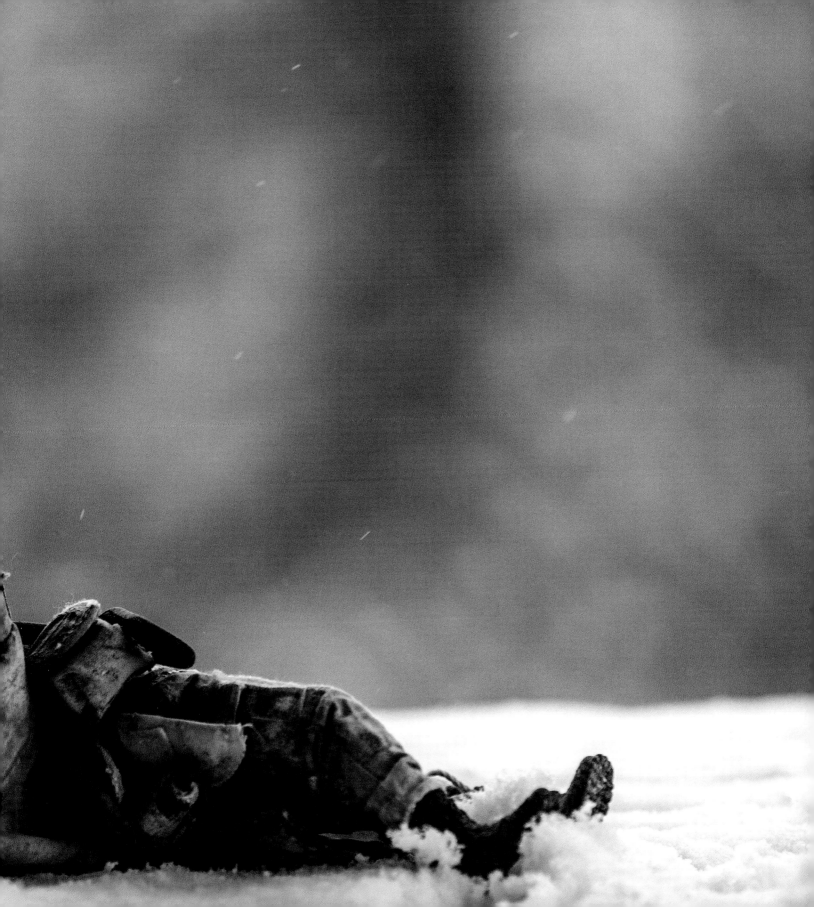

GREAT SCOTT!

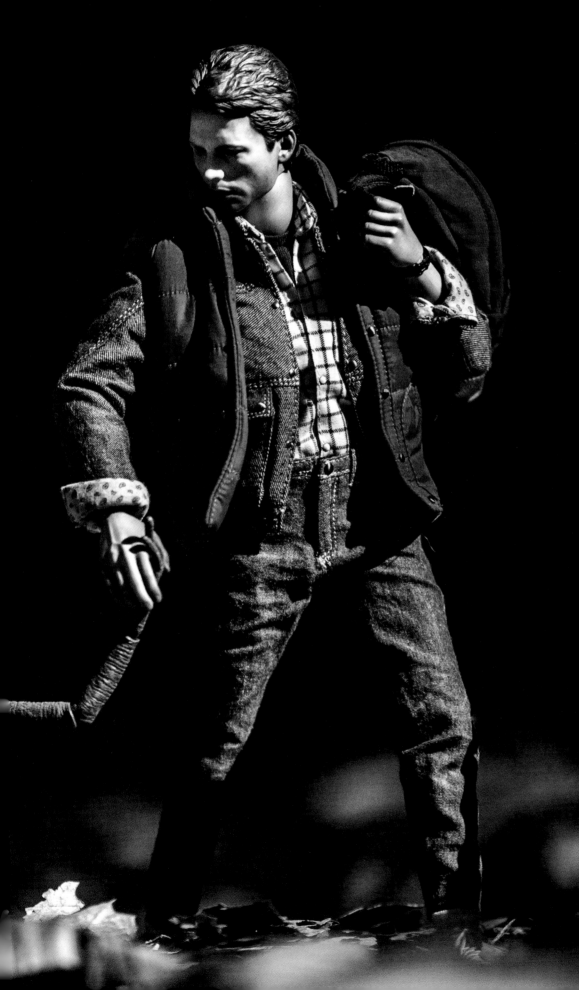

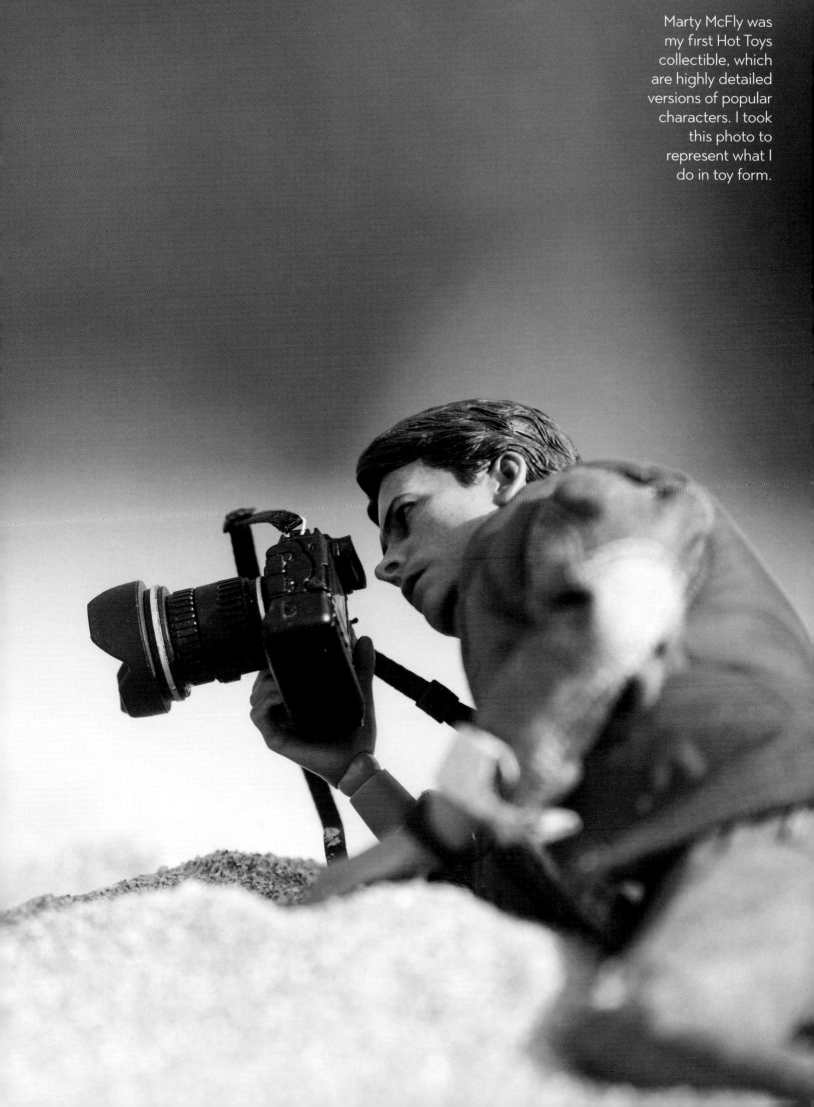

Marty McFly was my first Hot Toys collectible, which are highly detailed versions of popular characters. I took this photo to represent what I do in toy form.

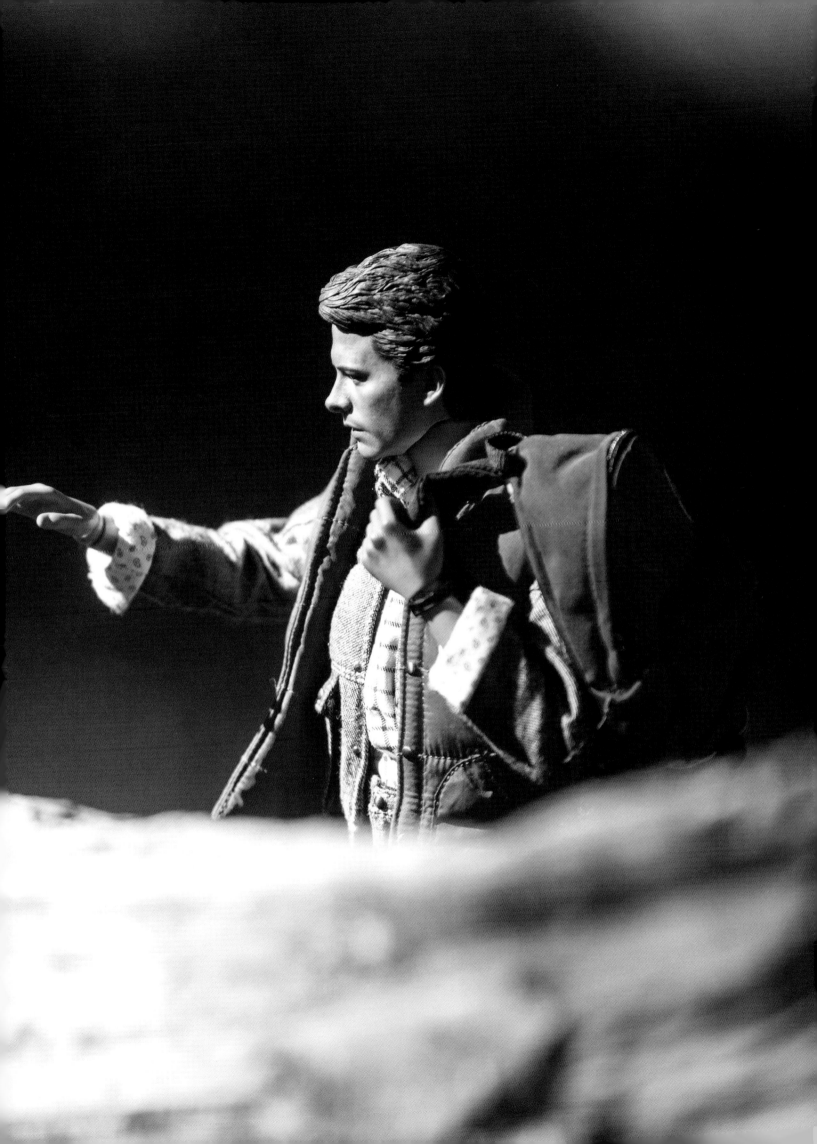

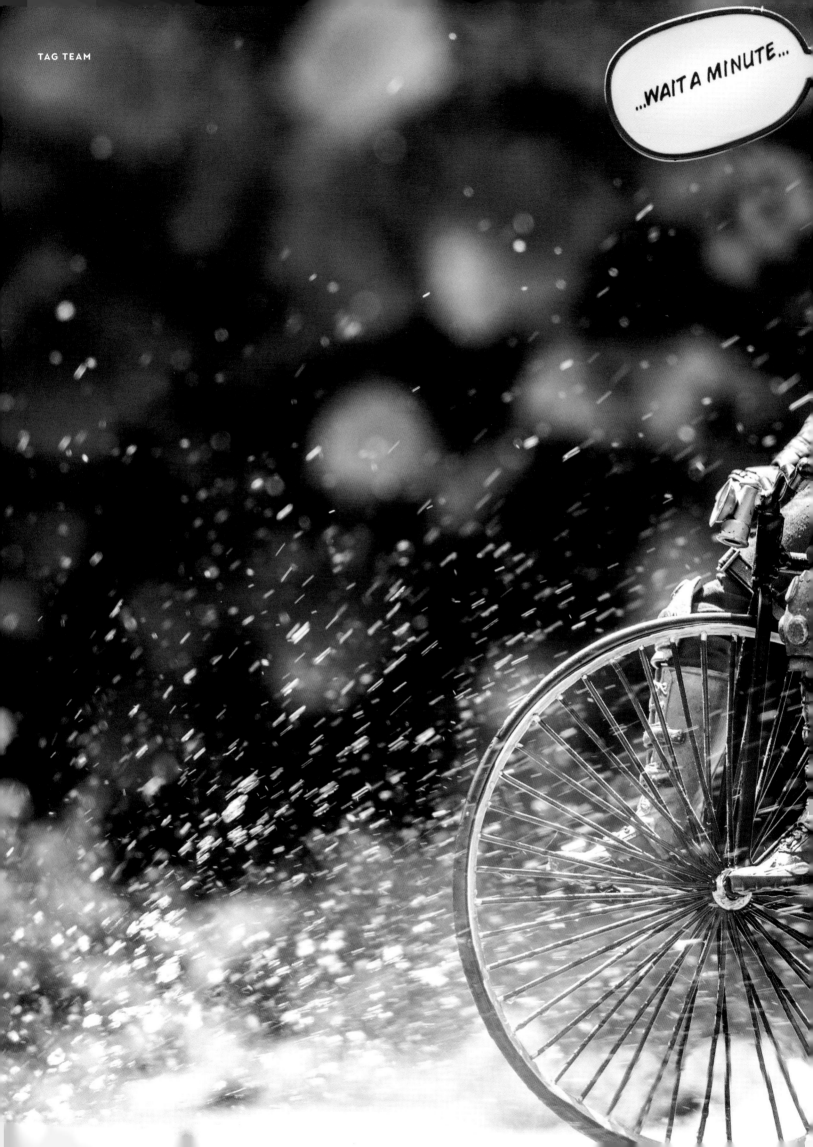

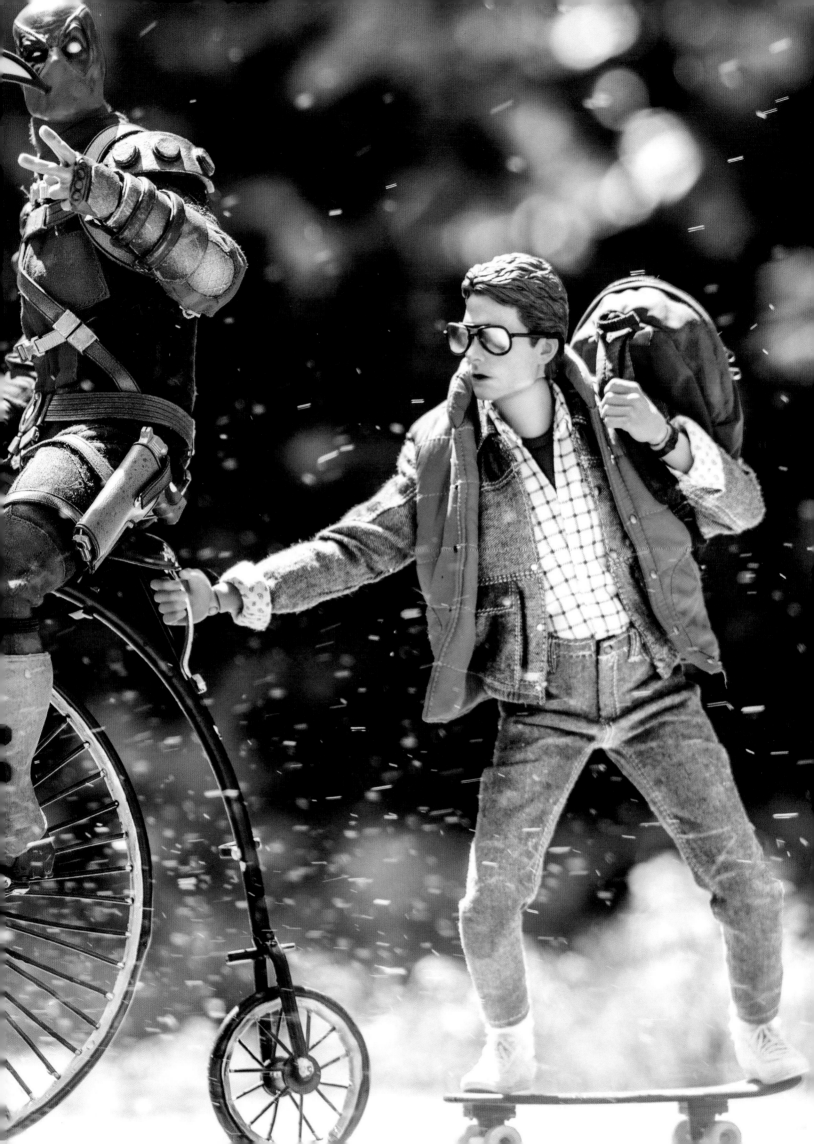

MEDIEVAL TIMES

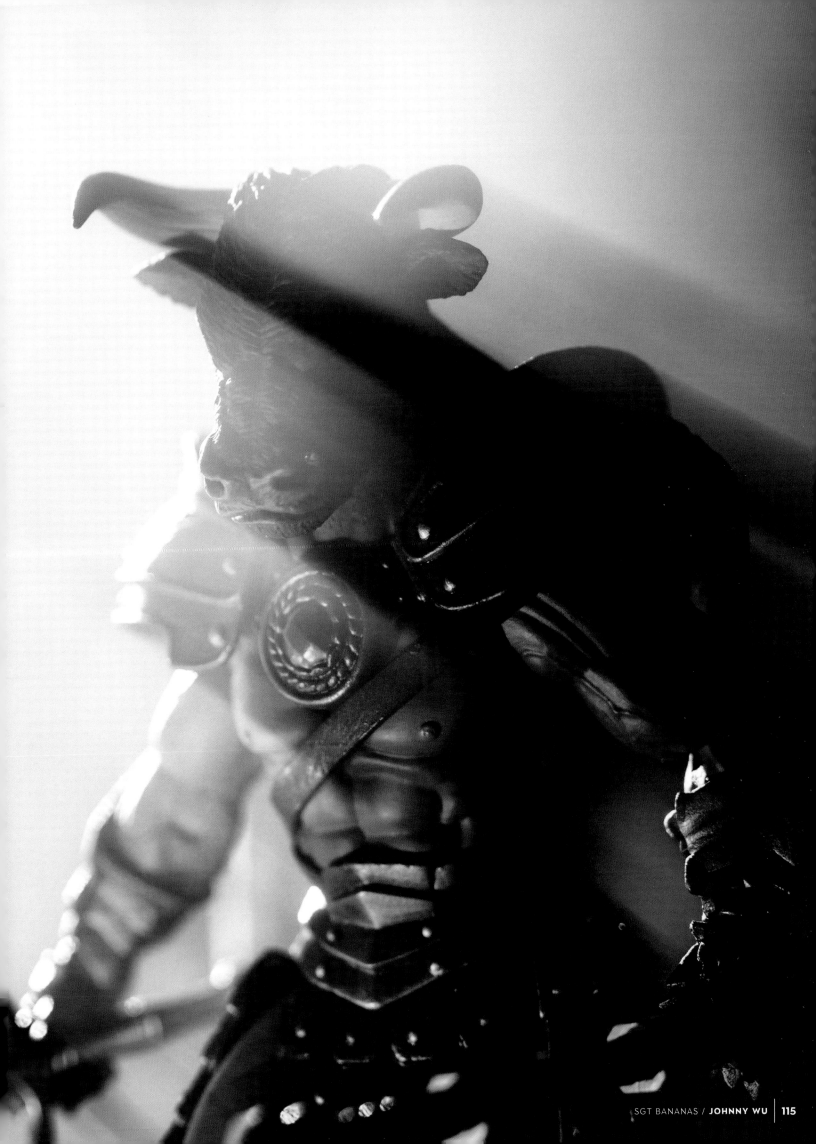

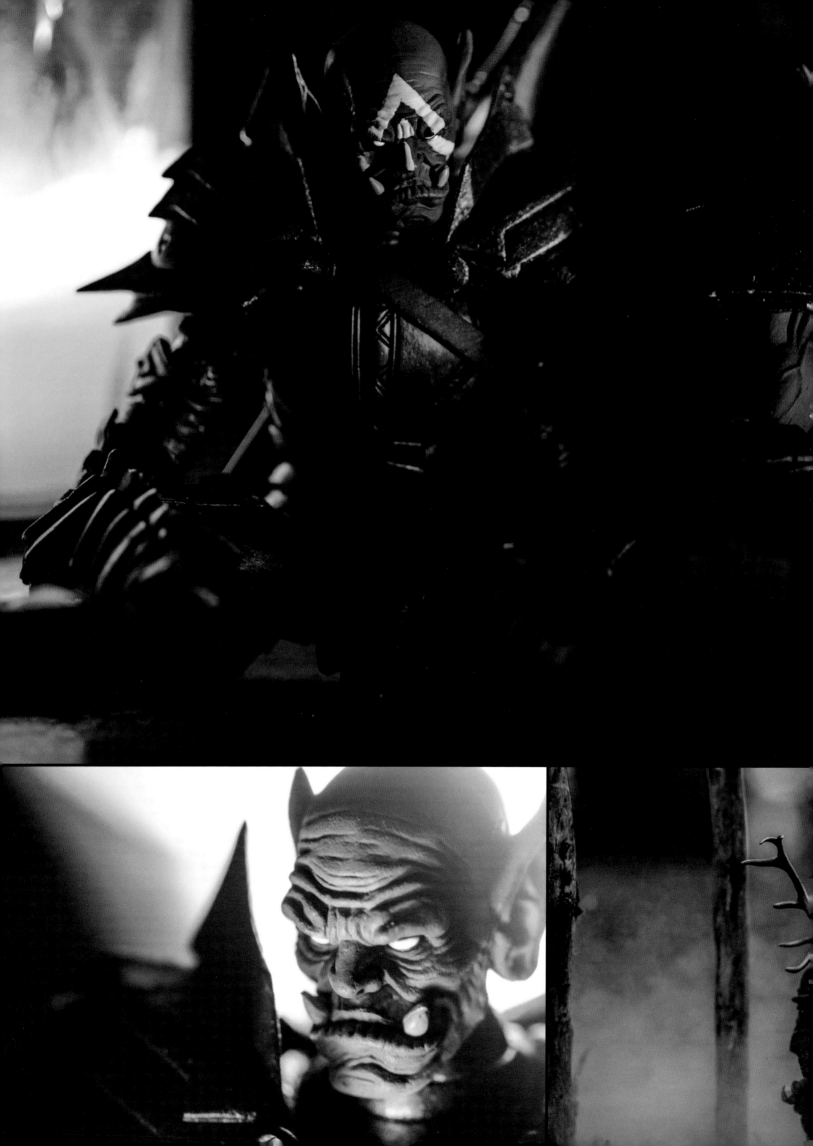

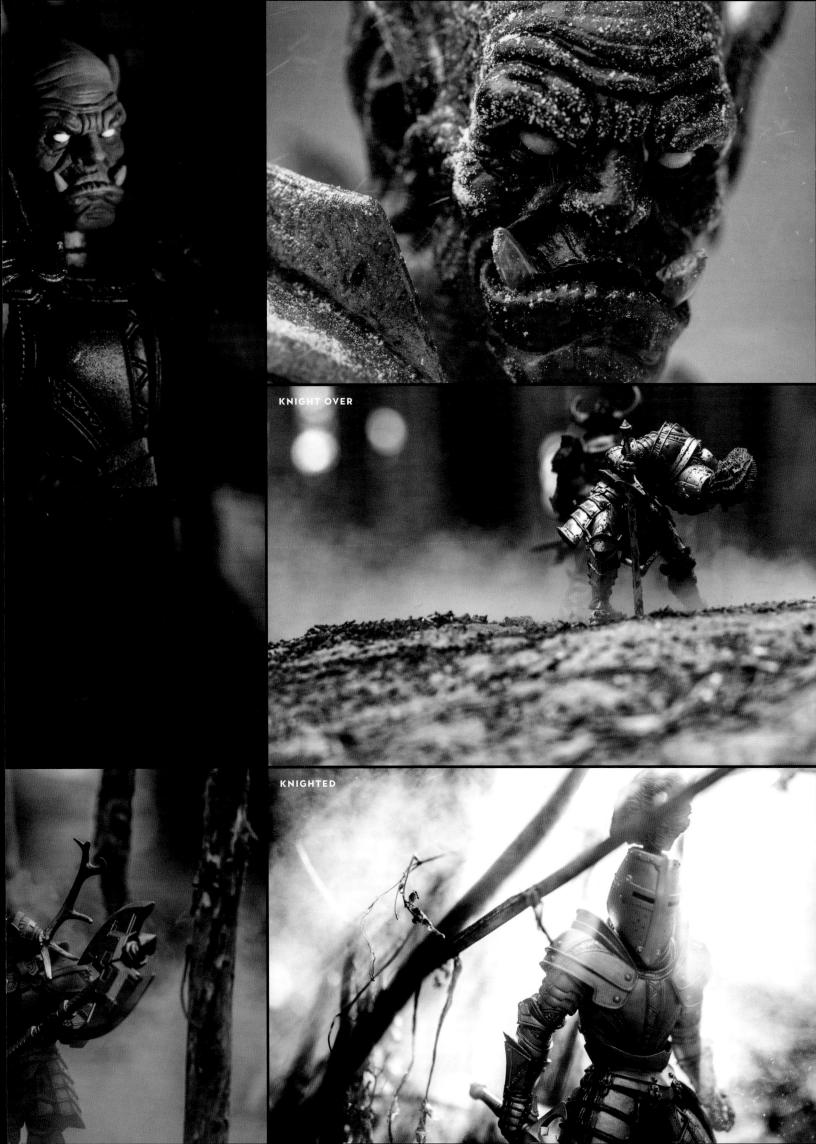

KNIGHT OVER

KNIGHTED

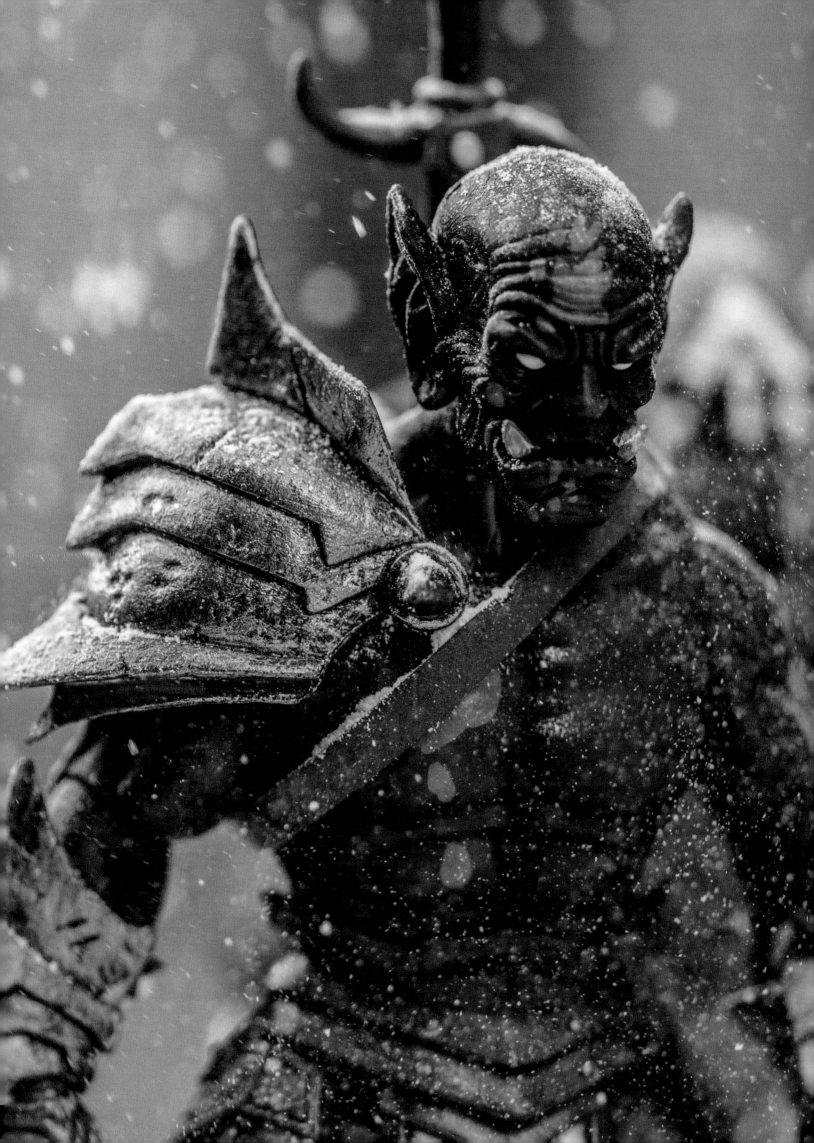

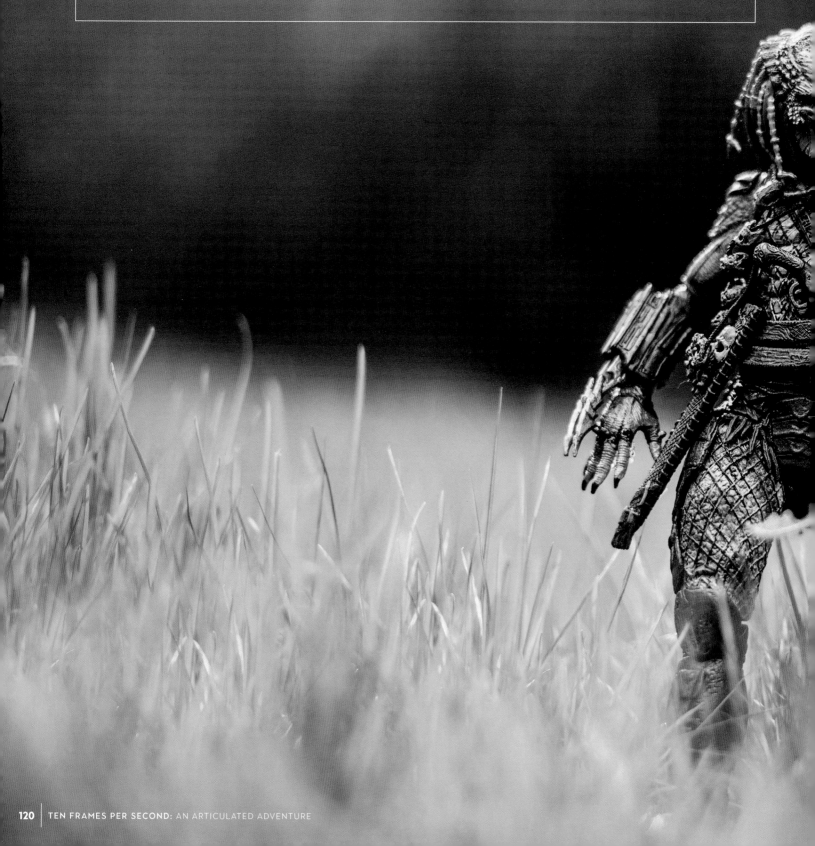

SPACE INVADERS

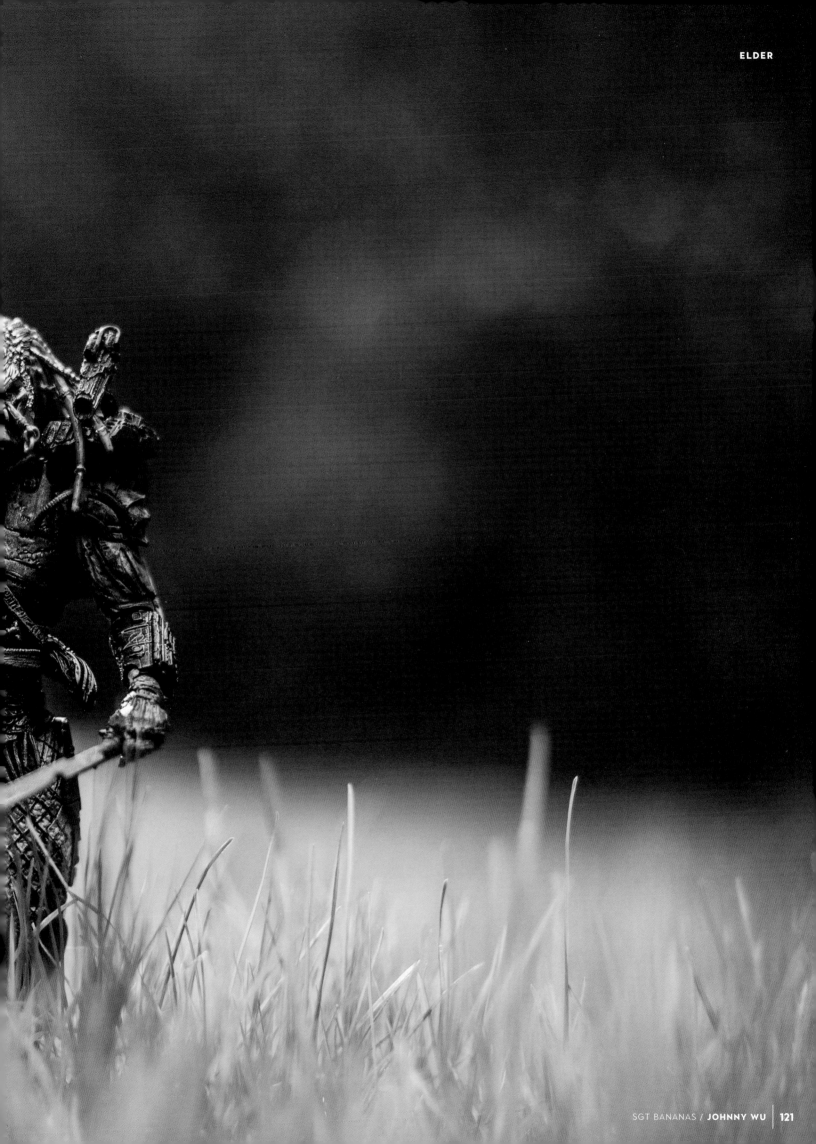

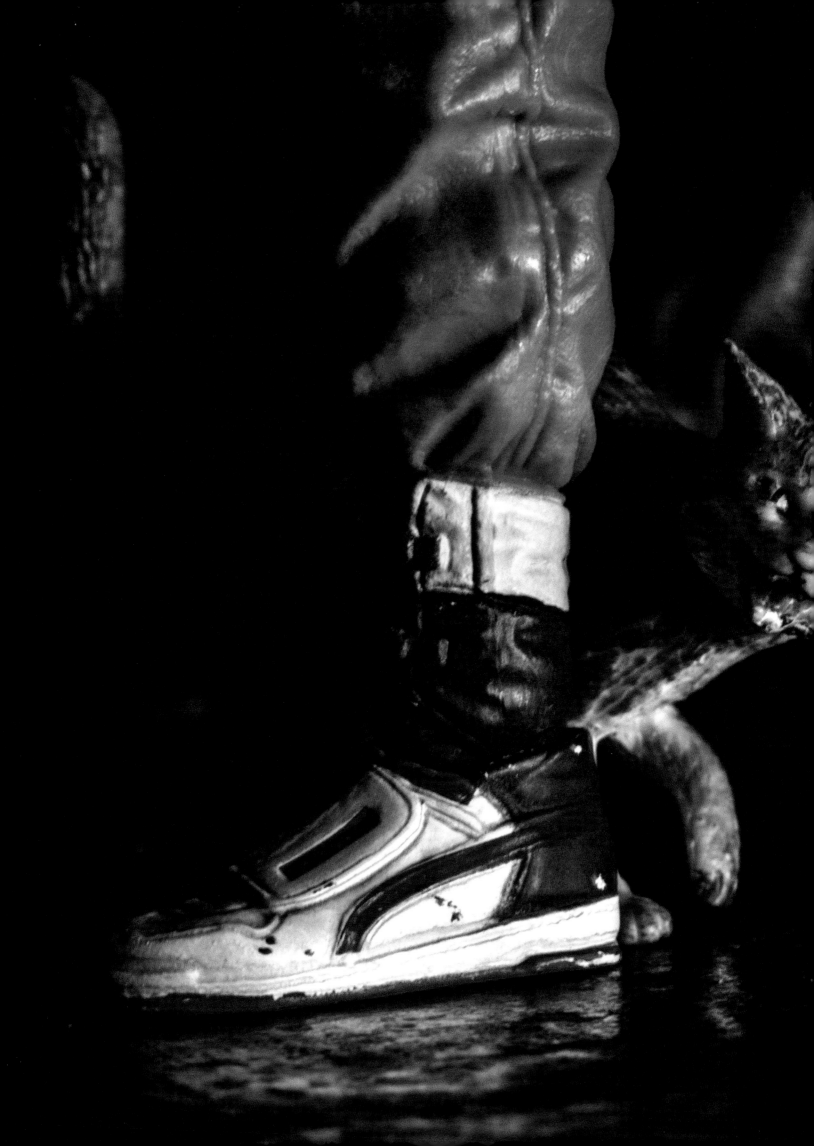

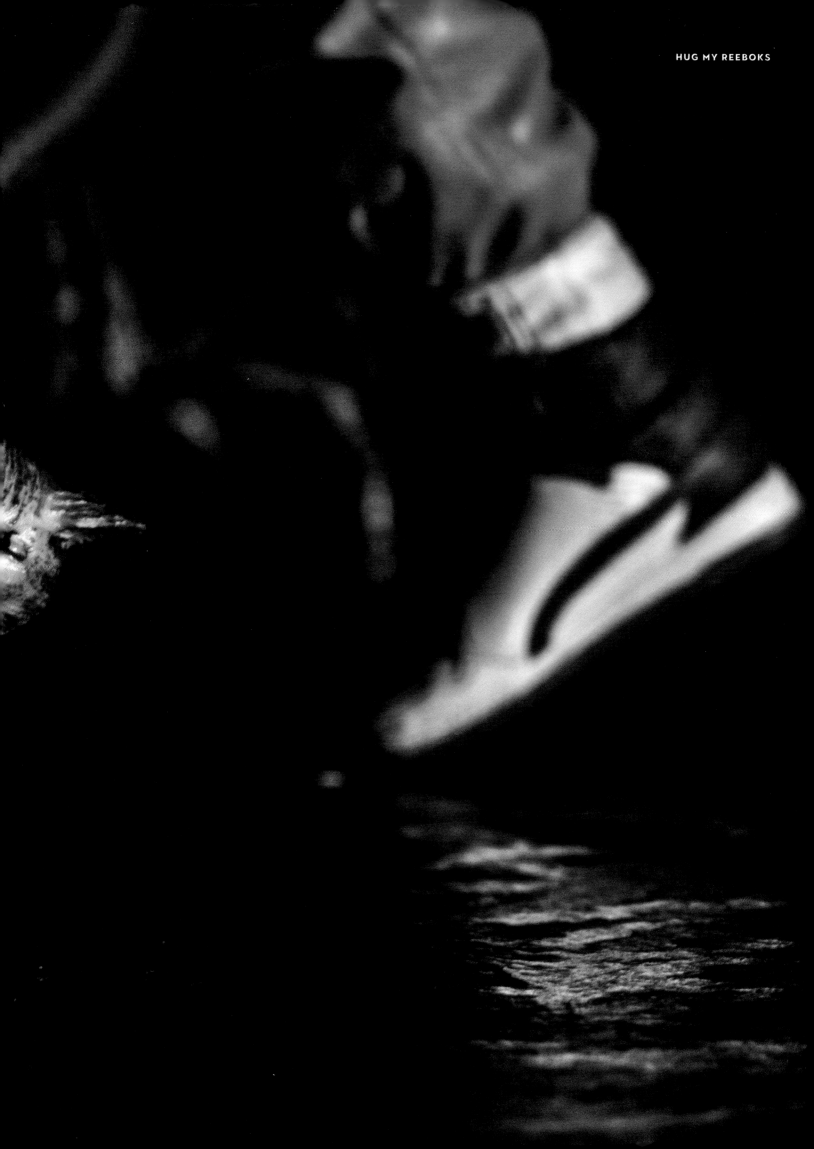

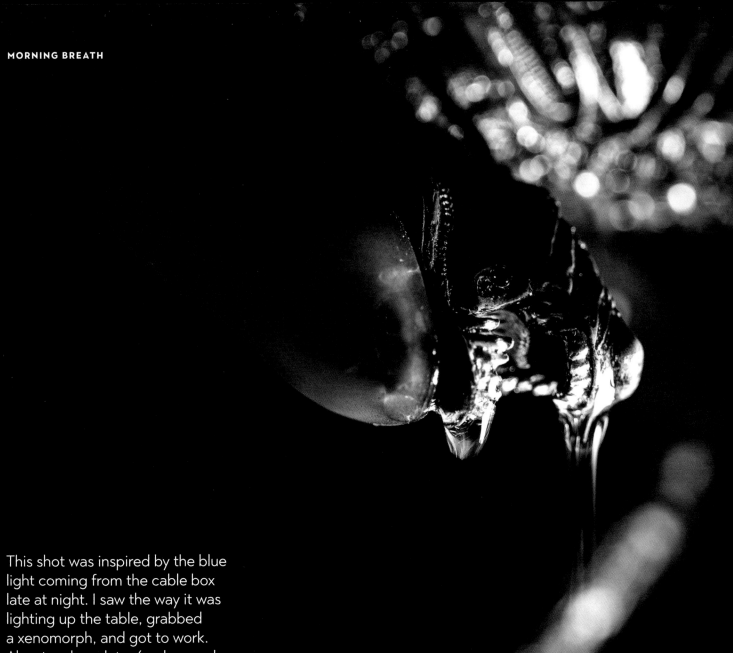

This shot was inspired by the blue light coming from the cable box late at night. I saw the way it was lighting up the table, grabbed a xenomorph, and got to work. About an hour later (and a good amount of hand soap), I walked away with this shot. Gotta strike when the iron's hot!

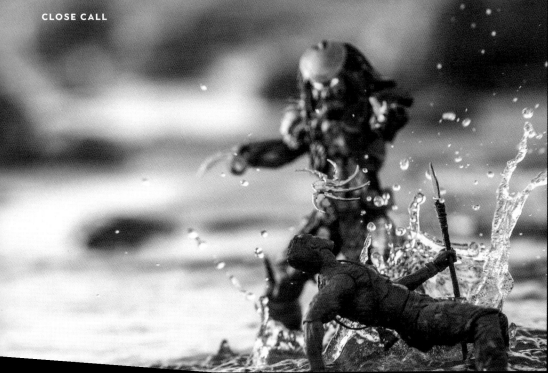

CLOSE CALL

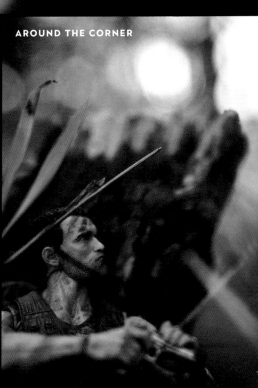

AROUND THE CORNER

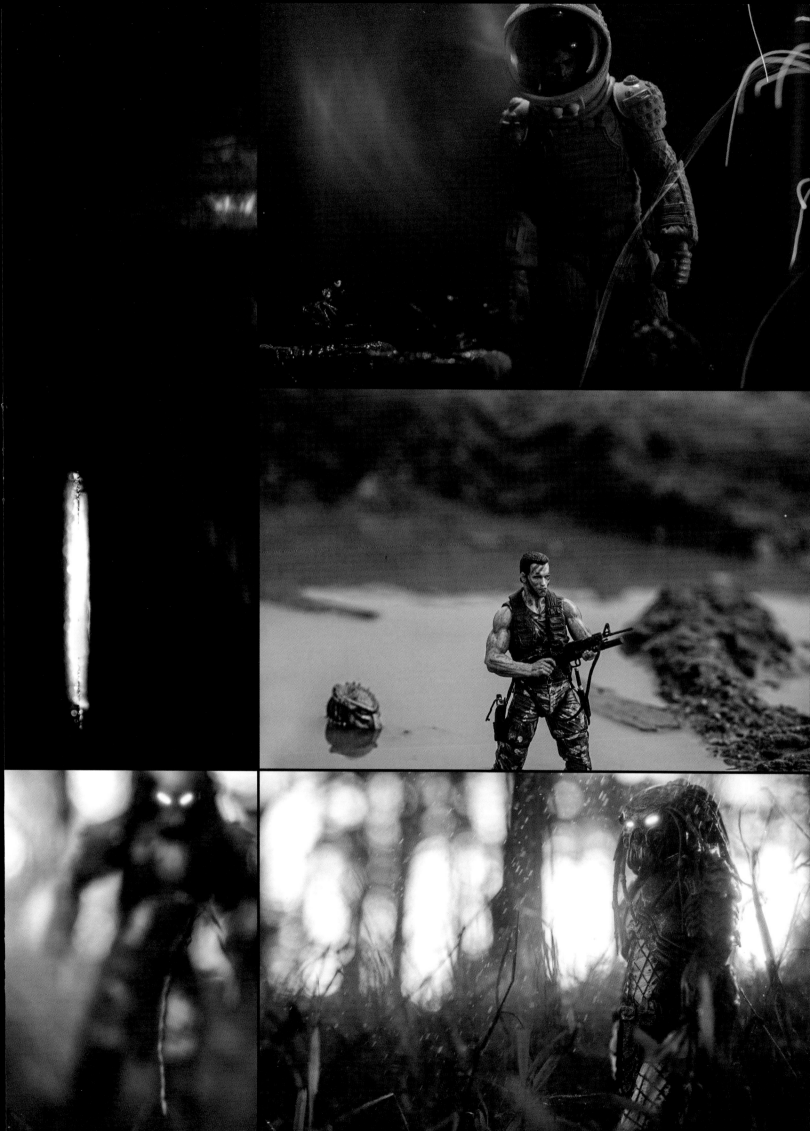

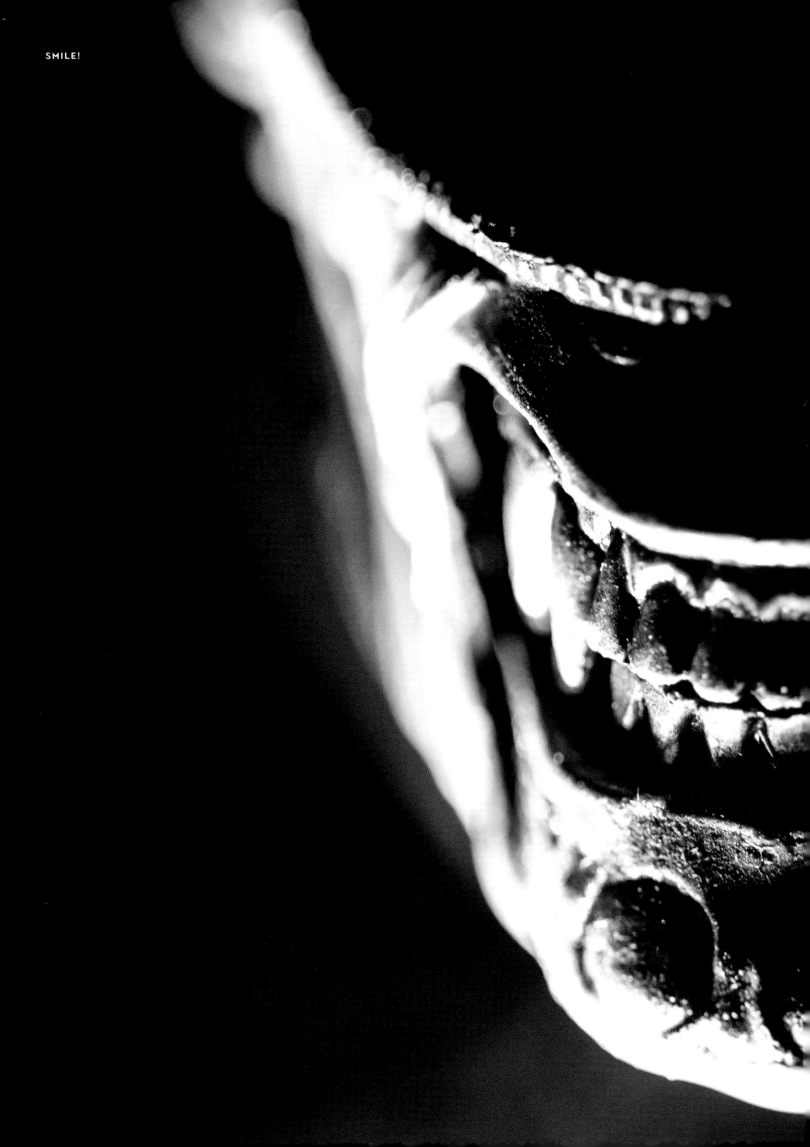

SMILE!

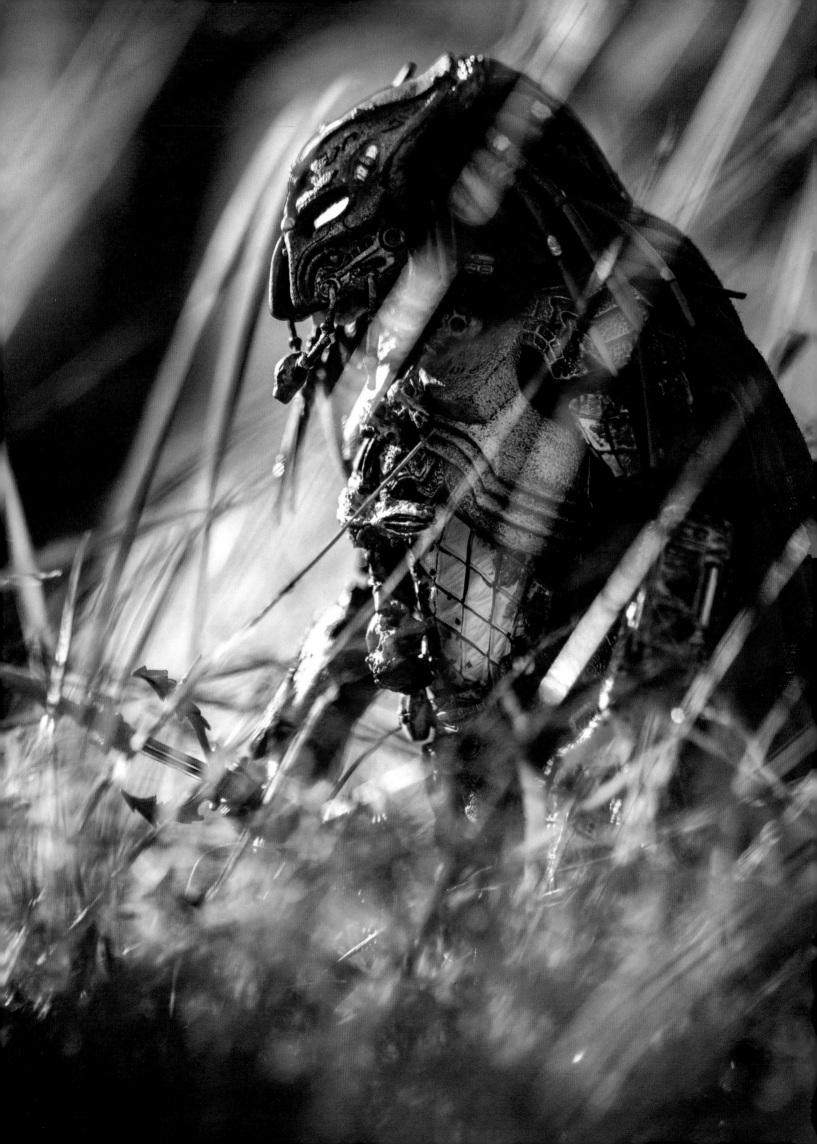

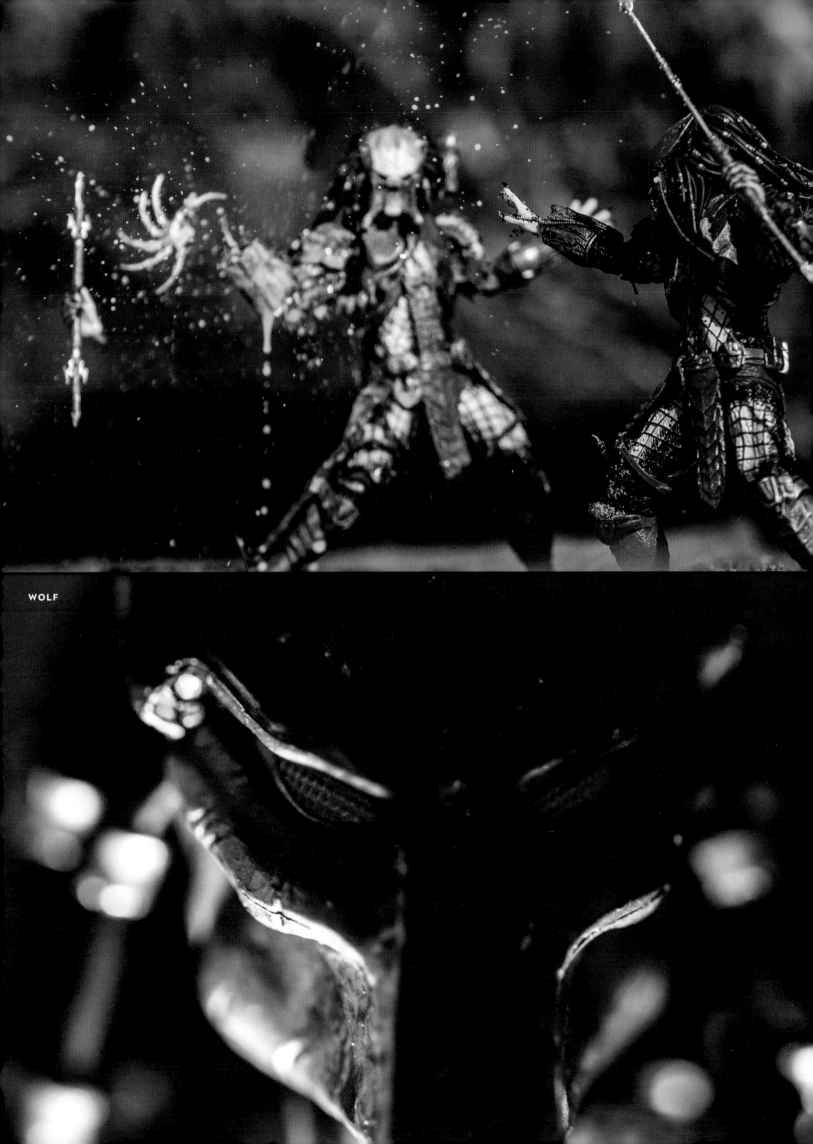

WOLF

BOTS

This was one of the first shots I took of the Iron Giant figure. I knew right away that he would become a favorite to work with because he was so photogenic.

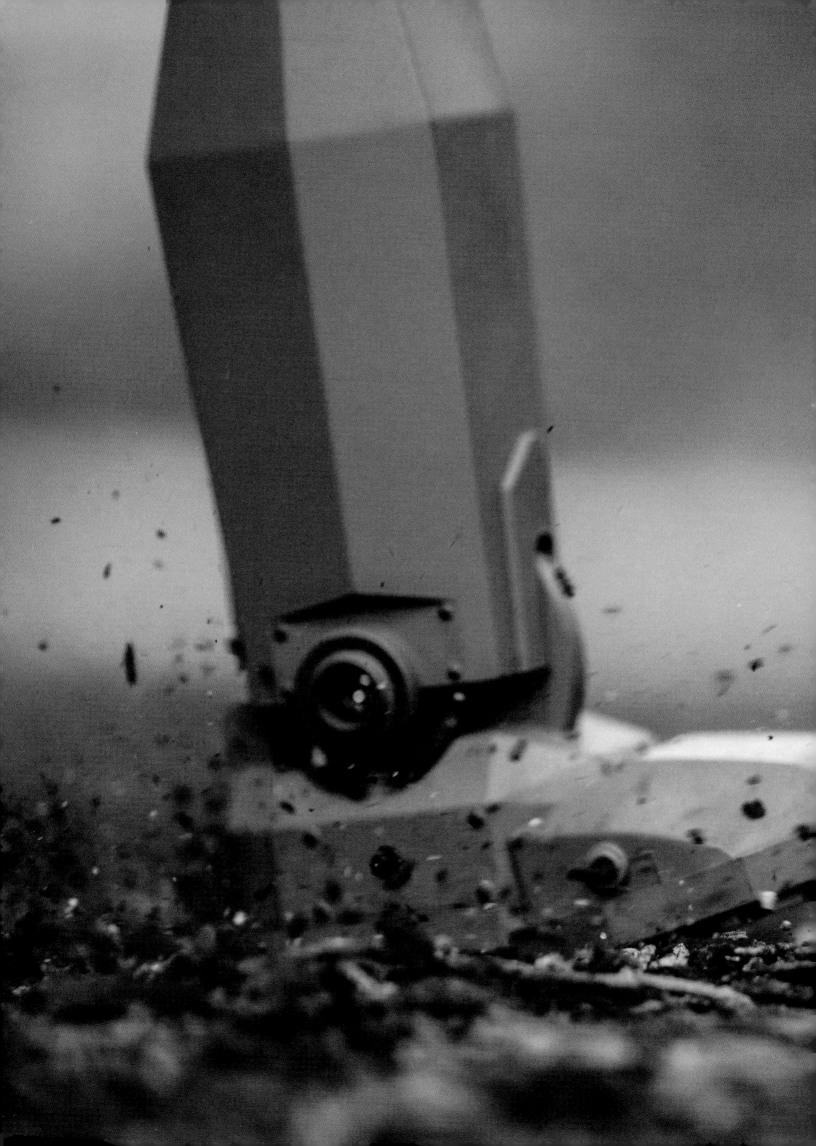

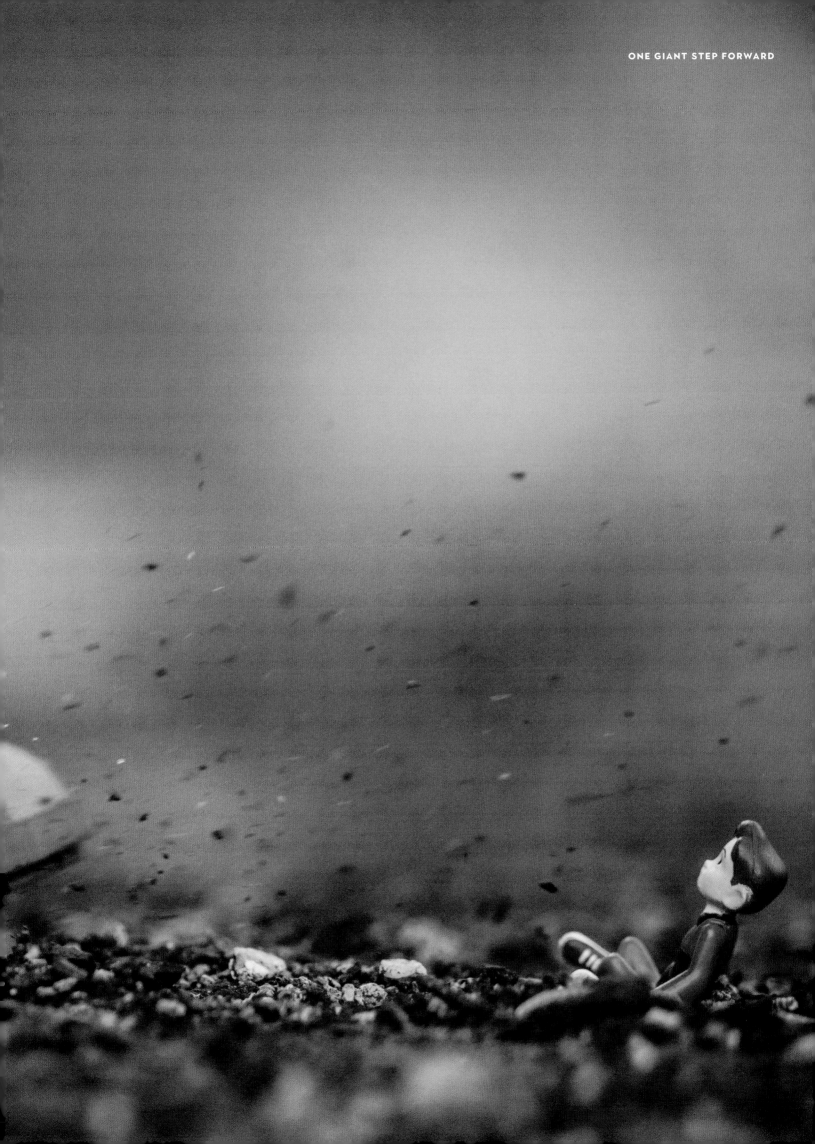

ONE GIANT STEP FORWARD

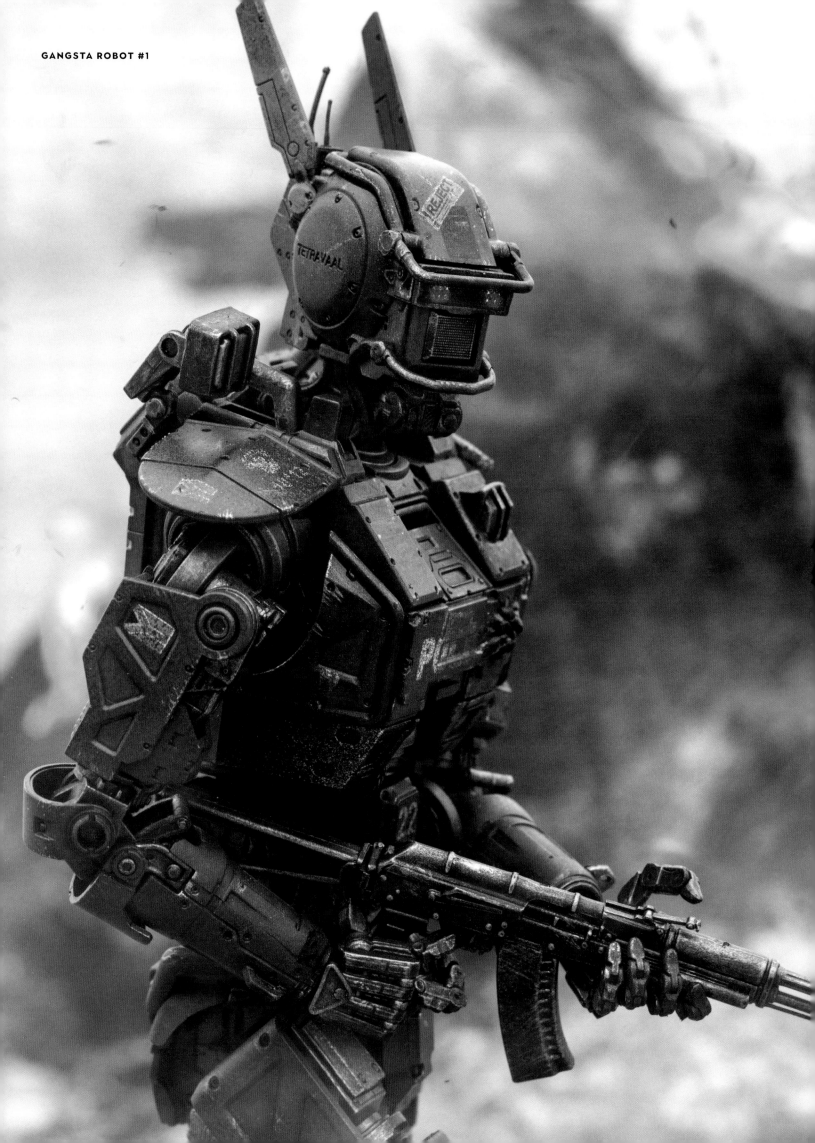

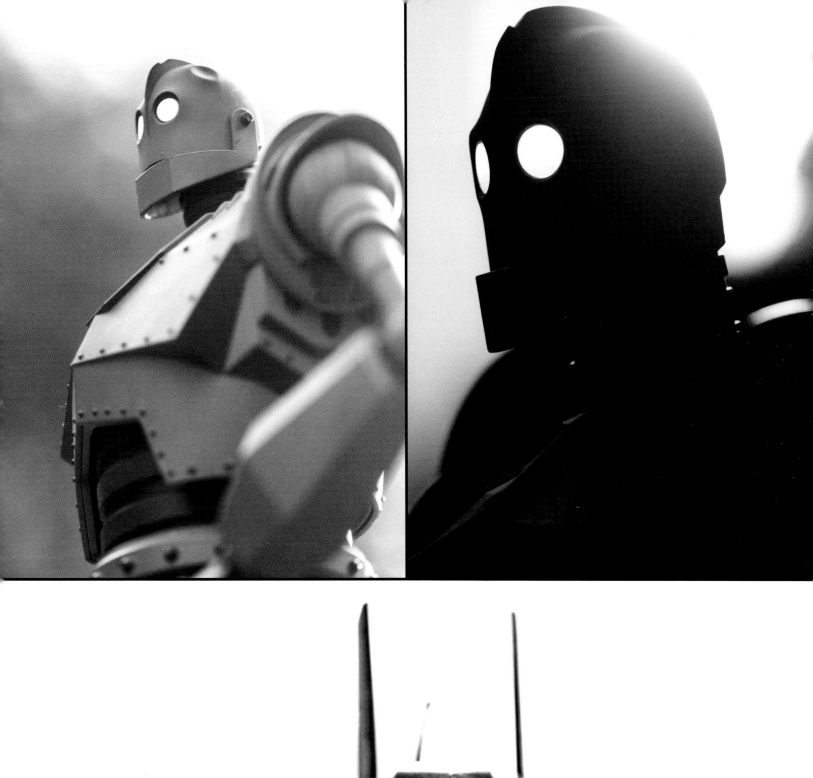
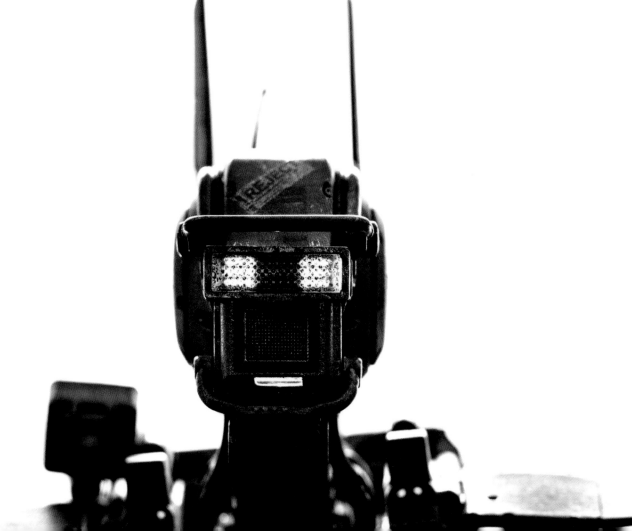

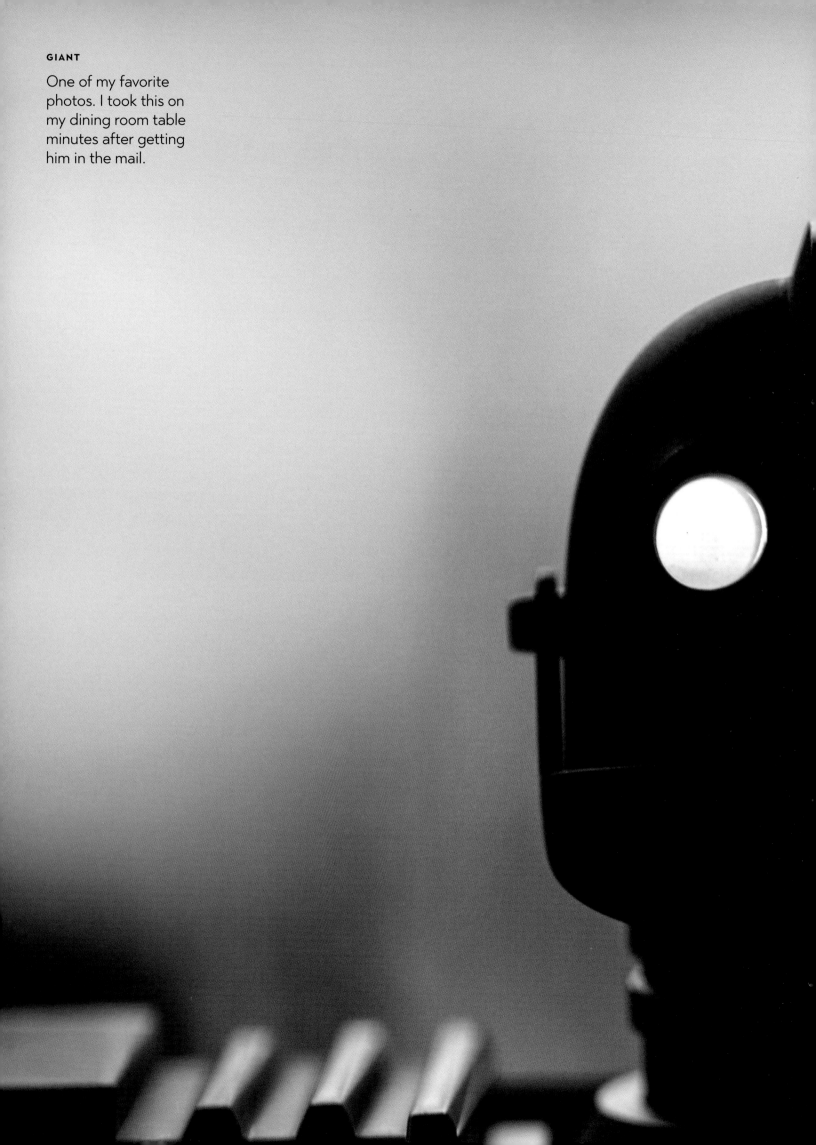

GIANT

One of my favorite photos. I took this on my dining room table minutes after getting him in the mail.

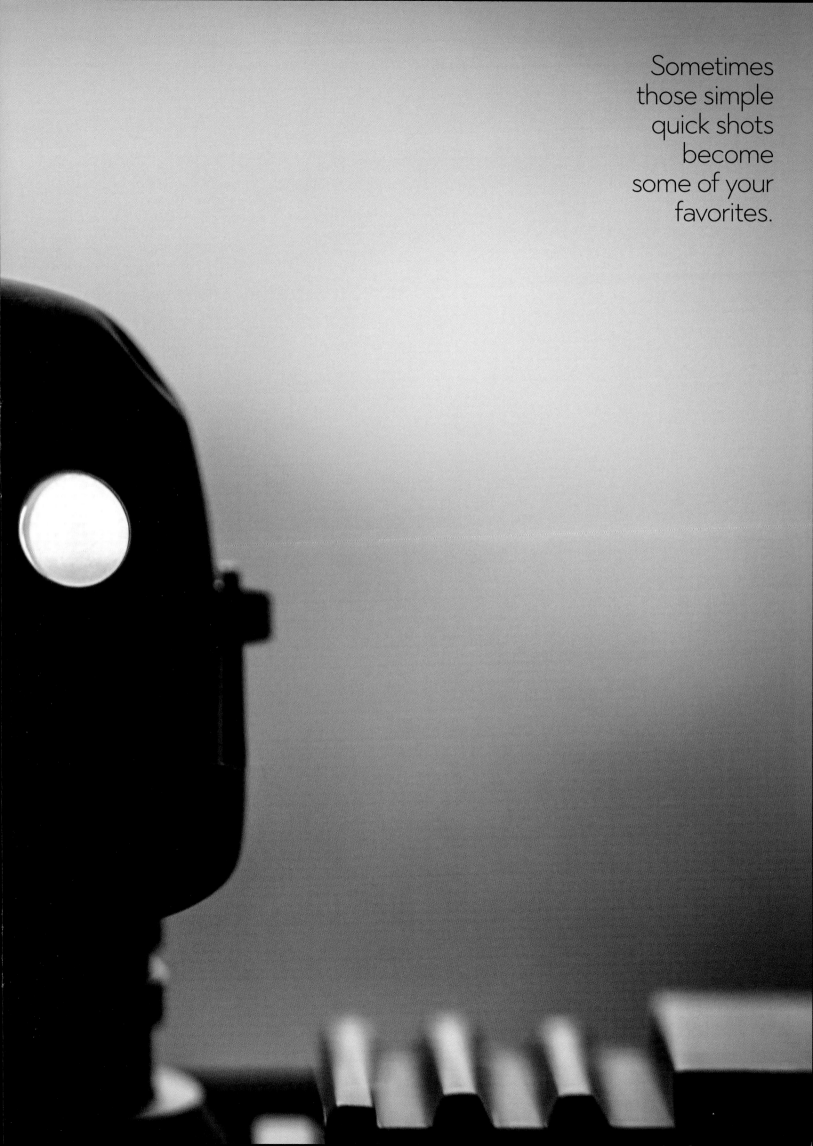

Sometimes those simple quick shots become some of your favorites.

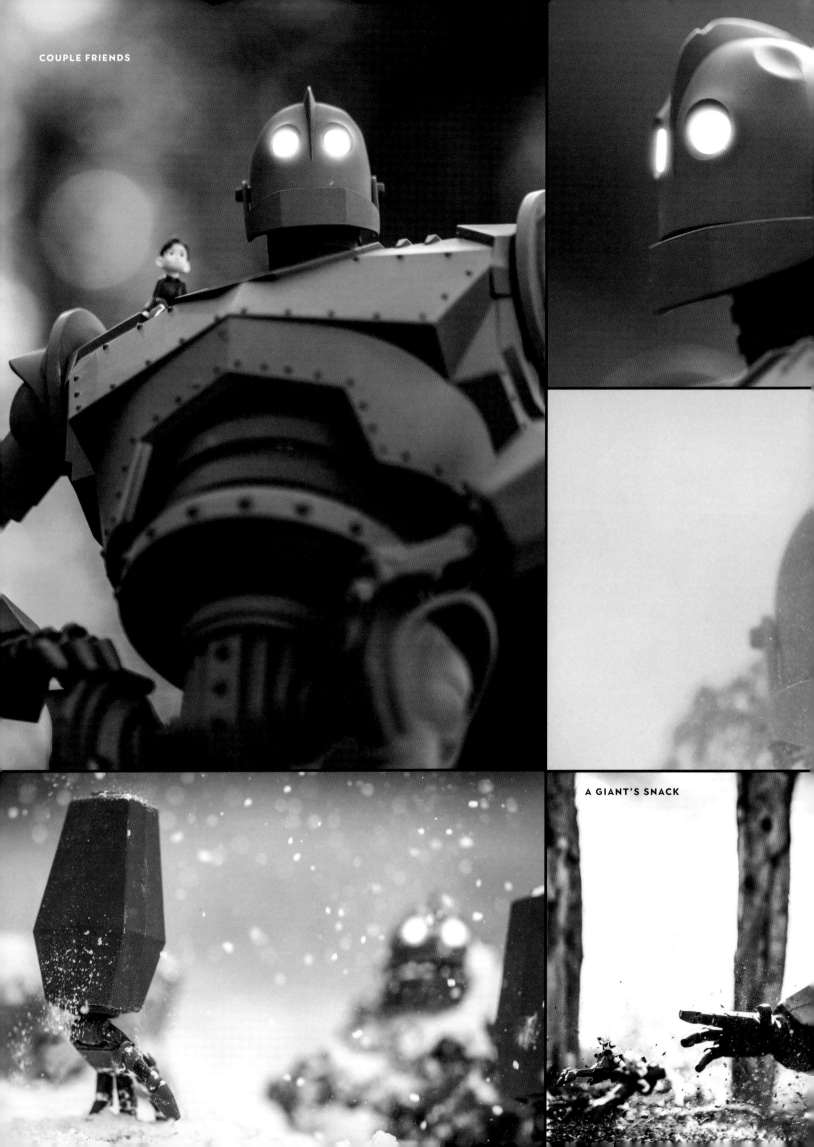

COUPLE FRIENDS

A GIANT'S SNACK

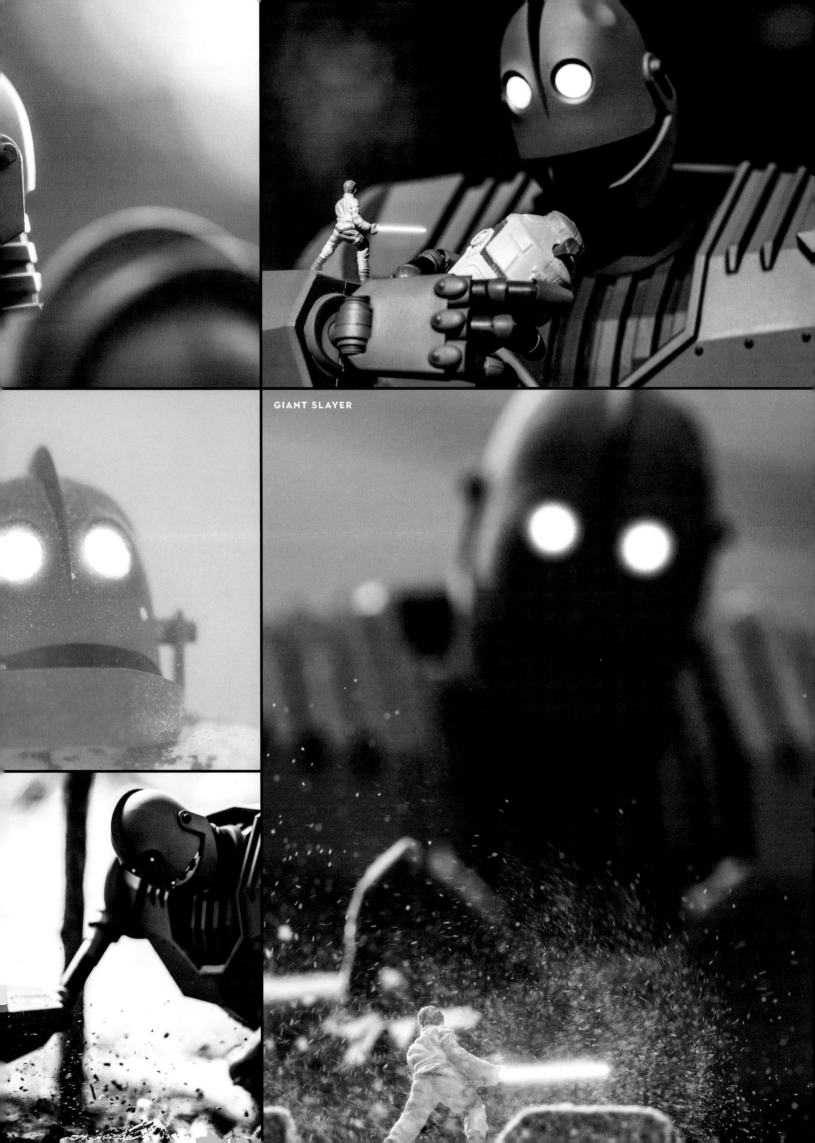

GIANT SLAYER

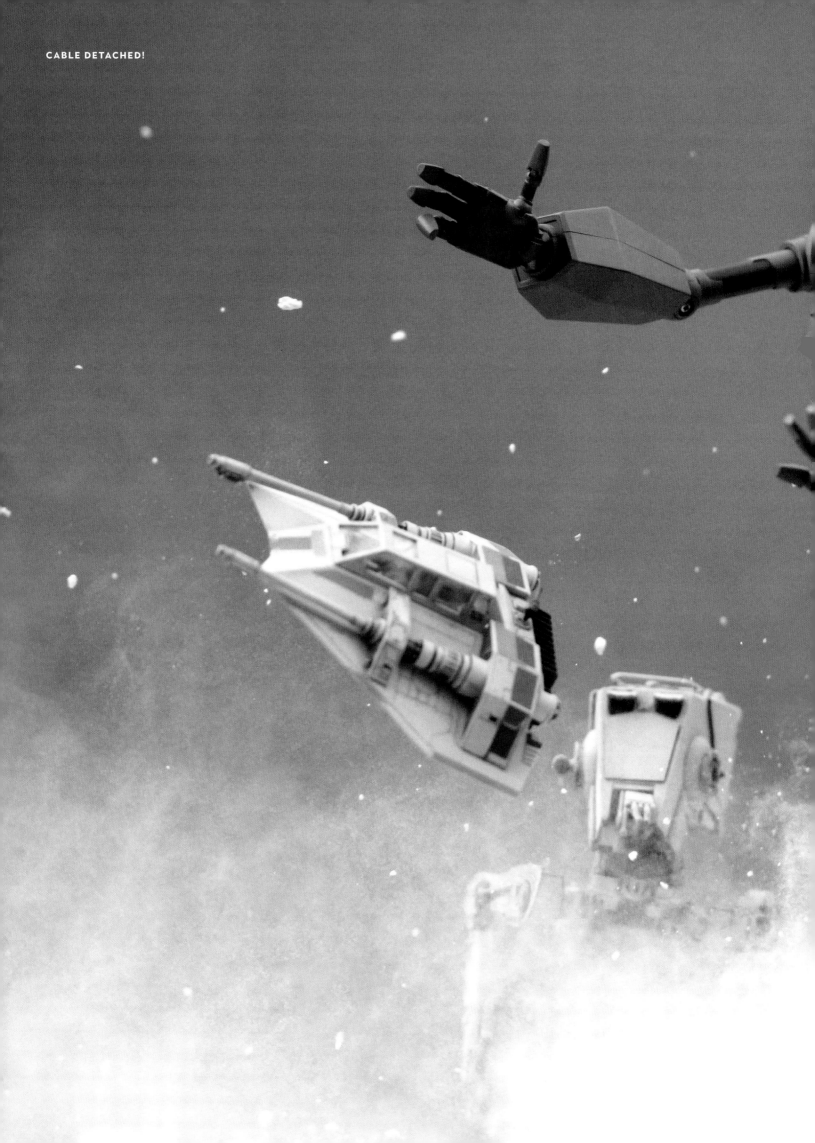

CABLE DETACHED!

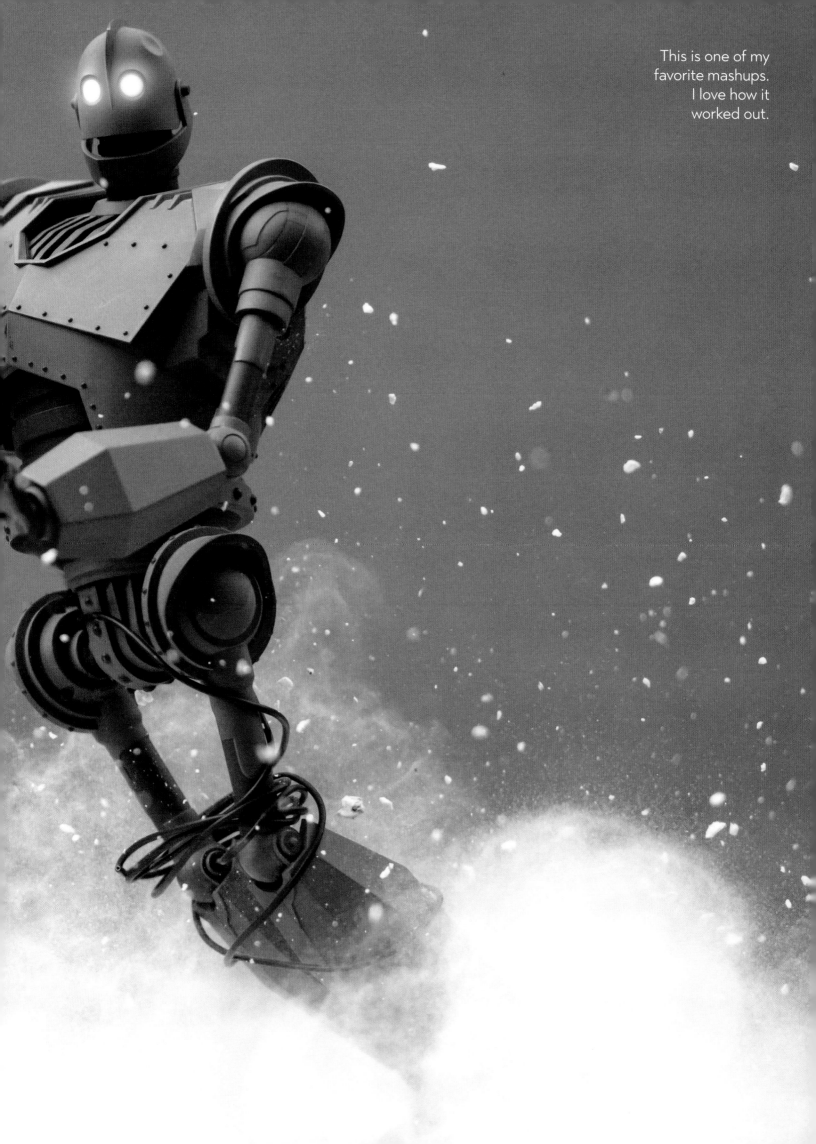

This is one of my favorite mashups. I love how it worked out.

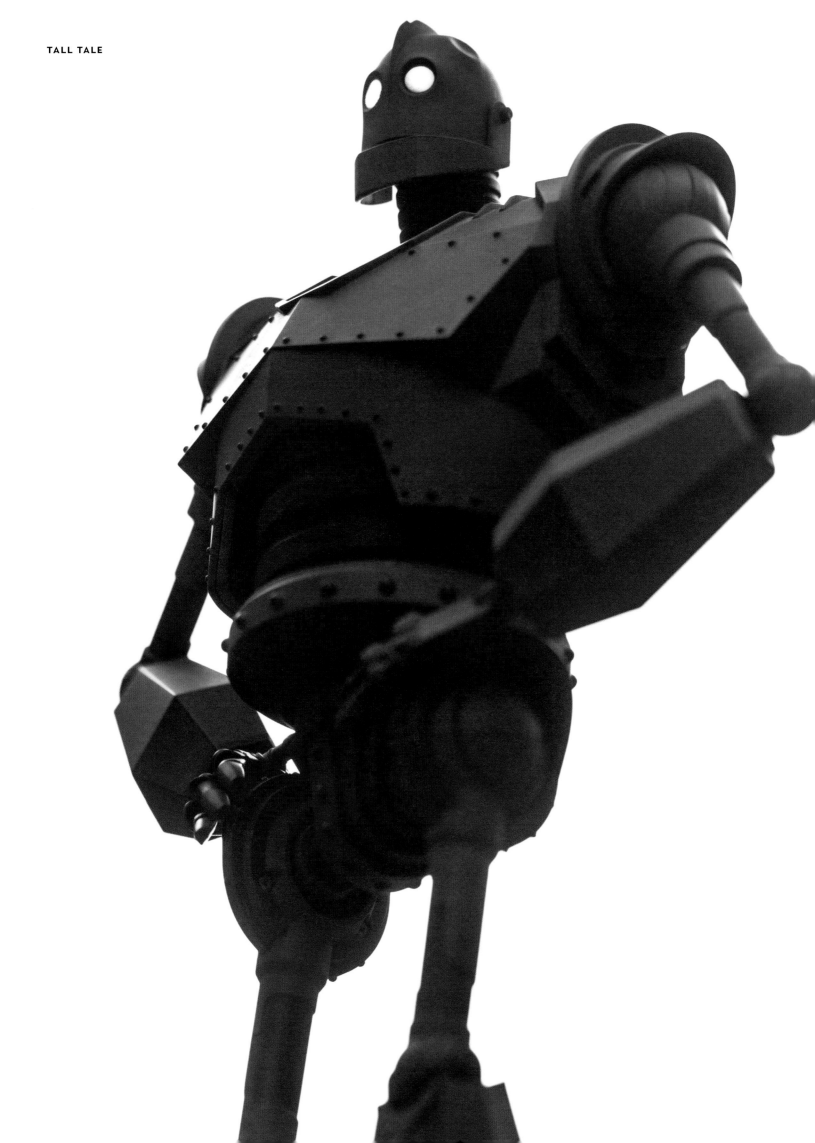

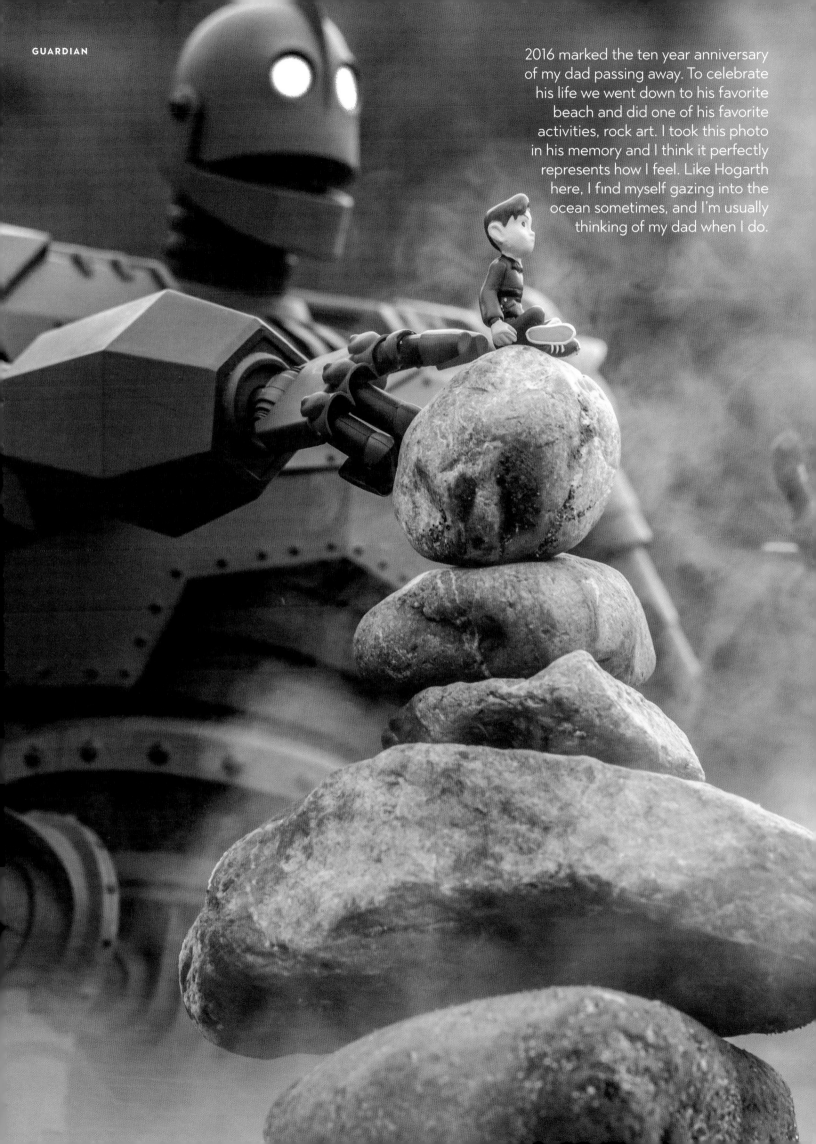

2016 marked the ten year anniversary of my dad passing away. To celebrate his life we went down to his favorite beach and did one of his favorite activities, rock art. I took this photo in his memory and I think it perfectly represents how I feel. Like Hogarth here, I find myself gazing into the ocean sometimes, and I'm usually thinking of my dad when I do.

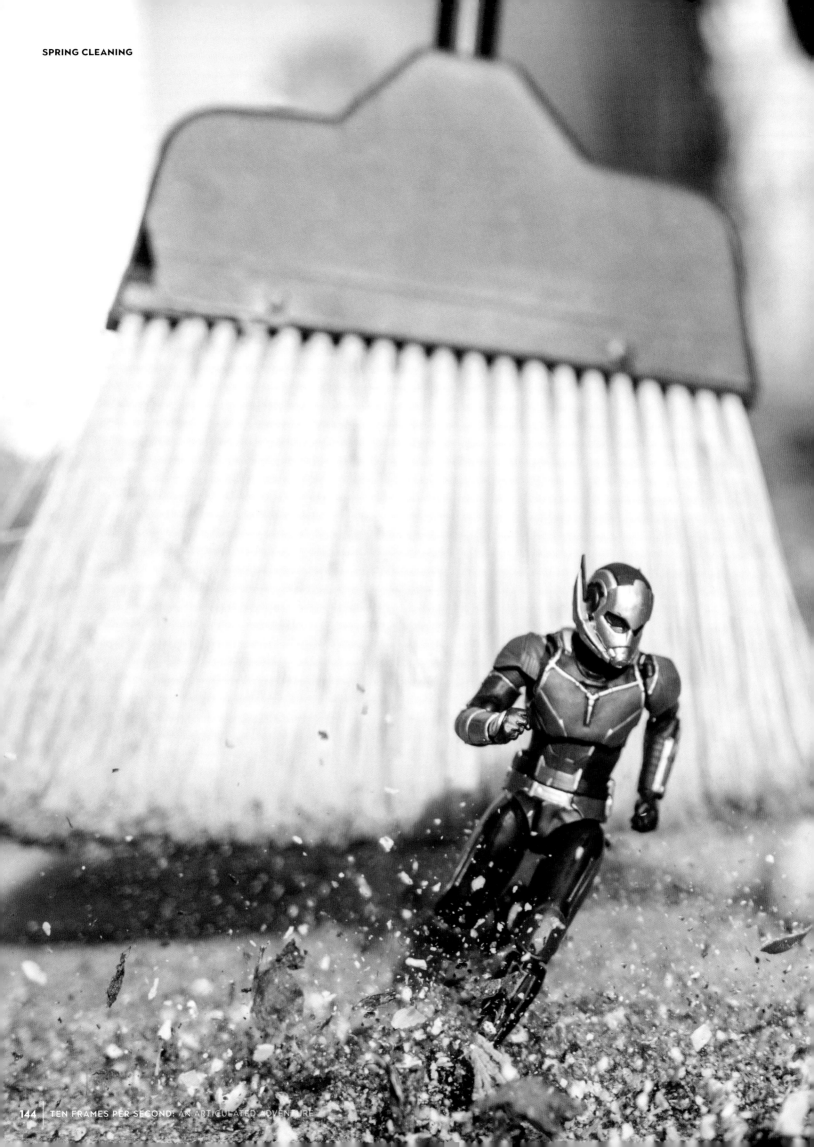

HEROES AND VILLAINS

Ideas can come from anywhere at any time—I've had to wake up in the middle of the night to write down ideas! This photo's premise was thought up during an Instagram livestream. That broom was in the background and people kept cracking jokes about it. I thought of having a character running from it and instinctively thought of Ant-Man.

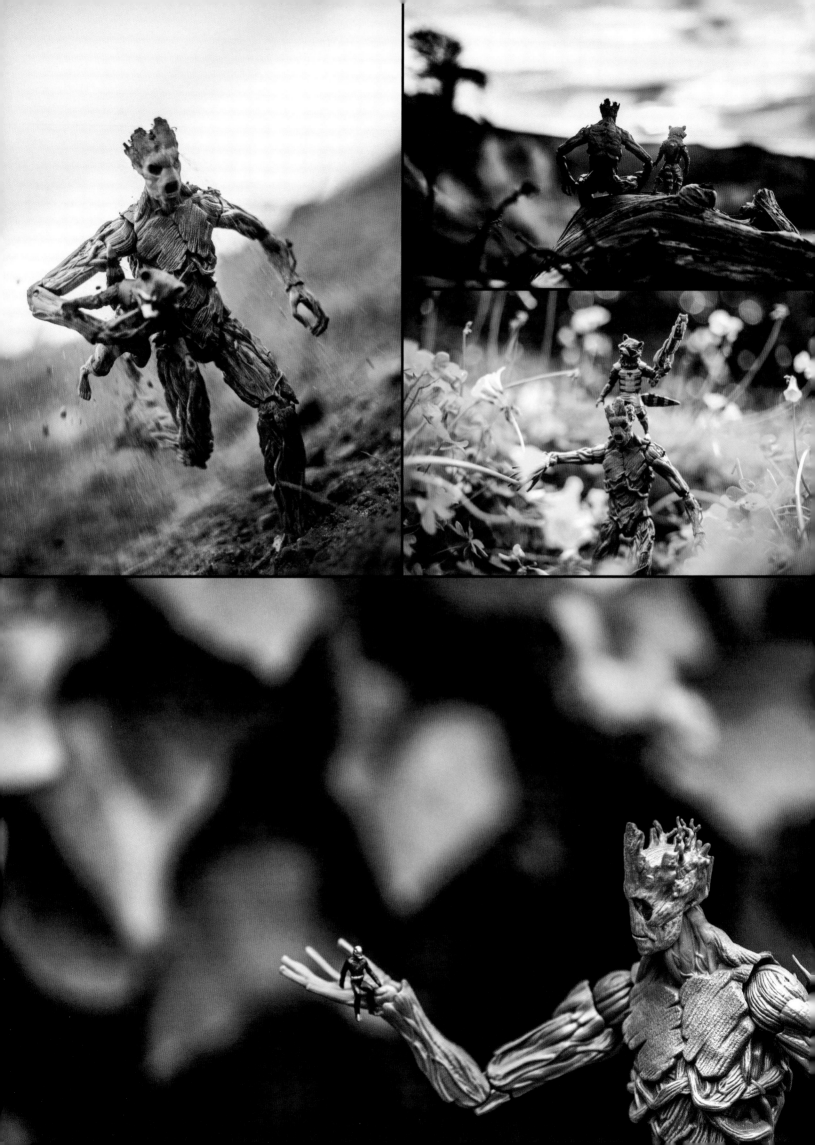

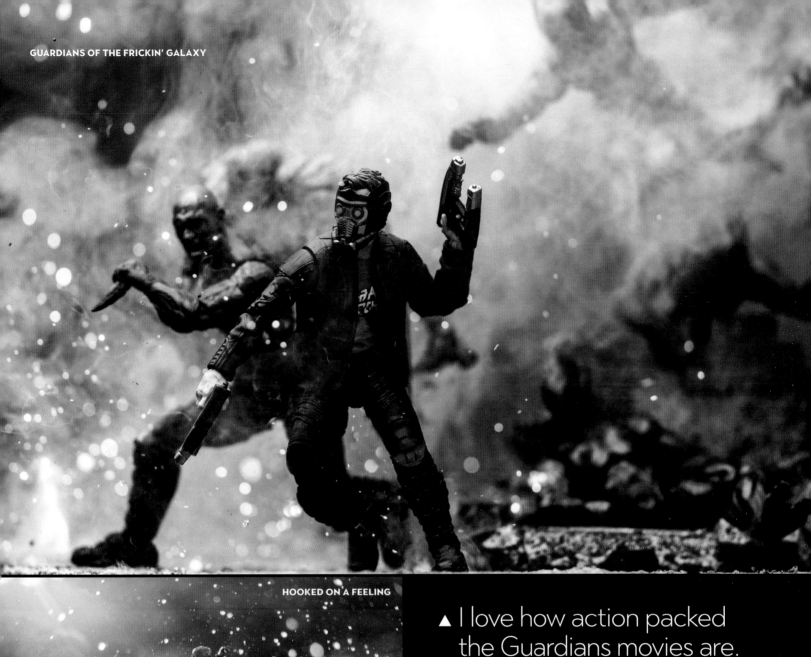

HOOKED ON A FEELING

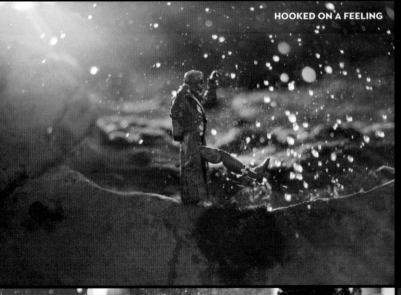

▲ I love how action packed the Guardians movies are. I also love using practical effects, so a shot like this was bound to happen. I've spent a small fortune on fireworks since this all started.

A LITTLE HELP, YONDU?

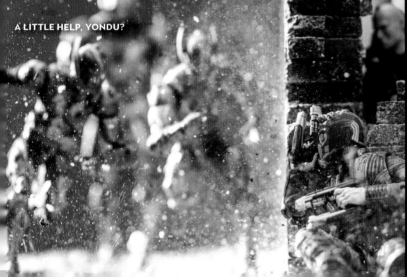

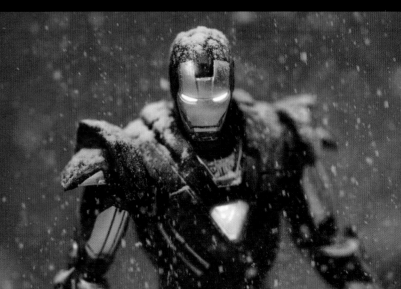

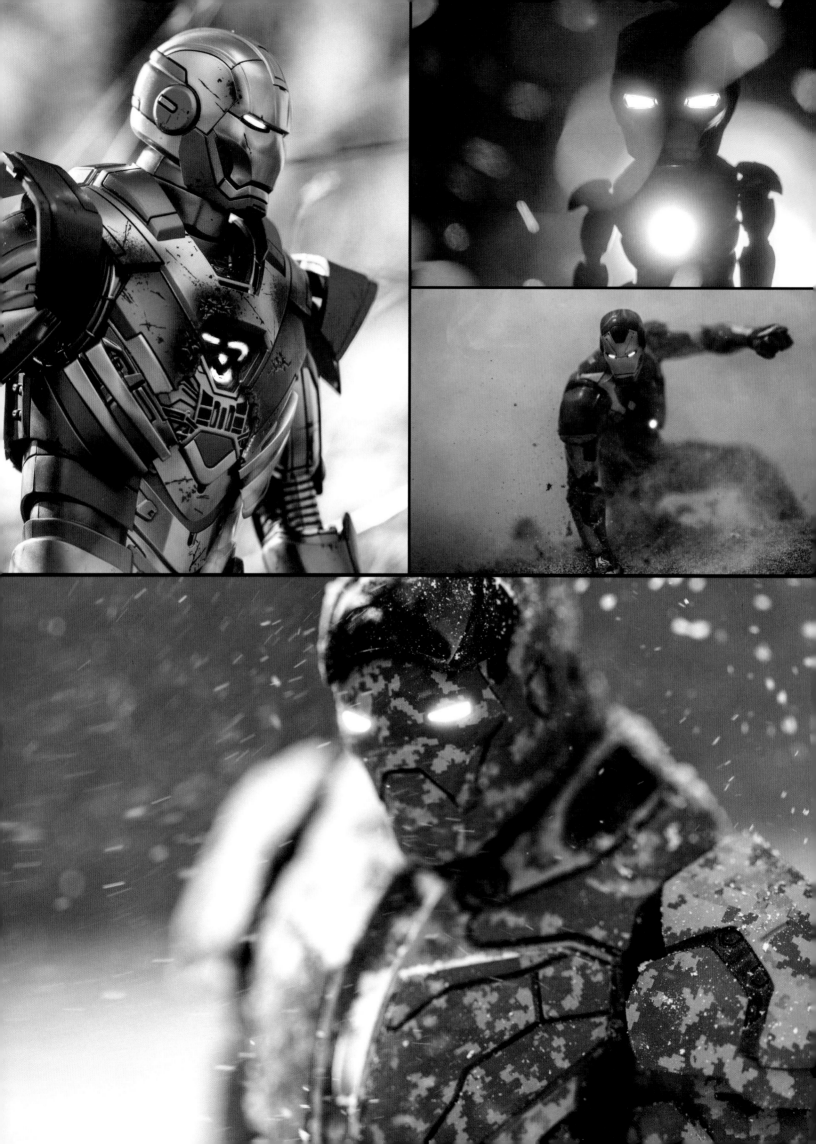

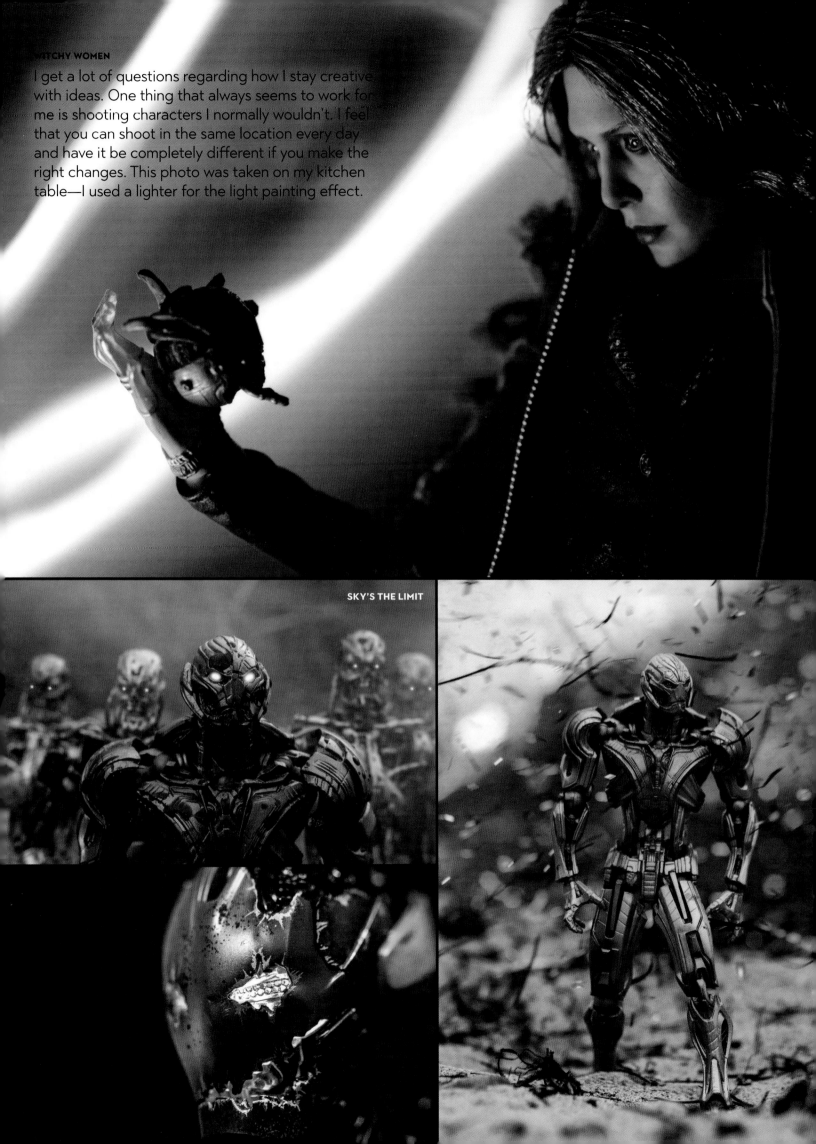

WITCHY WOMEN

I get a lot of questions regarding how I stay creative with ideas. One thing that always seems to work for me is shooting characters I normally wouldn't. I feel that you can shoot in the same location every day and have it be completely different if you make the right changes. This photo was taken on my kitchen table—I used a lighter for the light painting effect.

SKY'S THE LIMIT

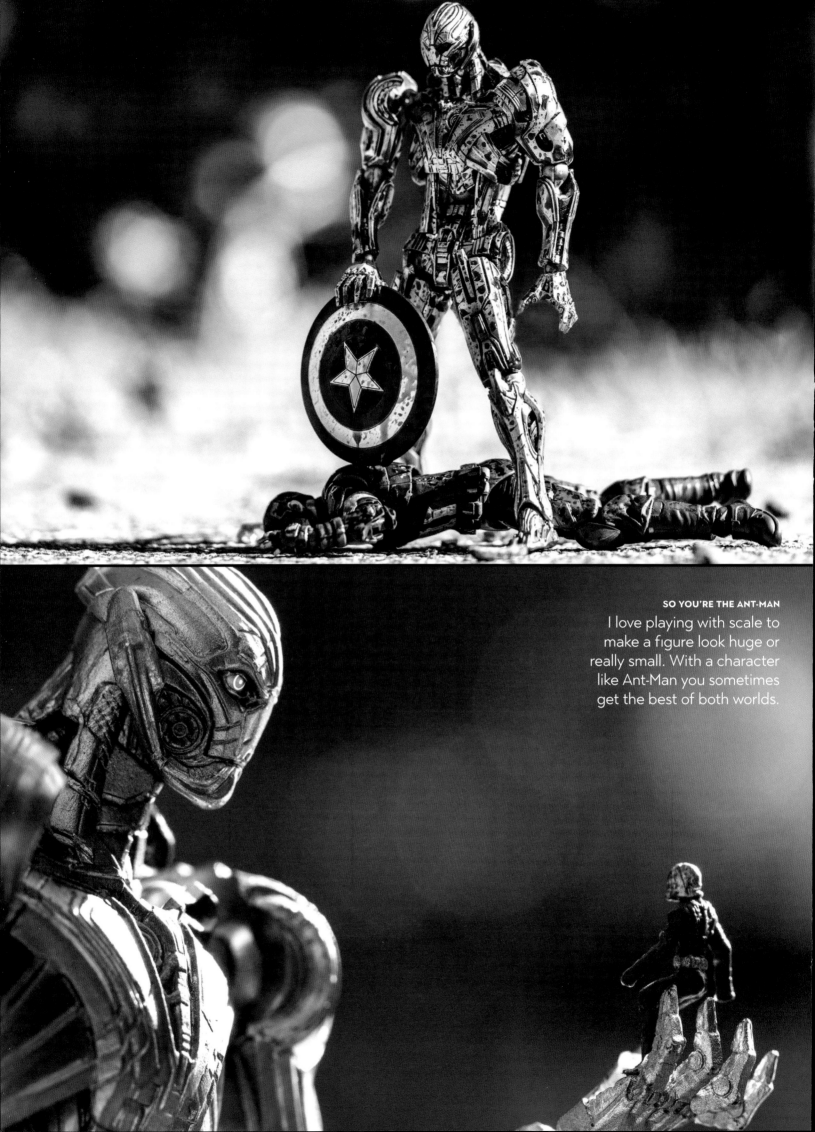

SO YOU'RE THE ANT-MAN
I love playing with scale to make a figure look huge or really small. With a character like Ant-Man you sometimes get the best of both worlds.

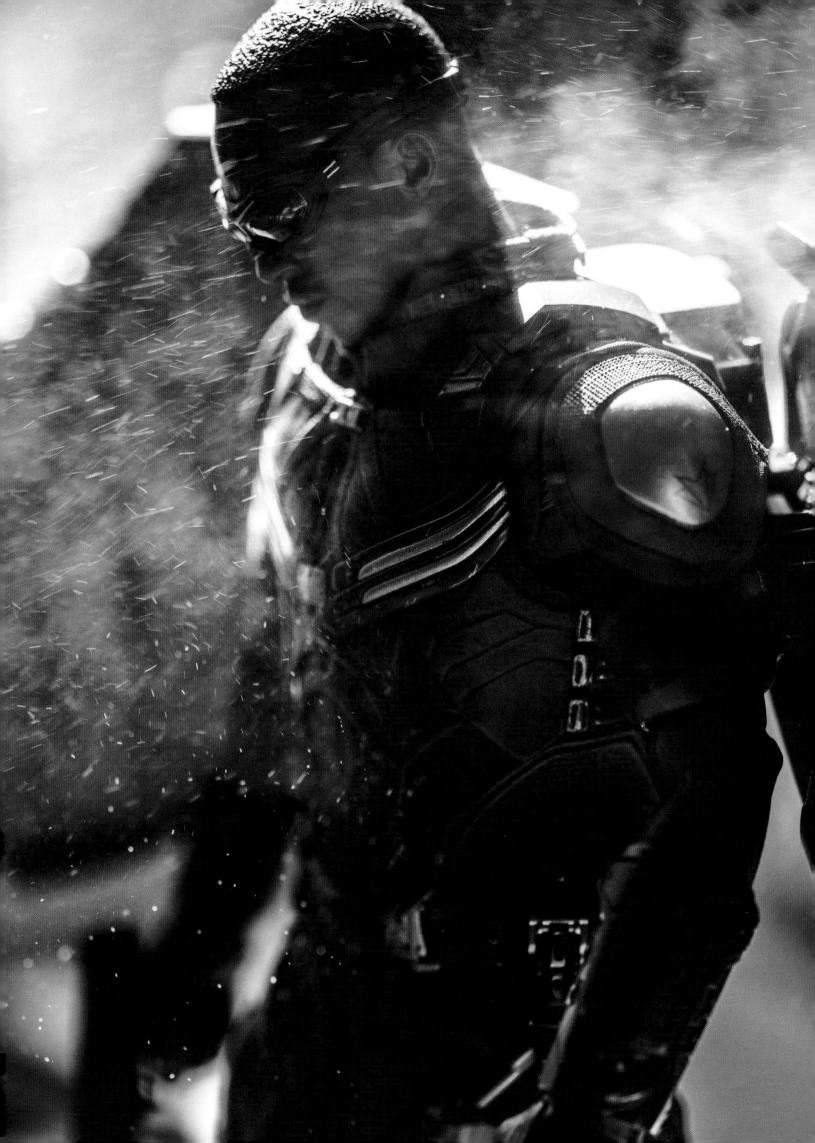

Instagram can be hard to figure out. Sometimes I'll post a photo I'm really proud of, and it won't receive a lot of attention, but then I post a filler shot, and it absolutely kills.

I don't know why, but 17,000 likes later, this stands as my most liked photo to date. ▼

DOUBLE VISION

I TOLD YOU SO

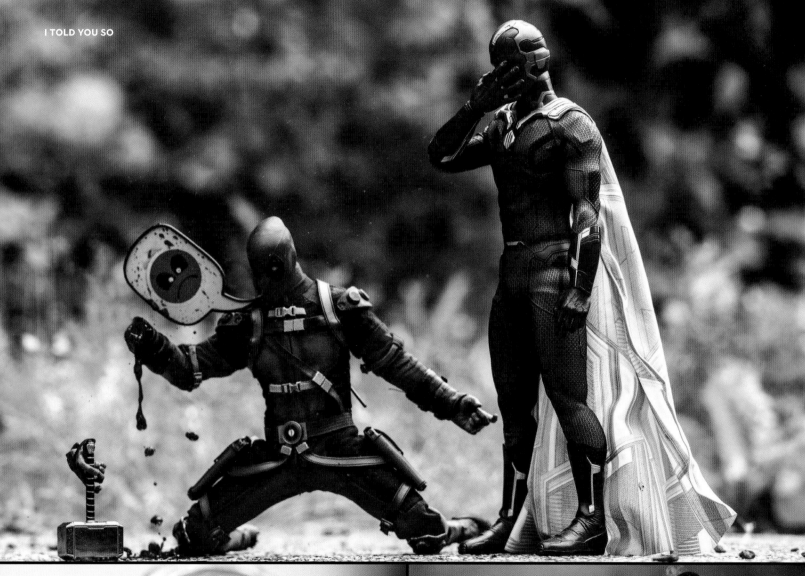

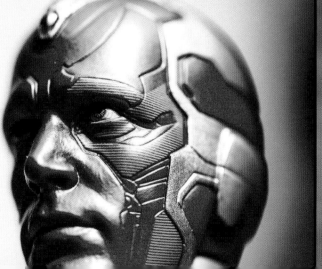

BORN YESTERDAY

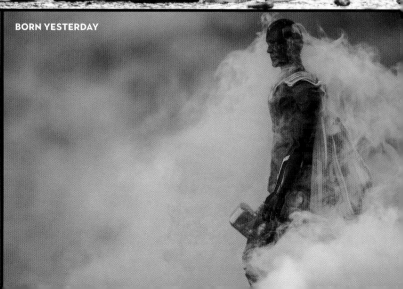

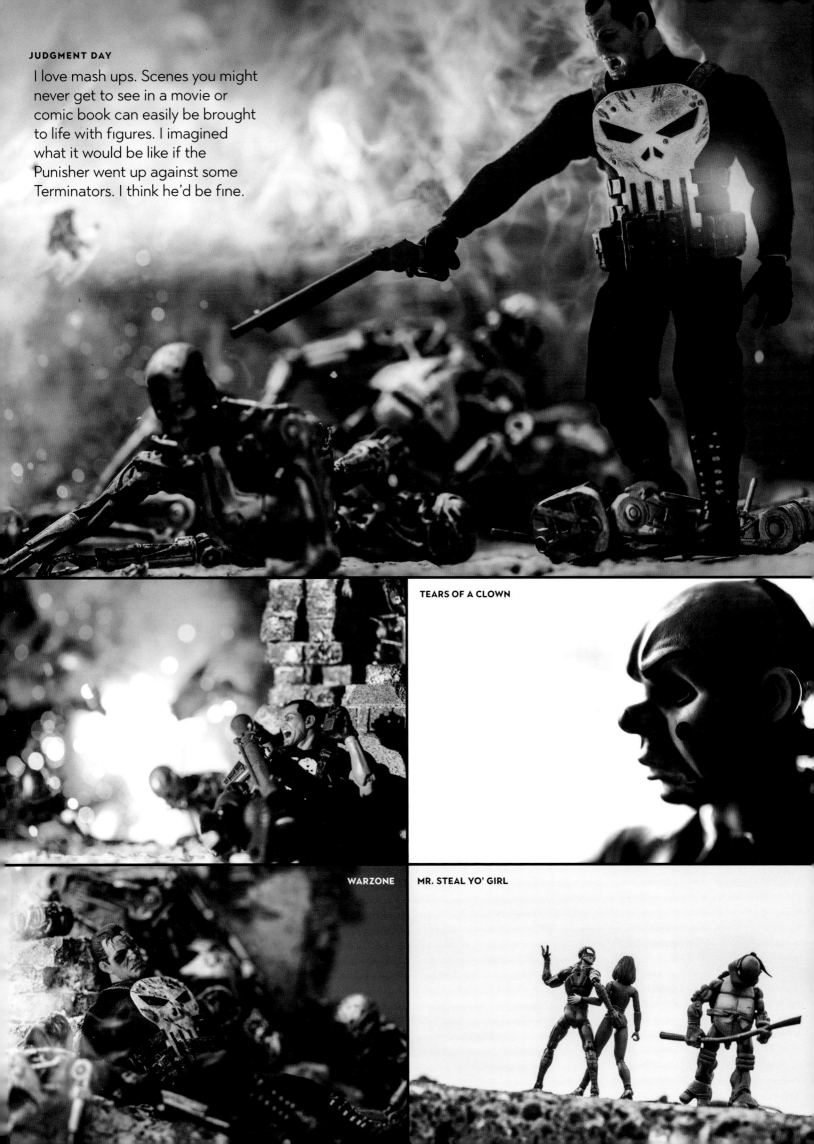

JUDGMENT DAY

I love mash ups. Scenes you might never get to see in a movie or comic book can easily be brought to life with figures. I imagined what it would be like if the Punisher went up against some Terminators. I think he'd be fine.

TEARS OF A CLOWN

WARZONE

MR. STEAL YO' GIRL

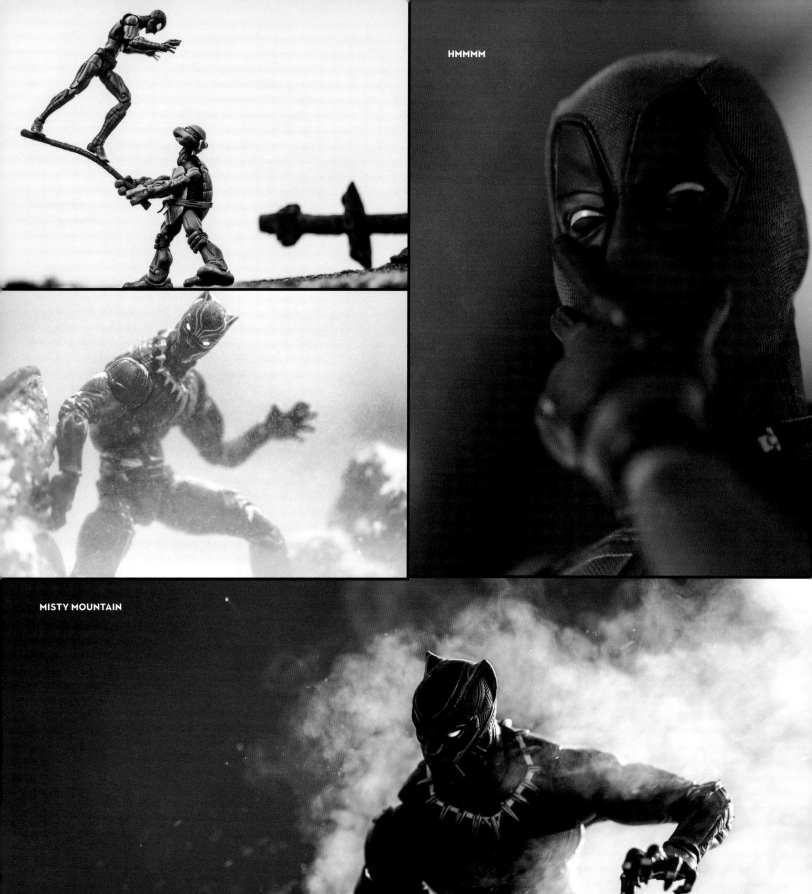

HMMMM

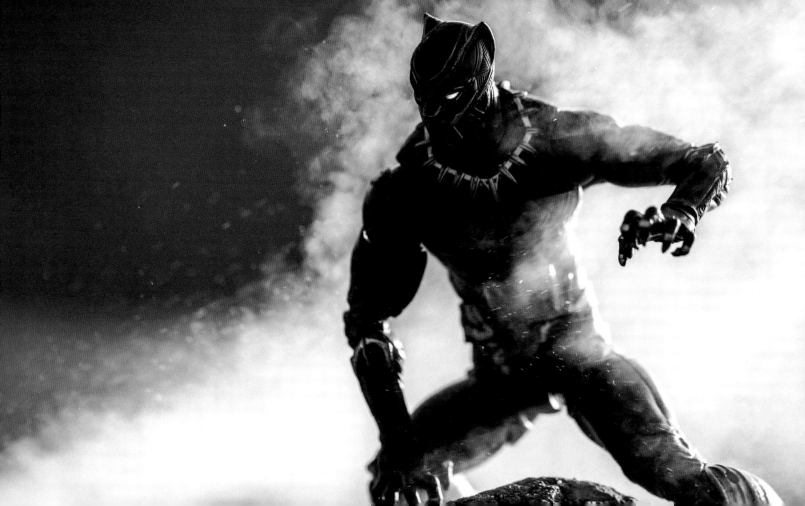

MISTY MOUNTAIN

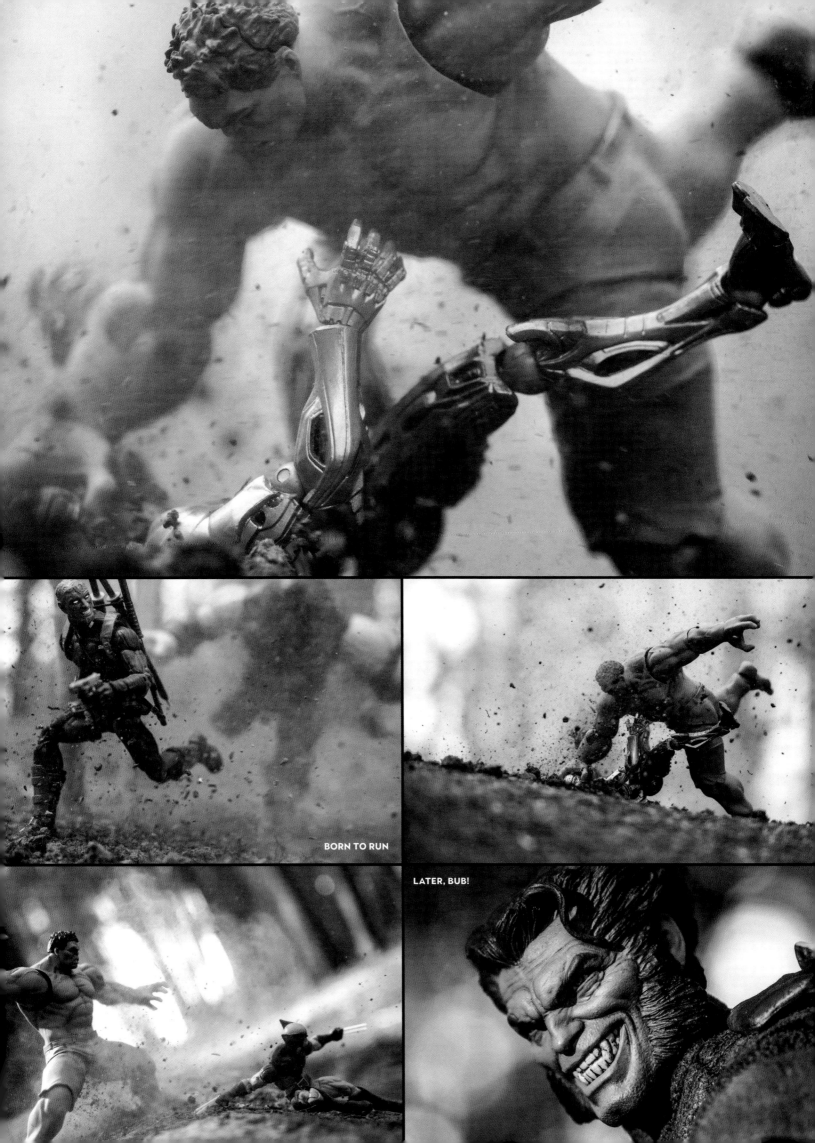

BORN TO RUN

LATER, BUB!

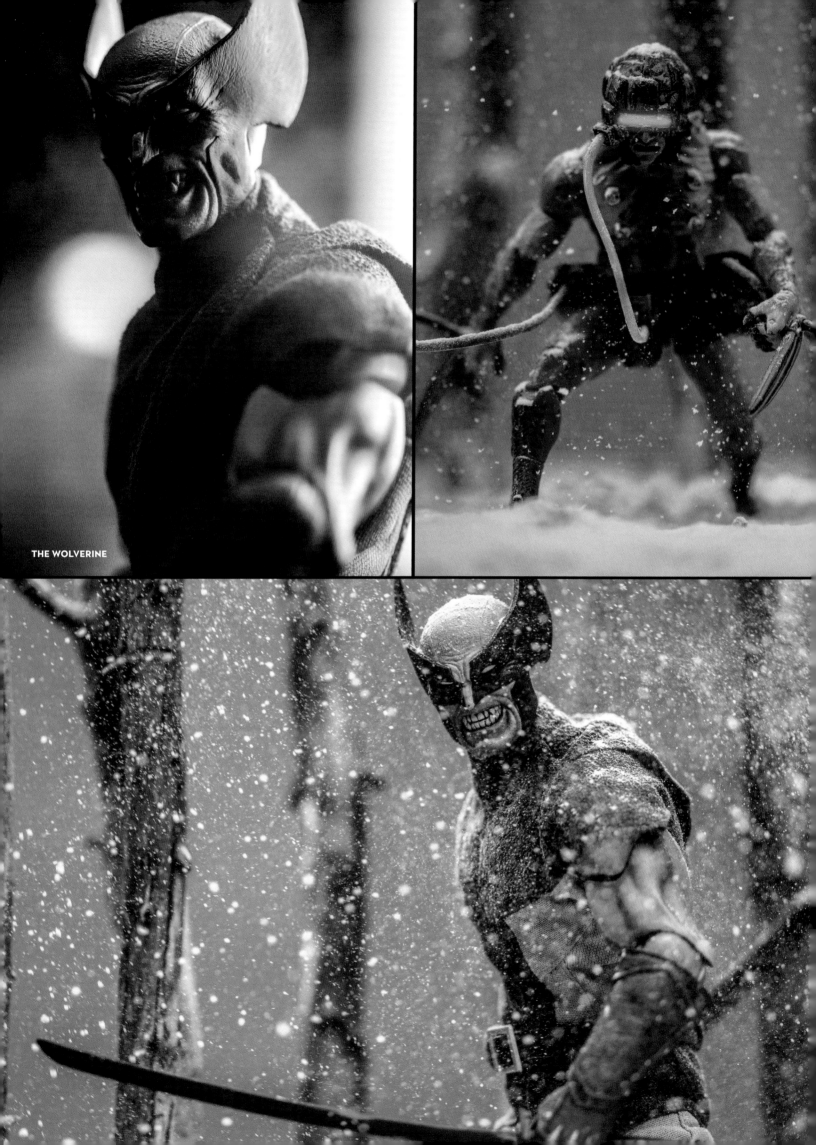

THE WOLVERINE

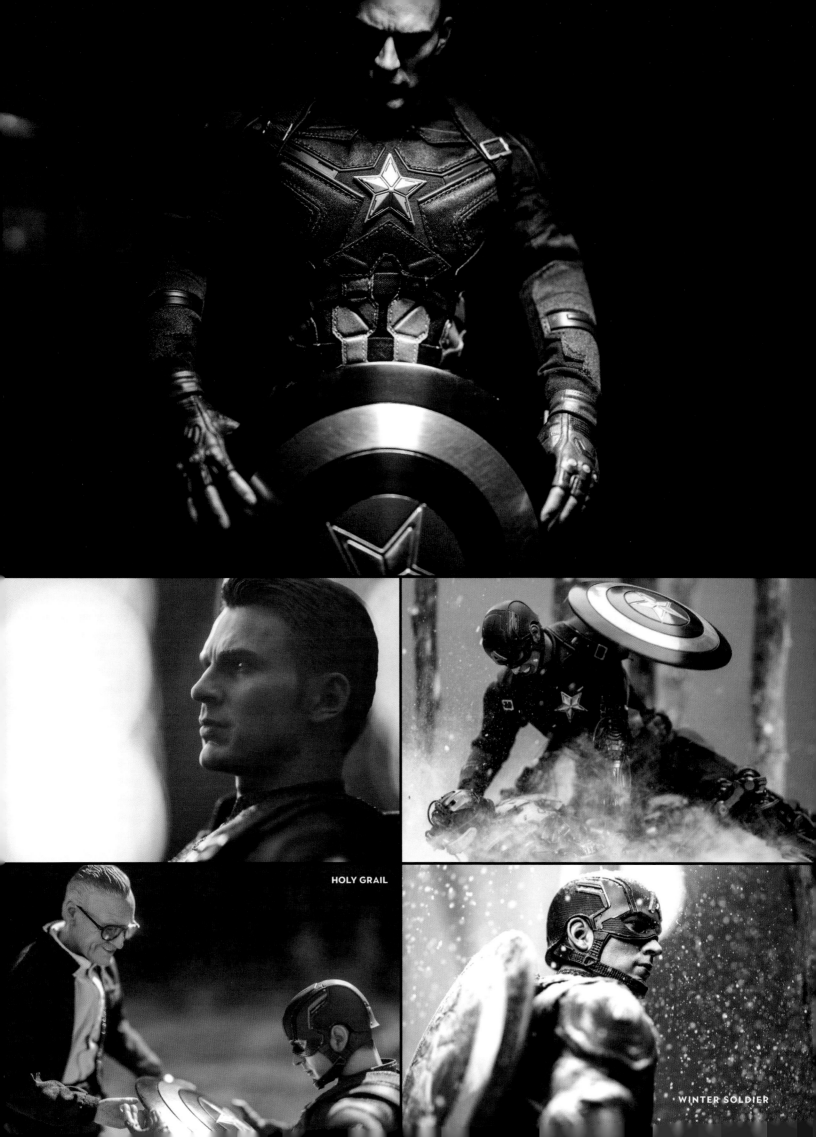

HOLY GRAIL

WINTER SOLDIER

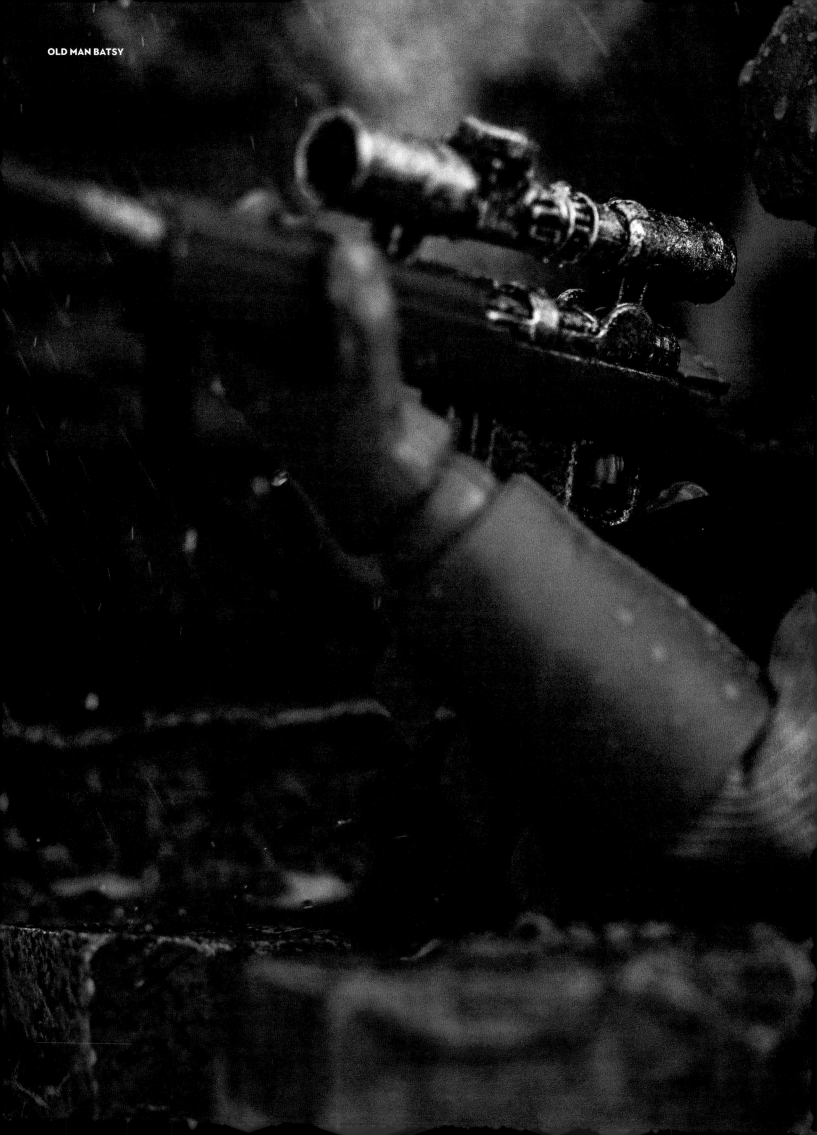

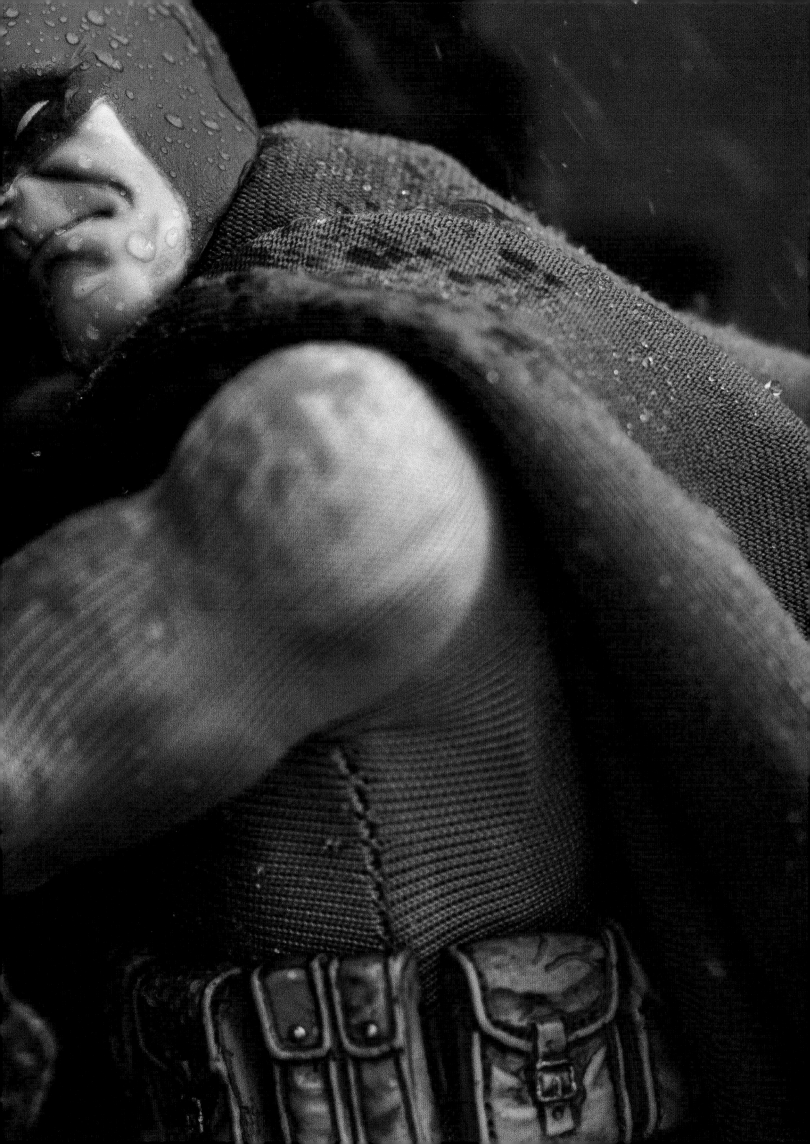

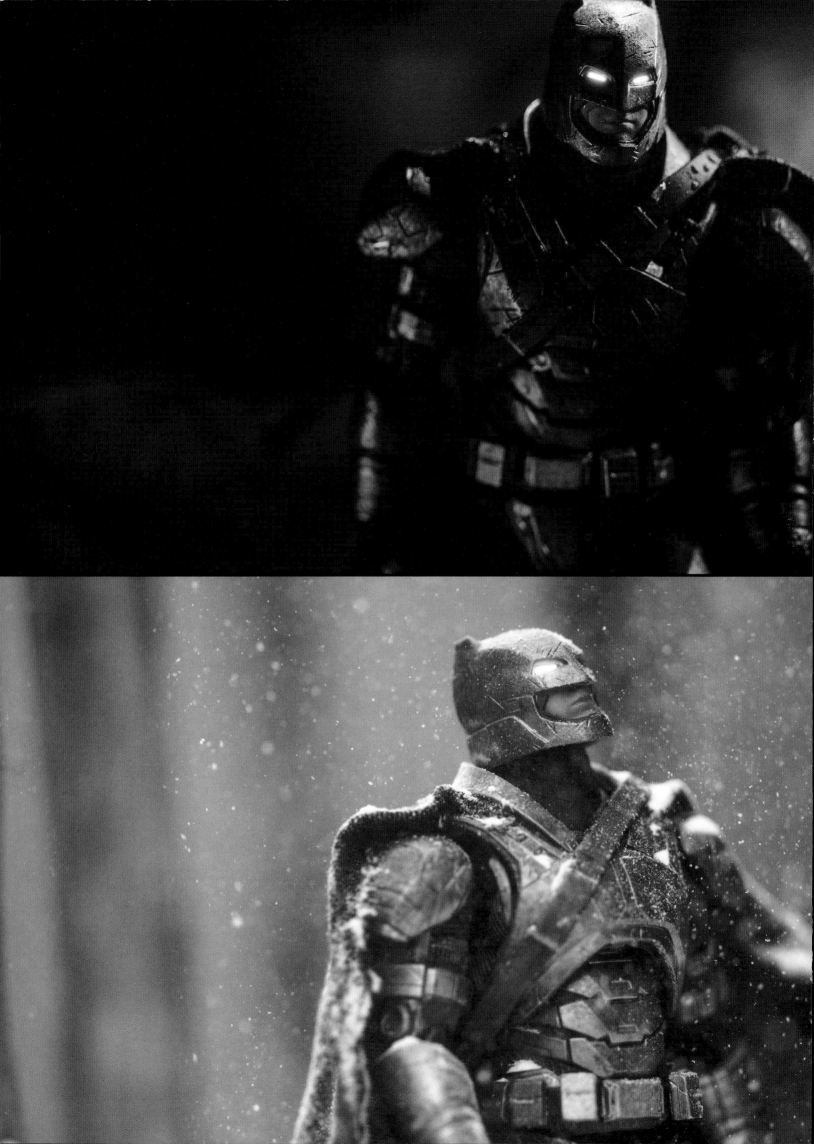

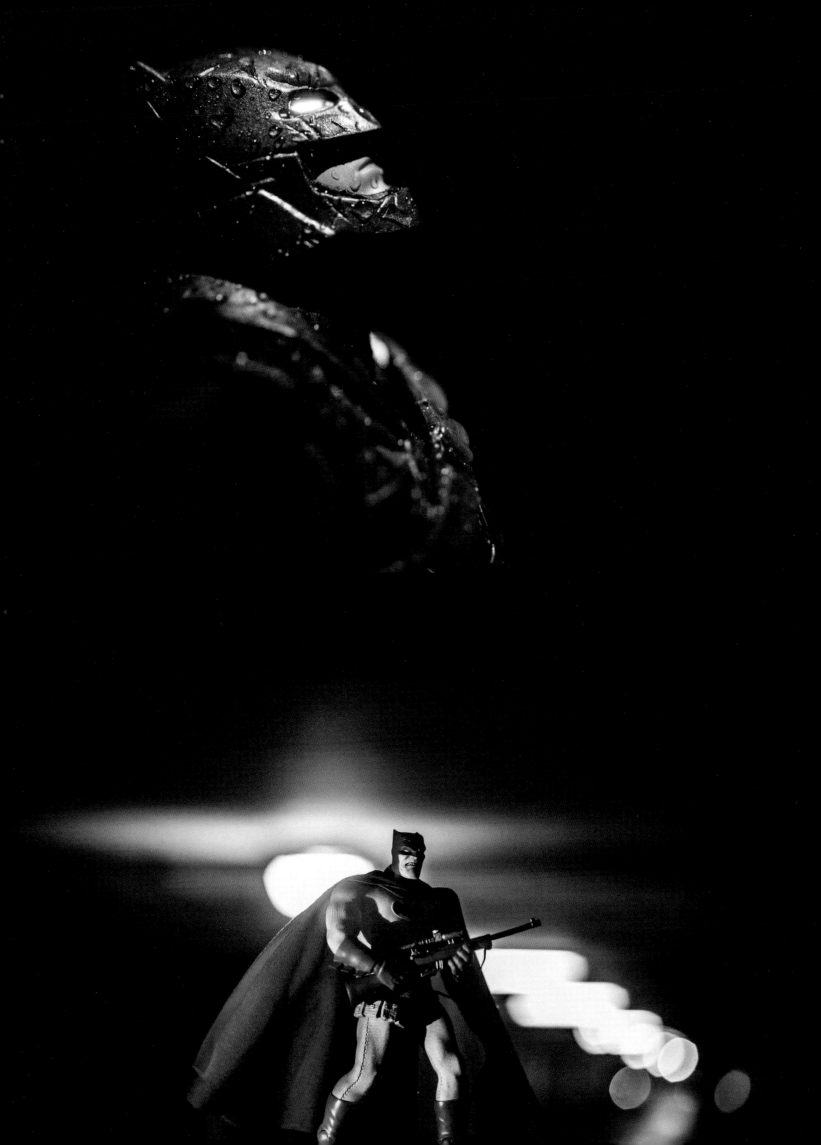

THE WOOKIEE

This Chewbacca has to be my favorite figure—he's just so damn cool. His fur is the main selling point. He's got so much personality that you can turn him into many different characters.

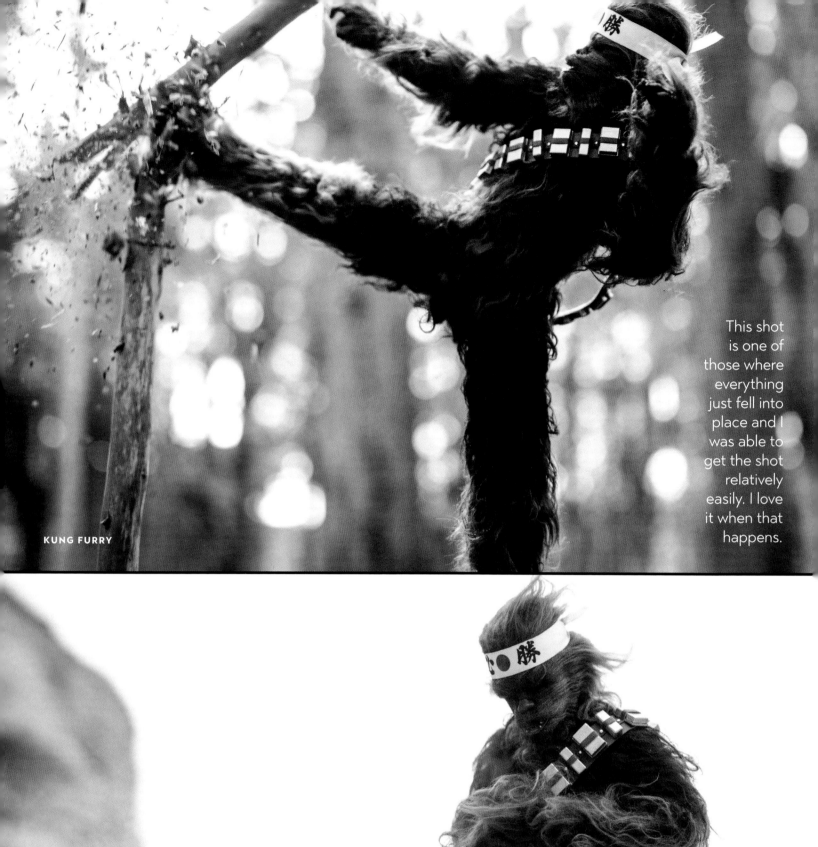

KUNG FURRY

This shot is one of those where everything just fell into place and I was able to get the shot relatively easily. I love it when that happens.

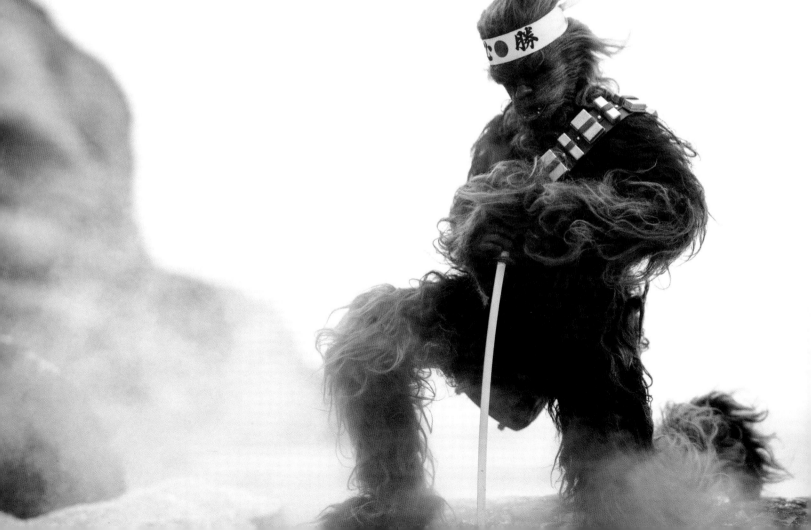

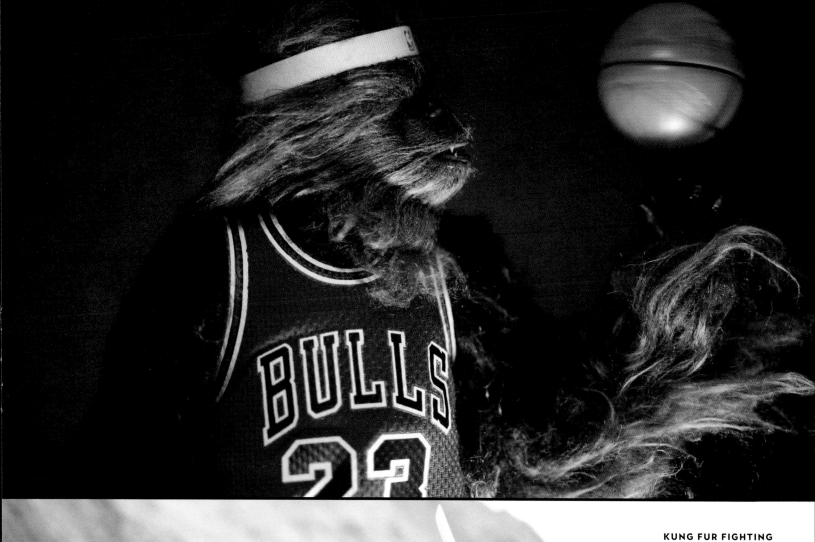

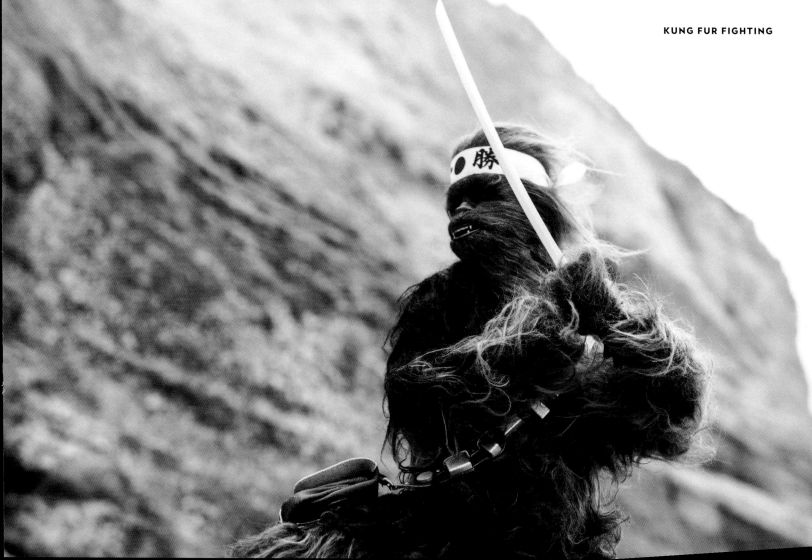

KUNG FUR FIGHTING

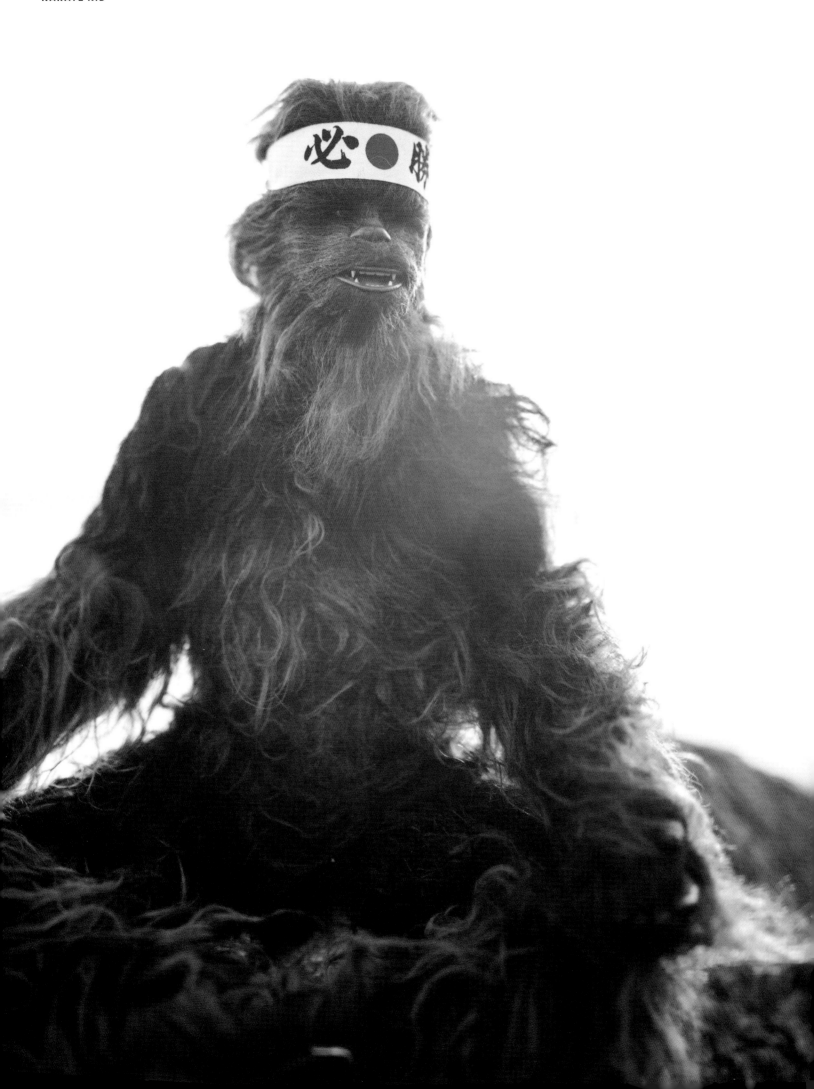

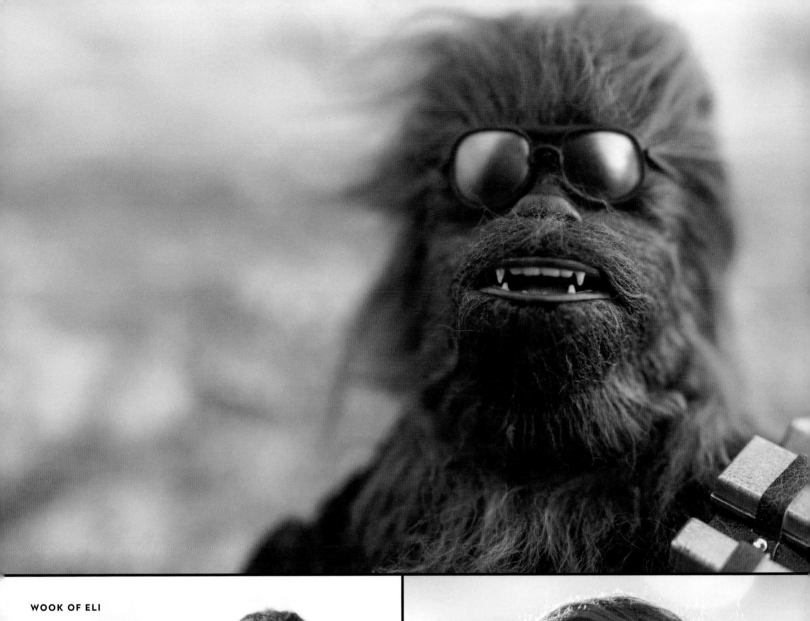

WOOK OF ELI

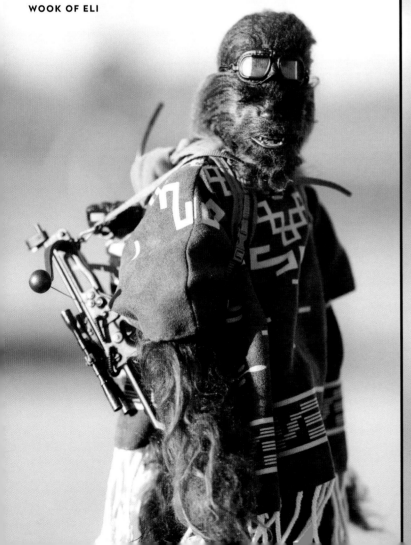

I've done a fair share of reflection photographs with other characters using water, but this idea happened by accident. I was taking a different photo of the samurai using a blood effect, and I noticed the pool of fake blood had a nice reflection in it. A few shots later and I had this.

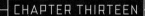

CHAPTER THIRTEEN

SLICE & DICE

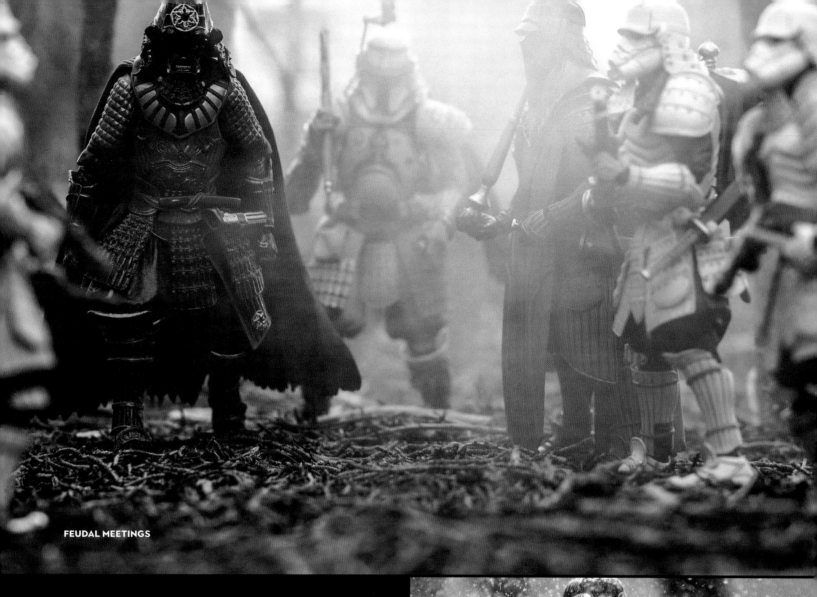

FEUDAL MEETINGS

▲This is my favorite toy line. When I first saw a photo of samurai Vader from Tamashii Nations, I couldn't believe it existed. Star Wars characters translate into the samurai style extremely well. The line has my undying support.

SUICIDE FOREST

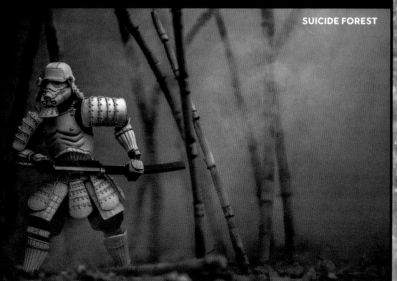

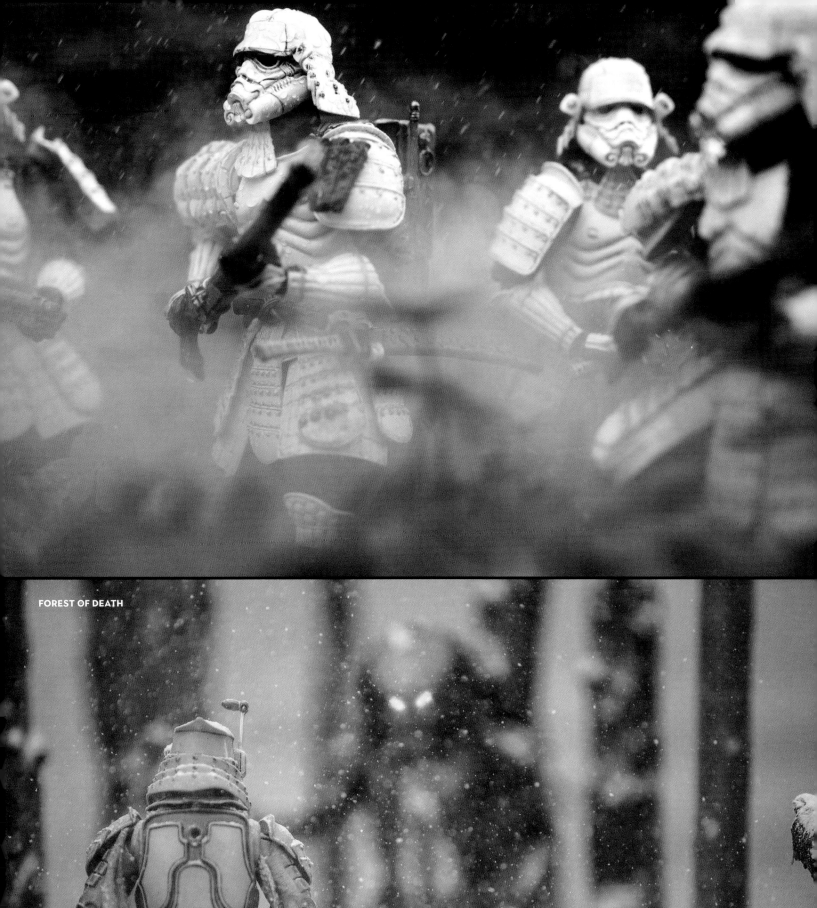

FOREST OF DEATH

Another mash-up I'd love to see on the big screen—two of the galaxy's most feared hunters squaring off in a snowy forest. I know I'd watch it!

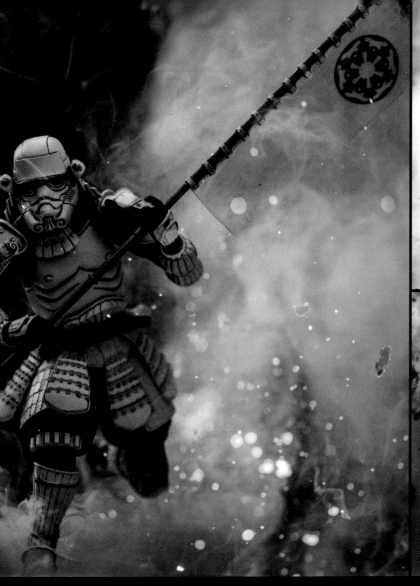

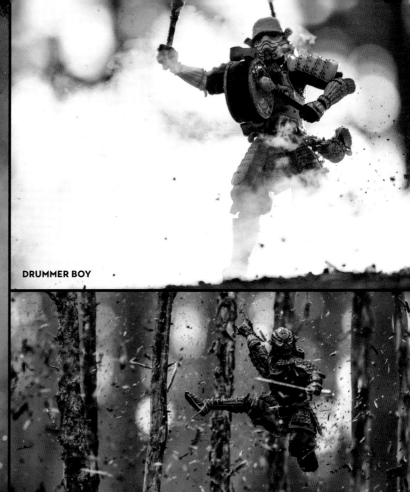

DRUMMER BOY

FRIENDLY NEIGHBORHOOD SAMURAI!

FEUDAL AVENGERS

▲ I've had some amazing opportunties as a result of my photography, including at Star Wars Celebration 2017, when Tamashii Nations displayed a slew of my photos at its booth, including this one.

It was a dream come true to be part of the display for my favorite toy line.

WAITING ...

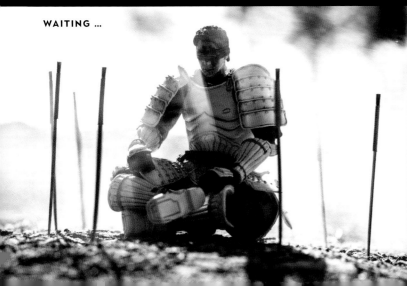

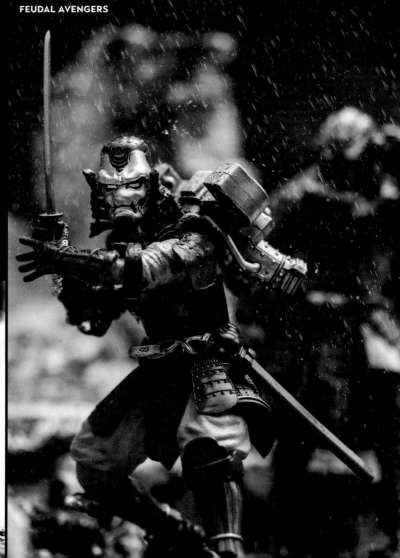

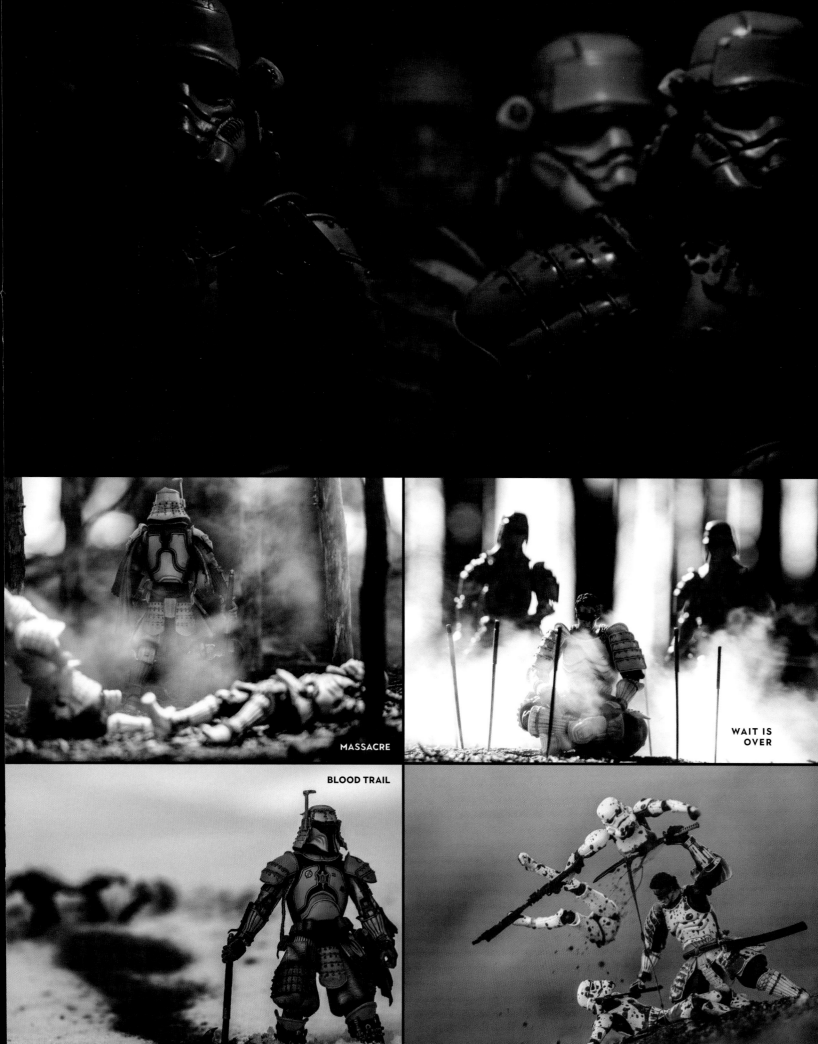

MASSACRE

WAIT IS
OVER

BLOOD TRAIL

SANDYS
This photo is significant to me because it's the first photo I took with my new camera and lens, which I paid for with money earned from doing toy photography. That was a proud moment for me.

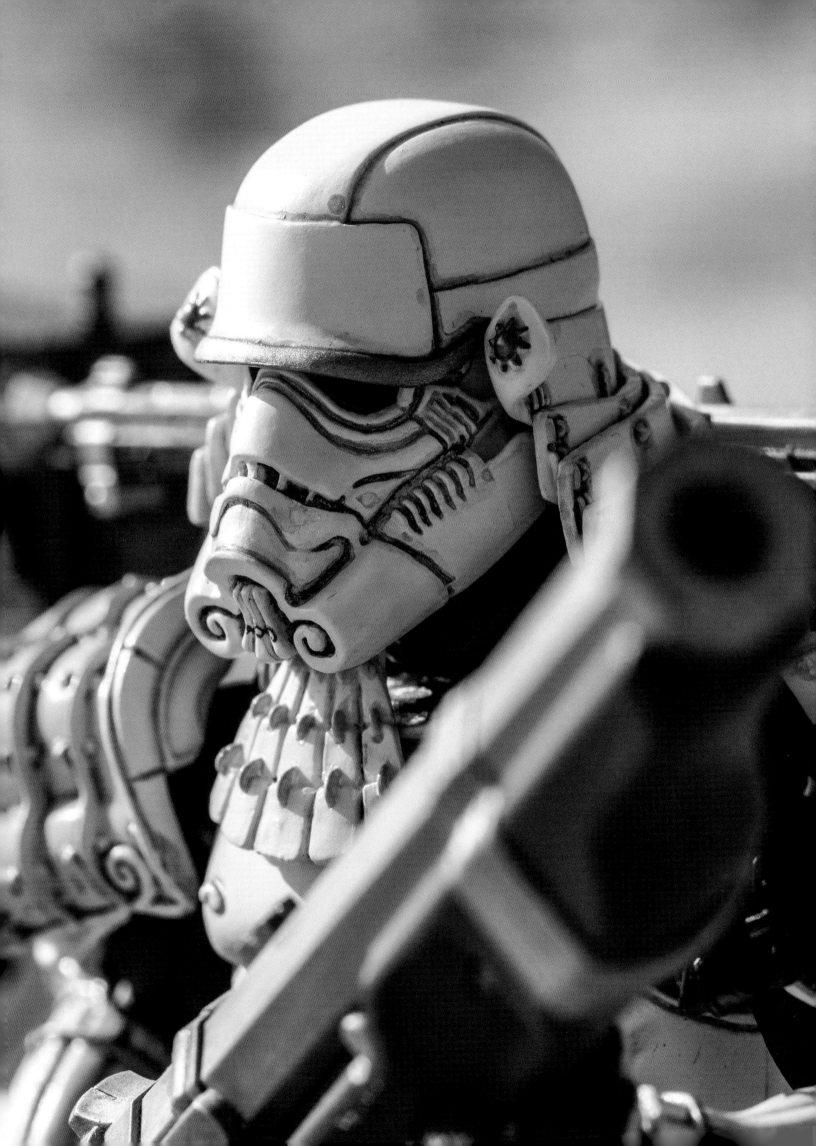

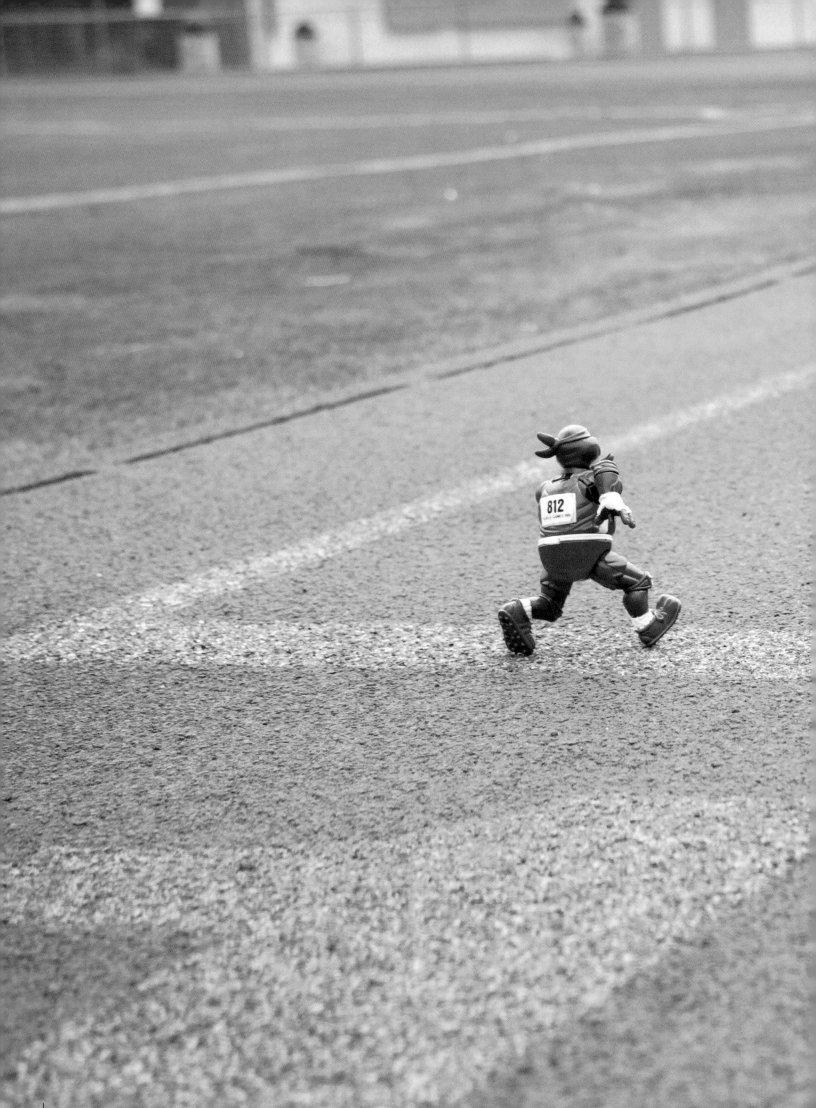

RUNNING MAN
This was one of my
early photographs, and
I remember how hard I
laughed back then. It still
makes me laugh today.

CHAPTER FOURTEEN

POSABLE JOKES

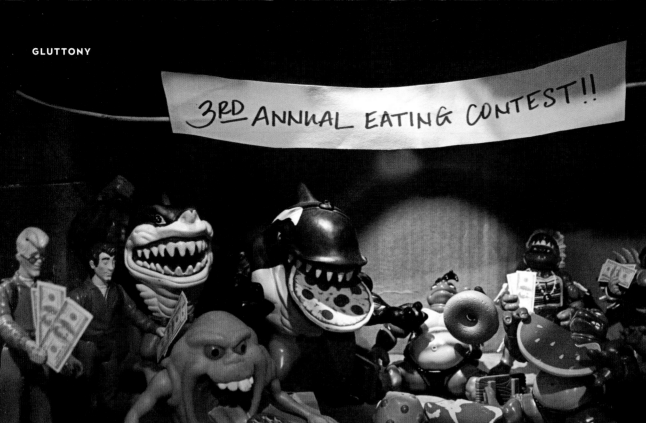

3RD ANNUAL EATING CONTEST!!

This photo is terrible, but I like the idea of Slimer and Jabba the Hutt going against each other in an eating contest.

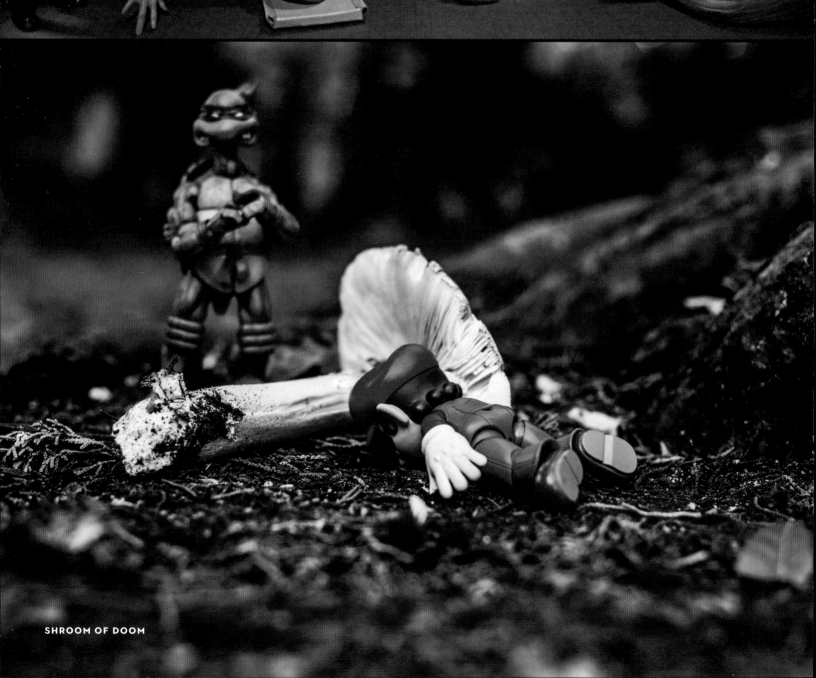

SHROOM OF DOOM

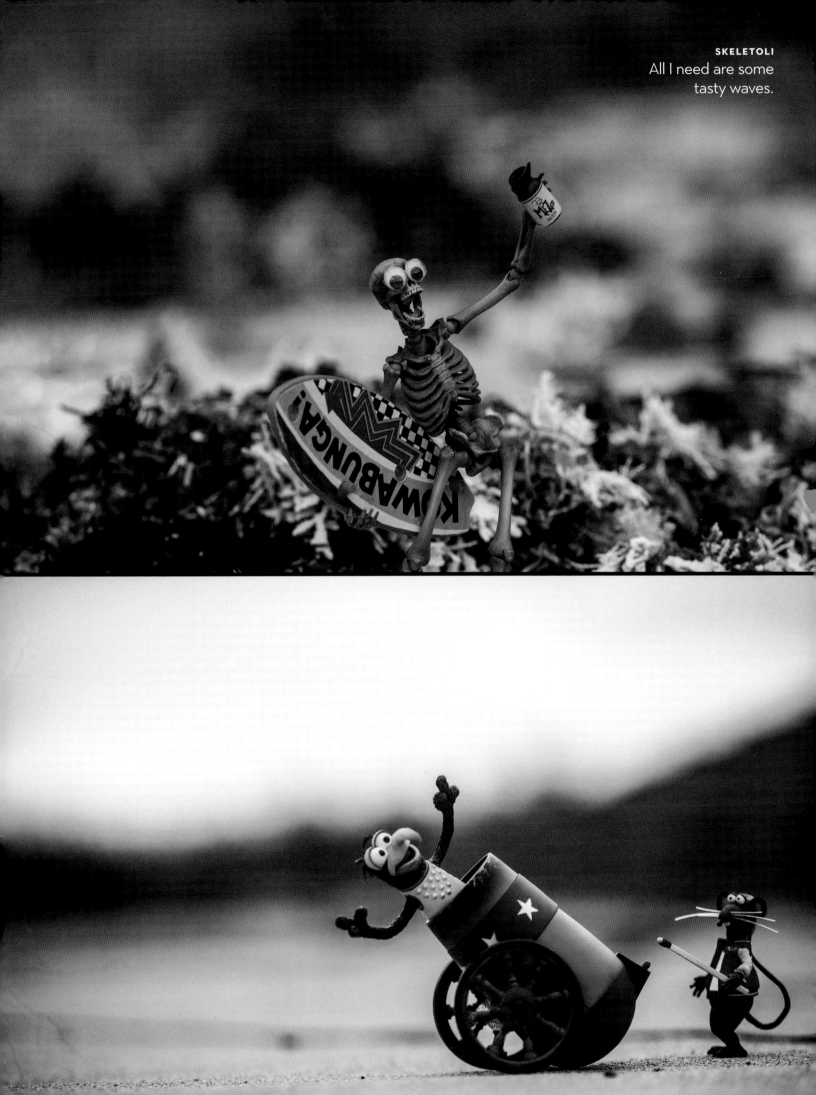

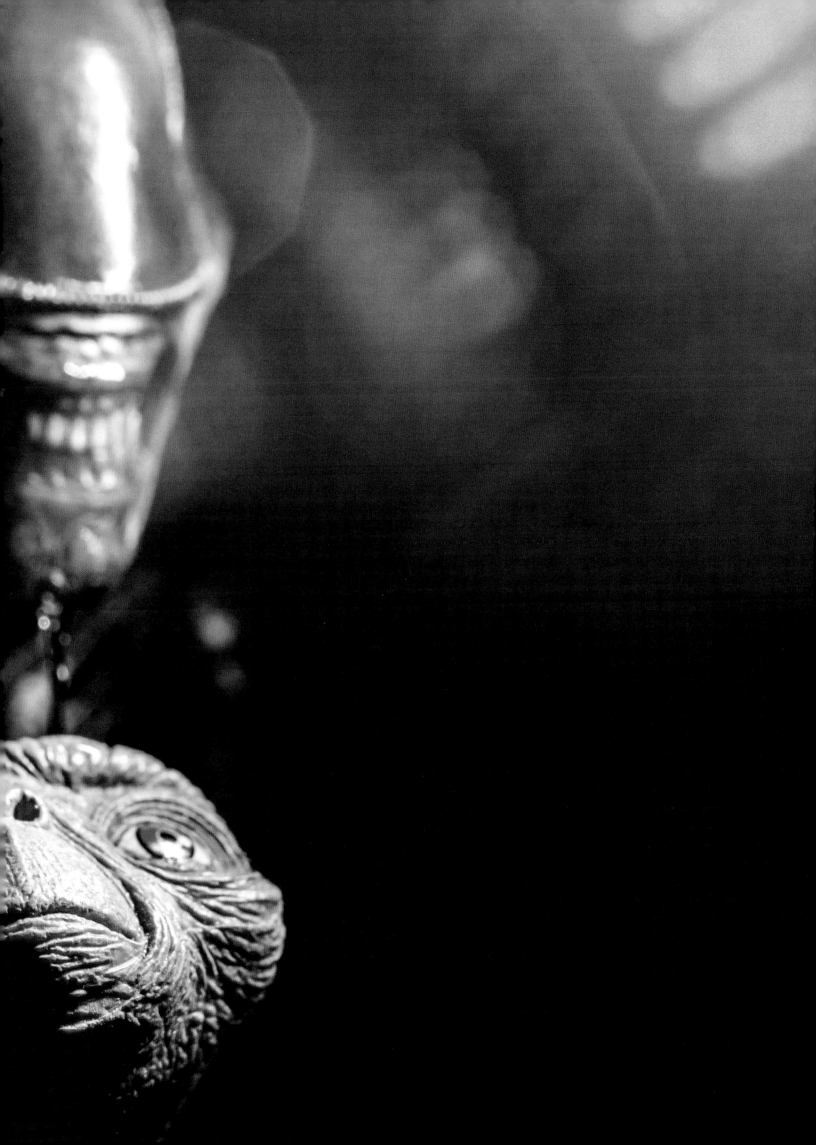

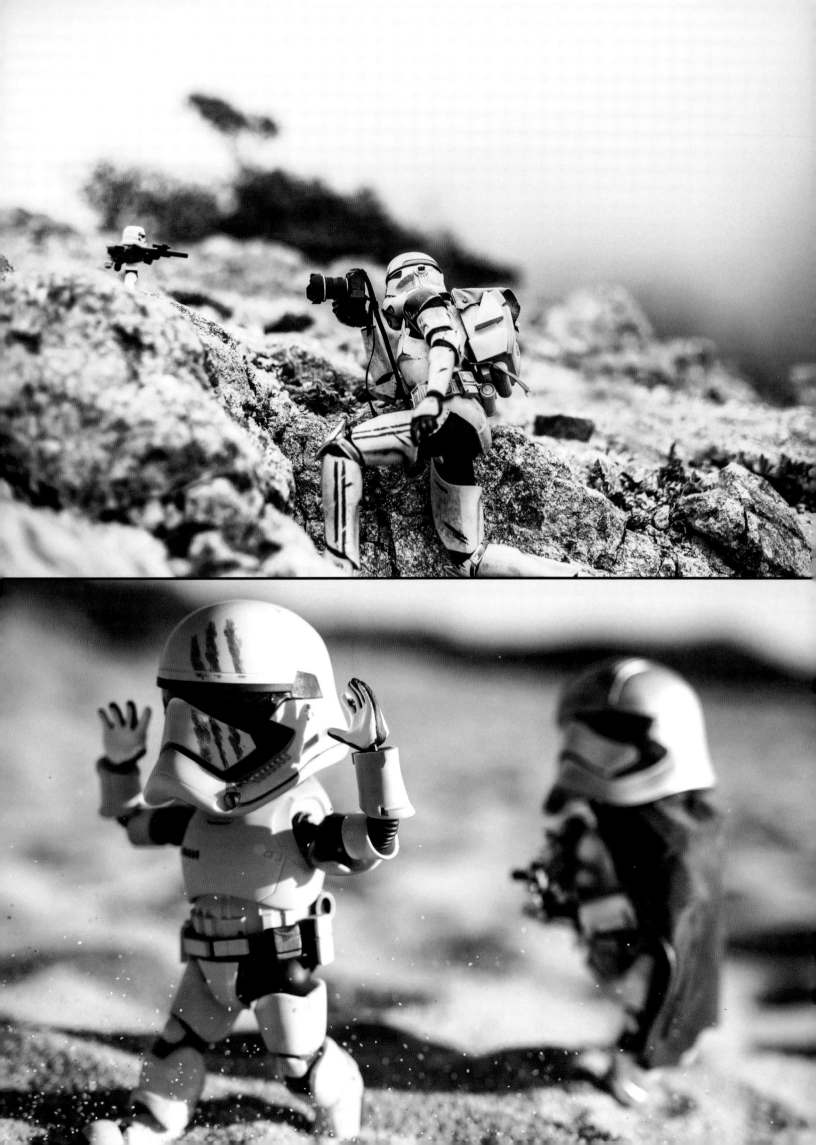

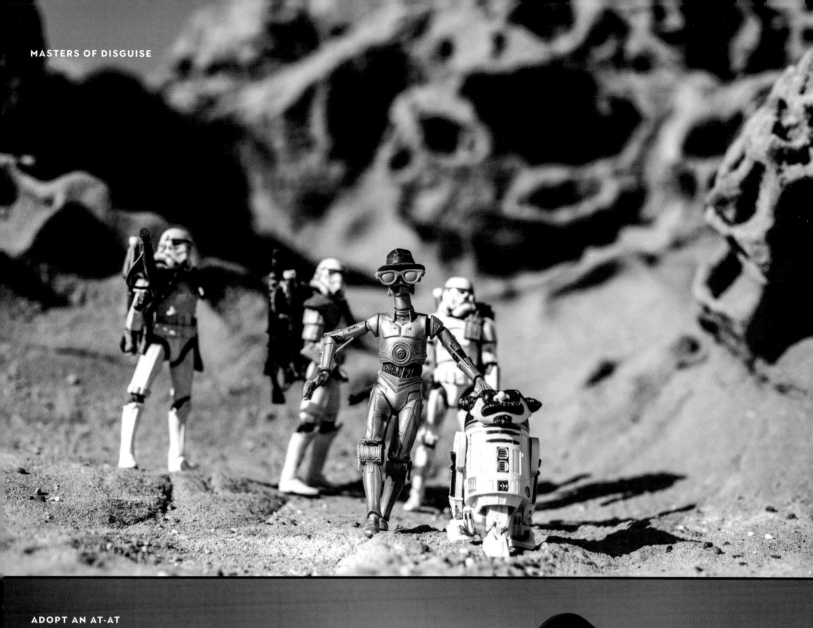

MASTERS OF DISGUISE

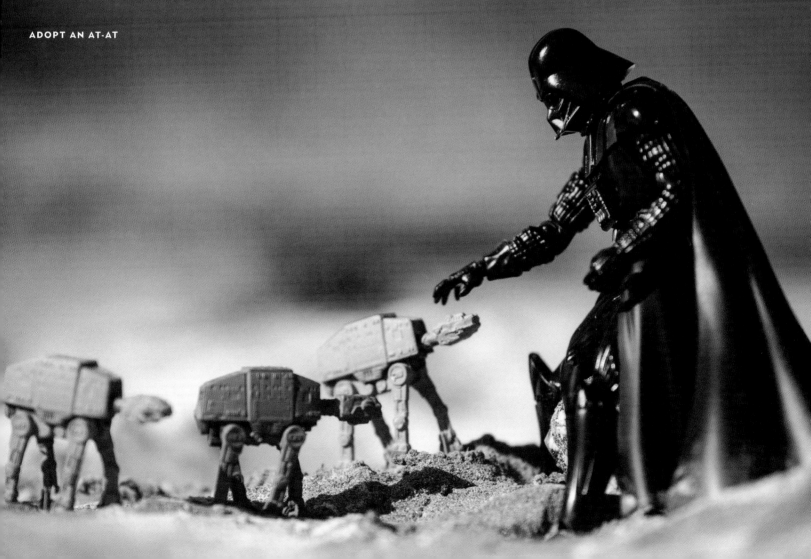

ADOPT AN AT-AT

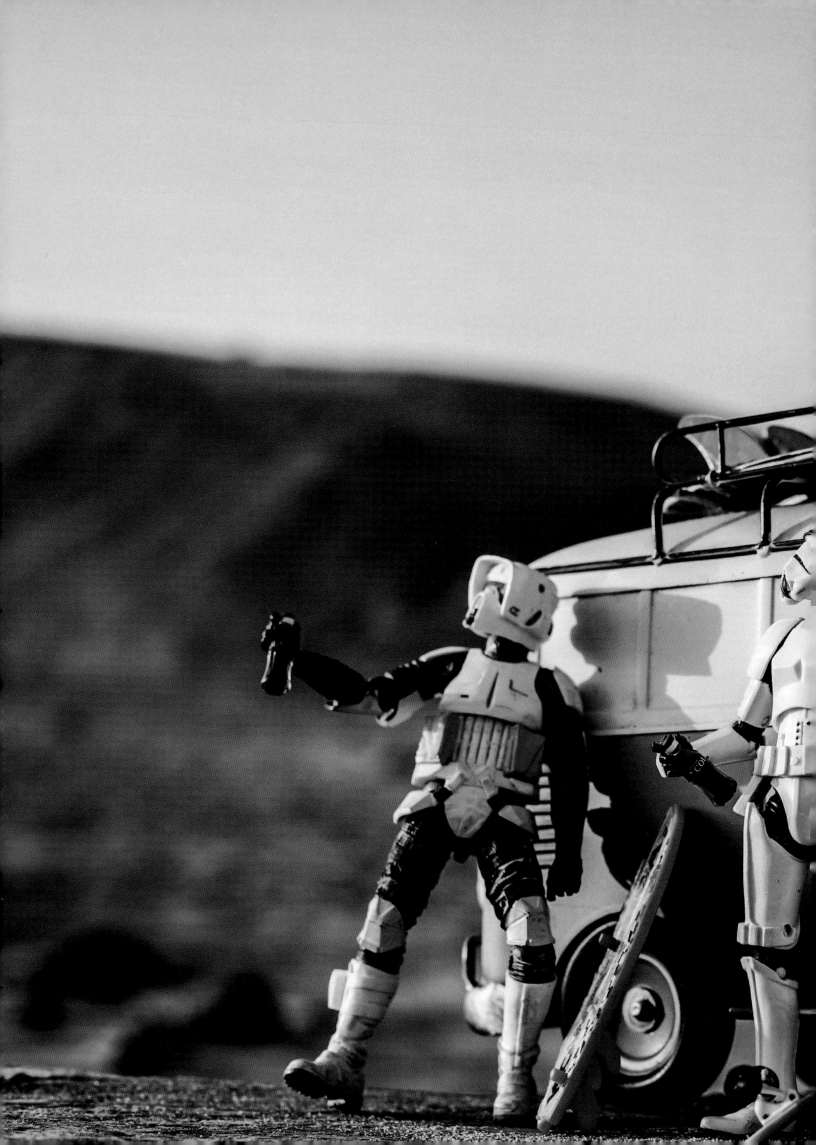

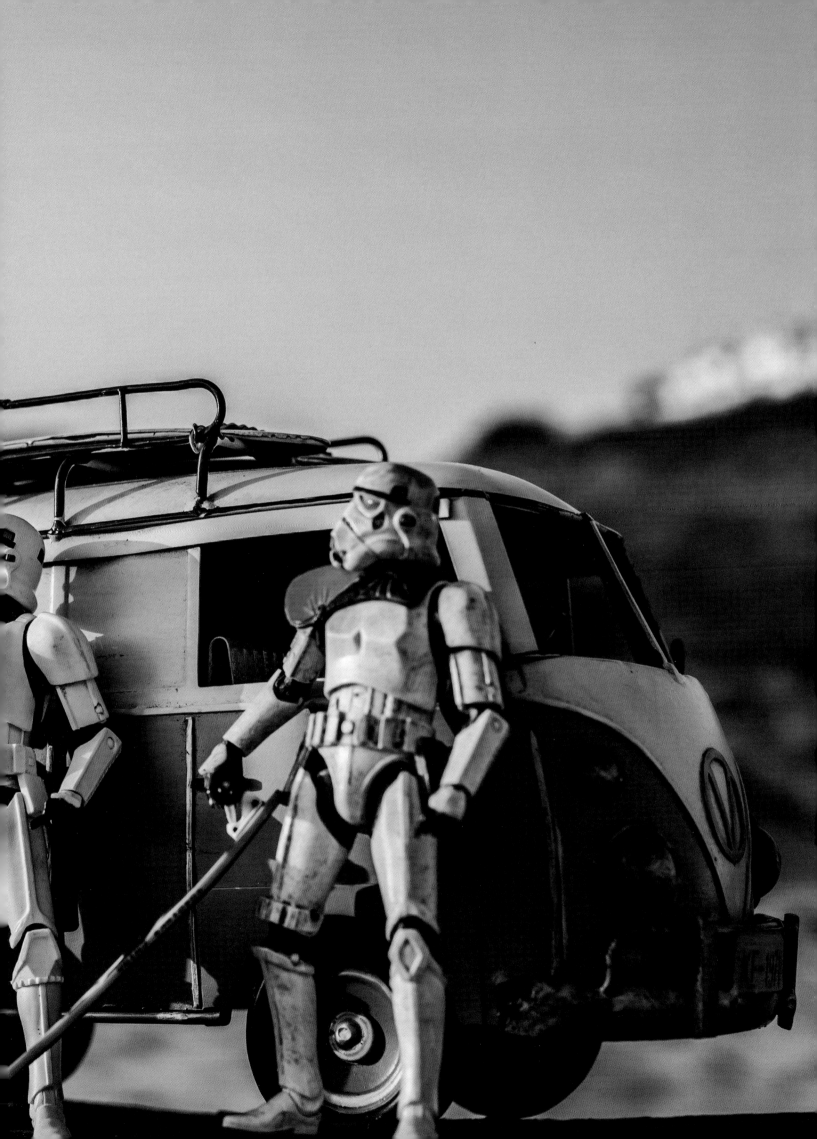

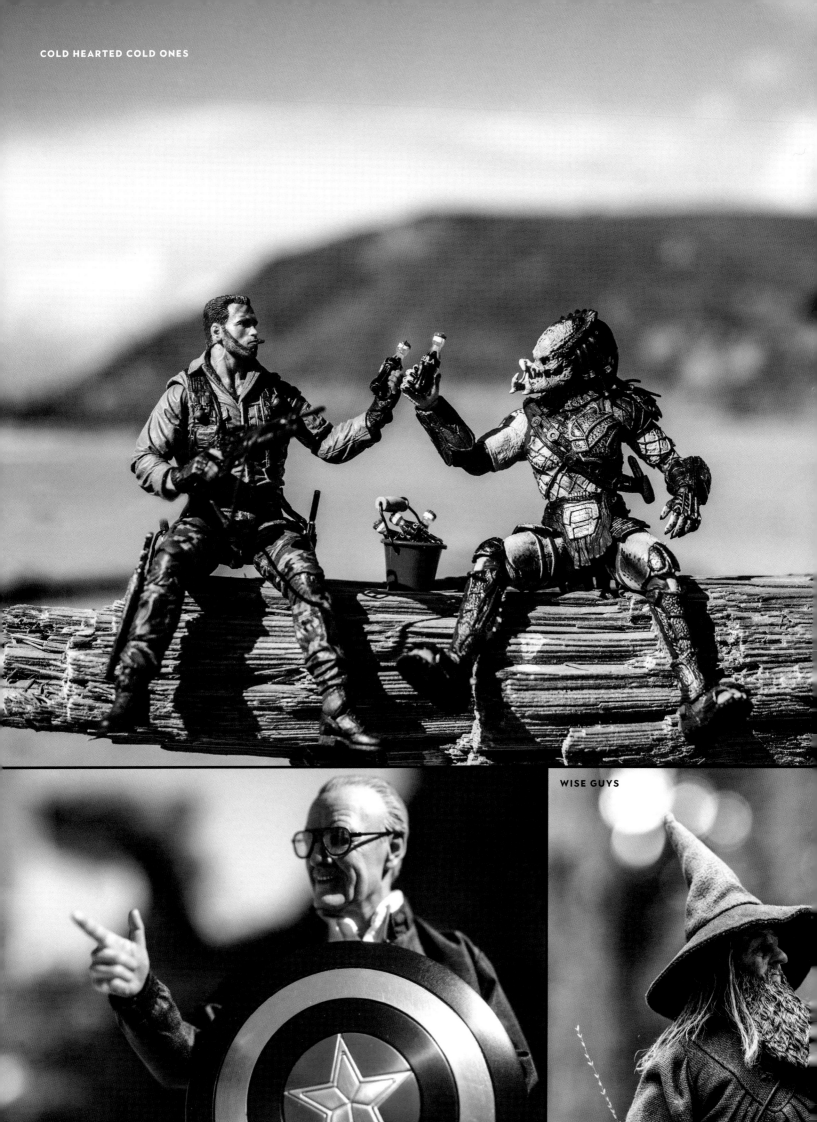

COLD HEARTED COLD ONES

WISE GUYS

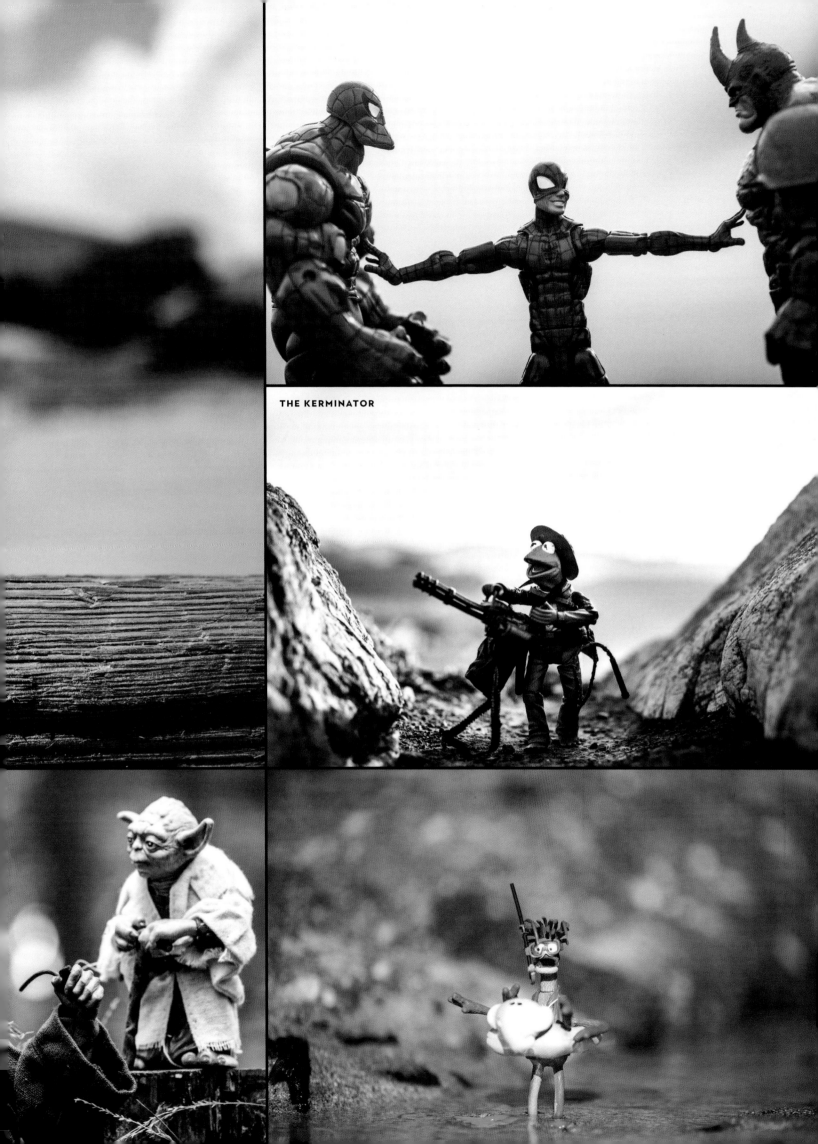

THE KERMINATOR

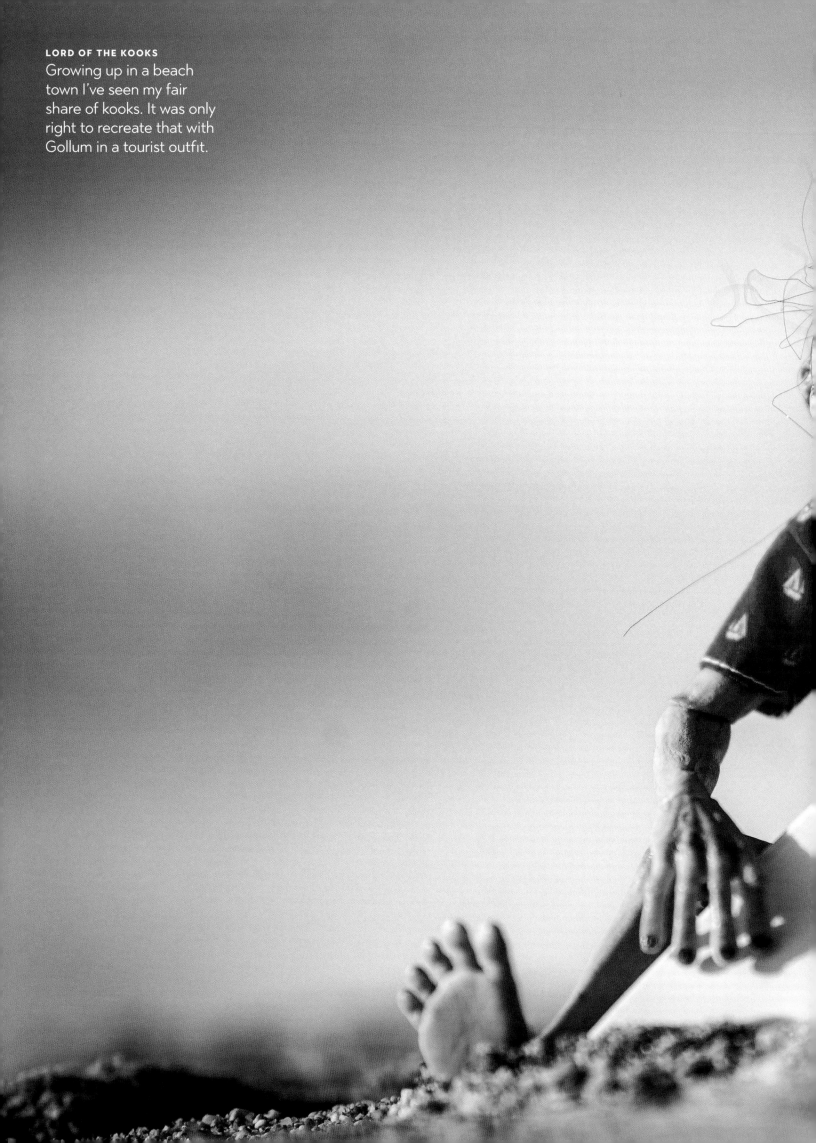

LORD OF THE KOOKS
Growing up in a beach
town I've seen my fair
share of kooks. It was only
right to recreate that with
Gollum in a tourist outfit.

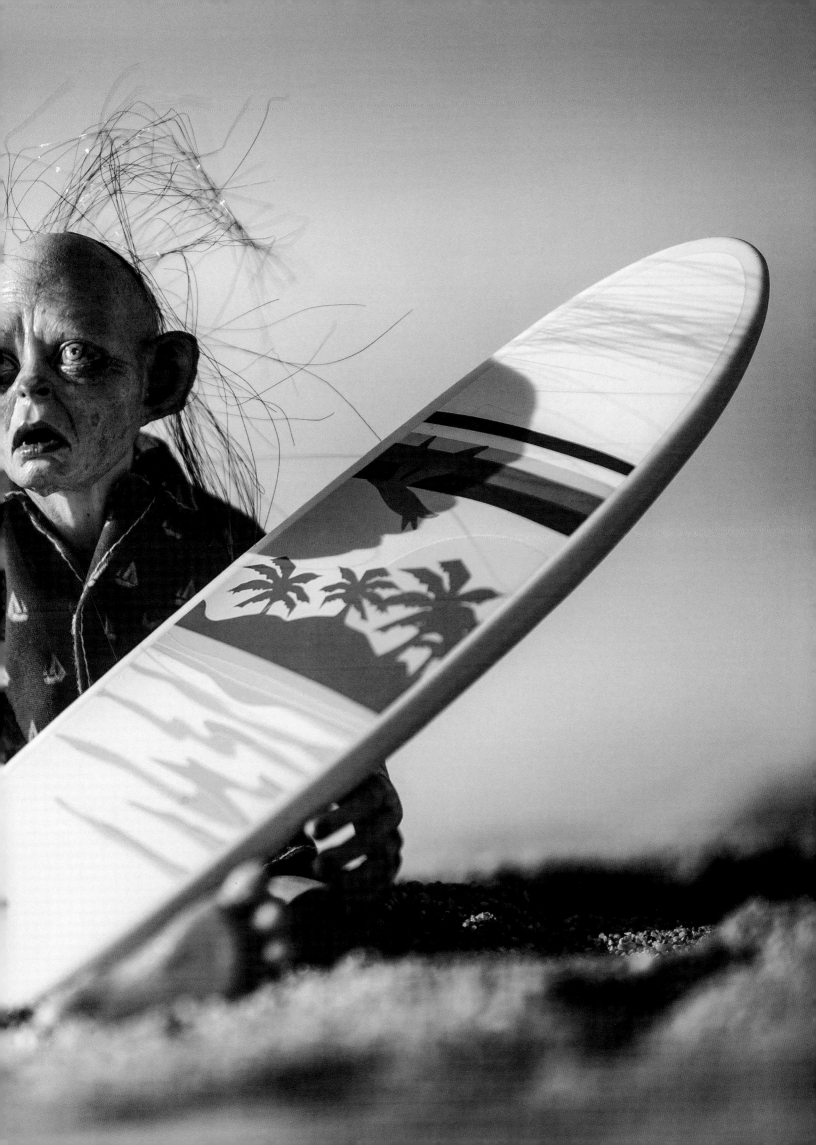

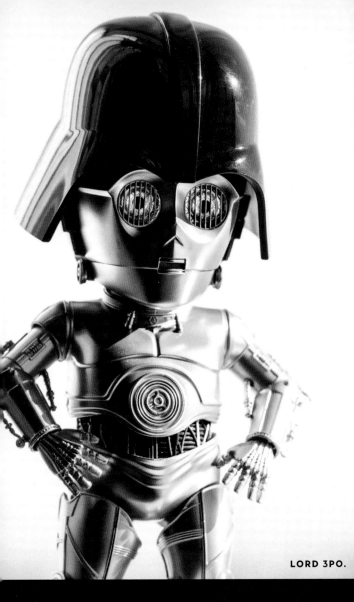

LORD 3PO.

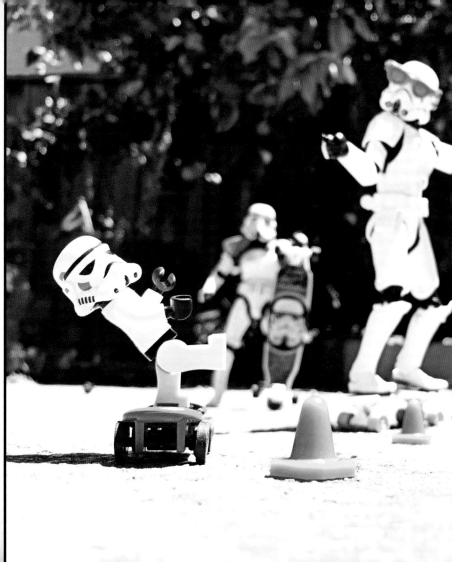

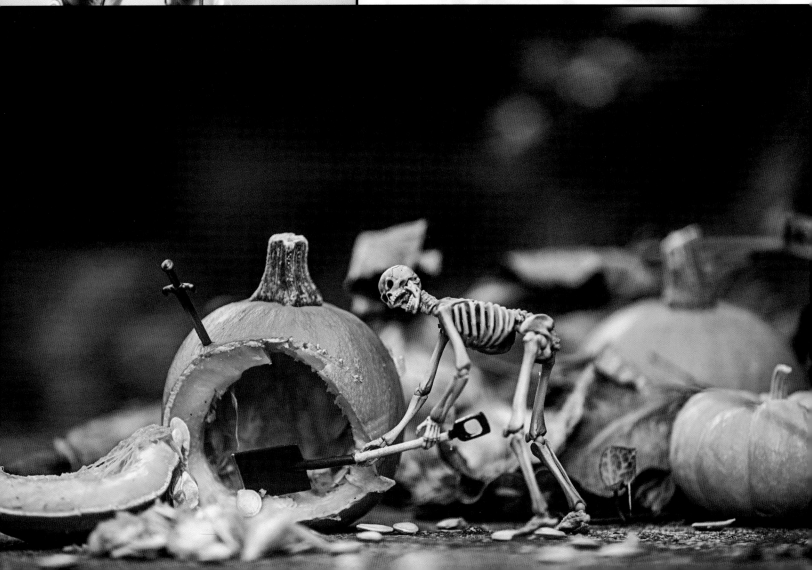

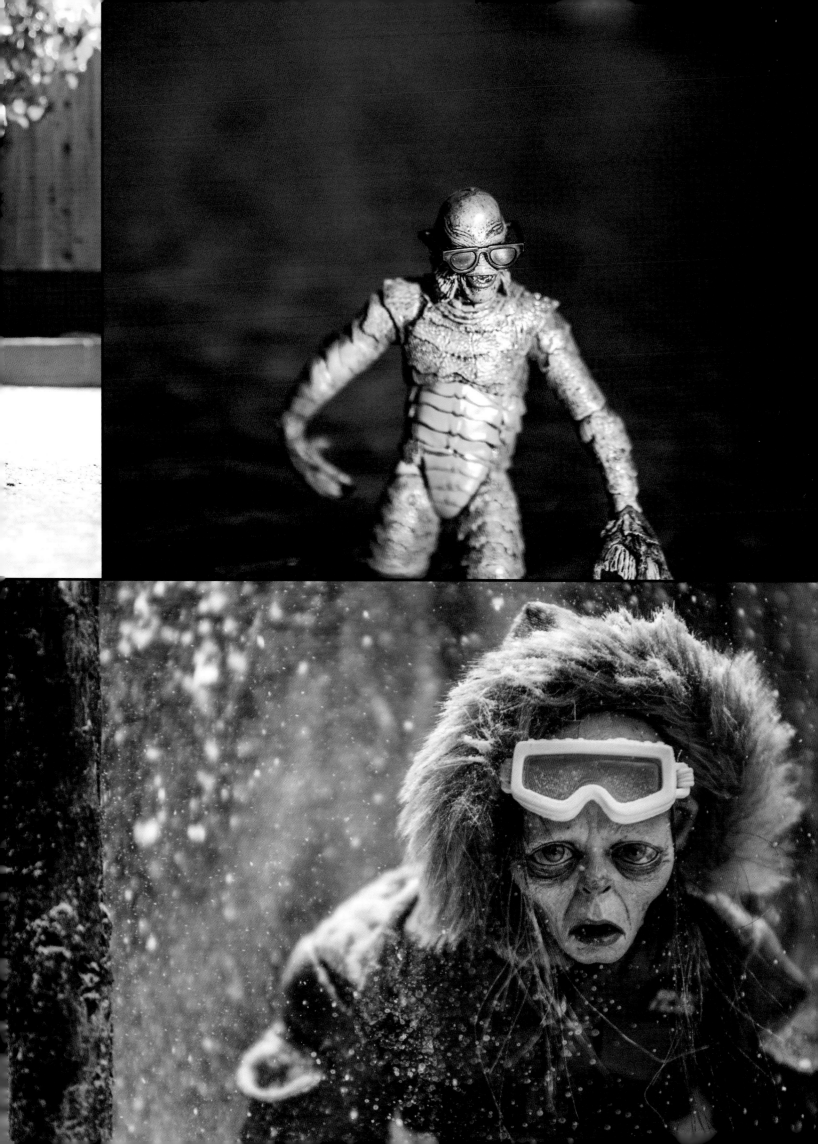

DON'T STOP ME NOW!

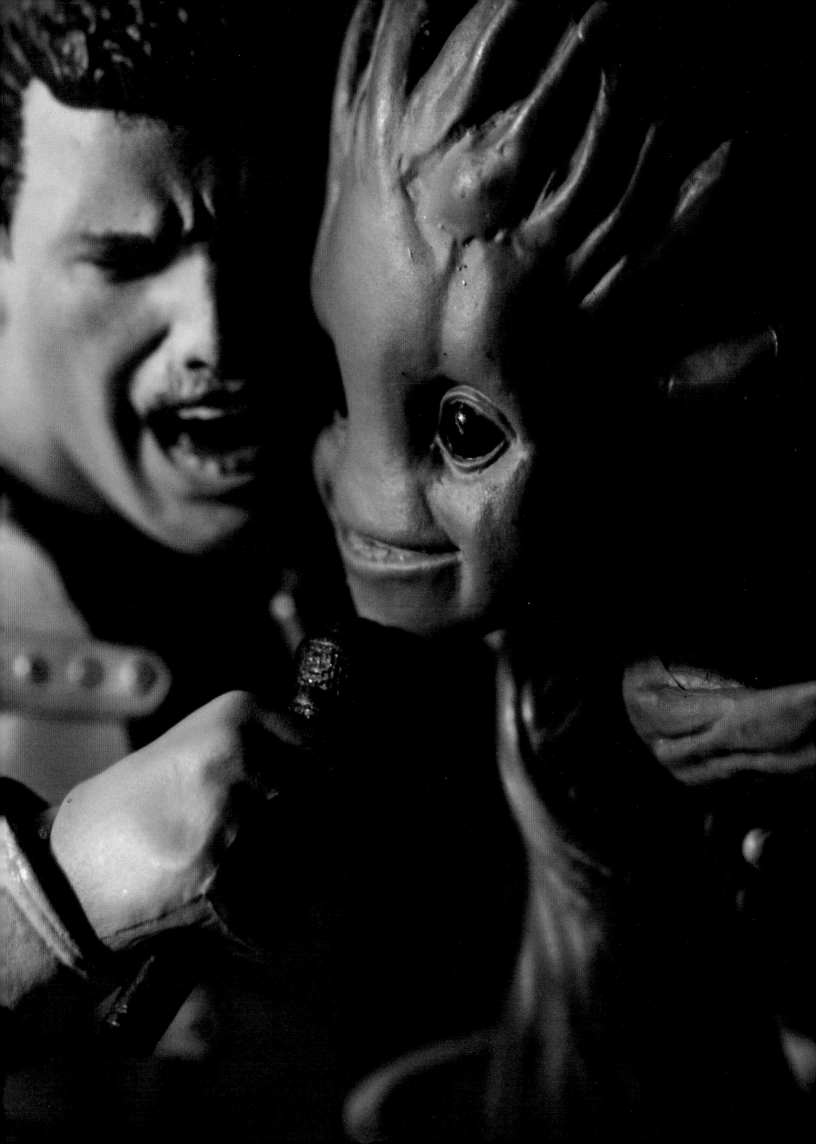

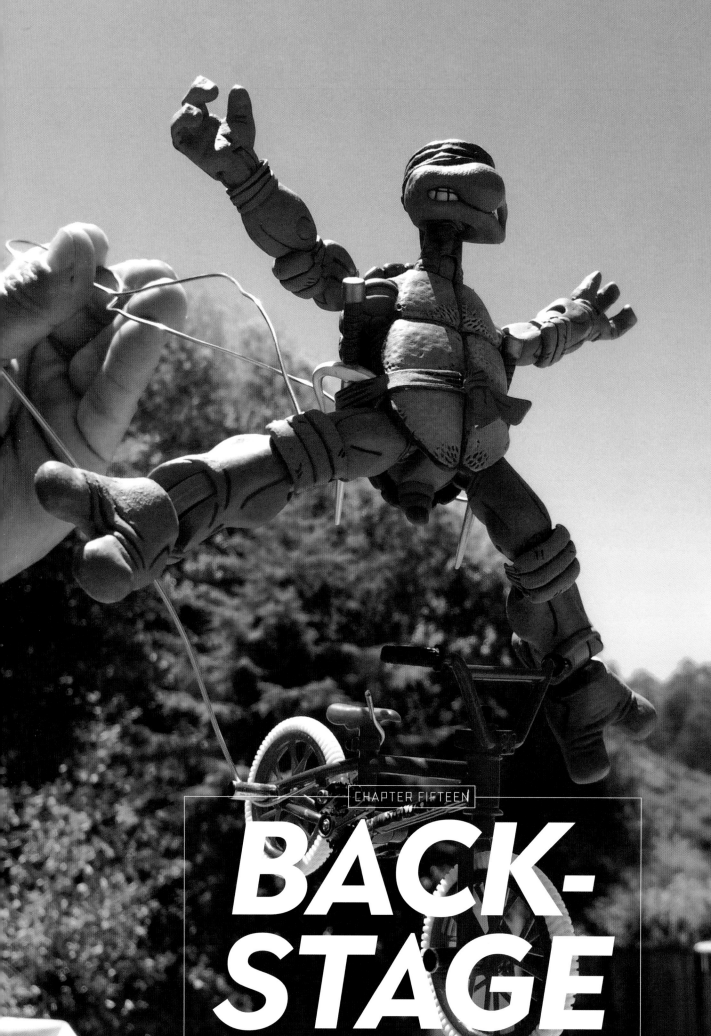

BACK-STAGE

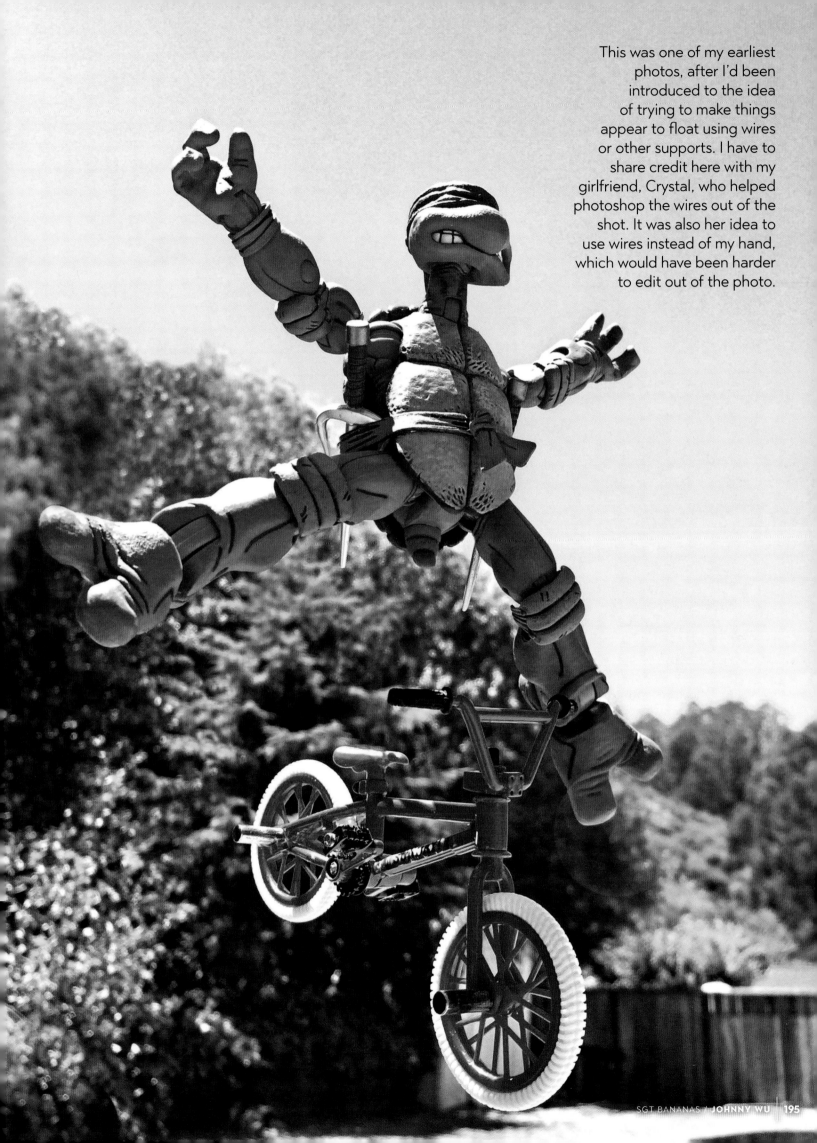

This was one of my earliest photos, after I'd been introduced to the idea of trying to make things appear to float using wires or other supports. I have to share credit here with my girlfriend, Crystal, who helped photoshop the wires out of the shot. It was also her idea to use wires instead of my hand, which would have been harder to edit out of the photo.

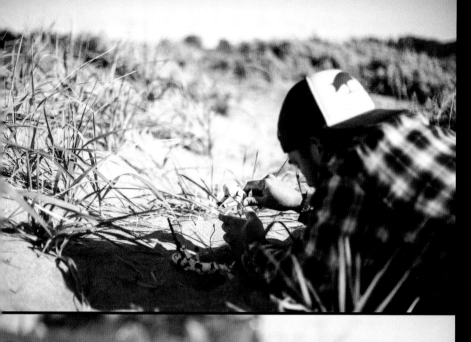

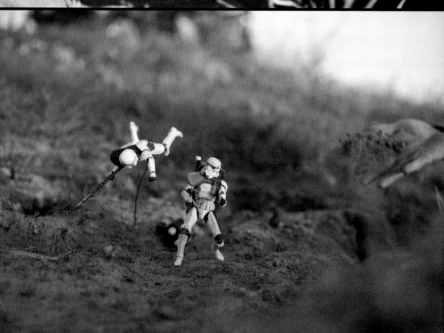

Sometimes photos are just meant to happen, and the sequence here is a perfect example. I was driving down the coast toward Santa Cruz with some friends when we ran out of gas. I decided to take out my camera and a few troopers to see if I could get some shots. The mix of dust and debris on the side of the road looked cool to me, and we set up one trooper on a wire to suspend him in the air. After I set up the scene, I had my friend toss some dirt while I took the shot. I'm glad we ended up stuck on the side of the road, or I wouldn't have found that exact spot and been able to capture this.

I was able to walk away with a shot I like and an even better story to go with it.

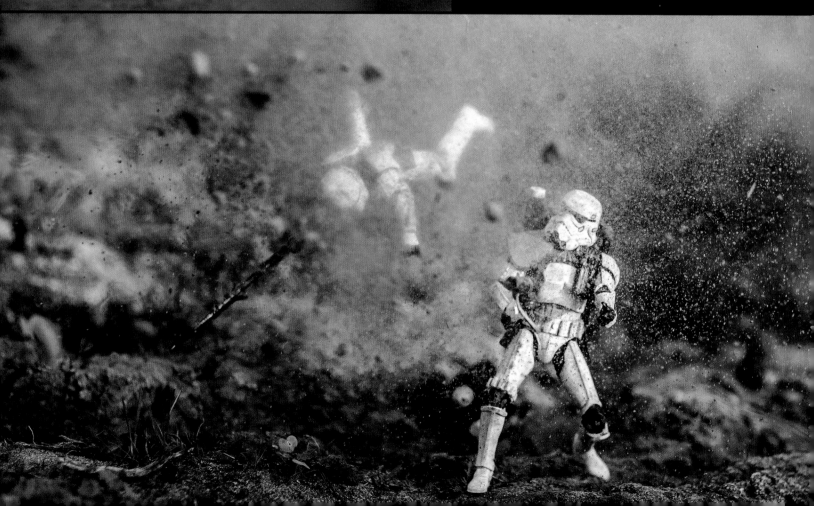

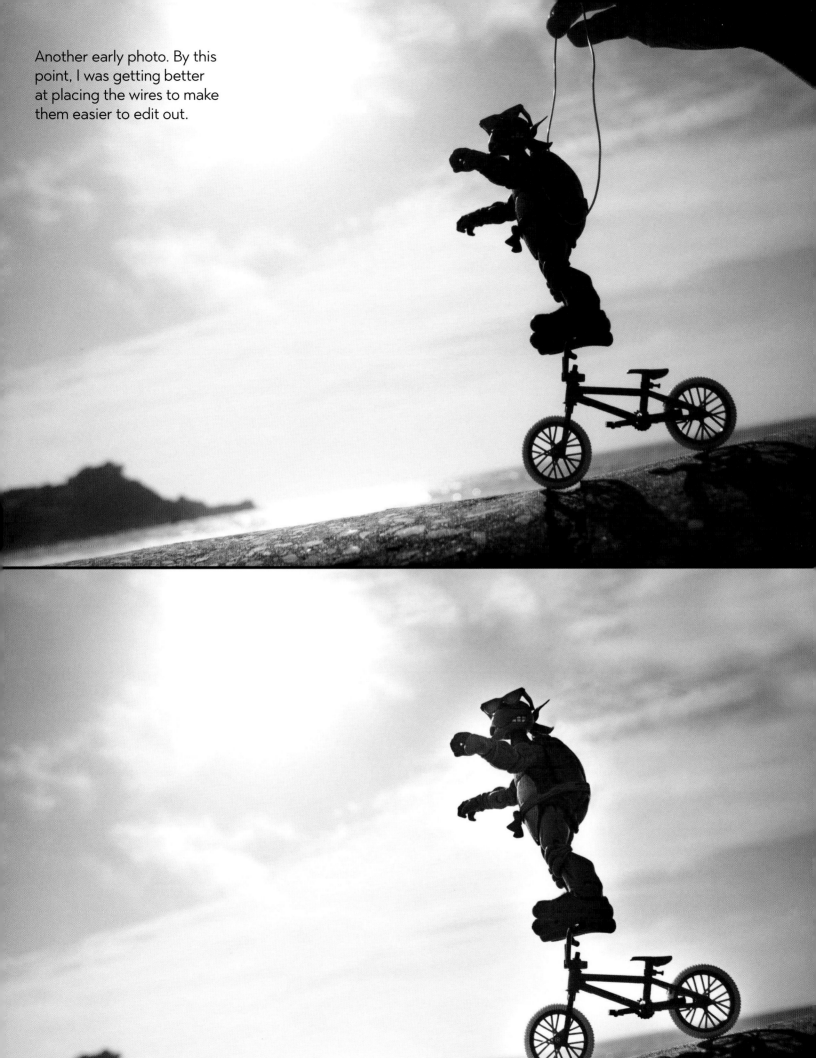

Another early photo. By this point, I was getting better at placing the wires to make them easier to edit out.

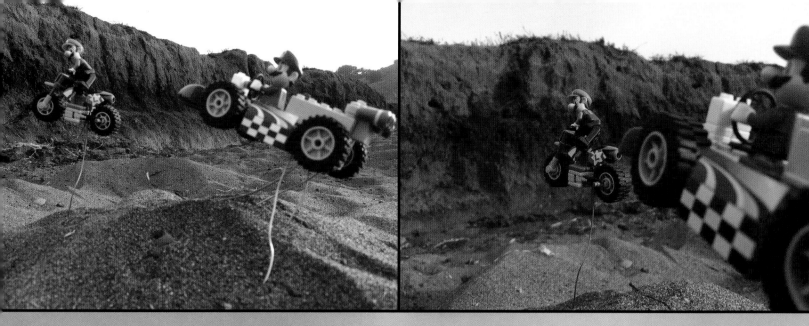

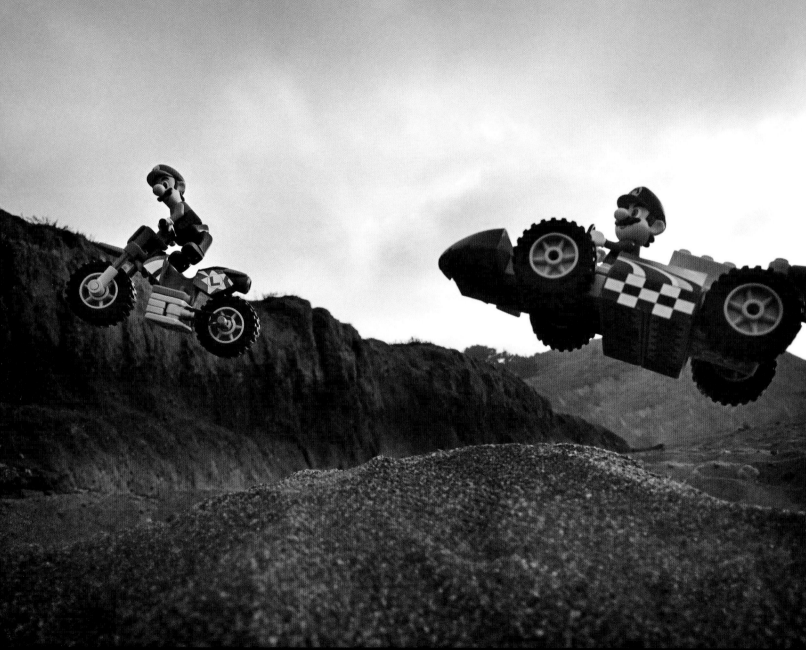

I vividly remember taking this shot because I had such a
hard time getting the wire to support Mario. A tip for those
attempting a shot like this—don't use sand! Find an area that's
soft enough to accept the wire but solid enough to support it.

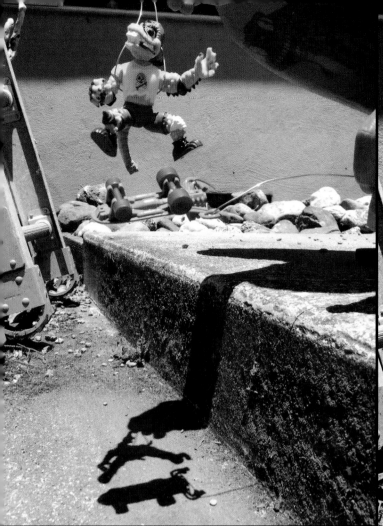

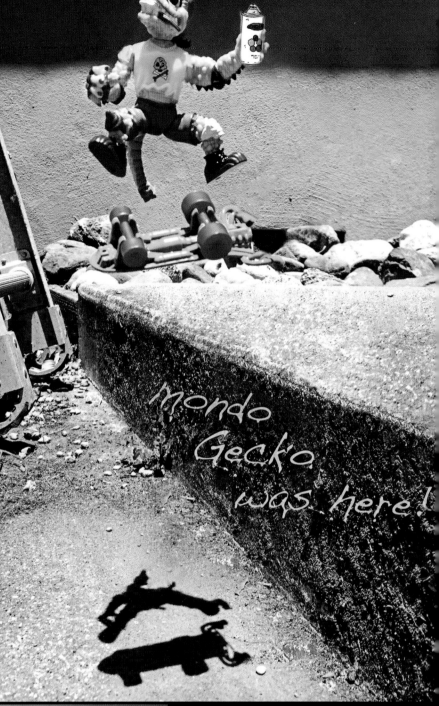

mondo
Gecko
was here!

I had so much fun thinking of all these ideas and trying to pull them off. I thought this photo was so cool when I took it—my girlfriend Crystal Photoshopped the graffiti for me. It looks pretty bad compared to what I feel I can do now. I still have as much fun as I did then, but I have more skill because I keep trying to progress and learn new techniques.

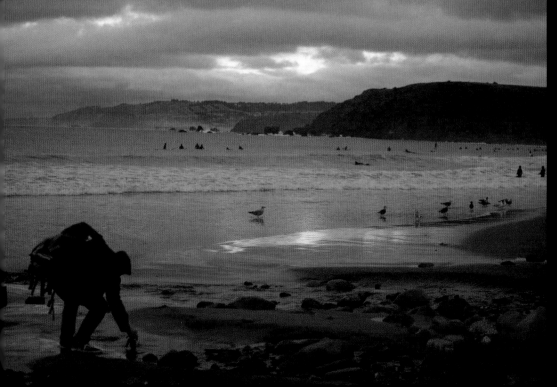

A rare photo of me out shooting at the beach between storms during winter. I wanted to use the streams for some Godzilla shots.

As corny as it might sound, when I'm out there setting up and shooting, I truly feel like I'm free.

The only thing I'm thinking of is the shot, and the rest of life is put on hold.

I took this at one of my favorite beaches, which has cool rock formations that make great environments. I originally wanted the entire ground to be covered in snow (flour) but I decided that unfinished or early snow fall look would work too. I sprinkled flour over the figure while using a wireless remote to take the picture. I wanted to show the different stages of this shot since it happened in a place that would never get snow.

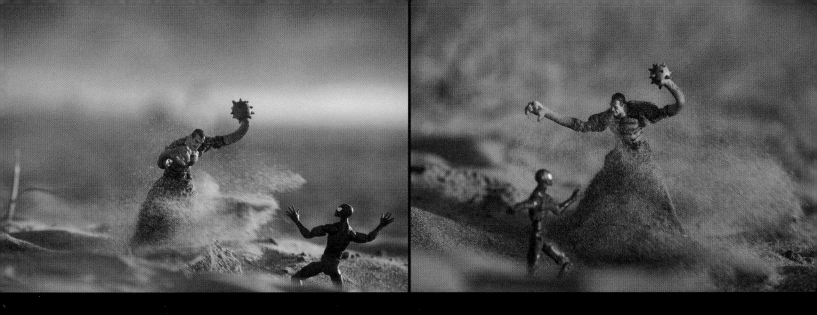

Sometimes I buy figures because they fit my style of photography, like this awesome Sandman. I took him to the beach and made a mound of sand to stick him into using a cup and some water. After I had him posed, I tossed some sand at the base of the mound to make it seem like he was coming out of the ground. I remember being really happy with the results.

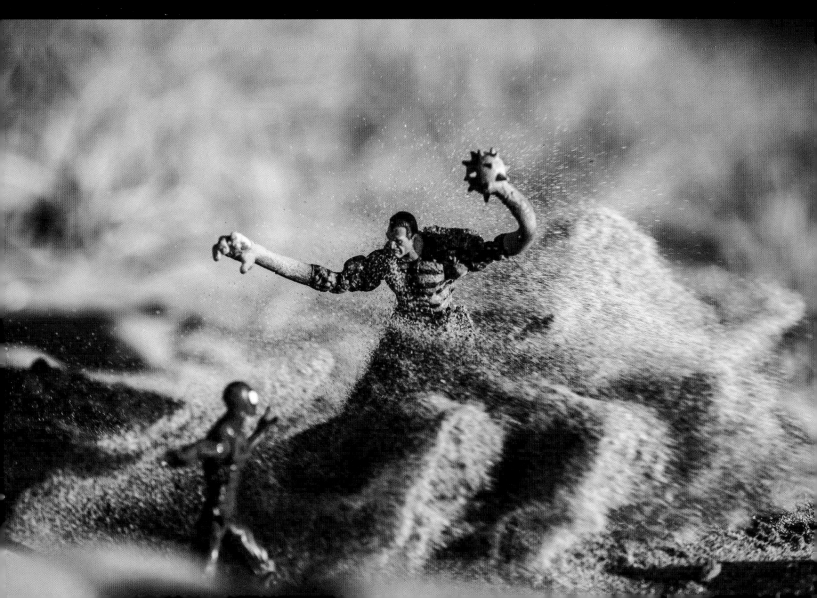

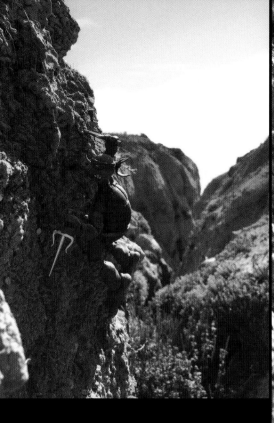

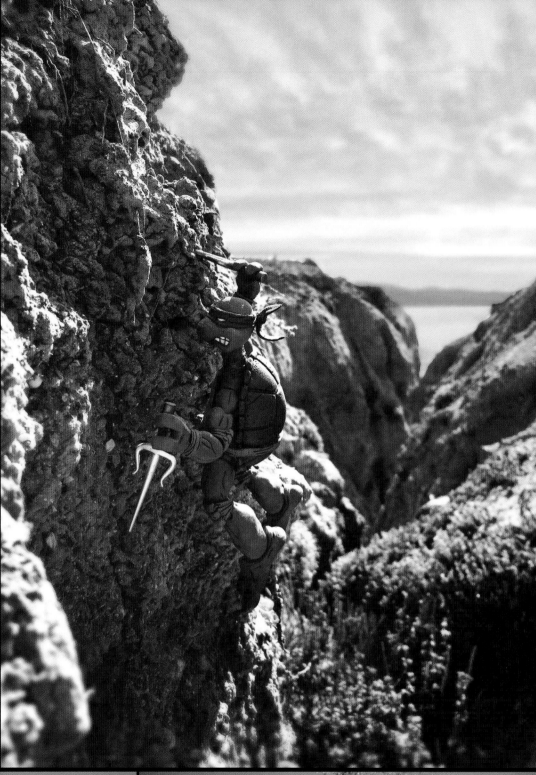

This is still one of my favorites. I like to be spontaneous and come up with ideas on the spot. This bluff inspired the idea to have Raph in a cliffhanging scene. This shows both the original shot and the edit, with post processing by Crystal. The post work really turned this into something cool.

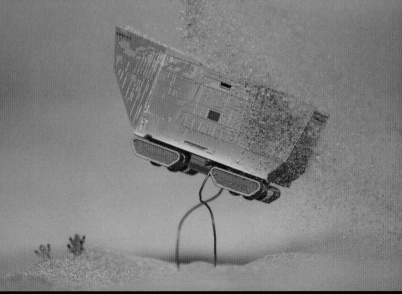

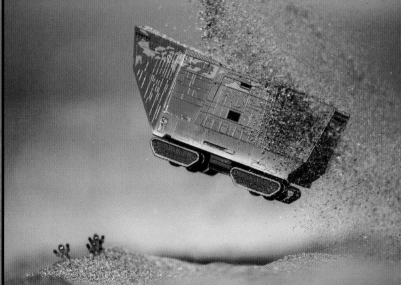

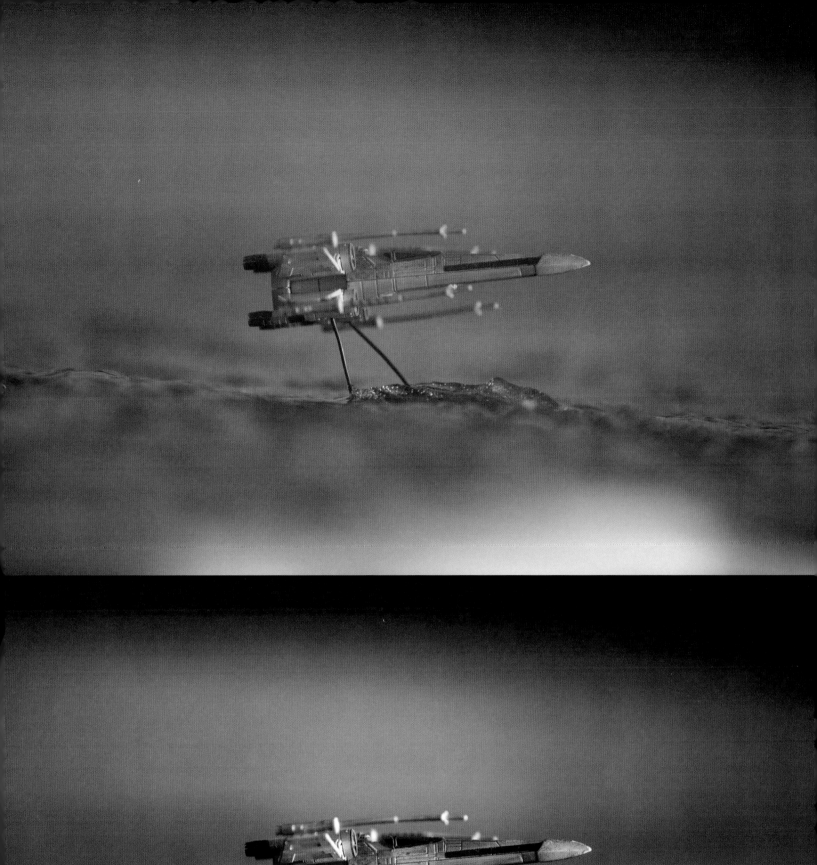
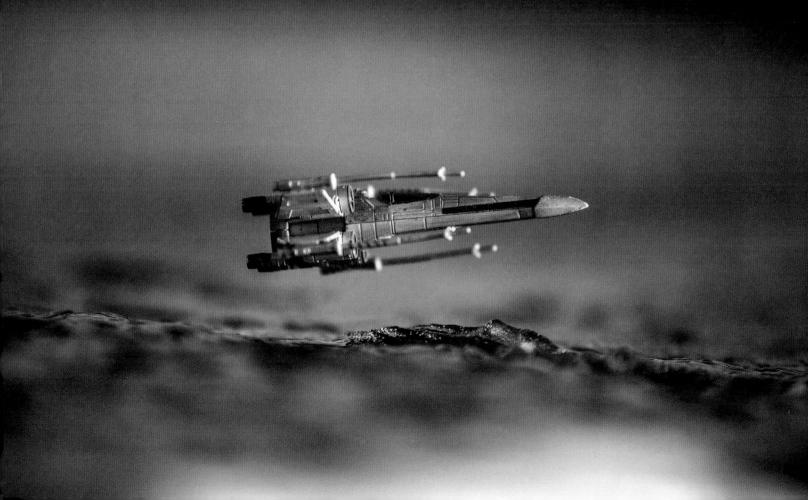

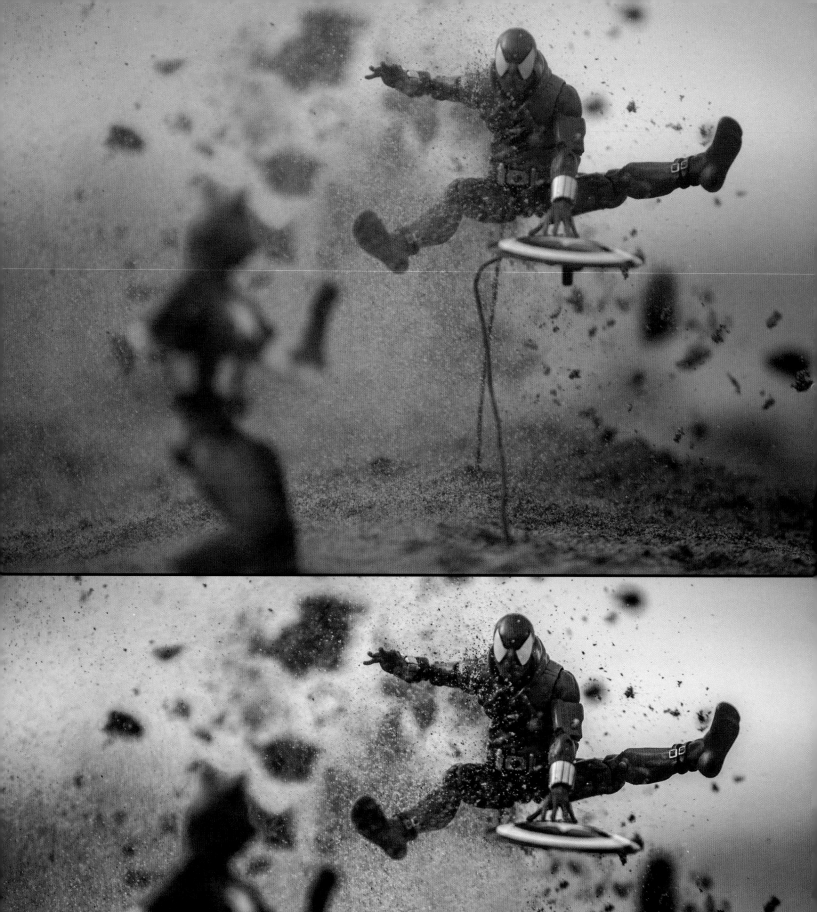
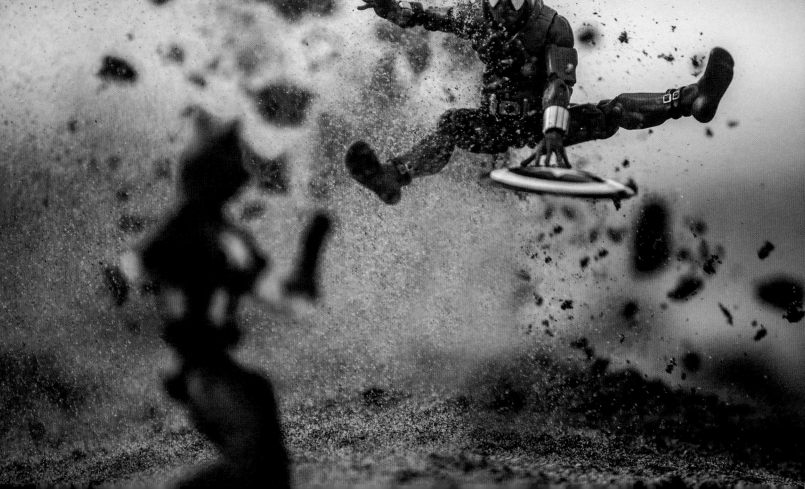

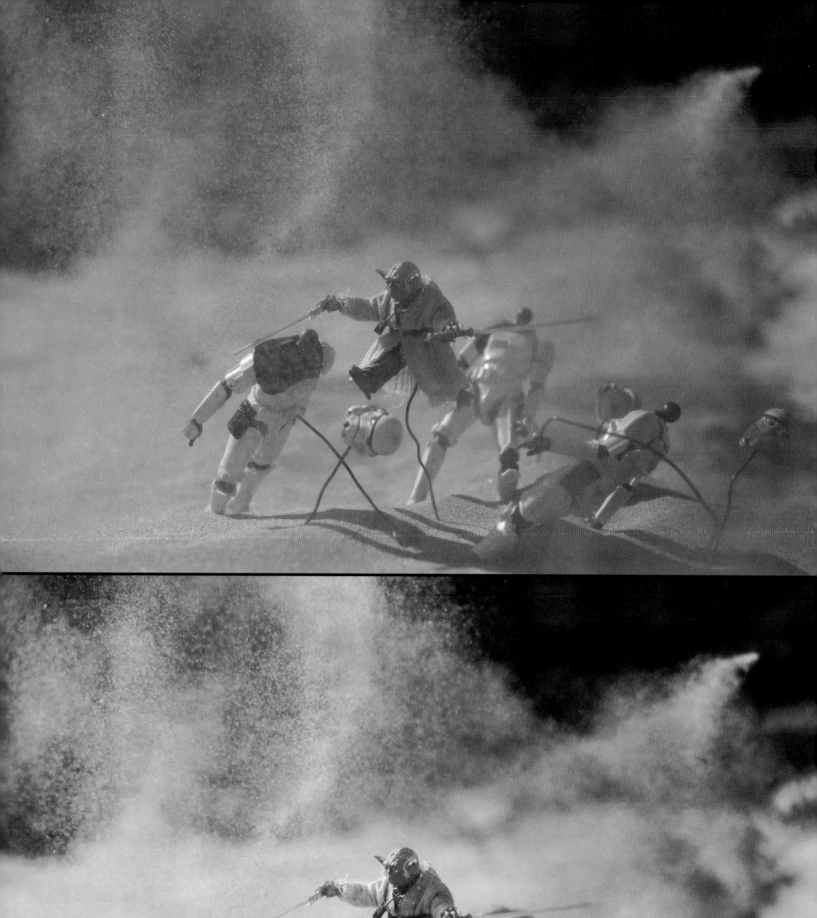
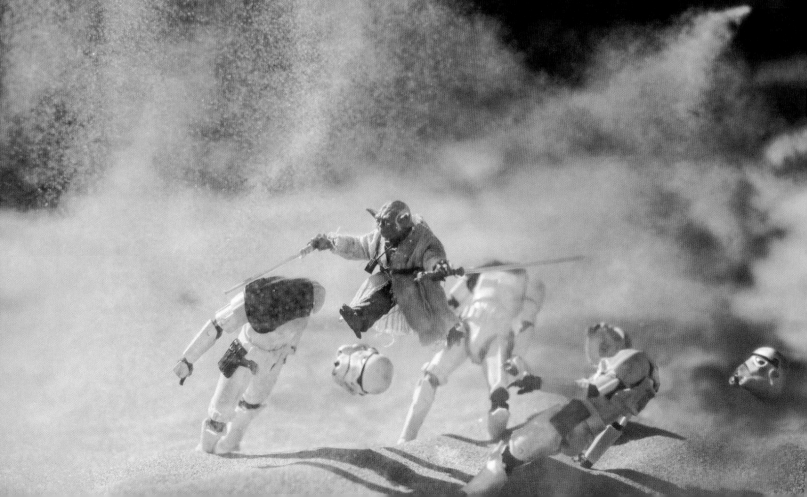

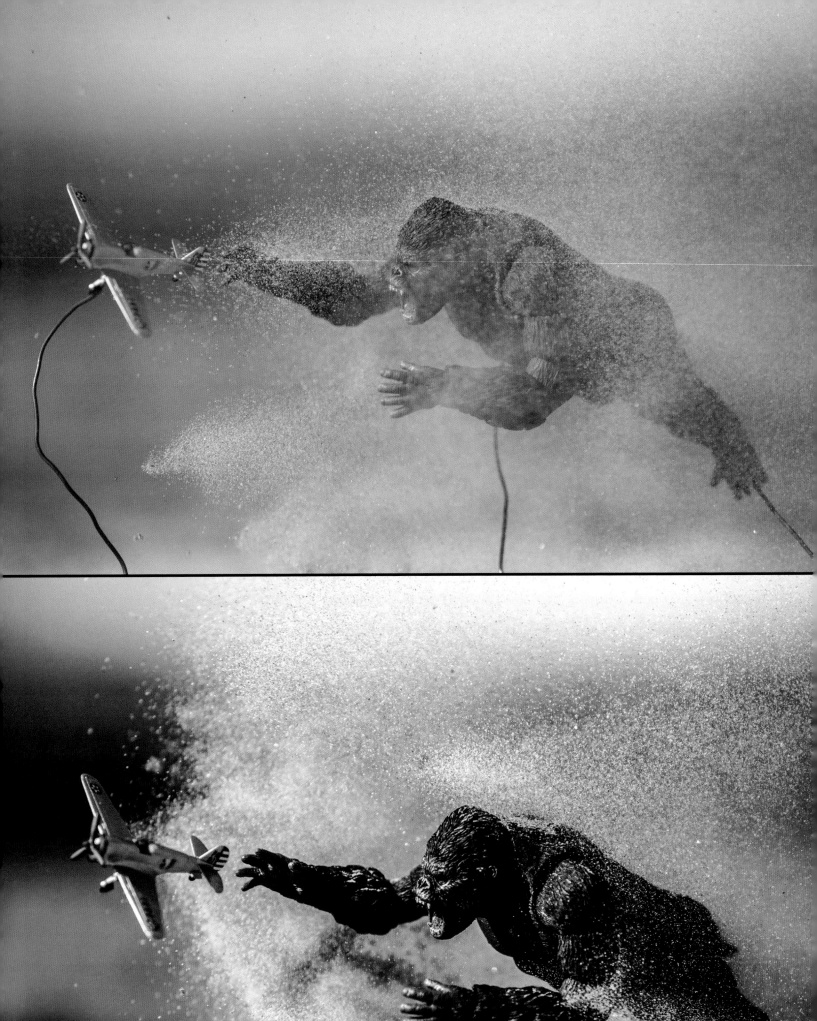

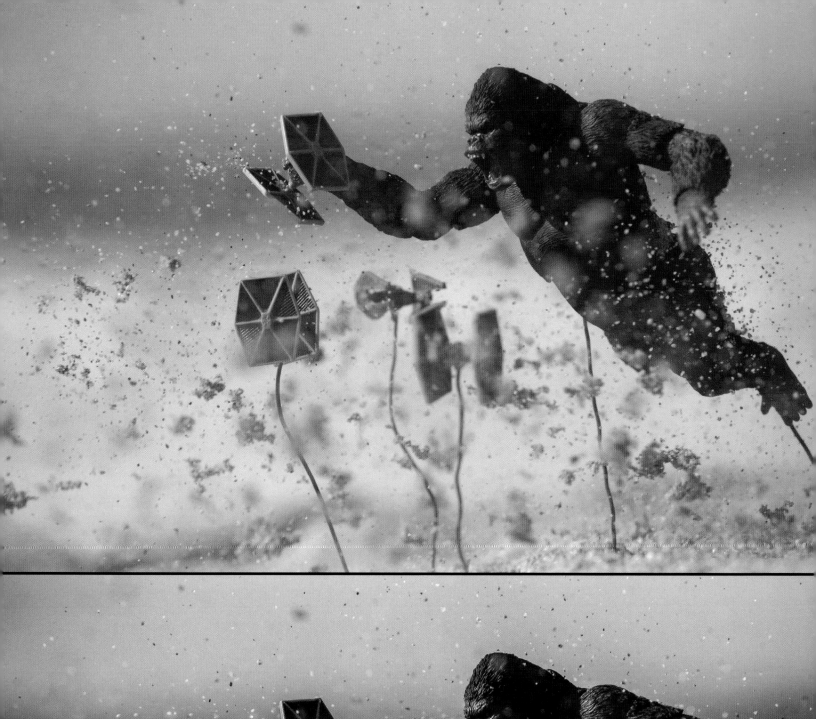
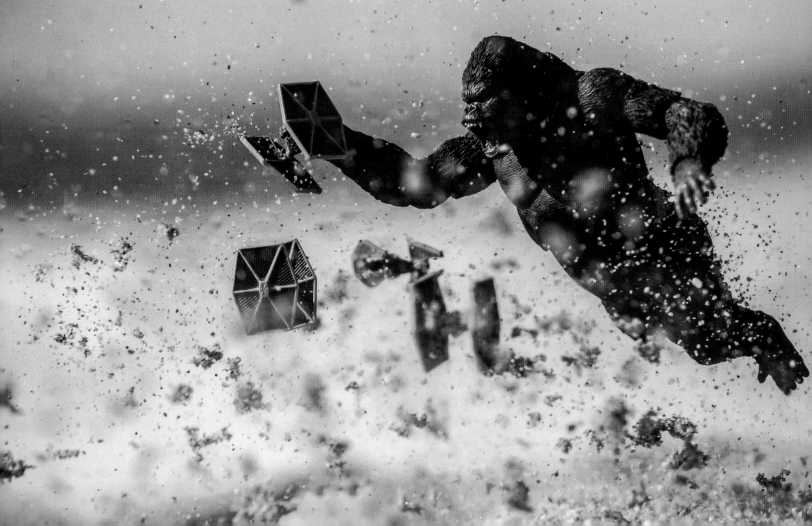

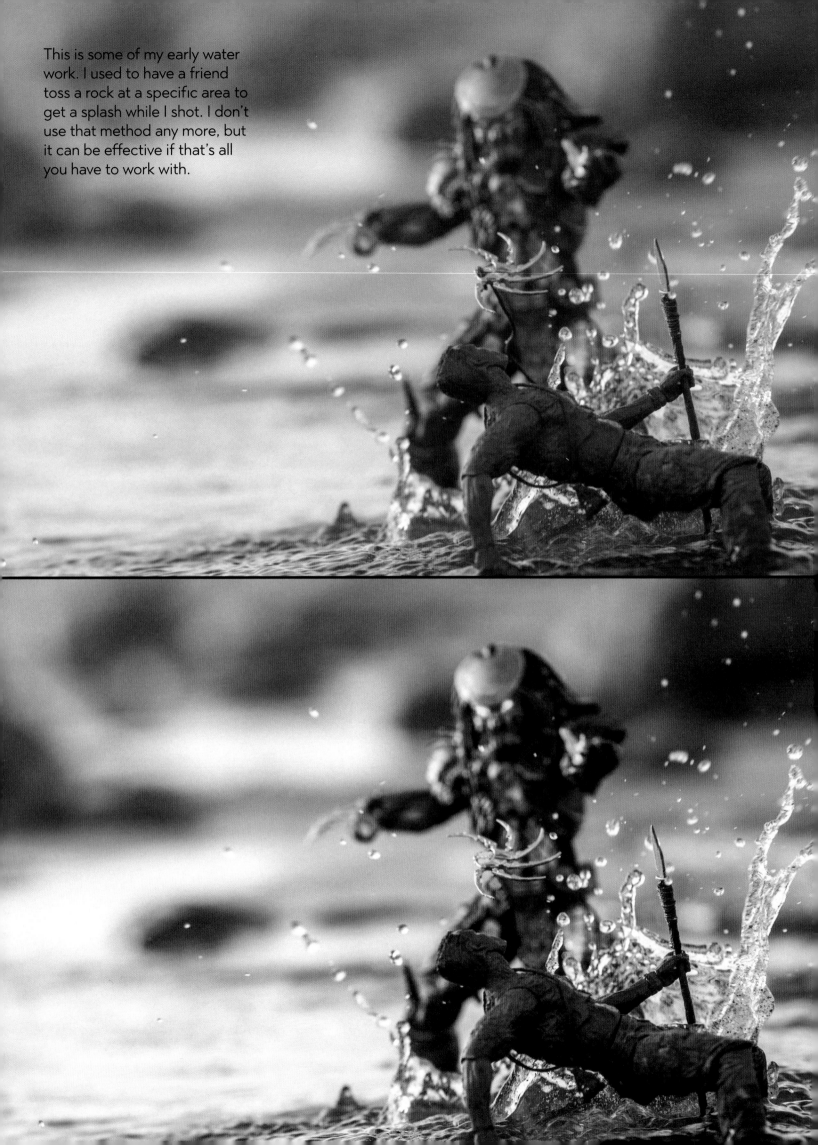

This is some of my early water work. I used to have a friend toss a rock at a specific area to get a splash while I shot. I don't use that method any more, but it can be effective if that's all you have to work with.

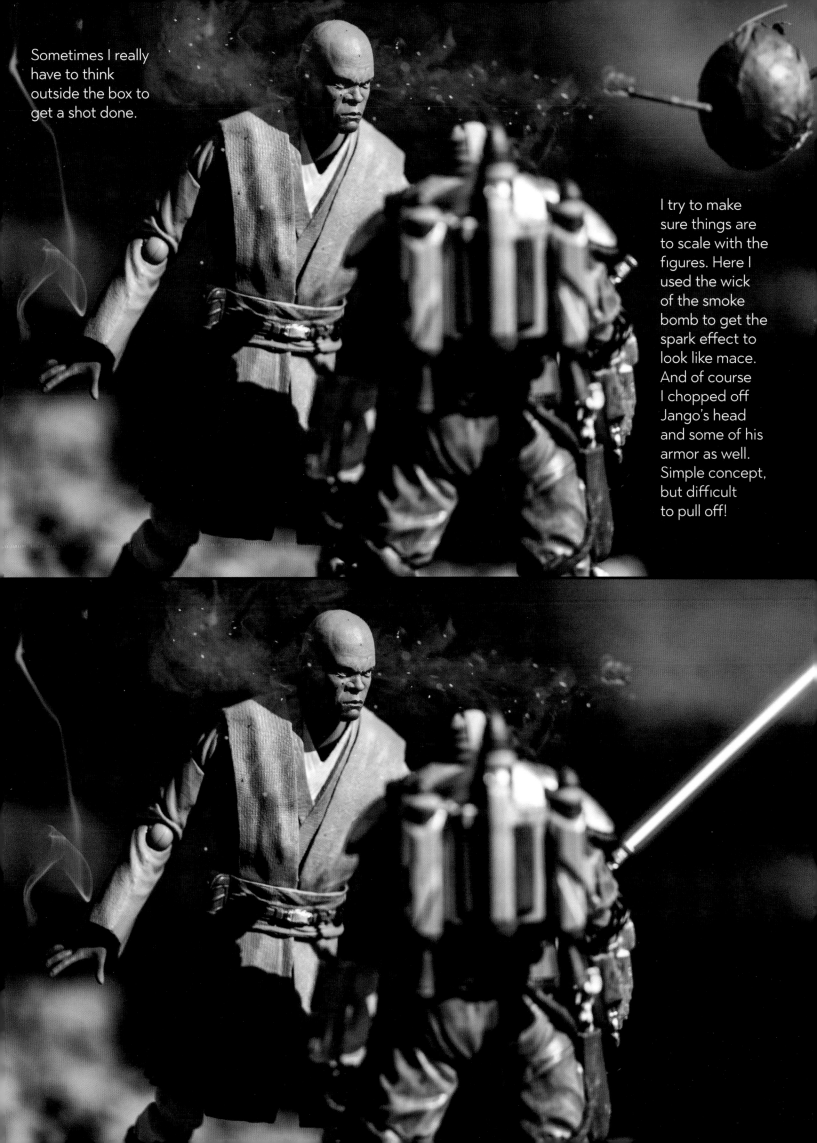

Sometimes I really have to think outside the box to get a shot done.

I try to make sure things are to scale with the figures. Here I used the wick of the smoke bomb to get the spark effect to look like mace. And of course I chopped off Jango's head and some of his armor as well. Simple concept, but difficult to pull off!

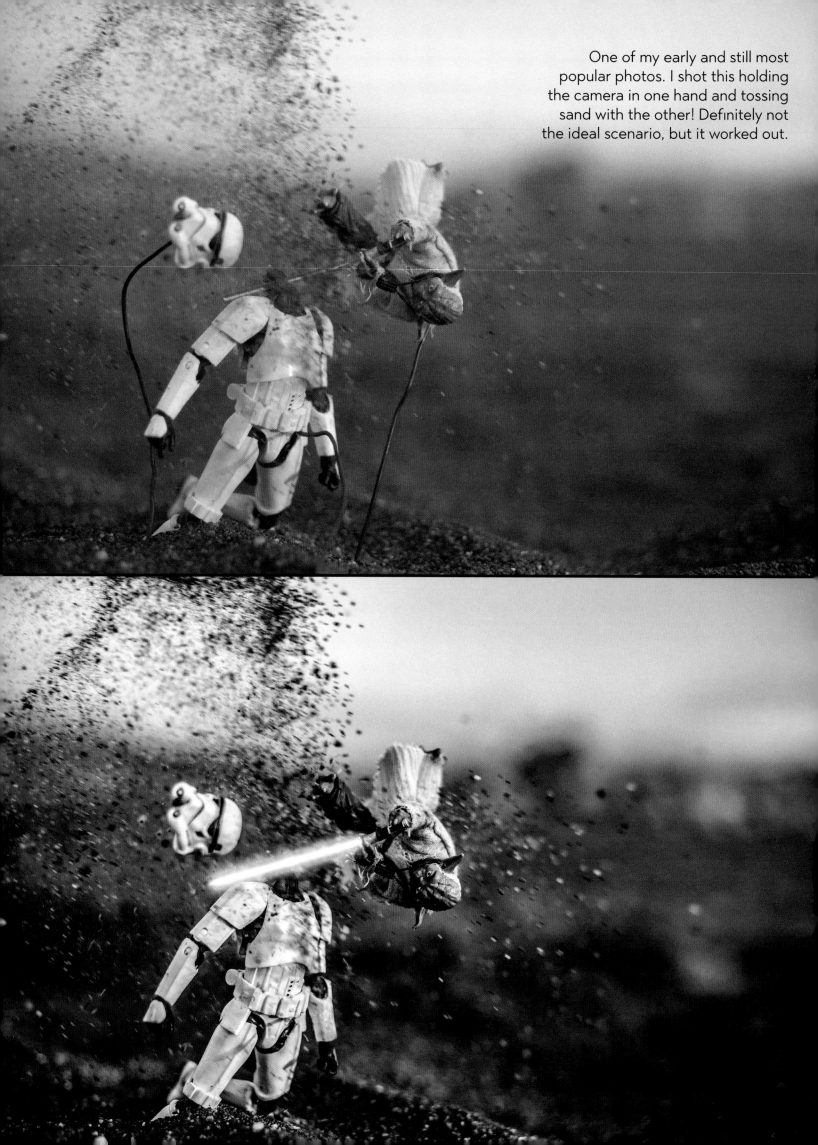

One of my early and still most popular photos. I shot this holding the camera in one hand and tossing sand with the other! Definitely not the ideal scenario, but it worked out.

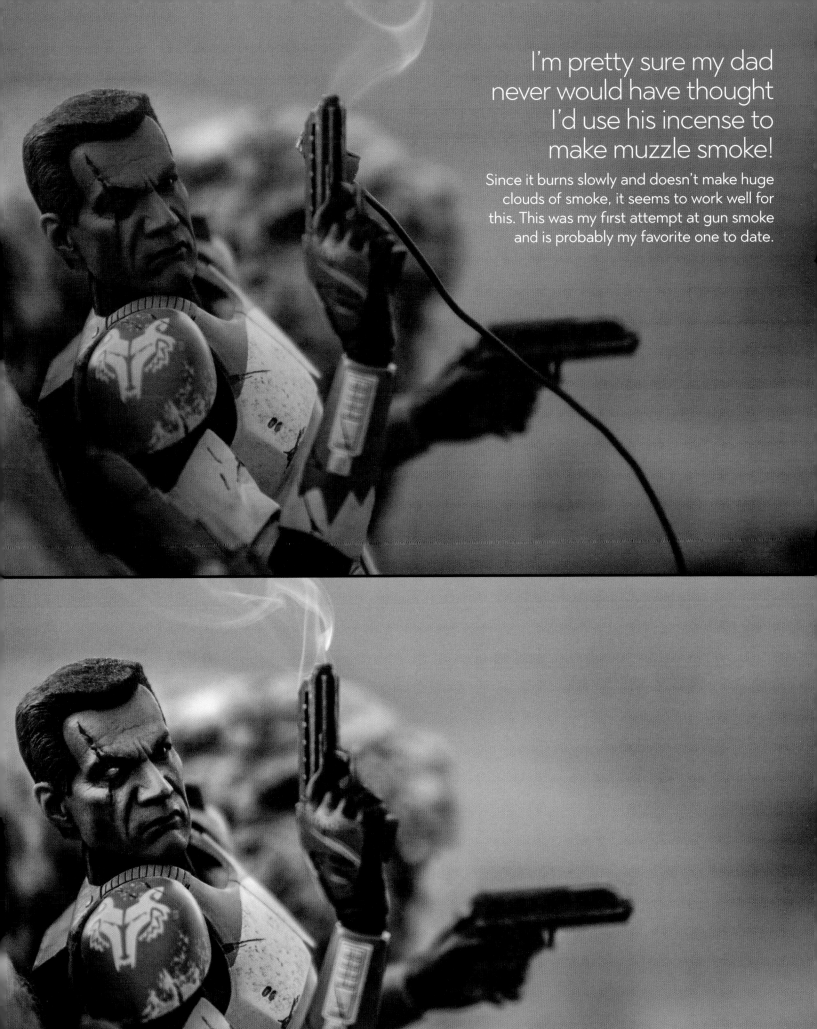

I'm pretty sure my dad never would have thought I'd use his incense to make muzzle smoke!

Since it burns slowly and doesn't make huge clouds of smoke, it seems to work well for this. This was my first attempt at gun smoke and is probably my favorite one to date.

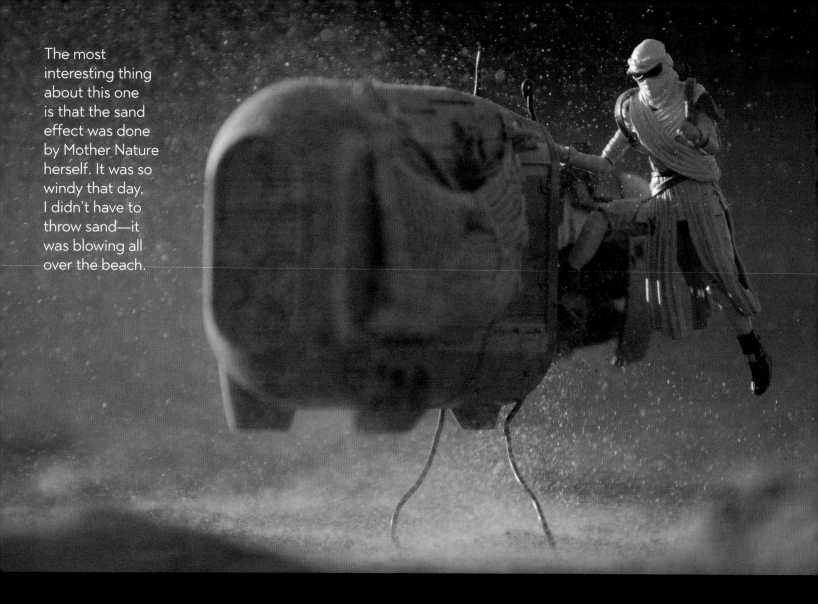

The most interesting thing about this one is that the sand effect was done by Mother Nature herself. It was so windy that day, I didn't have to throw sand—it was blowing all over the beach.

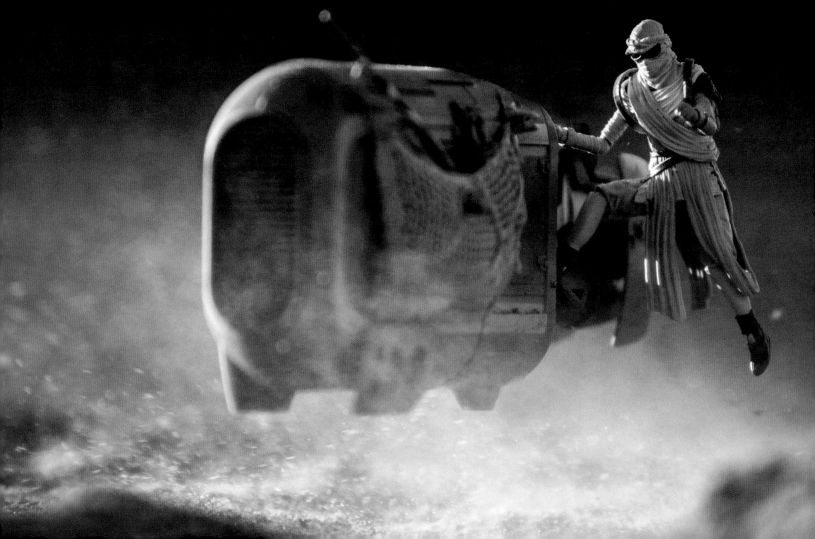

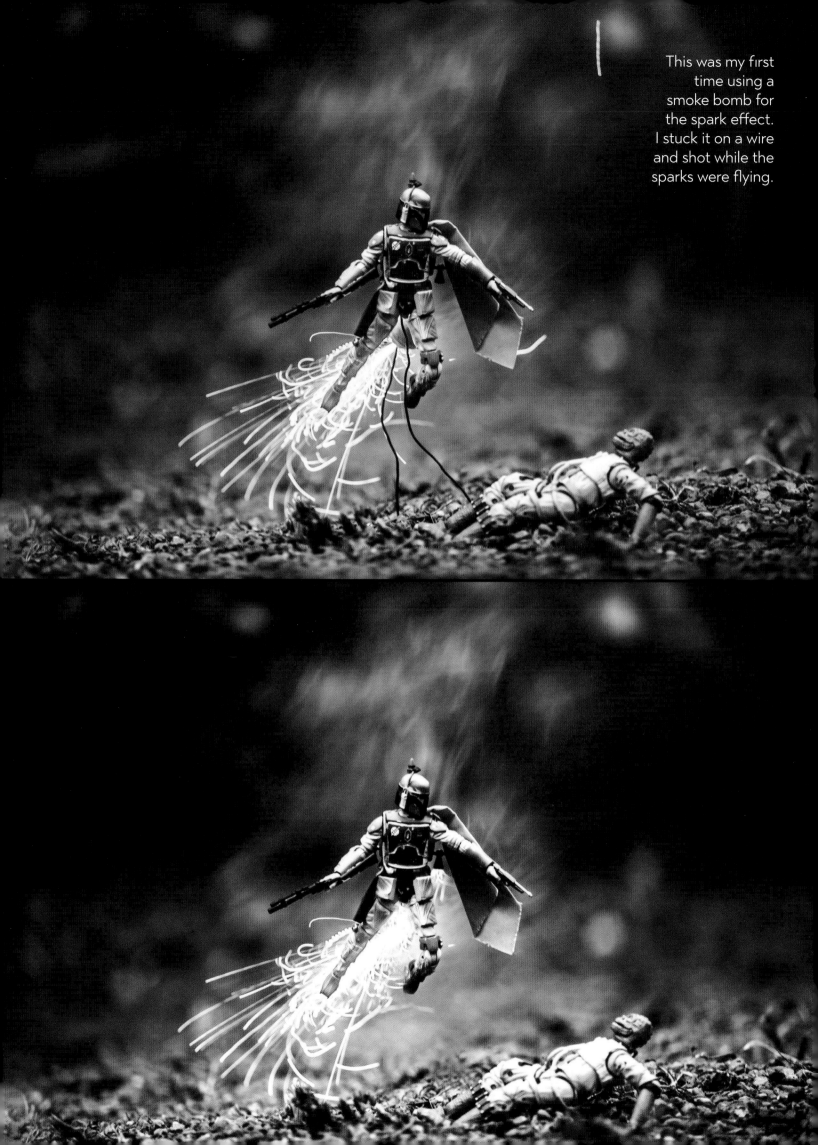

This was my first time using a smoke bomb for the spark effect. I stuck it on a wire and shot while the sparks were flying.

I took two wicks off some smoke bombs and used Sticky Tack to attach them to the inside of the figure's neck, then lit them while I took the photo.

This photo doesn't make much sense, but it was fun setting it up.

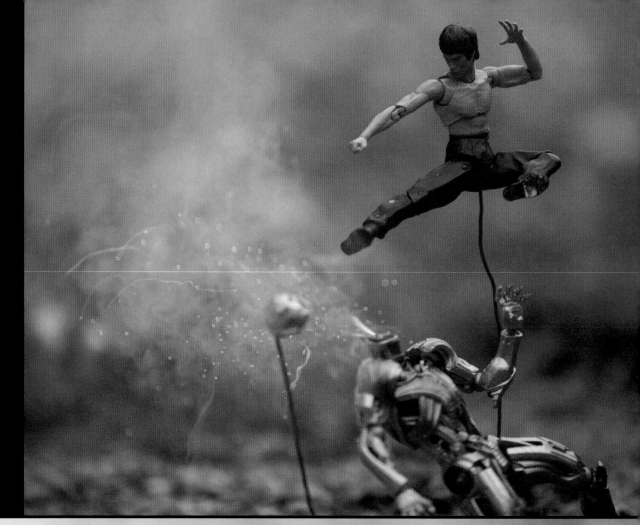

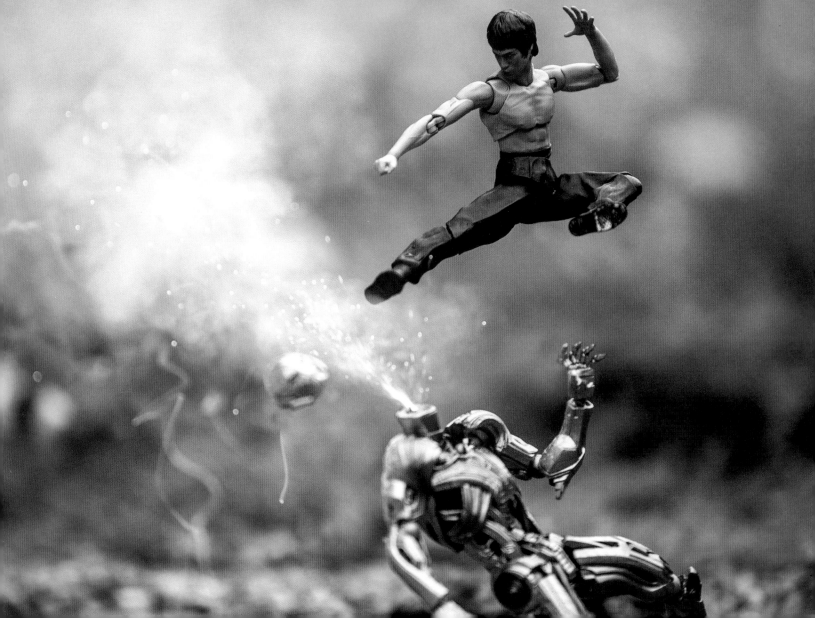

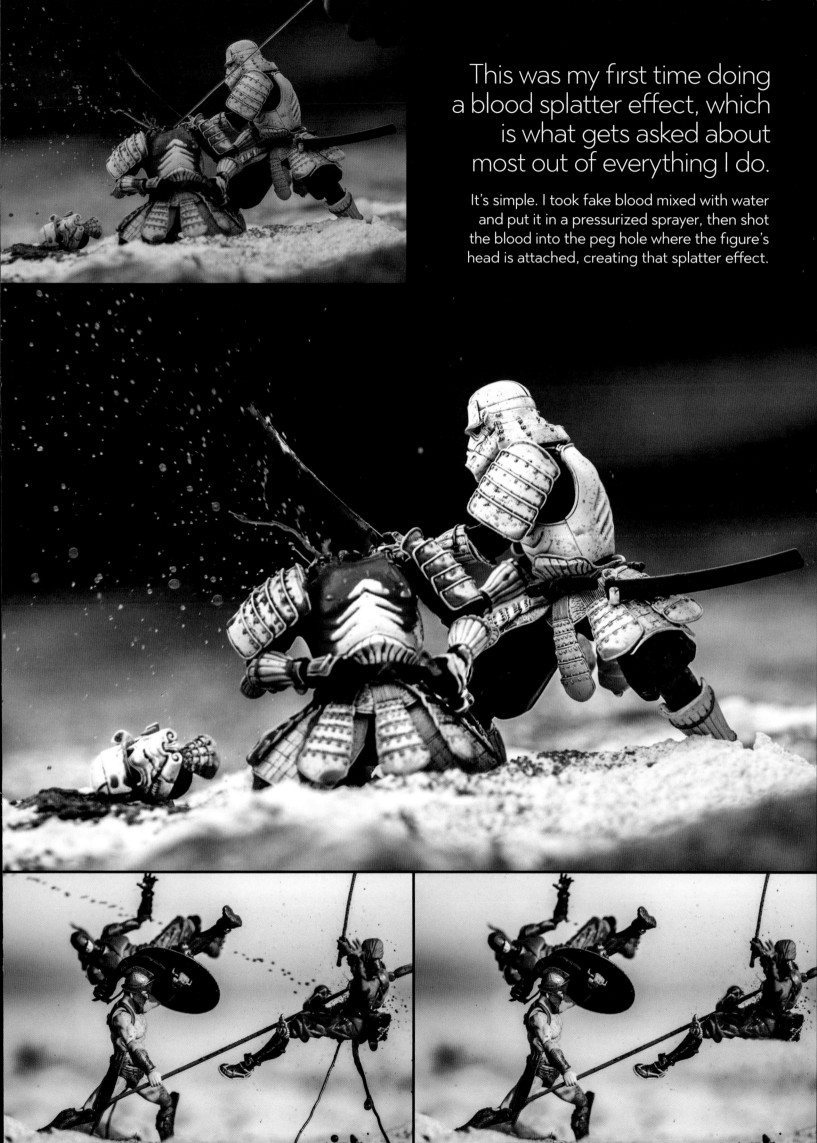

This was my first time doing a blood splatter effect, which is what gets asked about most out of everything I do.

It's simple. I took fake blood mixed with water and put it in a pressurized sprayer, then shot the blood into the peg hole where the figure's head is attached, creating that splatter effect.

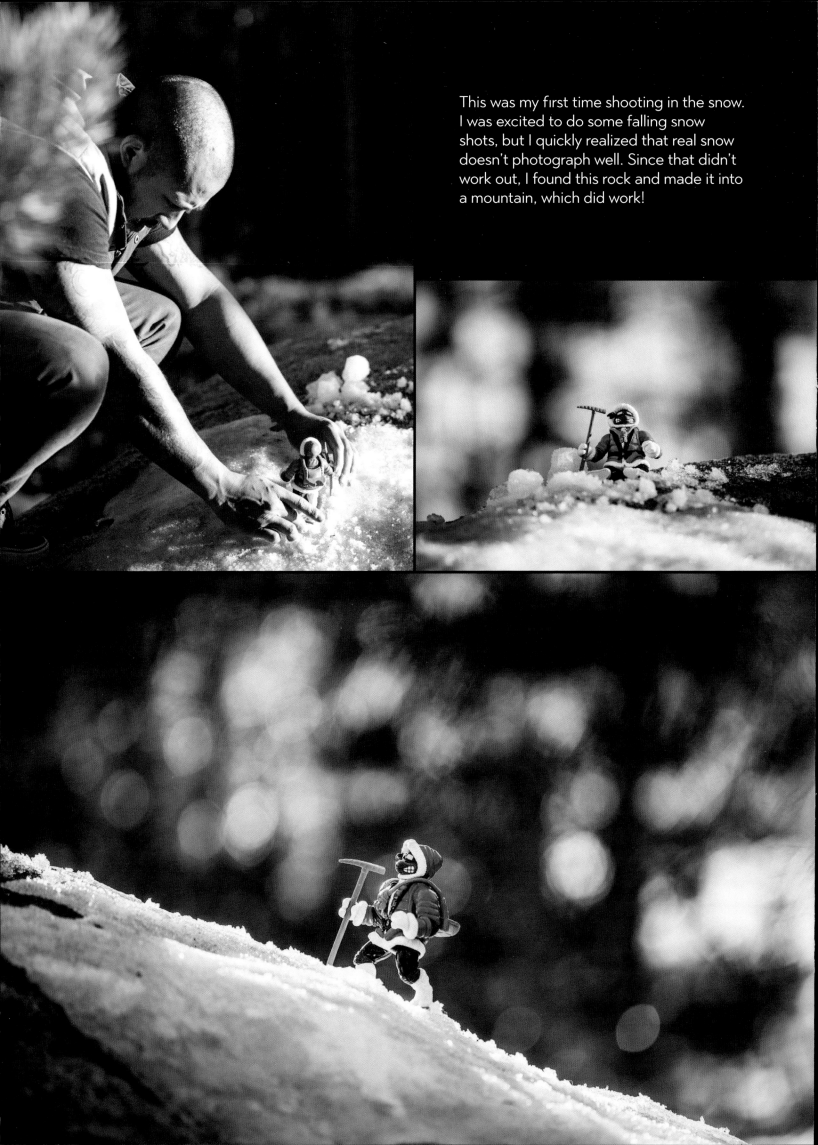

This was my first time shooting in the snow. I was excited to do some falling snow shots, but I quickly realized that real snow doesn't photograph well. Since that didn't work out, I found this rock and made it into a mountain, which did work!

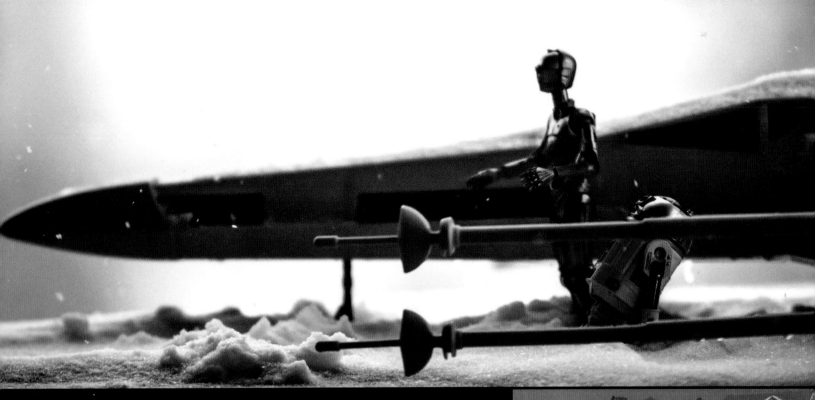

My second time shooting in the snow proved to be much more productive.

I stayed in Northstar Village, Lake Tahoe and took these shots from the balcony while the snow was coming down hard, which was just the look I wanted.

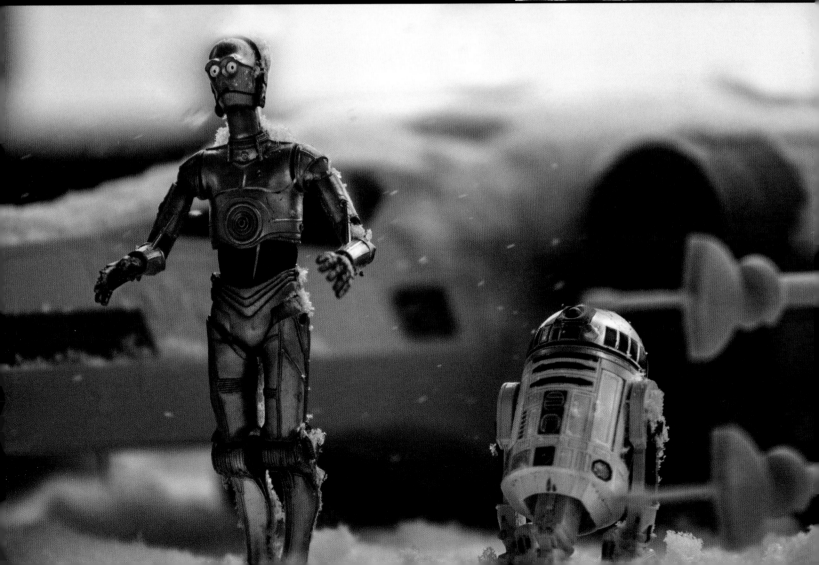

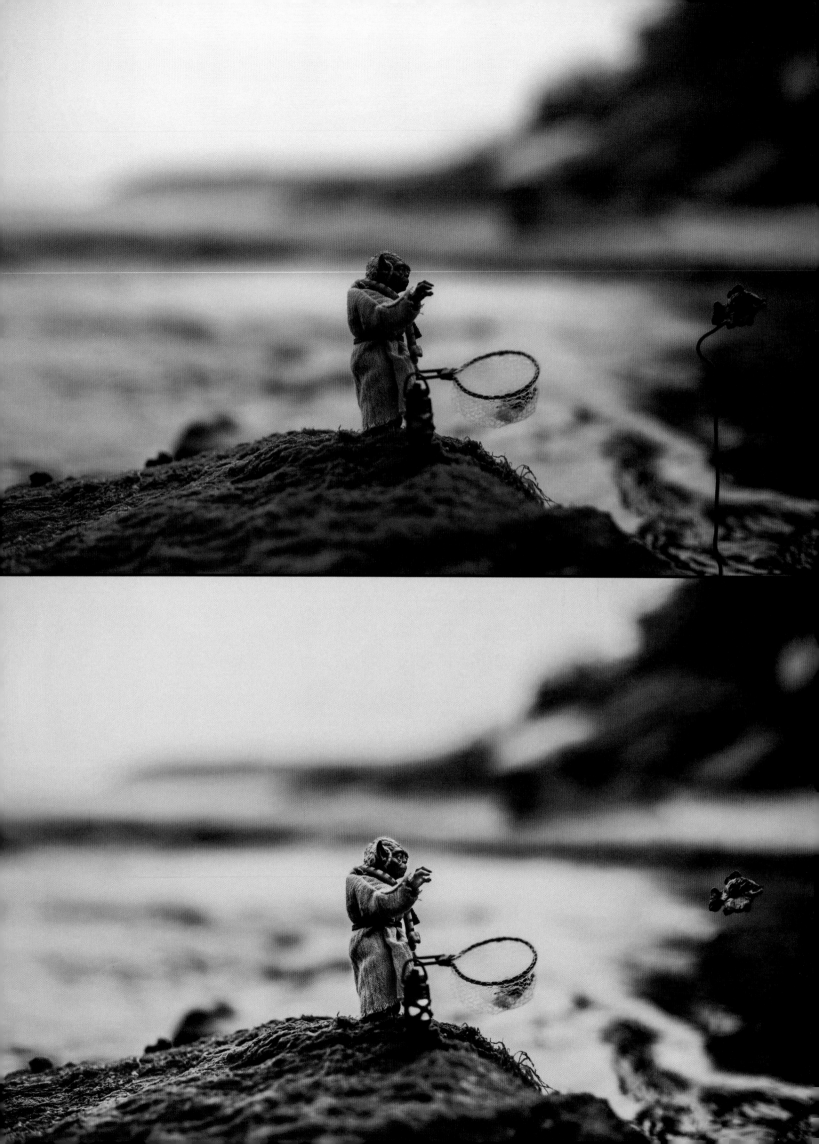

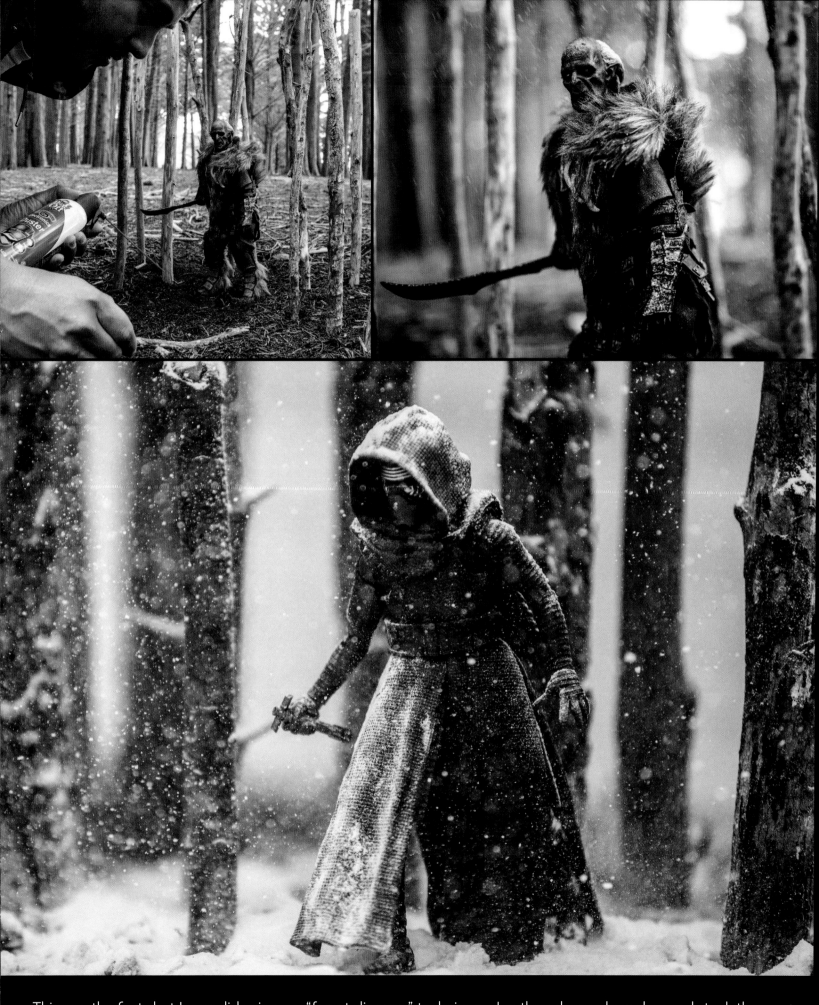

This was the first shot I ever did using my "forest diorama" technique—I gathered some branches and stuck them in the ground, then used some flour for the ground and falling effect. This diorama has provided me a lot of great shots for being such a simple solution.

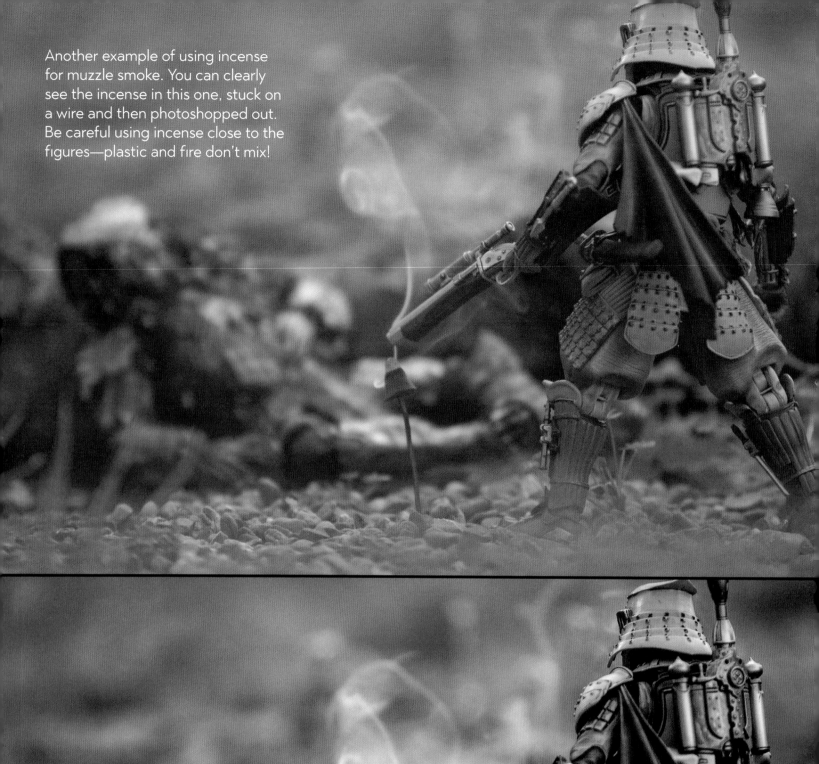

Another example of using incense for muzzle smoke. You can clearly see the incense in this one, stuck on a wire and then photoshopped out. Be careful using incense close to the figures—plastic and fire don't mix!

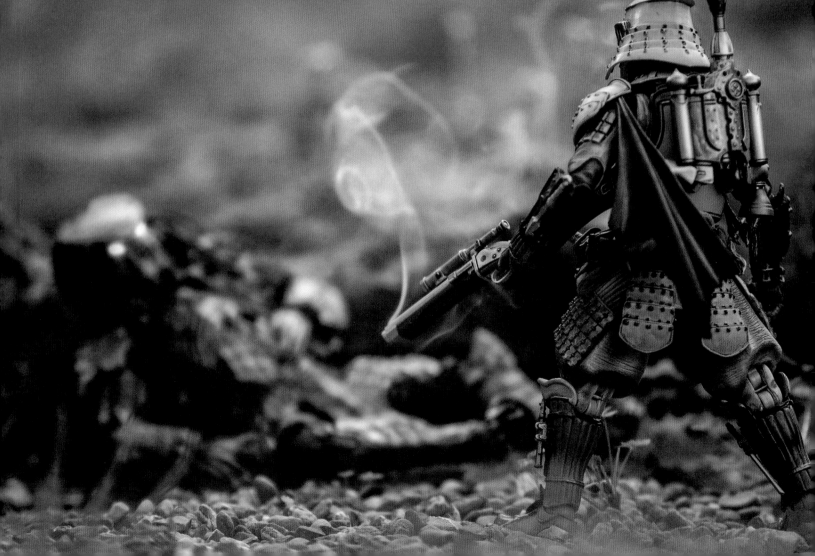

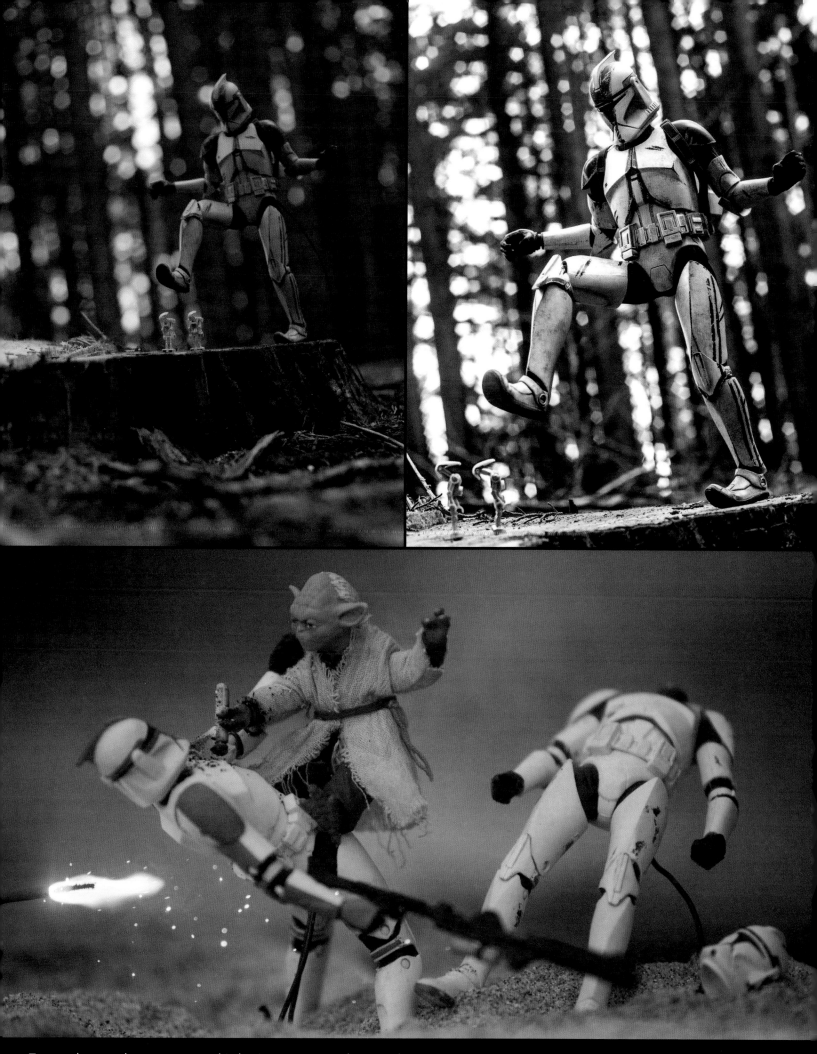

Fireworks are dangerous, and I don't recommend using them if you're just starting out. But if you do decide to use them, don't use them with anything you don't want to ruin. I've found that the risk can be worth the reward, if you're willing to go there. The clone trooper hero was burned pretty badly during this shoot.

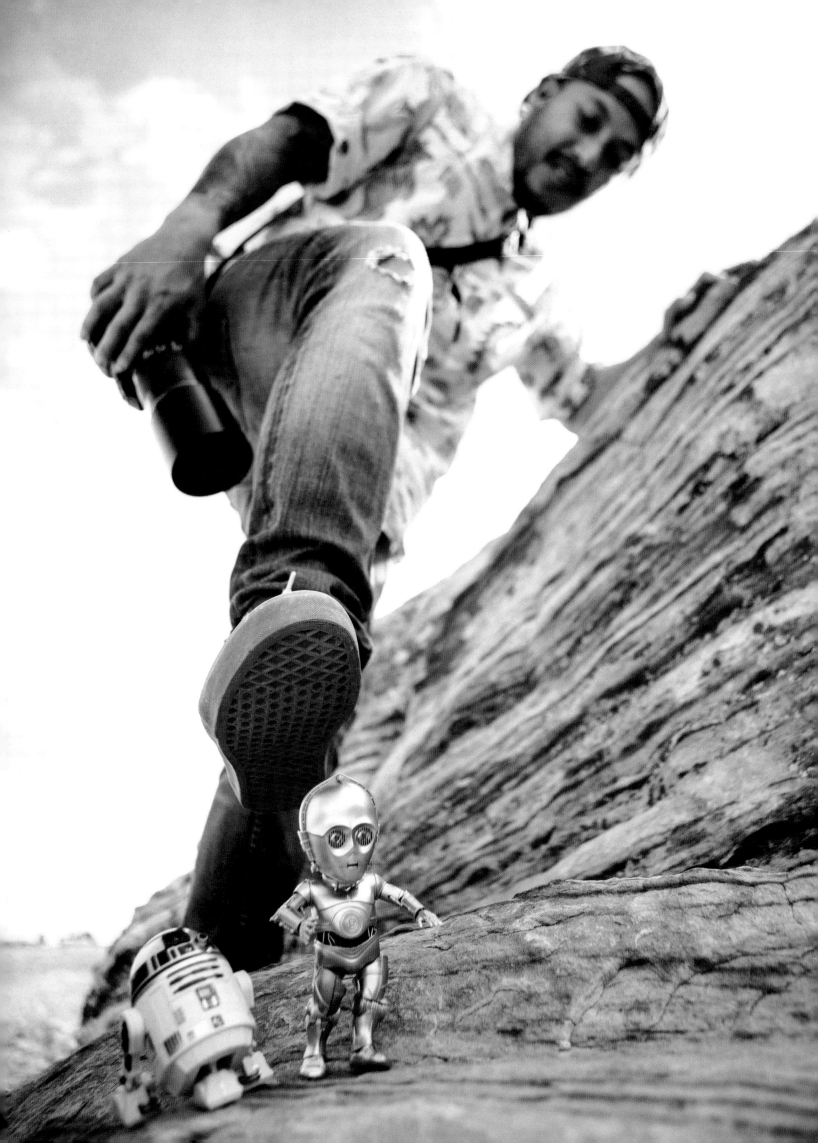

I was attending a photography convention in Vegas with my girlfriend and some of her coworkers when we decided to venture out to Red Rocks to take some photos. Nobody else in the group shoots toys, but Derek Gaumer—an extremely talented friend who was there—captured this shot of me at work. Thanks for the photo, D!

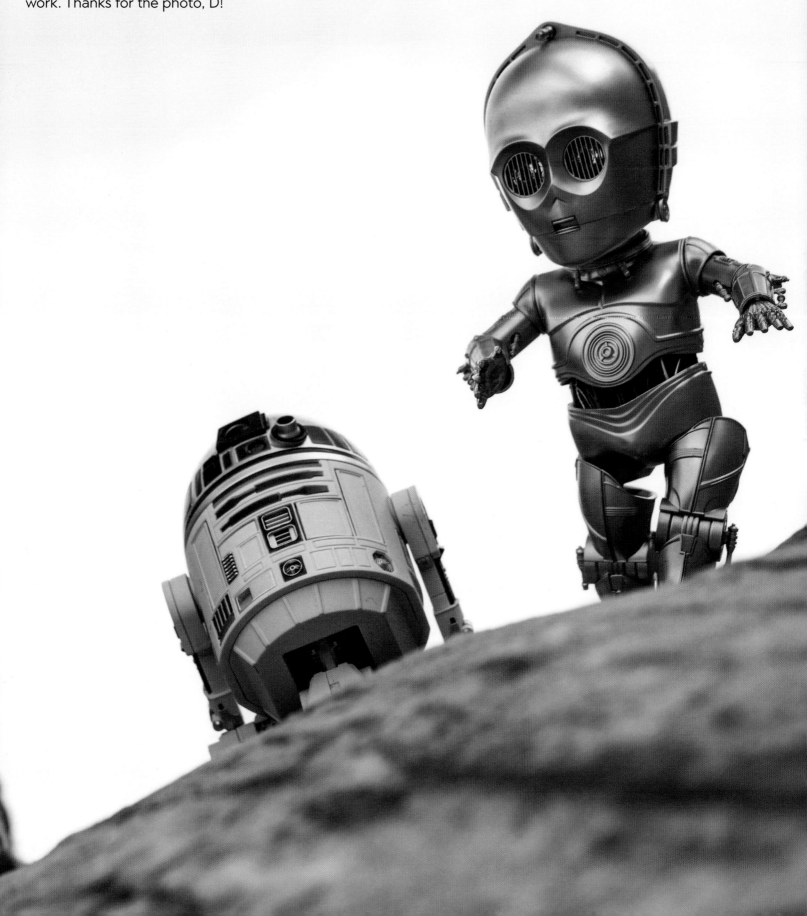

DEDICATION

For Crystal

You're one constant good thing in my life.
I wouldn't want to share this journey with anyone else.

I love you.